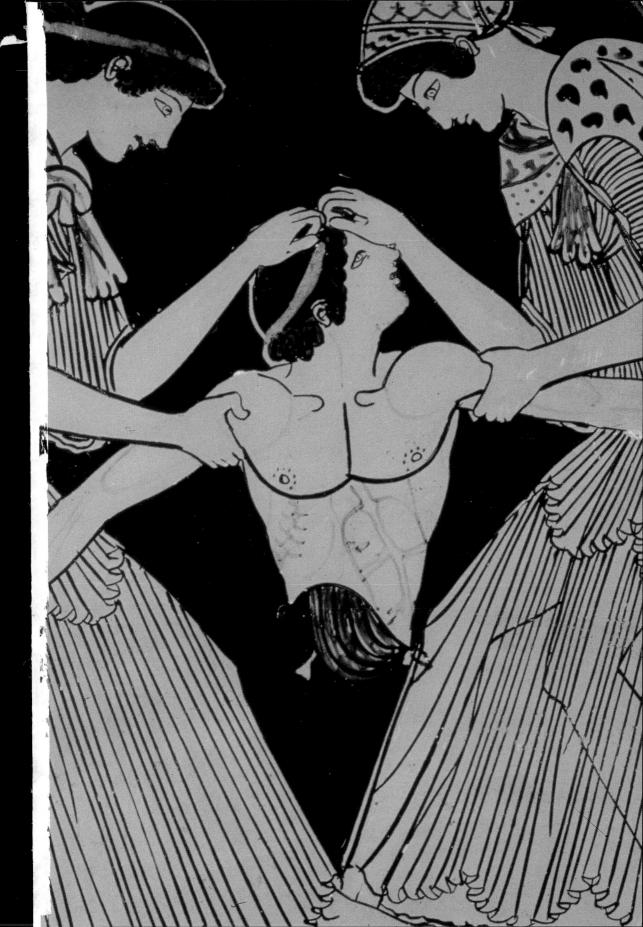

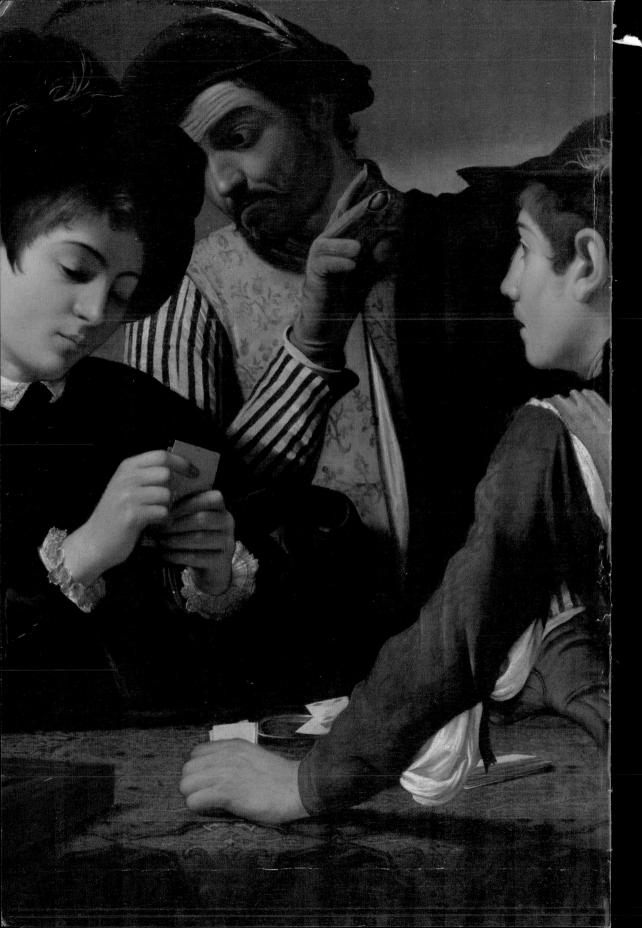

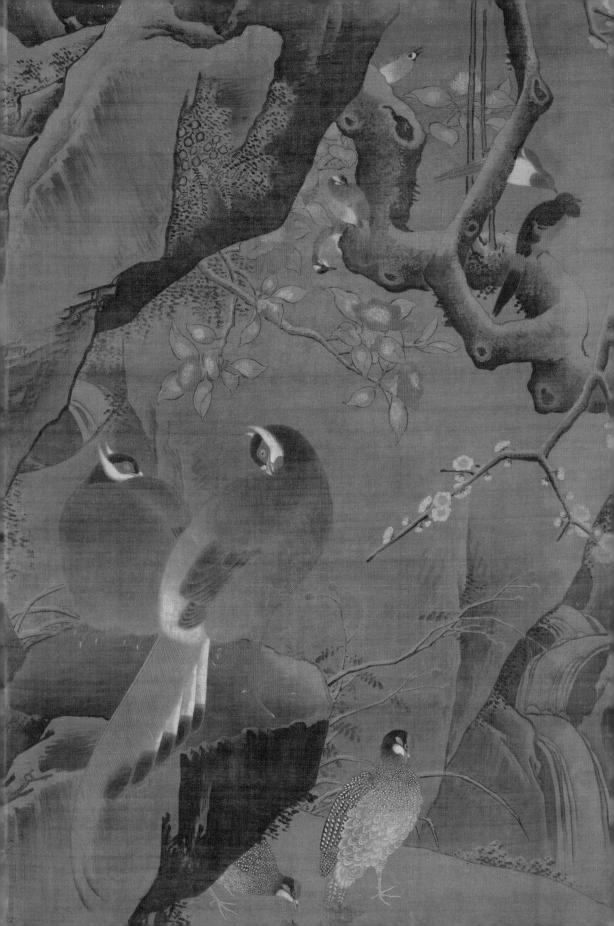

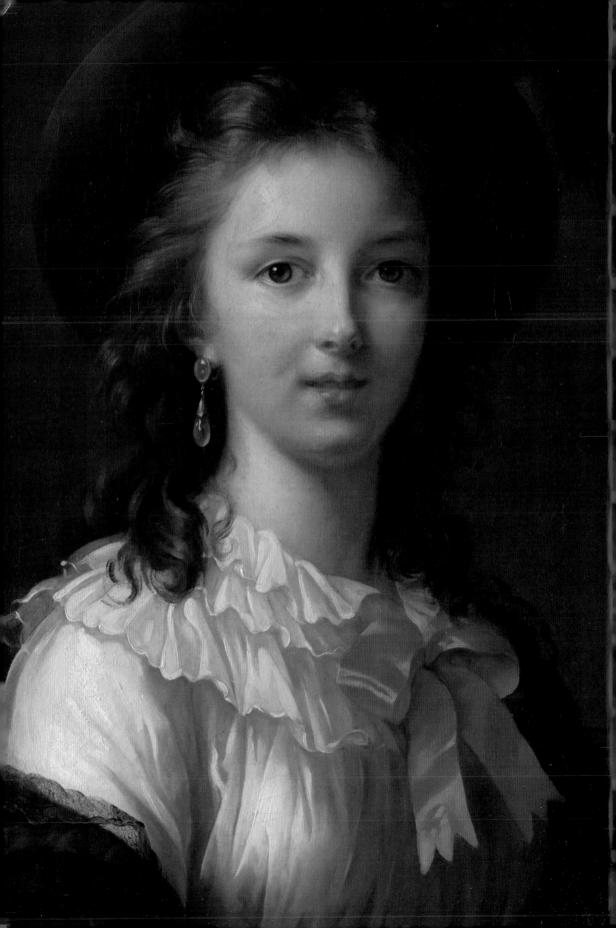

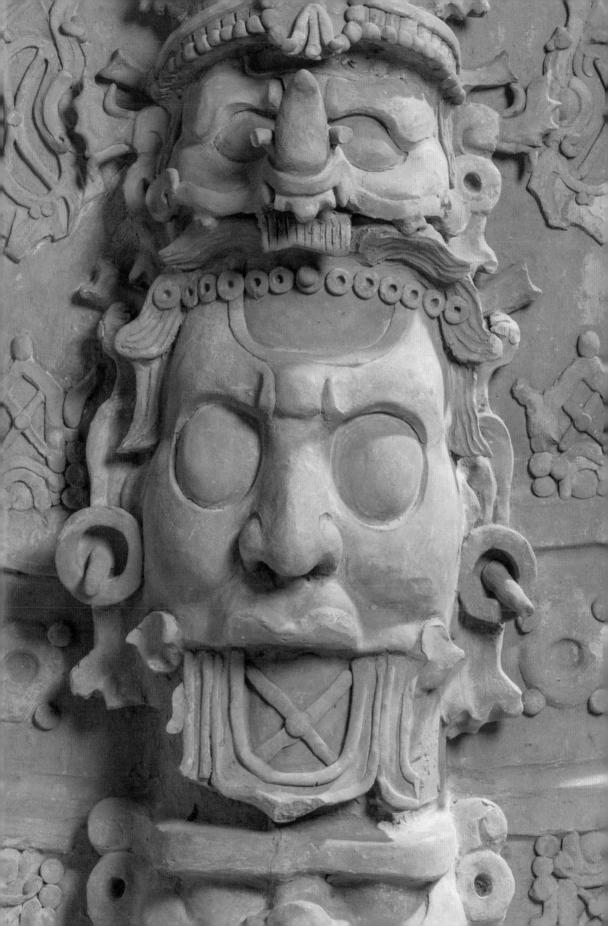

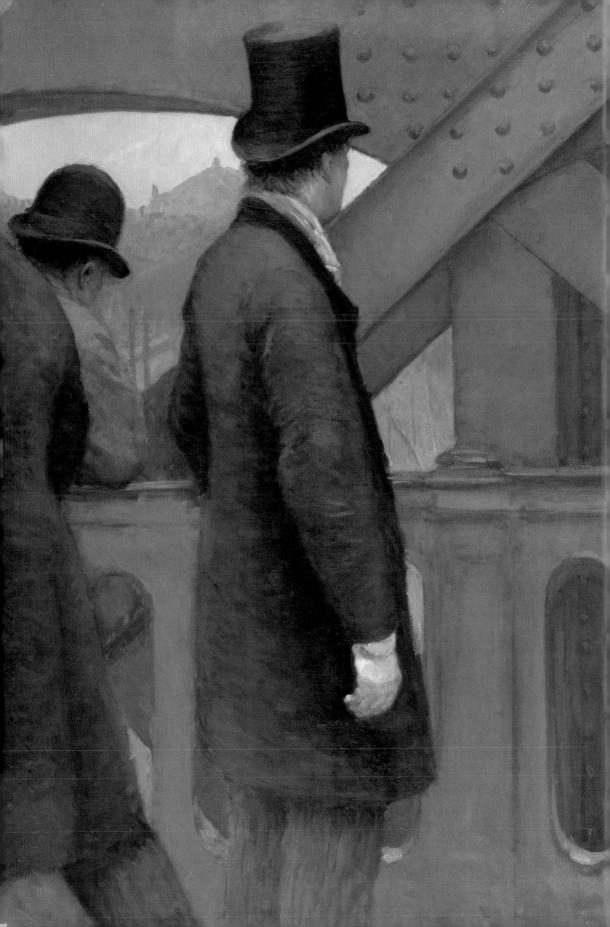

Kimbell Art Museum Guide

Edited by

Eric M. Lee

Kimbell Art Museum

FORT WORTH

Distributed by

YALE UNIVERSITY PRESS

NEW HAVEN AND LONDON

Published by the Kimbell Art Museum, Fort Worth Distributed by Yale University Press, New Haven and London

© 2013 by the Kimbell Art Museum

All rights reserved. This book may not be reproduced, in whole or in part, including illustrations, in any form (beyond that copying permitted by Sections 107 and 108 of the U.S. Copyright Law and except by reviewers for the public press), without written permission from the publishers.

Kimbell Art Museum 3333 Camp Bowie Boulevard Fort Worth, Texas 76107–2792 www.kimbellart.org

Yale University Press 302 Temple Street P.O. Box 209040 New Haven, Connecticut 06520-9040 www.yalebooks.com/art

Produced by the Publications Department of the Kimbell Art Museum Megan Smyth, manager of publications With thanks to Robert LaPrelle, Mark Marr, and Nancy Freeman

Designed by Tom Dawson Printed in Italy by Elcograf

ISBN: 978-0-300-19633-7

Library of Congress Control Number: 20133944164

Front cover: Paul Cézanne, Man in a Blue Smock (detail), c. 1896-97, oil on canvas. Acquired in 1980 (see pages 176-77)

Back cover: Kano Shigenobu, Wheat, Poppies, and Bamboo (detail), early 17th century, six-fold screen, ink, colors, and gofun on gold leaf paper. Acquired in 1969 (see page 283).

Frontispieces: Douris (painter), Red-Figure Cup Showing the Death of Pentheus (exterior) and a Maenad (interior) (detail), c. 480 BC, terracotta. Acquired in 2000 (see pages 10–11); Caravaggio (Michelangelo Merisi), The Cardsharps (detail), c. 1595, oil on canvas. Acquired in 1987 (see pages 64–65); Yin Hong, Birds and Flowers of Early Spring (detail), c. 1500, hanging scroll, ink and mineral pigments on silk. Acquired in 1982 (see page 255); Elisabeth Louise Vigée Le Brun, Self-Portrait (detail), c. 1781, oil on canvas. Acquired in 1949 (see pages 136–37); Censer Stand with the Head of a Supernatural Being with a Kan Cross (detail), Maya culture, c. AD 690–720, ceramic with traces of pigments. Acquired in 2013 (see page 337); Gustave Caillebotte, On the Pont de l'Europe (detail), 1876–77, oil on canvas. Acquired in 1982 (see pages 168–69)

Contents

Introduction	xi
Ancient Art	1
European Art	23
Asian Art	205
South and Southeast Asia	206
China	226
Korea	262
Japan	266
African and Oceanic Art	309
Precolumbian Art	321
Acknowledgments	353
Index of Artists and Titles	354
Photograph Credits	360

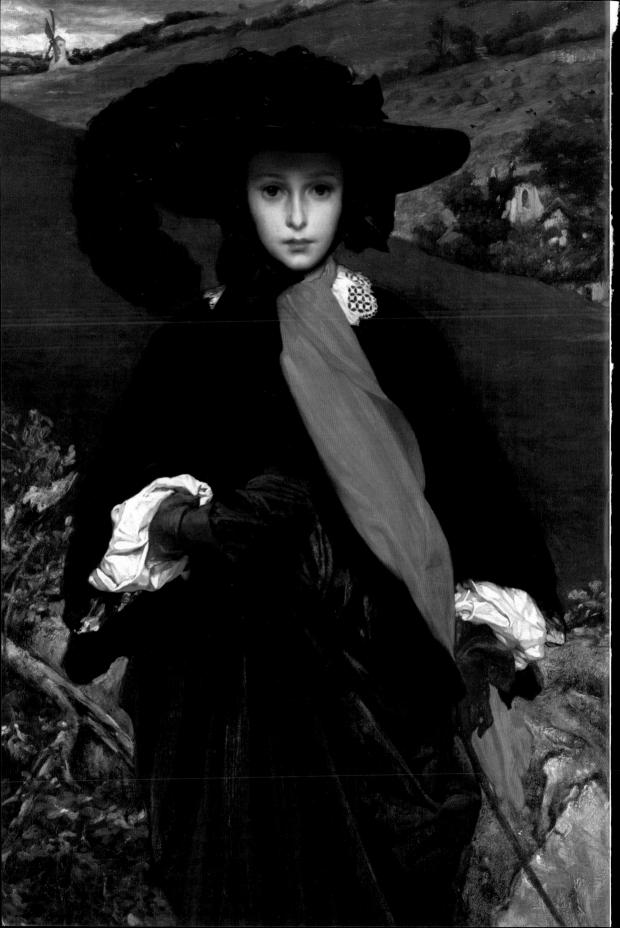

Introduction

Portraits of Kay and Velma Kimbell, painted by Dario Rappaport in 1935

THE VISION OF THE FOUNDERS

The Kimbell Art Museum, one of the most beloved museums in the world, opened to the public on October 4, 1972. The Kimbell Art Foundation, which owns and operates the Museum, had been established in 1936 by Kay Kimbell, a Fort Worth, Texas, entrepreneur, and his wife Velma, together with Kay's sister and her husband, Dr. and Mrs. Coleman Carter. Early on, the Foundation collected

mostly British and French portraits of the eighteenth and nineteenth centuries. By the time Mr. Kimbell died in April 1964, the collection had grown to 260 paintings and eighty-six other works of art, including such works as Hals's Rommel-Pot Player, Gainsborough's Portrait of a Woman, Vigée Le Brun's Self-Portrait, and Leighton's Portrait of May Sartoris. Motivated by his wish "to encourage art in Fort Worth and

Frederic Leighton, Portrait of May Sartoris (detail), c. 1860, oil on canvas, acquired in 1964

Velma Kimbell at the original Museum groundbreaking ceremony in 1969

Texas," Mr. Kimbell left his estate to the Foundation, charging it with the creation of a museum. Mr. Kimbell had made clear his desire that the future museum be "of the first class," and to further that aim, within a week of his death, his widow, Velma, contributed her share of the community property to the Foundation.

With the appointment in 1965 of Dr. Richard F. Brown, then director of the Los Angeles County Museum of Art, as the Museum's first director, the Foundation began planning for the future museum and development of the collection, both of which would fulfill the aspirations of Mr. Kimbell. To that end, in June 1966, under the leadership of its President, Mr. A. L. Scott, and in consultation with Brown, the nine-member Board of Directors of the Foundation—consisting of Mrs. Kimbell; Dr. Carter; his daughter and her husband, Mr. and Mrs. Ben J. Fortson; Mr. C. Binkley Smith; Mr. P. A. Norris, Jr.; Mr. J. C. Pace, Jr.; and attorney Mr. Benjamin L. Bird—adopted a policy statement for the future museum that outlined its purpose, scope, and program. That statement remains to this day the operative guide for the Museum.

In accordance with that policy, the Foundation acquires and retains works of "definitive excellence"—works that may be said to define an artist or type regardless of medium, period, or school of origin.

Elisabeth Louise Vigée Le Brun, *Self-Portrait*, c. 1781, oil on canvas, acquired in 1949 and dedicated to the memory of Mr. Bertram Newhouse of New York City

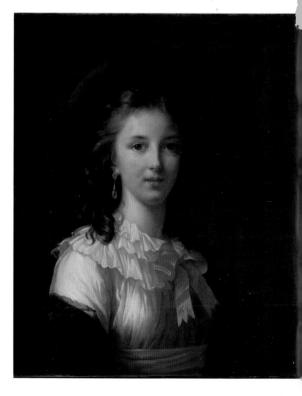

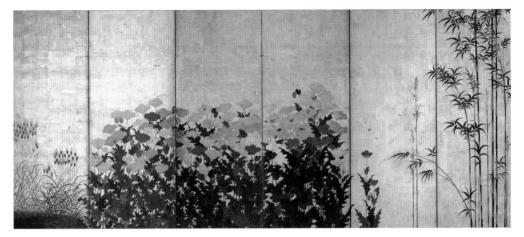

Kano Shigenobu, Wheat, Poppies, and Bamboo, early 17th century, six-fold screen; ink, colors, and gofun on gold leaf paper, acquired in 1969

Through the acquisition of individual objects of "the highest possible aesthetic quality" as determined by condition, rarity, importance, suitability, and communicative powers, the Kimbell strives to educate and to inspire, believing that a single work of outstanding merit and significance can be more effective than a larger number of representative examples. Allied with this decision to build through acquisition and

refinement a small collection of key objects of surpassing quality was an expansion of vision to encompass world history. The Kimbell collection today consists of about 350 works—not only from Europe, but from Asia, Africa, Oceania, and the ancient Americas—works that epitomize their periods and movements and touch individual highpoints of aesthetic beauty and historical importance.

Kimbell galleries, 1979

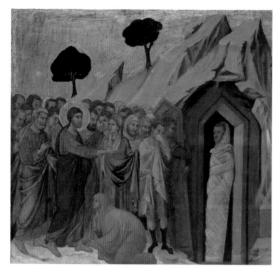

Duccio di Buoninsegna, *The Raising of Lazarus*, 1310–11, tempera and gold on panel, acquired in 1975

A COLLECTION OF MASTERPIECES

Even before the Museum opened to the public, the trustees were at work expanding the collection with key purchases. A pre-Angkor-period bronze *Bodhisattva Maitreya* from Prakonchai, Thailand, was the first acquisition made during Brown's tenure and the first work of Asian art to enter the collection. Other purchases of the first decade (1965–75) included several works that today rank among the treasures of the collection: Monet's *Point de la Hève at Low Tide*; Bellini's *Christ Blessing*; and an eighth-century Maya stone panel depicting the *Presentation of Captives*.

In 1975, Mrs. Ben J. Fortson, beloved niece of Kay Kimbell, was appointed President of the Foundation's Board of Directors—a leadership role many assumed she would one day have when she was elected to the Foundation Board at the age of twenty-one in 1956. Mrs. Fortson serves

in that position to this day. Also in the 1970s, the various businesses of the Kimbell estate were converted to income-producing assets by the executors, all of which were also Foundation Directors, providing critical funding to the Foundation for acquisitions. That funding made it possible to add such important works as Duccio's *Raising of Lazarus*, El Greco's *Portrait of Dr. Francisco de Pisa*, Rubens's *Equestrian Portrait of the Duke of Buckingham*, and Cézanne's *Man in a Blue Smock*. The Foundation acquired the latter at auction in 1980, after Brown's unexpected death in the previous year, and designated the painting as a memorial

The Bodhisattva Maitreya, Thailand, late 8th century AD, bronze, acquired in 1965

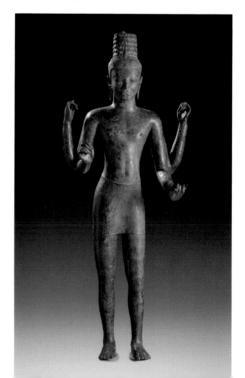

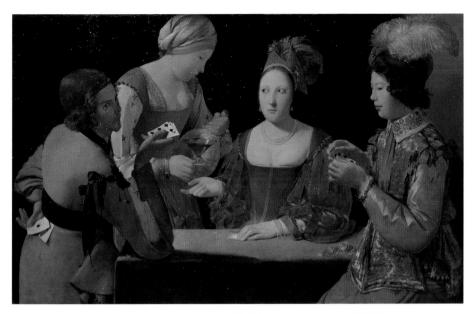

Georges de La Tour, The Cheat with the Ace of Clubs, c. 1630–34, oil on canvas, acquired in 1981

to its first director, in recognition of his outstanding service to the Foundation and the community.

Dr. Edmund P. Pillsbury succeeded Brown as the Museum's director. During Pillsbury's tenure (1980–98), nearly 150 works were added to the collection, among them La Tour's Cheat with the Ace of Clubs; its influential Italian antecedent, Caravaggio's long-lost Cardsharps; an expressive early work by Annibale Carracci, The Butcher's Shop; a late subject picture by David, The Anger of Achilles; an imposing full-length portrait by Vélazquez, Don Pedro de Barberana; Picasso's bold and powerful Nude Combing Her Hair, a major Cézanne landscape, Maison Maria with a View of Château Noir, Caillebotte's Impressionist city view On the Pont de l'Europe; Friedrich's Mountain Peak with Drifting Clouds, the first of his works to enter a public collection outside Europe; a rare genre scene by the Spanish master Murillo, Four Figures on a

Step; a jewel by Fra Angelico, Saint James Freeing Hermogenes; Interior of the Buurkerk, Utrecht, a masterpiece by the Netherlandish painter Saenredam; Matisse's brilliantly colored late-period L'Asie; Mondrian's 1914 Tableau and 1939–42 Composition; and Monet's gestural Weeping Willow. During this time, the Kimbell's ancient, Asian, African, and Precolumbian collections

Caravaggio, *The Cardsharps*, c. 1595, oil on canvas, acquired in 1987

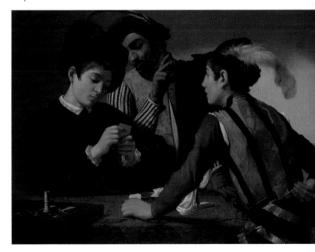

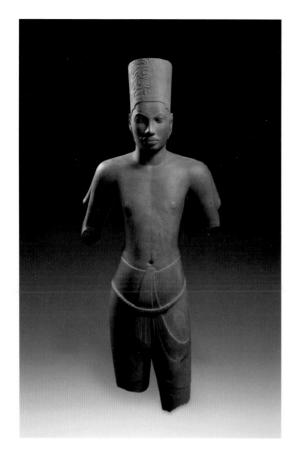

Harihara, Cambodia, c. 675–700, stone, acquired in 1988 with the assistance of a generous grant from the Sid W. Richardson Foundation of Fort Worth

Pentheus by the Douris painter; Raeburn's Allen Brothers, a nod to the genesis of the Foundation's collection of British portraiture; an inlaid figurine of a Standing Dignitary from the Wari culture of Peru, the first South American work to enter the collection; Bernini's striking Modello for the Fountain of the Moor; a masterwork by Lucas Cranach the Elder, The Judgment of Paris; and a rare eighth-century Japanese dry lacquer Gigaku Mask.

During the tenure of Dr. Eric M. Lee, director since 2009, the Kimbell has further enriched the collection with the acquisition of Michelangelo's *Torment of Saint Anthony*,

were also greatly enhanced by masterworks such as a Japanese *Shaka Buddha* by the sculptor Kaikei; an incised Maya *Conch Shell Trumpet*; the sensuous Chinese Tangperiod *Bodhisattva Torso*; a striking life-size Pre-Angkor stone image of the Hindu god *Harihara* from Cambodia; an exquisite terracotta head that may represent a king, from the Ife culture of Nigeria; and a New Kingdom Egyptian *Kneeling Figure of Senenmut*.

Under the directorship of Dr.
Timothy Potts, from 1998 to 2007, the diversity of the collection was expanded with works such as an ancient Greek
Red-Figure Cup Showing the Death of

Standing Dignitary, Wari culture, Peru, c. AD 600–1000, wood with shell-and-stone inlay and silver, acquired in 2002

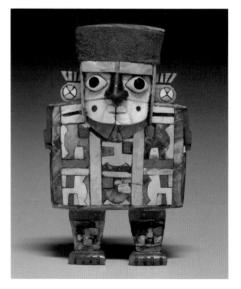

Michelangelo Buonarroti, *The Torment of Saint Anthony*, c. 1487–88, tempera and oil on panel, acquired in 2009

the artist's first known painting, believed to have been executed when he was twelve or thirteen years old; Guercino's tender and majestic *Christ and the Woman of Samaria*; and Poussin's *Sacrament of Ordination (Christ Presenting the Keys to Saint Peter)*, from the artist's first series of the Seven Sacraments, which is among the most celebrated groups of paintings in the entire history of art. In keeping with its commitment to represent world cultures, the Foundation acquired

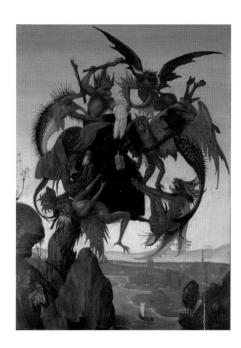

in 2013 two monumental terracotta *Censer Stands*, made by Maya sculptors at Palenque about 700 AD.

 $Nicolas \ Poussin, The \ Sacrament \ of \ Ordination \ (Christ \ Presenting \ the \ Keys \ to \ Saint \ Peter), c. 1636-40, oil on \ canvas, acquired in 2011$

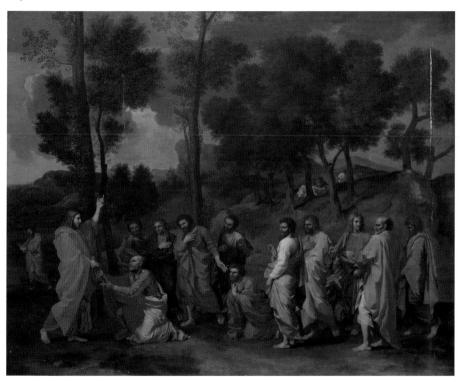

EXHIBITIONS TO EDUCATE AND TO INSPIRE

Equally important in the development of the Kimbell as a major museum has been its initiation of highly acclaimed international loan exhibitions accompanied by Kimbellproduced publications and nationally attended symposia, including monographic exhibitions devoted to Poussin (the first exhibition of the artist held in America), Ribera, Tiepolo, Jacopo Bassano, Ludovico Carracci, Matisse, and Vigée Le Brun, as well as timely surveys of seventeenthcentury Spanish still-life painting, French mythological painting of the eighteenth century, and Japanese Buddhist sculpture. Other major exhibitions originated or coorganized by the Kimbell include *The Blood* of Kings: A New Interpretation of Maya Art (1986), Monet and the Mediterranean (1997), Stubbs and the Horse (2004), Gauguin and Impressionism (2005), Picturing the Bible: The Earliest Christian Art (2007), Caravaggio and His Followers in Rome (2011), and Bernini:

Sculpting in Clay (2013). The Museum has also played host to major traveling exhibitions, beginning in 1973 with Impressionist and Post-Impressionist Paintings from the U.S.S.R., which marked the first time these works had traveled outside the Soviet Union, and including The Great Bronze Age of China (1980), Cézanne to Matisse: Great French Paintings from the Barnes Collection (1994), The Path to Enlightenment: Masterpieces of Asian Sculpture from the Musée Guimet (1996), Hatshepsut: From Queen to Pharaoh (2006), The Impressionists: Master Paintings from the Art Institute of Chicago (2008), and Fiery Pool: The Maya and the Mythic Sea (2010).

Visitors in the exhibition Bernini: Sculpting in Clay, 2013

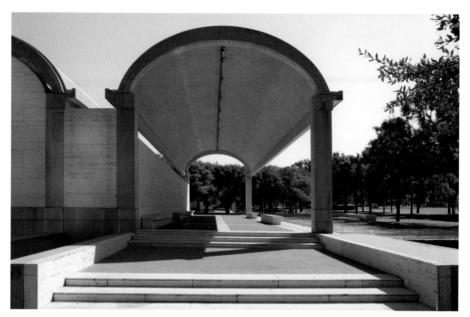

View of the north portico of the Kahn building looking south

BUILDINGS OF DISTINCTION

In October 1966, Louis I. Kahn (1901–1974) received the commission to design the Kimbell Art Museum. From the moment it opened in October 1972, it was deemed not only the apotheosis of Kahn's ever–evolving ideas about the architectural union of light and structure, but also one of the finest art museums ever built. It was the last work the architect would see to completion before his death.

Although Mrs. Kimbell had expressed a wish that the Museum be "of classical design," the Kimbell Art Foundation imposed no stylistic conditions on Kahn. The Foundation made clear, however, that it wanted architecture that would succeed not only on aesthetic grounds, but also from a functional standpoint. It was a conviction shared by Kahn, who distinguished himself by a deep sense of the practical as well as the spiritual.

The Museum's director, Brown, felt that the Kimbell should have an inward orientation and imaginative garden treatments. But what was most important to him was that the art be experienced with natural light and outdoor views—an opinion that went against the prevailing trend of the day, which was to unify and

Architect Louis I. Kahn in front of the Kimbell's portico, August 3, 1972

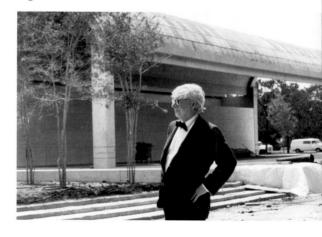

control lighting conditions in museums through artificial illumination. The Kimbell, on the contrary, would offer a different experience on every visit, as the light would vary according to the time of day, the season, and the weather. These programmatic parameters were essential to Kahn's creative process, as he famously needed to understand the "nature of a building" before he could determine what it "wanted to be."

From his earliest sketches and models, Kahn conceived the Museum as a series of long, narrow galleries, each with its sources of light—both natural and artificial—and conditioned air. Kahn's plan is classical: an axis passing west to east through the front to rear entries is crossed by a longer north-south axis, along which the galleries are positioned in harmony with the site.

The north and south sides of the Museum's three-section pavilion are composed of six parallel, 100-by-20-foot, lead-roofed, post-stressed concrete vaults, while the center section is made of four. Due to its structural strength, the vault only requires the support of four square columns. The building is composed of three levels: the upper floor, housing most of the galleries and the auditorium, library, bookstore, café, and two garden courtyards; the lower floor, encompassing the lower-level entry gallery, conservation studio, offices, and shipping and receiving areas; and a sub-floor basement.

The conservation laboratory, significantly, was constructed at the heart of the building's nonpublic zone. From the beginning, in fact, the founders of the Kimbell Art Museum envisioned a conservation program to "preserve for future generations what has been entrusted to its care." The pre-architectural plan called for a conservation studio with an "open studio work area" with the caveat: "must face north, with entire wall glazed; it is impossible to get enough light in this room!" In fulfilling this mandate, the Kimbell became the first museum in Texas to create a purpose-built, professional paintings conservation studio. With a double-height vault, it would be an

ideal environment in which to examine, clean, and restore works of art, one that would serve as a model for many museum conservation laboratories. Adjacent to photography, storage, and the registrar's office and within easy access of the curators' and director's offices, the conservation studio was thoroughly embedded within the total Museum program.

Kahn envisioned a museum with "the luminosity of silver," illuminated by "natural light, the only acceptable light for a work of art, [with] all the moods of an individual day." He achieved this through a design with "narrow slits to the sky" to admit daylight and pierced metal reflectors hanging beneath them to diffuse and spread the light from its hidden source onto the underside of the cycloid-shaped vaults and down the walls. Courtyards, lunettes, and light slots introduce more light, varying quality and intensity. Architectural space and light are further unified by the choice of materials: deftly handled structural concrete is juxtaposed with Italian travertine, finegrained white oak, dull-finished metal, and clear glass. Kahn characterized the Museum building as being inspired by "Roman greatness." The classical appearance of its porticos, arches, and vaults is often cited.

With this skillful union of inspiring design and functionality, the resulting

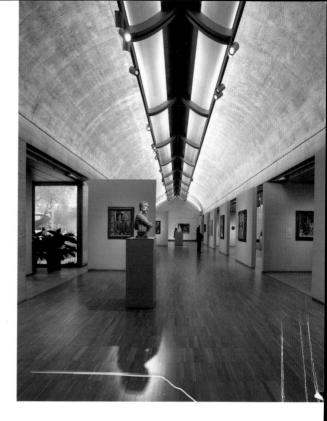

Museum building would be acclaimed a modern classic from the moment of its opening. Brown proudly declared, in a dictum worthy of Kahn, that the Kimbell was "what every museum has been looking for ever since museums came into existence." Brown was referring especially to the open, flexible plan, describing it as "a floor uninterrupted by piers, columns, or windows and perfect lighting, giving total freedom and flexibility to use the space and install the art exactly the way you want." Indeed, the natural glow of its galleries, so compelling and transcendent, inspired architects and museum professionals, in subsequent decades, to bring natural light into museum structures. The Foundation Board of Directors also seemed to understand the building's significance and potential for future inspiration. On behalf of

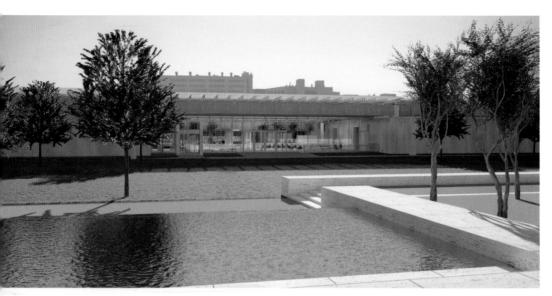

Rendering of the pavilion's east facade with a detail of the Kahn fountains, 2012, Renzo Piano, architect. © 2012 Visual Immersion. LLC

the full Board, Mr. A. L. Scott, its President, declared: "This design will still be new and fresh 50 years from now, we think . . . What we have is magnificent."

In the ensuing decades, the Kimbell's activities—particularly the growth of its exhibition and education programs—made the need for more space ever greater. In November 2013 the Kimbell opened a second museum building located to the west of the landmark Kahn structure. Designed by world-renowned architect Renzo Piano, this pavilion provides much-needed space for the institution. New galleries, to be used primarily for exhibitions, allow the Kahn building to be devoted to the permanent collection. The Piano building also provides the classrooms and studios that are essential to a full-scale museum education department, as well as an auditorium considerably larger than the one in the Kahn building, an expanded library, and generous underground parking.

Piano's building acknowledges its

older companion in its respectful scale and general plan, while at the same time asserting its own more open, transparent character. It is physically quite separate from the Kahn building, at what Piano calls "the right distance for a conversation, not too close and not too far away." The parklike area between the two buildings enhances the serene sound and cool sensation of the fountains that parallel the north and south porticos of the Kahn building. The siting of the new building and its parking garage, furthermore, corrects the tendency of most visitors to enter Kahn's building by what he considered the secondary entrance, directing them naturally to his main entrance in the west facade.

The Piano building consists of two connected structures. The first and more prominent is a pavilion that faces and subtly mirrors the Kahn building. Here, on a tripartite facade, robust concrete walls flank a recessed entrance bay of glass. The pavilion houses a large lobby in the center,

with exhibition galleries to either side, all naturally lit from an elaborately engineered roof. In the galleries, Renzo Piano strove for an even more exquisite light quality than he has achieved before: the roof system incorporates aluminum louvers, glass, solar cells, wood beams, and stretched fabric scrims. The north and south walls of the pavilion are glass, with colonnades outside to support the beams and roof, which overhang generously for shade.

From the lobby, visitors enter either of the galleries to the sides or proceed, through a glass passageway, into the building's second structure. In contrast to the front structure, this half of the building is self-effacing from the outside, covered by a grassy roof open to the public for recreational activities. It contains a third gallery that is not top-lit and is therefore suitable for especially light-sensitive works, as well as the auditorium, library, and education center. The double-height auditorium is on axis with the entrance, and there is a view to the glass wall and light well behind the auditorium stage, through various spaces and layers of glass, from the building's entrance. Piano's objective was to unify the spaces of his building with that of Kahn's through harmonies of scale, materials, and the celebration of light. The careful siting of the building ensured that

the axial space between the two structures—and most especially between their paired entrances, facing each other across sixty-five yards—becomes the new central core of the Kimbell Art Museum campus.

The buildings of the Kimbell Art Museum stand at the center of Fort Worth's Cultural District, with visual arts institutions that include the Amon Carter Museum of American Art (Philip Johnson, 1962 and 2001) and the Modern Art Museum of Fort Worth (Tadao Ando, 2002). Like its sister institutions, the Kimbell is the product of citizens of Fort Worth who have believed in the power of works of art to elevate the spirit. Dedicated to preserving the intimate and personal experience of great works of art for the individual, the Kimbell, now in its fifth decade, strives to maintain and nurture that essential encounter—for visitors not only from Fort Worth, the state of Texas, and North America, but from across the world. We hope that this Guide will be an introduction—and an invitation—to that experience.

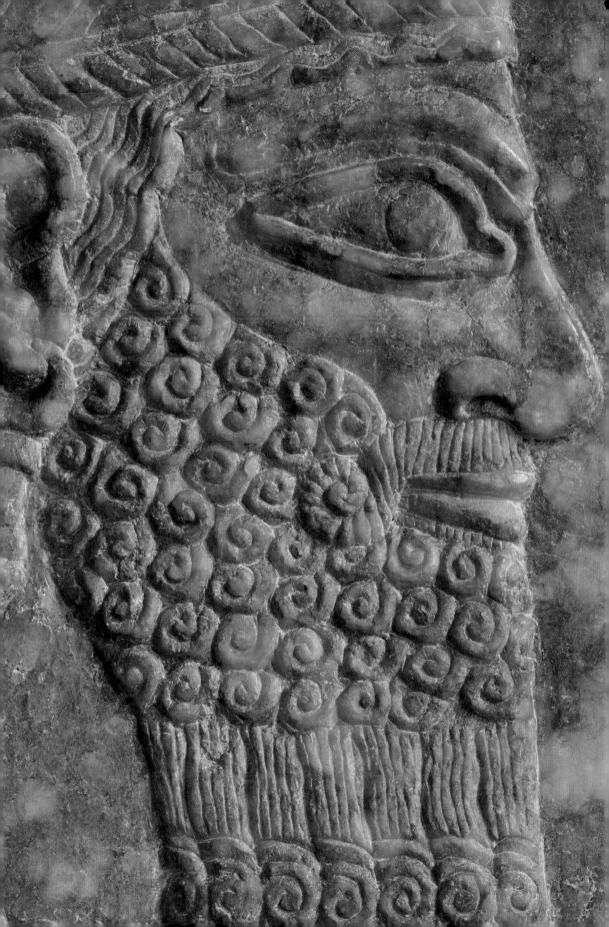

BASTIS MASTER

Cyclades Islands, Greece

Female Figure

Early Cycladic II phase, c. 2500–2300 BC Marble; 16 ¹/₄ x 5 ¹³/₁₆ in, (41,2 x 14.7 cm)

Acquired in 1970, Gift of Ben Heller

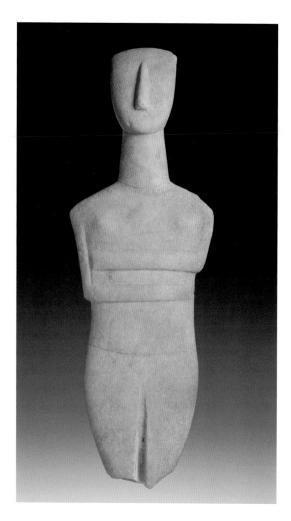

Characterized by its minimalist stylization, this marble statuette of a female figure was produced by the Early Bronze Age culture that flourished in the Cyclades Islands of Greece more than 4000 years ago. Foldedarm figures of this kind were typically

placed in burials, along with elegantly shaped marble vessels and other funerary offerings. Their original burial conditions were never recorded, so their function remains a matter of speculation—they may be magical representations of venerated ancestors, companions for the dead, cult images of a divinity, or even toys. Their strikingly stylized shapes made them a source of great interest to early modern sculptors in the first decades of the twentieth century.

The Kimbell sculpture was probably carved by the Bastis Master, so named after the previous owner of a work now in the Metropolitan Museum of Art, New York. The Kimbell's marble, whose legs are missing from the knees down, would originally have measured about fifty-five centimeters, placing it among the artist's larger and more developed works. Figures by this sculptor are typified by long, angular heads with a prominent, arching nose and rounded chin; curving incisions at the neck, hips, knees, and ankles; small, wide-spaced breasts; and a clearly marked pubic triangle. Here, the undulating curves of the female anatomy are modeled with great sensitivity. Two red dots on the right cheek are all that remain of the original, more extensive painted decoration. The artist follows a convention of separating the forearms by a clear space, which gives the figure an asymmetrical appearance.

Group Statue of Ka-Nefer and His Family

Probably Saqqara, Egypt; Old Kingdom, Dynasty 5, c. 2465–2323 BC Limestone, with traces of original painted decoration; $13\frac{5}{8} \times 5\frac{3}{4} \times 8\frac{7}{8}$ in. (34.6 x 14.6 x 22.5 cm)

Acquired in 2005

Inscriptions on this tomb sculpture name the main figure as the court official Ka-nefer, "Overseer of the Craftsmen, Priest of Ptah," and the others as "His wife, the Royal Confidant, Tjen-tety" and "His son, the Overseer of Craftsmen, Khuwy-ptah." Carved from limestone, the figures were originally painted and retain much of their color on the hair and eyes, with traces on the skin, garments, and jewelry.

Ka-nefer holds a cylinder (a common symbol of office) and is represented much larger than the other figures, following the Egyptian artistic convention of indicating rank and importance through scale. His facial features, especially the broad nose, are most closely paralleled in sculptures from the reign of King Sahure (c. 2458–2446 BC), which provides an approximate date for the work. The Old Kingdom was the formative period of Egyptian art, when its distinctive motifs and principles of representation crystallized into the classic style that would remain largely unchanged throughout three thousand years of pharaonic history.

The statue was probably made for Ka-nefer's tomb at Saqqara, the principal burial ground of the Old Kingdom capital, Memphis. In Egyptian belief, some tomb sculptures also served as "homes" for the spirits of the deceased, especially when the embalmed body had perished. While Ka-nefer's tomb has not been found, two

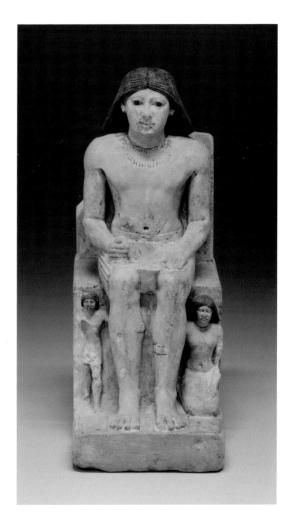

offering tables from it are today in the British Museum, London, and the Ny Carlsberg Glyptotek, Copenhagen. Objects from his son's tomb at Saqqara have also been found.

Kneeling Statue of Senenmut, Chief Steward of Queen Hatshepsut

Temple of Montu (?), Armant, Egypt; New Kingdom, Dynasty 18, c. 1473–1458 BC Gray green schist; $16\frac{1}{6} \times 6 \times 12$ in. $(41 \times 15.2 \times 30.5$ cm)

Acquired in 1985

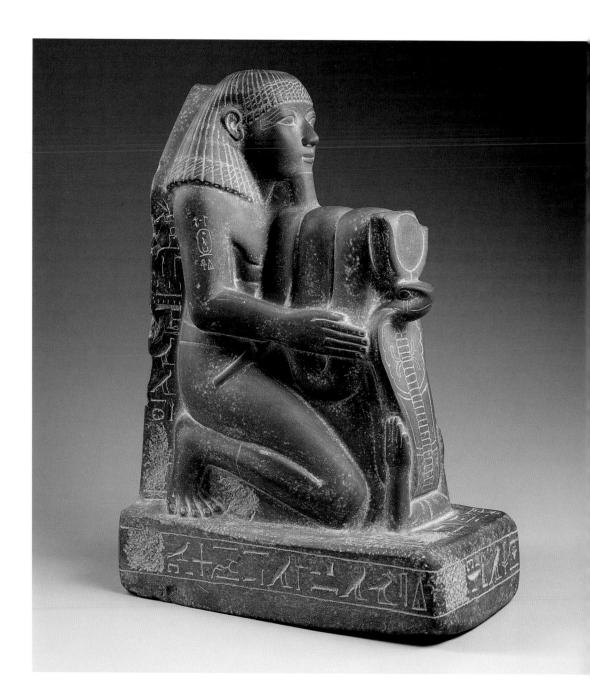

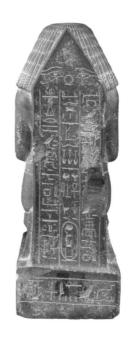

This masterpiece of New Kingdom art portrays Senenmut, the most favored official of the dowager Queen Hatshepsut, who reigned as pharaoh from about 1473-1458 BC. Senenmut offers an image of Renenutet, goddess of the harvest and nourishment, on behalf of the wellbeing of his sovereign and in hopes of eternal blessings for himself. Senenmut was the first commoner since the Old Kingdom to enjoy a level of wealth and privilege approaching that of royalty. As the queen's advisor and tutor of her only daughter, Neferure, Senenmut held more than eighty titles—including Great Treasurer of the Queen and Overseer of the Treasury, Granary, Fields, and Cattle of Amun. These permitted him control over the vast resources of the royal family as well as of the state god, Amun. As chief royal architect, he was also responsible for many major building projects, including the splendid funerary temple of Queen

Hatshepsut at Deir-el-Bahri in western Thebes (c. 1458 BC).

In this portrait statue, carved from a gray green schist, Senenmut grasps a symbolic cobra that supports a sun disk and cowhorns and rests on a base composed of two upraised arms (the hieroglyphic sign for "Ka")—a magical gesture intended to preserve life and ward off evil. The inscription of incised hieroglyphs begins on the statue's obelisk-shaped back pillar and continues on the base, the top edge of the base, and vertically on the edges of the back. The name of Senenmut has been intentionally erased from the inscription, probably in the aftermath of Hatshepsut's demise or by priests hostile to Amun. The cartouche on the right arm reads: "The good goddess, Maat-ka-Re [Hatshepsut's throne name], given life." Sculptures of Senenmut are rare, and of the twenty-two known examples, only a handful survive intact.

Portrait Statue of Pharaoh Amenhotep II

South Karnak, Egypt; New Kingdom, Dynasty 18, c. 1400 BC Recarved for Ramesses II (the Great), Dynasty 19, c. 1250 BC Red granite; $40^{1/2} \times 18 \times 15$ in. (102.8 $\times 45.7 \times 38.1$ cm)

Acquired in 1982

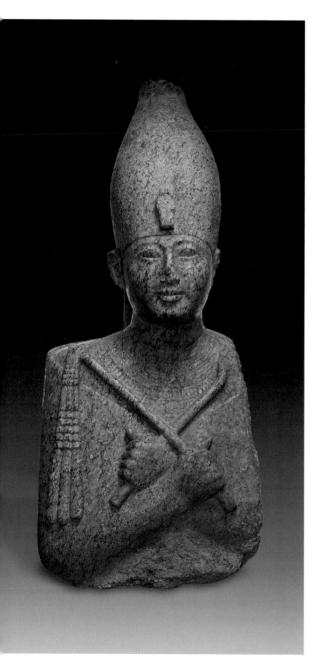

The regal figure of Amenhotep II holds the traditional insignia of kingship against his chest—the scepter in the form of a crook in his left hand and the flail or whip in his right. He wears Upper (i.e., southern) Egypt's distinctive crown, embellished by the uraeus cryptogram, or royal cobra, and a broad collar composed of five bands. His body is enveloped in the jubilee robe worn by kings at festivals, particularly the Sed-festival—in which he was physically and spiritually rejuvenated. Usually the Sed-festival was observed after a reign of thirty years. Since most pharaohs never reached their thirtieth year, however, some, including Amenhotep II, celebrated it prematurely. The sculpture was originally part of a larger figure seated on a throne. which was excavated in 1896 at the Temple of Mut at South Karnak. Fragments of the throne that are now lost bore inscriptions of Ramesses II ("the Great"), who lived more than a century after Amenhotep II. Ramesses usurped this and many other sculptures of his predecessors and converted them into images of himself. In this case, Amenhotep's eyebrows were erased and his eyes, nose, and mouth slightly reshaped to make them resemble those of Ramesses.

Cylinder Seal with Griffin, Bull, and Lion

Assyria (Iraq); Middle Assyrian period, 1300–1200 BC Chalcedony; $1\frac{7}{16}$ x $^{11}/_{16}$ in. (3.6 x 1.7 cm)

Acquired in 2001

Cylinder Seal with Winged Genius and Human-Headed Bulls and Inscription

Assyria (Iraq); Neo-Assyrian period, c. 700 BC Blue chalcedony; $1^9/_{16}$ x $7/_{8}$ in. (4 x 2.2 cm)

Acquired in 2001

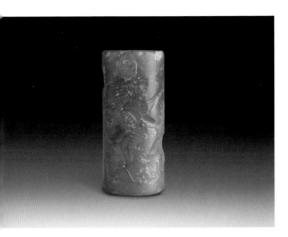

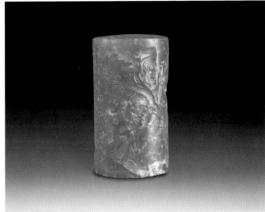

These Assyrian seals are both made of hard chalcedony, which allows for the representation of very fine detail at a miniature scale. The first shows a winged griffin dispatching a bull before a rampant, snarling lion. Epitomizing Mesopotamian miniature art at its best, the artist has taken great care in defining the musculature, fur, and wings of the creatures, which represent divine forces in Mesopotamian religion. Since it is uninscribed, this was probably a personal seal, whose iconography was chosen to ward off malevolent forces.

The second seal shows an Assyrian winged genius between rampant, winged, human-headed bulls. All wear the horned headdress of deities and supernatural beings and have long curled hair and beards.

These semi-divine beings frequently appear on bas-reliefs (like those in the Kimbell's collection) and elsewhere in Assyrian art, especially in connection with the king.

A deer is shown at a smaller scale in the space below the inscription. This text, in Assyrian cuneiform, states: "Belonging to Nabu-apla-iddin, son of Bel-shuma-ibni . . ."

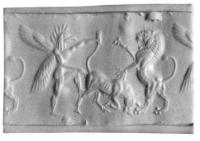

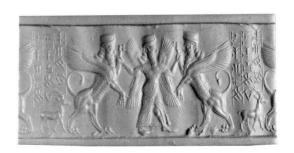

Pair of Winged Deities

Room L, Northwest Palace, Nimrud, Assyria (Iraq); Reign of Ashurnasirpal II, c. 874–860 BC Gypsum; left: $36^{1/4}$ x 27^{9} /16 in. $(92 \times 70 \text{ cm})$; right: 35^{11} /16 x 28^{15} /16 in. $(90.7 \times 73.5 \text{ cm})$

Acquired in 1981

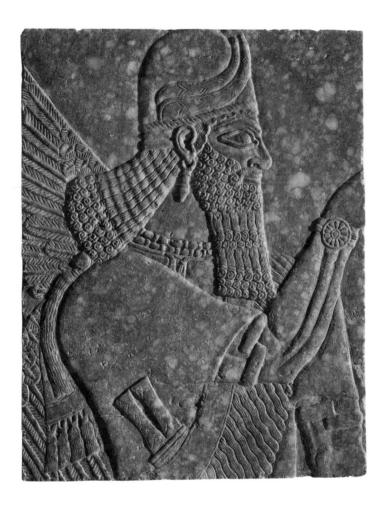

In 1845, the British archaeologist Austen Henry Layard uncovered the earliest of the surviving royal residences of the Assyrian kings at Nimrud, called Kalhu in ancient times. Now called the Northwest Palace of Ashurnasirpal II—a king who reigned 883–859 BC—the structure, which consisted of a series of long, narrow rooms grouped around large courtyards, was lavishly decorated with monumental gateway figures and reliefs. Seven-foot-high stone

slabs that lined the walls of many of the rooms were carved with elaborate narrative, mythological, and ritual scenes in low relief. The greatest and most original artistic achievement of the Assyrians, these images and accompanying inscriptions record the kings' military campaigns and testify to their prowess as warriors and hunters as well as their sanctity as the representatives of the Assyrian pantheon on earth.

One of the most recurrent and potent

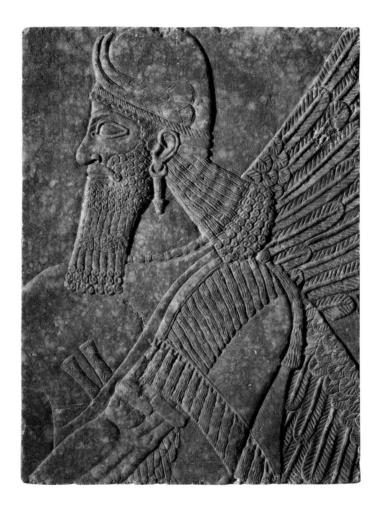

images on these reliefs is the depiction of a magic purification or protective ritual in which winged griffin-demons (apkallu, "sages") or winged anthropomorphic deities, holding ritual "buckets" and pinecone-shaped objects, flank a "Sacred Tree" that they sprinkle with holy water or pollen. The Kimbell's winged deities are fragments of two such full-length figures enacting this magic ritual. As such, each figure would originally have held a bucket

in his left hand and a cone in his right. The deities, marked as divine by their wings and horned helmets, are conceived in the image of the monarch, reflecting his facial features, stance, and physical strength. Their exaggerated musculature and luxuriant, tightly curled hair and beards suggest something of the king's vainglorious power and virility. These reliefs come from a room that may have been used by the king for ritual ablution.

Greek (Athens), active c. 500-460 BC

Red-Figure Cup Showing the Death of Pentheus (exterior) and a Maenad (interior)

Late Archaic period, c. 480 BC Terracotta; h. 5 in. (12.7 cm); diam. 11½ in. (29.2 cm)

Acquired in 2000

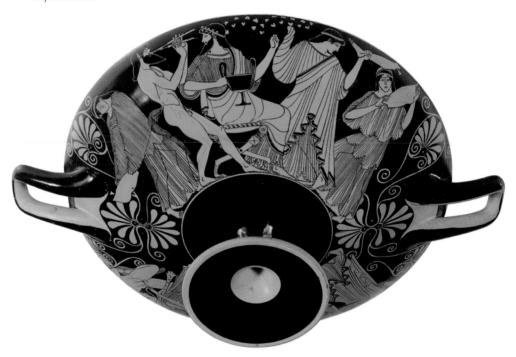

Pentheus, a mythical king of Thebes, offended the god Dionysos by denying his divinity and forbidding his worship. The vengeful god—shown with a wine cup—worked a group of women into an ecstatic frenzy (above). Coming upon Pentheus in the woods, they mistook him for a wild beast and, as the god had wished, tore him limb from limb. Two of the women grasp Pentheus's head and twisted torso, his guts hanging out, his eyes staring blankly in the knowledge of death (above right). Four other women hold his dismembered legs, while a fifth, perhaps the king's mother, holds his

garment and gazes skyward, not knowing her victim.

The interior of the cup shows a *maenad* (female follower of Dionysos) who grasps a young leopard by the tail with one hand and a *thyrsos* (magic staff) with the other. An inscription praises her charms: "The girl is beautiful." She is shown turning her head, perhaps in response to the fearful events unfolding in the main scene.

Working at the beginning of the Classical period, when Greek artists were preoccupied with the naturalistic representation of the human body, the

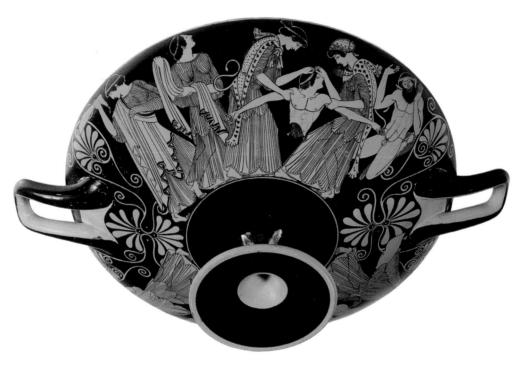

renowned painter Douris does his best to transcribe three-dimensional reality to a flattened surface. A meticulous draftsman, he first sketched in the figures with the blunt end of the brush and then painted them in with a controlled hand. Thinned paint was used for internal details like the musculature of the satyrs, and blobs of thick black paint for patterns of hair. Red paint was added sparingly for hair bands and Pentheus's blood. Both for the quality of its conceptions and drawing, and for the exceptional state of its preservation, this cup ranks among the finest expressions of Douris's mature art.

Detail of interior

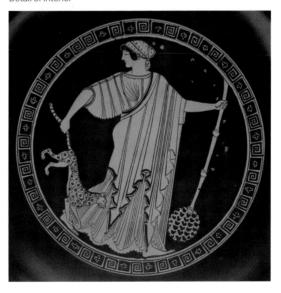

BRYGOS PAINTER

Greek (Athens), active c. 490-470 BC

Red-Figure Lekythos Showing Eros in the Role of Archer

Late Archaic period, c. 490–480 BC Terracotta; 13½ x 5½ in. (34.3 x 13.5 cm)

Acquired in 1984

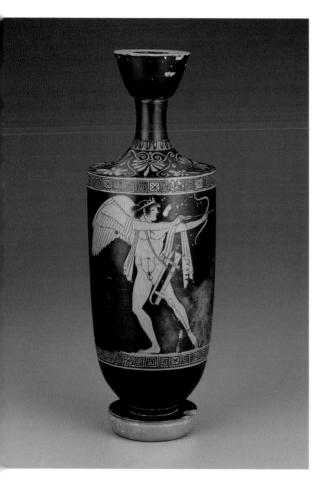

The image on this lekythos (one-handled oil jug) marks the earliest known appearance of Eros, the god of love, in his role of archer. It predates by forty to fifty years the representation of the subject on one of the sculpted panels atop the entrance of the Parthenon. Before acquiring the bow and arrow, Eros pursued lovers with cruder weapons, such as an ax, whip, or pair of sandals. Arrows would become his more common attribute because of their literary association as shafts of desire.

The lekythos is attributed to the Brygos Painter, a second-generation master of the red-figure style. Dating from c. 490-480 BC, it is probably among his early works and epitomizes the freshness and vigor of Late Archaic art. An acute observer, the Brygos Painter usually depicted scenes from daily life: revels, symposia, athletes, warriors with horses, men and youths courting, and erotic scenes. Here the figure of Eros, nude but for the mantle draped over his shoulders, has the artist's typical poise and balance while retaining the potentiality for sudden movement: the figure is set frontally, his weight on his right, forward-moving foot, while his head turns back in profile as he draws his bow

Young Female Attendant

Attica (?), Greece; Late Classical period, c. 340–330 BC Marble; $46 \times 18^{1/2} \times 10^{1/2}$ in. ($116.9 \times 47 \times 26.7$ cm)

Acquired in 1972

The woman with flowing robes portrayed here is probably one of a group of votary figures that originally accompanied a statue of a goddess in the performance of a solemn ceremonial rite. Although it probably dates from a century later than the maidens from the famous frieze of the Parthenon in Athens, the attendant shares their stately attitude. Her figure, however, has the ease and languid grace that were introduced into Attic sculpture by fourth-century-BC masters like Praxiteles and Lysippos. Her gown, held close to the body by a cord at the shoulder and waist, falls in soft folds over her weight-bearing right leg while revealing her flexed left leg underneath. Corresponding to similar objects preserved on funerary monuments, the jewelry box she bears may have been intended as an offering to the deity.

The statue is carved in the round, but it is less finished in the back, where the rough chisel marks left by the artist are still evident. This difference in finish indicates that the attendant was intended to be viewed from the front.

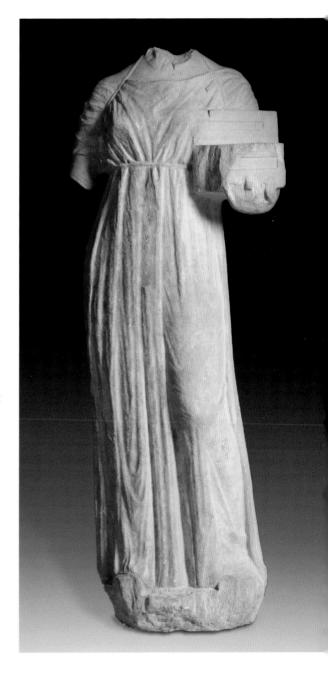

Head of an Athlete (Apoxyomenos)

Hellenistic or Roman, c. 2nd–1st century BC Probably after Lysippos (Greek, c. 365–310 BC) Cast bronze; $11\frac{1}{2}$ x $8\frac{1}{4}$ x $10\frac{3}{4}$ in. (29.2 x 21 x 27.3 cm)

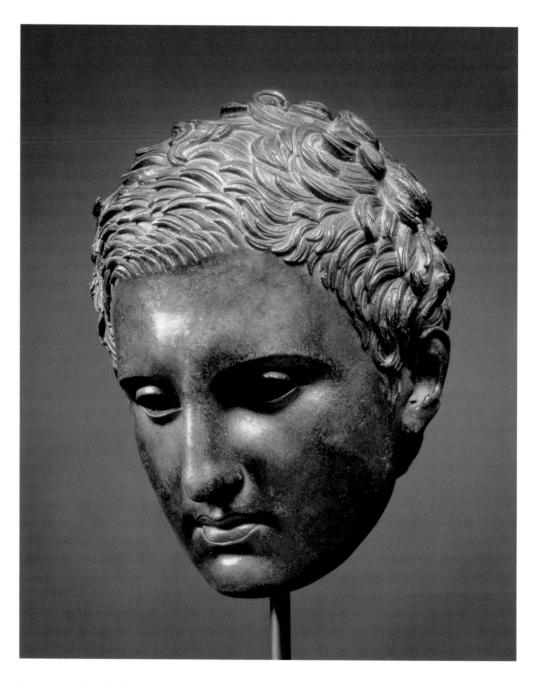

This exceptionally fine and rare head comes from a bronze statute of an athlete scraping oil from his naked body after exercising. Other more complete versions of this statue make it possible to reconstruct the full figure. The lost original behind all these sculptures was probably the bronze Apoxyomenos ("Scraper") by Lysippos, the court sculptor of Alexander the Great. One of the most celebrated sculptures of classical antiquity, Lysippos's Apoxyomenos was originally installed in the Roman general Marcus Agrippa's public baths in Rome around 20 BC; later, the emperor Tiberius became so enamored of it that he had it moved to his bedroom.

The Kimbell's thick-walled bronze is the finest of the surviving casts of the head of this popular subject and may be dated on stylistic grounds to around 340–330 BC. It fits well with what we know of Lysippos's distinctive style, particularly the emphasis on the athlete's carefully modeled hair. The young man's lips were originally overlaid with copper, and the eyes inlaid with stone, glass, and metal.

Lysippos introduced a new canon of proportions for the ideal male body, with slimmer limbs, smaller heads, and a more fluid musculature than his predecessors.

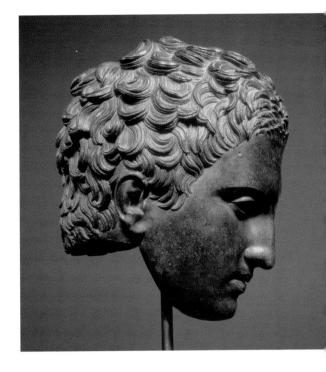

According to Pliny, whereas other artists had depicted men as they really were, Lysippos claimed to show them as they appeared to be. Taking nature rather than other sculptors as his teacher, he was renowned for his fastidious attention to even the smallest details of his figures, which were later said to lack only movement and breath.

Head of Meleager

Roman, Late Republican–Early Imperial period, 50 BC-AD 100 After Skopas (Greek, c. 370–330 BC)

Marble; 113/4 x 8 x 91/2 in, (29.8 x 20.3 x 24.1 cm)

Mar 510, 1174 N 0 N 3 72 III. (23.0 N 20.3 N 24

Acquired in 1967

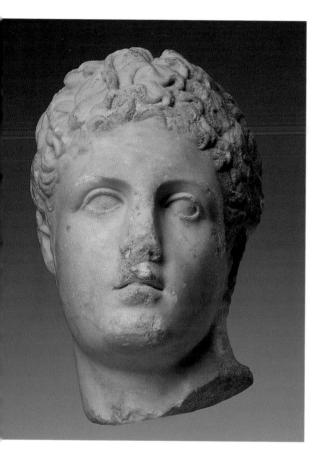

This head is from a Roman copy of a fulllength statue by the famed fourth-century-BC Greek sculptor Skopas. Other copies of this lost statue show the mythological hero Meleager with a hunting dog and the head of the Kalydonian boar. Along with Praxiteles and Lysippos, Skopas was one of the great sculptors of his age, renowned especially for his depictions of gods. His style was notable for its introduction of an intense depiction of human emotion into the previously more reserved psychology of Greek classicism. Typical of Skopas's innovations are the slightly parted lips, the low forehead that protrudes over the bridge of the nose and eyes, and the heavy roll of flesh swelling over the outer corners of the eyes. These elements—all of which would be further exaggerated in Hellenistic sculpture—contribute to the quality of barely suppressed agitation.

Ancient viewers understood Meleager's emotional state. According to Homer, the Kalydonian boar was sent by Artemis to ravage the countryside after Oeneus, king of Kalydon and Meleager's father, failed to sacrifice to the goddess. Meleager then led the hunt to kill the boar, but in its aftermath quarreled with his mother's two brothers and killed them. Fourth-century-BC artists favored narratives such as this, which humanized the gods and involved mythic heroes in the sufferings and imperfections of man.

Crouching Aphrodite

Roman, Late Republican–Early Imperial period, c. 50 BC–AD 140 Based on a Greek original of c. 3rd–2nd century BC Marble; $25 \times 13\% \times 19\%$ in. (63.5 x 35.3 x 49.2 cm)

Acquired in 1967

According to the primal Greek myth recounted in Hesiod's *Theogony* (genealogy of the gods), Aphrodite, the goddess of love, was born of the *aphros*, the foam created when Kronos threw the genitals of his father, Uranos (Heaven), into the sea. The impregnated foam floated across the Mediterranean to Cyprus, where the goddess was born as she stepped ashore fully grown. Reflecting this aqueous origin, Aphrodite is frequently depicted in relation to water and is sometimes accompanied by a seashell or dolphin.

Aphrodite was a very popular subject in Greek art. The most famous sculptural representation—by Praxiteles in the fourth century BC, showing the goddess unrobing to bathe—established the first ideal of nude female beauty that could stand alongside the canon of the athletic male. The theme of Aphrodite crouching in her bath also enjoyed great popularity and was the subject of numerous sculptures known from ancient authors and Roman copies. The Kimbell Aphrodite is one of many variations on a famous Hellenistic original by an unknown artist. The composition embodies the qualities of beauty and voluptuous sensuality that characterize the goddess of love. She was shown crouching to bathe, her head turned sharply to the right, her left arm brought across the body to touch the right

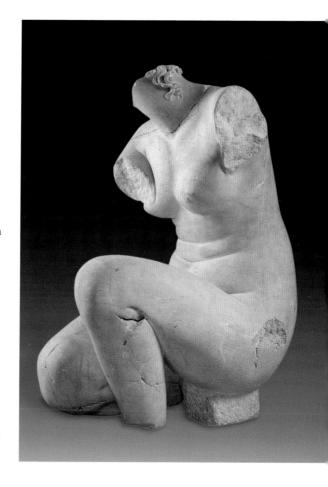

thigh, her right arm held up to near the left breast and shoulder. The somewhat spiral effect of her stance appealed to the Hellenistic taste for animated poses that embrace and engage with the space around them.

Mummy Mask

Egypt; Roman period, c. AD 120–70 Stucco/gesso with paint, gold leaf, and glass inlays; $11\%_{16}$ x 7% x 5% x 5% in. (29.4 x 19.4 x 14 cm)

Acquired in 1970

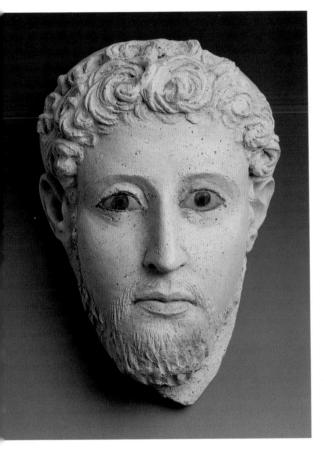

The most distinctive aspect of ancient Egyptian funerary practice was the ritual preservation of the body through mummification. Often, the Egyptians also made a likeness of the deceased individual as a cover for the face, so that if the mummy should become damaged, the spirit—after its nightly wanderings—would recognize it and return. During the Roman occupation of Egypt, this ancient practice continued, but with a distinctly Italic accent. The Kimbell mask shows the melding of these two cultures. The materials are traditionally Egyptian: gesso; paint, visible on the lips; gold leaf, patches of which are still present on the beard and hair; and glass, used to inlay the green, black, and cream-colored eyes. The facial structure and fashion of the face, however, are not at all Egyptian or North African, but Roman. The hair and beard styles are typical of second-century Rome, where they were made fashionable by the emperor Hadrian.

Throughout Egyptian history, the use of mummy masks was restricted primarily to the wealthy and political elite. We do not know the identity of the person who owned this mask. Perhaps he was a wealthy merchant or government official. His physiognomy suggests that he was at least partially European; yet he was Egyptian enough to give his remains and his soul to the ancient gods.

Priestess of the Imperial Cult

Roman, AD 170–80 Marble; $13^{1/4} \times 10^{5/8} \times 9^{5/8}$ in. (33.6 x 27 x 24.5 cm)

Acquired in 1969

This life-size head of a young woman was originally part of a full-length, draped statue. Once identified as a portrait of Empress Faustina the Younger, the wife of Emperor Marcus Aurelius and daughter of Antoninus Pius, the subject is now thought to be a priestess of the imperial cult. The work is datable on stylistic grounds to the period AD 170–80, suggesting that the three now-headless busts emerging from the headband represented Marcus Aurelius (reigned AD 161–80) and other members of the Antonine line—perhaps Hadrian and Antoninus Pius.

The face has many of the features that the ancient Romans prized in women: a wide smooth brow, wavy hair, softly modeled cheeks, small firm chin, and gentle smile. As in most Roman portraiture, these features are also intended to convey a sense of character, and we may see here something of the sitter's modesty, virtue, and harmony.

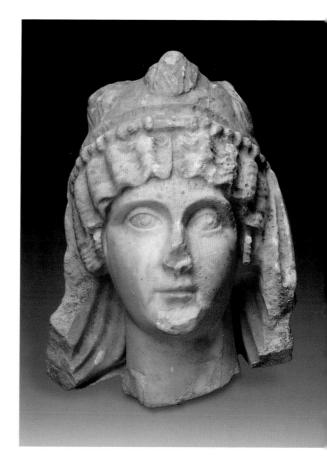

Portrait of Emperor Marcus Aurelius

Roman, c. AD 210–25 Marble (probably from Carrara, Italy); 14^3 /s x 9^7 /s x 10^1 /4 in. (36.5 x 25.1 x 26 cm)

Acquired in 1967

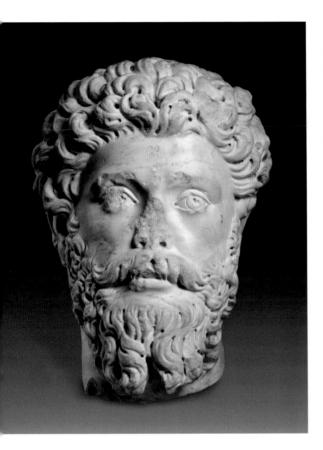

The Roman emperor Marcus Aurelius (reigned AD 161–80) was the archetypal "philosopher-king," perhaps best known today as the author of the Stoic philosophical treatise *The Meditations*. From a patrician family, Marcus gained the attention of the emperor Hadrian while

still a child and was the subject of imperial portraiture from his youth. The ensuing corpus of official portraits records the emperor's changing facial features as well as his evolving hair and beard styles. The Kimbell head, which comes from a bust or full-length figure, replicates the fourth and last of Marcus's official portrait types, characterized by upswept curls above the forehead, a thick mustache covering the upper lip and partially overlapping the lower, and a full beard that falls in two main groups of curls.

The powerfully modeled features lend this portrait a quietly authoritative and intelligent air, the lofty upward gaze signifying the emperor's divine nature. Some features, especially the distinctive, drilled pupils of the eyes, find parallels in later portraits of the emperors Caracalla and Alexander Severus, suggesting that this may be a posthumous work made under the subsequent Severan dynasty. Septimius Severus, an army general who established the new dynasty in AD 193, claimed the deified Marcus Aurelius as his adoptive father to legitimize his claim to the throne. Atypical features of this head include the lack of incisions to render the eyebrows and the absence of a small tuft of beard below the lower lip.

Lion

Syria; Roman, c. AD 450–62 Mosaic; 42 ½ x 76 ½ in. (108 x 195.5 cm)

Acquired in 1972

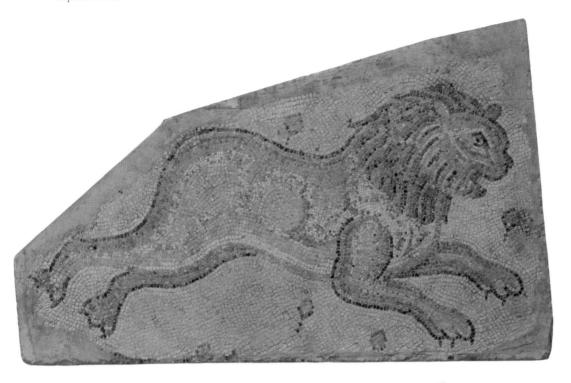

This schematized image of a rampant lion probably came from a large mosaic floor in an early Christian church in Homs, Syria, dated by an inscription to AD 450-62. The other subjects in the floor included a leopard, a gazelle, and a griffin. Animals appear frequently in pavement art, where the use of sacred images and symbols had been prohibited in areas where worshippers would walk (an imperial decree of AD 427 forbade the representation of crosses on church floors). Narrative biblical scenes and images of Christ were permitted on walls, but floors tended to remain within the traditional secular repertory inherited from Roman times. Animal, marine, and pastoral subjects appeared in the nave of

the church, which was associated with the created world. Designs of a more abstract, metaphysical nature decorated the sanctuary, denoting the world of the spirit.

The ferocious lion of this fragment most likely represents part of a hunt scene, though it could be a motif in a religious narrative or purely symbolic. The subject of the hunt originated in Near Eastern royal hunt scenes and was very popular in Roman pagan imagery. Early Christians associated the symbol of the hunt with the concept of duality—the triumph of good over evil—and dangerous animals could be identified with irrational elements of the human soul. The lion, however, also stood as a royal emblem, and could therefore symbolize Christ.

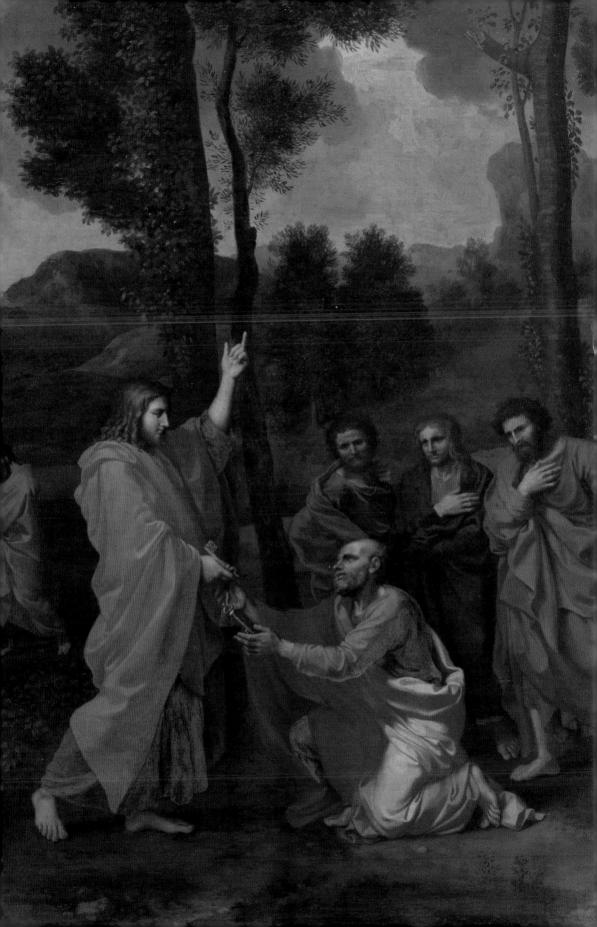

Reliquary Arm

Mosan (Liège?); c. 1150–1200 (crystal possibly added in the 15th century) Silver, champlevé enamel on copper, gilt bronze, wood core, glass cabochons, and crystal; $24 7 {\rm fs} \times 6 \times 3 7 {\rm kin}$ in. (62.1 \times 15.3 \times 9.9 cm)

Acquired in 1979

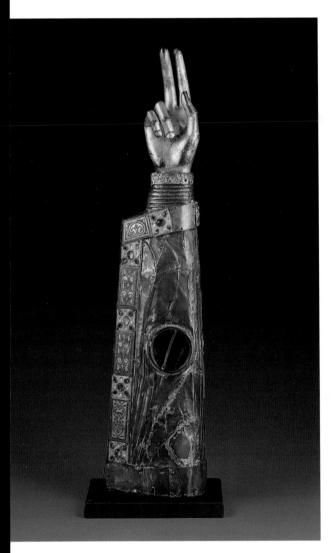

The veneration of the physical remains of saints-or objects with which they had come into contact—began to be practiced during the Early Christian era. Placed inside reliquaries and set on altars, these sacred objects soon became an essential part of Christian ceremony and were frequently ascribed miraculous powers. During the medieval era, their numbers proliferated, and reliquaries were decorated with lavish and costly materials. Apart from shrines, reliquaries often took the form of arms, hands, feet, or heads. The Kimbell Reliquary Ann, with hand raised in the gesture of the Latin benediction, encased the bone fragment of an unknown saint. A crystal was set into the arm at a later date, probably the fifteenth century, transforming the reliquary into a monstrance so that the relic could be viewed by the faithful.

The beautiful champlevé enamel work is characteristic of Mosan art, which flourished during the twelfth and thirteenth centuries in the Meuse valley (today in Belgium and northeastern France).

Reliquary Casket

French (Limoges); c. 1200-1220

Champlevé enamel on copper, wood core; 8 7/8 x 9 1/2 x 4 1/8 in. (22.6 x 24.2 x 10.5 cm)

Acquired in 1979

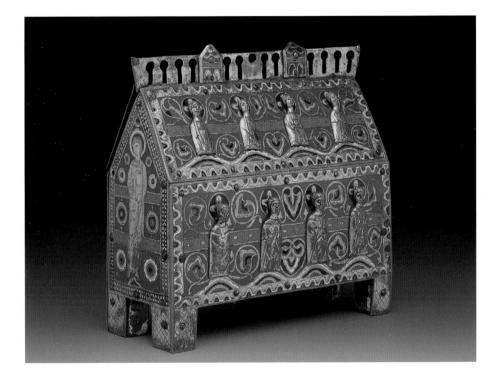

Limoges, located in southwestern
France along several ecclesiastical and pilgrimage routes, was a major center of the manufacture and export of exquisitely crafted reliquaries in the Middle Ages.
Limoges workshops producing liturgical objects employed the technique of champlevé enamel, whereby brilliantly colored, powdered glass was placed in cavities gouged into a copper plaque that was then fired at high temperatures.

This *Reliquary Casket* (chasse), which probably contained the relics of several saints, features eight half-length, gilded

figures of saints against a richly enameled ground decorated with halos, scrolling floral motifs, and wavy cloudbanks. These appliqué relief figures, known as *poupées* (dolls), are portrayed with various liturgical gestures, such as upraised palms. In contrast to these figures, the full-length saints holding books on the gabled end panels are engraved in reserve on the enamel ground. The casket, with its gabled roof and cresting, recalls not only a tomb enshrining the relics, but also the Church in the form of a cathedral that represents the Heavenly Jerusalem, where the saints eternally abide.

The Barnabas Altarpiece

Southwestern French or Northern Spanish (?); c. 1275–1350 Tempera, oil, and gold on panel; left panel: $35^{13}/_{16} \times 14^{3}/_{8}$ in. (91 x 36.5 cm); central panel: $35^{13}/_{16} \times 22^{7}/_{16}$ in. (91 x 57 cm); right panel: $35^{13}/_{16} \times 14^{9}/_{16}$ in. (91 x 37 cm)

These three panels are fragments of a oncelarger ensemble, which has been named *The Barnabas Altarpiece* because of the inscriptions on its lower border alluding to an unidentified Bishop Barnabas. Originally, the altarpiece was likely constructed with at least three enframed tiers of panels. The crowned, enthroned Virgin nursing the infant Christ is represented as Queen of Heaven, a symbol of the Church. Saints Peter and Paul, protectors of the Church, stand to the left and right, respectively.

Examination of the panels during conservation has confirmed a medieval date. The background, originally an indigo layer of pigment, had faded and was repainted at an early (possibly Renaissance) date, and the outlines of the figures were strengthened. Surviving altarpieces from the Gothic era are very rare, and there has been little scholarly consensus regarding this work's place of origin. The wooden support is linden (basswood), which was used primarily in southern Europe and not in England or Scandinavia. Moreover, the use of gypsum as a preparation ground also rules out most of the northern countries. These investigations thus support a growing consensus that the painting originates from southwestern France or northern Spain.

DUCCIO DI BUONINSEGNA

Italian, active 1278-1318

The Raising of Lazarus

1310-11

Tempera and gold on panel; $17^{1}/8 \times 18^{1}/4$ in. (43.5 x 46.4 cm)

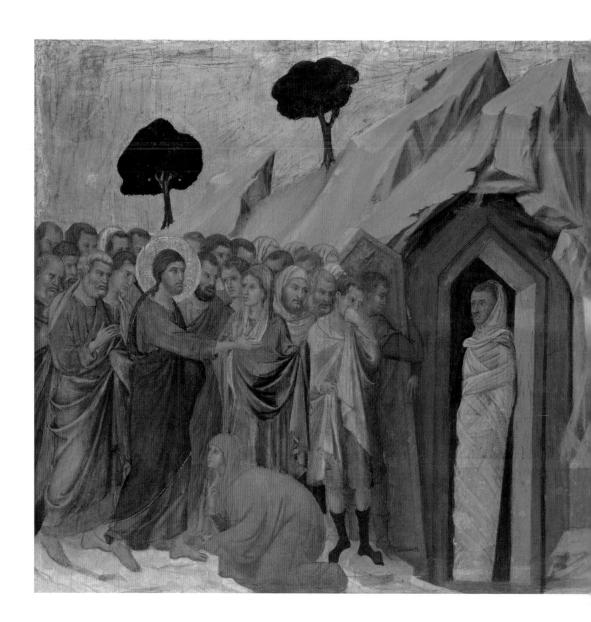

Duccio was the preeminent Sienese painter in the early fourteenth century. He infused the prevailing Byzantine style with a more naturalistic, narrative mode. The Kimbell painting originally formed part of the altarpiece known as the Maestà (Majesty), made for the high altar of Siena Cathedral. The Maestà was among the most beautiful and complex altarpieces ever made. Originally some sixteen feet high, it was painted on both sides, the front showing the Madonna and Child enthroned with saints and the rear showing episodes from the life of Christ. The front predella (a boxlike base) depicted events from Christ's childhood, and the back predella recounted his ministry.

The Kimbell's *Raising of Lazarus* was most likely the final scene of this back

predella; it depicts Christ bringing a man back from the dead, which provided the climactic proof of his divinity. According to John 11:1–44, when Lazarus fell ill, his sisters Martha and Mary sent for his friend Jesus. By the time Jesus arrived in Bethany, Lazarus had already been dead four days. Duccio shows the moment when Christ called Lazarus forth from the tomb, prefiguring his own Resurrection.

A noteworthy compositional change is apparent at the lower right. The paint surface, thinned by age, reveals an underlying paint layer showing a horizontal sarcophagus.

This and several other panels became separated from the *Maestà* after it was dismantled in 1771. Most of the panels are today in the Siena Cathedral museum.

FRA ANGELICO (FRA GIOVANNI DA FIESOLE)

Italian, c. 1395/1400-1455

The Apostle Saint James the Greater Freeing the Magician Hermogenes

c. 1426-29

Tempera and gold on panel; 10% x 93/8 in. (26.8 x 23.8 cm)

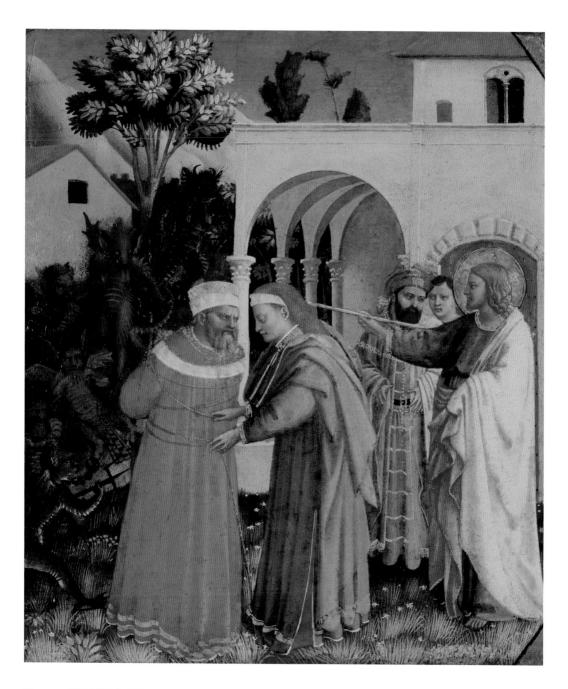

Born Guido di Piero, the artist known as Fra Angelico acquired his nickname soon after his death, when he was referred to as "Angelicus" by a Dominican monk for his pious life and artworks. He was already an established painter and illuminator of manuscripts in Florence when he entered the Observant Dominican Order as Fra Giovanni sometime between 1418 and 1423.

The rare subject of this picture is taken from the thirteenth-century *Golden Legend*, in which Saint James the Greater orders the Christian convert Philetus to free the repentant magician Hermogenes, who had been bound by the very devils he sent to vanquish Saint James. A haloed Saint James taps Philetus with his staff, empowering

him to unloose the cords of Hermogenes, metaphorically absolving his sins.

This painting originally formed part of the predella of an unidentified altarpiece. The four other extant panels are devoted to the lives of the Virgin and various saints. Using rational perspective and lighting, Fra Angelico was among the first Florentine artists to adopt the younger artist Masaccio's pictorial innovations.

The panel is exceptionally well preserved. The refinement of Fra Angelico's technique is apparent in his use of pure pigments, such as vermilion and lapis lazuli, in the delicate hatched strokes modeling the forms, and in his masterful use of gilding in the decorative borders of the drapery.

ATTRIBUTED TO DONATELLO (DONATO DI NICCOLÒ DI BETTO BARDI)

Italian, 1386/87-1466

Virgin and Child (The Borromeo Madonna)

c. 1450

Terracotta; $32\% \times 20\frac{1}{2}$ in. (83.5 x 52.1 cm)

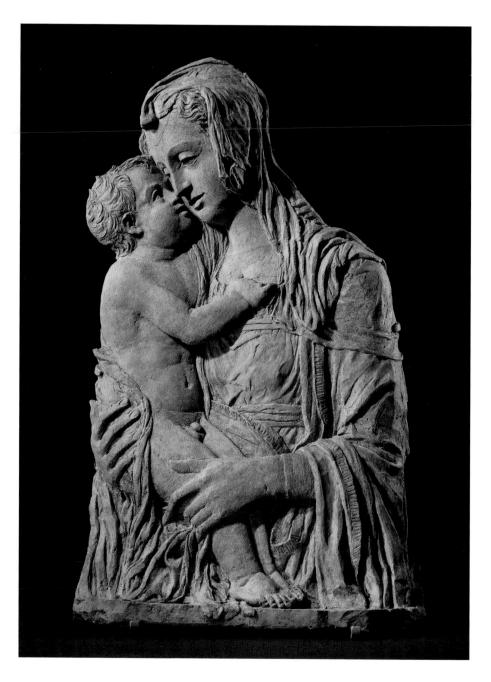

Celebrated for his powers of invention, range of expression, and technical prowess, Donatello was the preeminent Italian sculptor of the fifteenth century. Madonna reliefs were among the most common works of art produced during this time, and Donatello's conception of the genre—its spirituality, naturalism, and rendering of mass and depth in shallow plane—counts among the most extraordinary achievements of the period. Because of the demand for these devotional works, they were much copied and imitated. Among the many "Donatellesque" Madonna reliefs that survive, those likely to have been sculpted by the master himself are rare.

The Kimbell relief, known as the Borromeo Madonna after the presumed first owner, remained in the church of San Giovanni Battista in Lissaro di Mestrino, a village near Padua, until 1902. In the fifteenth century, the church was under

the exclusive patronage of the Borromeo family, wealthy bankers and merchants in Milan, Padua, and Venice. Antonio Borromeo and his son were on the board of the basilica of Sant'Antonio in Padua (the Santo), which commissioned Donatello's masterwork, a complex bronze altarpiece completed by 1450. A member of the Borromeo family probably acquired the Kimbell's Madonna relief around this time. although it is not documented at Lissaro di Mestrino until about 1500. Over time, the original painted and gilded surface of the relief was disfigured by layers of stucco and overpaint. A recent cleaning removed these later accretions, revealing the quality of the modeling. The sense of intimate and intense emotion is characteristic of Donatello. Christ trains his eyes on his mother, whose gaze is wistful and diverted in prescience of his future sacrifice on the cross.

GIOVANNI BELLINI

Italian, c. 1438-1516

The Madonna and Child

c. 1465

Tempera, possibly oil, and gold on panel; $32\frac{1}{2} \times 23$ in. (82.5 x 58.4 cm)

Acquired in 1971

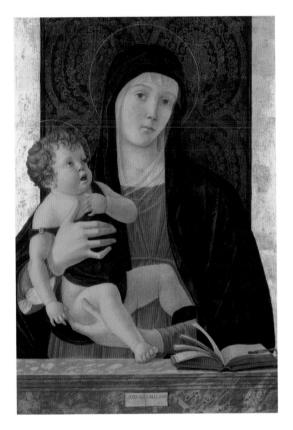

Giovanni Bellini's half-length devotional paintings of the Madonna and Child enjoyed great popularity in Venice, and later in his career he employed a large workshop to meet the demand. Having trained with his father, Jacopo, who introduced to Venice a more intimate type of devotional painting, Bellini created tender images that appeal to the viewer's sentiments. They typically feature a sweet, wistful Virgin who signals her awareness and acceptance of the preordained fate of her son. The many variations of pose and motif serve to remind the worshipper of Christ's redemptive role.

Here, Bellini's Madonna stands behind a veined marble parapet, in front of a cloth of honor brocaded with pomegranates to symbolize the Resurrection. The parapet recalls both Christ's tomb and the altar upon which his sacrifice is reenacted in the Eucharistic offering. This meaning accounts for Mary's determined display of her Child, whom she presents to the devout viewer as the living Host. The illusionistic cartellino affixed to the parapet and inscribed with Bellini's name attests both to his identity as an artist and to his own religious devotion. Although the head of the Christ Child and the book are well preserved, other parts of the composition, especially the face of the Virgin, have suffered abrasion.

ERCOLE DE' ROBERTI

Italian, c. 1455/56-1496

Portia and Brutus

c. 1486-90

Tempera, possibly oil, and gold on panel; $19\frac{3}{16}$ x $13\frac{1}{2}$ in. (48.7 x 34.3 cm)

Acquired in 1986

Ercole de' Roberti spent the latter half of his career at the court of Ercole I d'Este. Duke of Ferrara, painting altarpieces, small devotional works, portraits, and fresco cycles for the Este residences, as well as producing decorative objects like beds and carriages. Ercole's panel is one of three scenes of virtuous women that were likely painted for the duchess of Ferrara, Eleonora of Aragon. Depictions of female worthies who exemplified virtues such as chastity, fidelity, and patriotism were inspired by the writings of ancient authors, such as Valerius Maximus and Plutarch, and Renaissance texts, especially Boccaccio's On Famous Women (1361-75). Here Portia, the wife of Marcus Junius Brutus, demonstrates her bravery and fortitude by wounding her foot with a razor the evening before her husband's attempt to assassinate Julius Caesar. She explains that she inflicted the wound herself to confirm that she would be ready to endure death should the plan not succeed. Eleonora may have installed Ercole's exquisitely painted works in her own suite of rooms in the Castello Vecchio of Ferrara, refurbished around 1490.

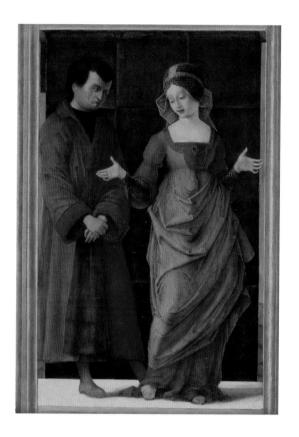

ANDREA MANTEGNA

Italian, c. 1430/31-1506

The Madonna and Child with Saints Joseph, Elizabeth, and John the Baptist

c. 1485-88

Distemper, oil, and gold on canvas; $24\frac{3}{4} \times 20\frac{3}{16}$ in. (62.9 x 51.3 cm)

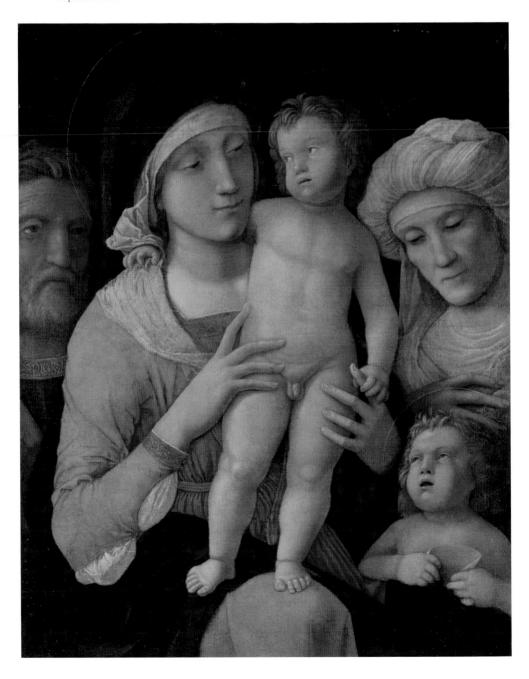

Trained in the humanist university town of Padua, Andrea Mantegna developed a lifelong passion for antiquity that profoundly informed his own work. His incisive drawing, brilliant coloring, and novel spatial effects soon established him as one of the major artists of his day and led to his appointment as court painter to the Gonzaga family in the duchy of Mantua. His famous, frescoed "Camera Picta" in the Ducal Palace was described by a contemporary as "the most beautiful room in the world."

In the Kimbell's Madonna and Child with Saints, the five closely grouped figures press forward in the shallow space, a series of diagonals guiding the worshipper's eye to dwell on the mystery of the Incarnation: the Word made flesh.

The triumphant *contrapposto* pose of the Christ Child derives from antique Roman sculpture, which was then being ardently collected.

In this and other devotional paintings, Mantegna experimented with distemper, a glue tempera, painted on a fine linen canvas. This delicate technique facilitates the great precision in handling for which he is renowned. Mantegna's thin and exquisitely rendered surfaces are very fragile, and some abrasion has occurred to this work in areas such as the Virgin's coral-colored robe, which was once embellished with a gold pattern. In some of the best-preserved areas of the painting, such as the head of the young Baptist, the wonder of the artist's extraordinary technique can still be appreciated.

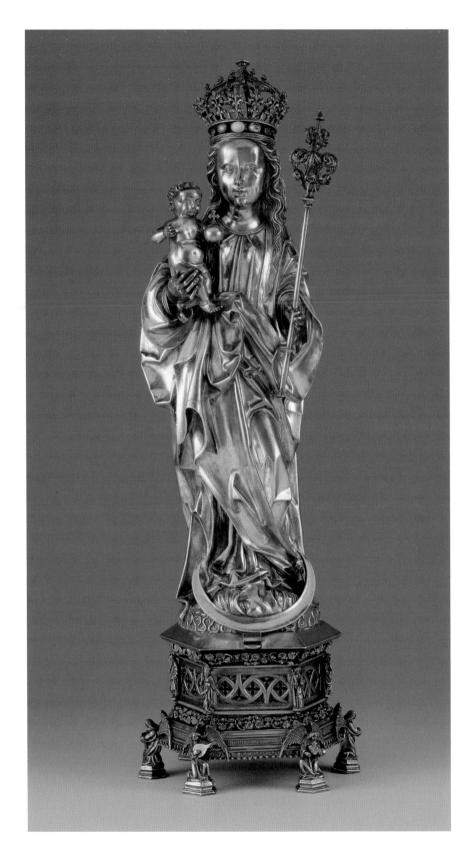

Virgin and Child

South German; 1486 Silver, parcel-gilt, stones (opal, clear and pale sapphires, garnets, and pale emeralds); $21\times6\%4\times6\%4$ in. (53.3 x 17.2 x 17.2 cm)

Acquired in 2002

The subject of this rare example of Late Gothic church sculpture is the Virgin of the Apocalypse or the Virgin in the Sun, whose imagery—the aureole of the sun, the twelve stars in her crown, and the crescent moon beneath her—is derived from the book of Revelation (12:1–5): "And there appeared a great wonder in heaven, a woman clothed with the sun, and the moon under her feet, and upon her head was a crown of twelve stars . . . And she brought forth a man-child, who was to rule all nations."

The figure of the Virgin was executed in repoussé (shaped by hammering from the reverse side). Her hair, the moon, and other details of the sculpture are gilded. The identity of the exceptionally skilled

goldsmith, who may have worked from another artist's model, is unknown.

The plinth bears the heraldic shield of Wilhelm von Reichenau, a bishop of Eichstätt—a small city in southern Germany—who gave this silver Virgin to the Eichstätt Cathedral. Represented on the base of the statue above angels playing musical instruments are Eichstätt's popular saints—including Saint Willibald, the city's first bishop.

The Virgin and Child was probably removed and sold following the secularization of the Diocese of Eichstätt at the beginning of the nineteenth century. It was later in the collection of Mayer Carl von Rothschild in Frankfurt and remained in private hands until its acquisition by the Kimbell.

MICHELANGELO BUONARROTI

Italian, 1475-1564

The Torment of Saint Anthony

c. 1487-88

Tempera and oil on panel; $18^{1/2} \times 13^{3/4}$ in. $(47 \times 34.9 \text{ cm})$

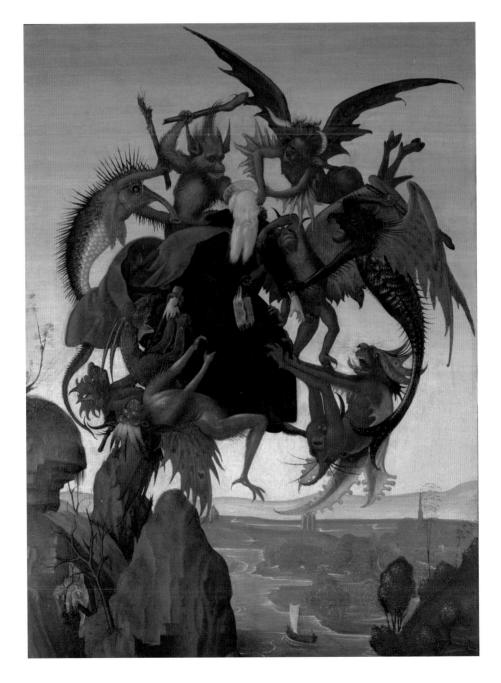

This is the first known painting by Michelangelo, believed to have been painted when he was twelve or thirteen years old. Although Michelangelo considered himself first and foremost a sculptor, he received his early training as a painter, in the workshop of Domenico Ghirlandaio (c. 1449-1494), a leading master in Florence. Michelangelo's earliest biographers, Giorgio Vasari and Ascanio Condivi, tell us that, aside from some drawings, his first work was a painted copy of the engraving Saint Anthony Tormented by Demons by the fifteenth-century German master Martin Schongauer. The rare subject is found in the life of Saint Anthony the Great, written by Athanasius of Alexandria in the fourth century. It describes the Egyptian hermit-saint's vision, in which he levitated into the air and was attacked by demons, whose torments he withstood.

Created when he was informally associated with Ghirlandaio's workshop and under the guidance of an older friend, the artist Francesco Granacci, this painting earned Michelangelo widespread recognition. Both Vasari and Condivi recounted that to give the demonic creatures veracity, he studied the colorful scales and other parts of specimens from the fish market. Michelangelo subtly revised Schongauer's composition, making it more compact and giving the monsters more animal-like features. notably adding fish scales to one of them. He also included a landscape that resembles the Arno River Valley around Florence. The work is one of only four easel paintings generally regarded as having come from his hand and the first painting by Michelangelo to enter an American collection.

Jacob Obrecht

Netherlandish or French; 1496 Tempera, oil, and gold on panel; 20 $^1/_4$ x 14 $^1/_4$ in. (51.4 x 36.2 cm) Acquired in 1993

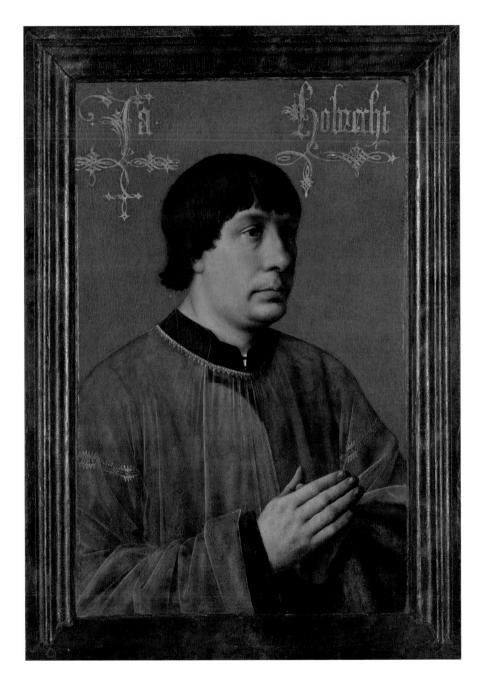

The gilt Gothic inscription on this masterpiece of northern Renaissance portraiture identifies the subject as Jacob Obrecht (1457/58–1505), a renowned choirmaster and one of the greatest composers of his age. On the engaged frame are inscribed both the date of the painting, 1496, and the sitter's age, 38. Obrecht was born in Ghent and took posts in Bergen op Zoom, Cambrai, Bruges, and Antwerp. Such was his international standing that he was invited to the court of Ferrara by Duke Ercole I d'Este. He died from the plague, eulogized as "a most learned musician, second in the art to no one, in respect to either voice or cleverness of invention."

The painting is probably the left-

hand side of a diptych; it would have been attached to a facing panel showing the Madonna and Child or a similar devotional subject. Preserved in exceptional condition, the painting is remarkable for the virtuosity of its details, such as the folds of Obrecht's lace-trimmed surplice and the soft gray fur of the *almuce* (the badge of office of a canon) draped over his left arm. The technical refinement of the paint layers, from the finely hatched brushstrokes in the hands to the smoothly blended flesh tones, suggests that the artist used a mixed medium of egg tempera and oil. The painting shows some stylistic affinity to the work of the Bruges master Hans Memling, but the identity of the artist remains a mystery.

ATTRIBUTED TO GIAN CRISTOFORO ROMANO

Italian, 1465-1512

Portrait of a Woman, Probably Isabella d'Este

c. 1500

Terracotta, formerly polychromed; 21³/₈ x 21¹/₂ in. (54.3 x 54.6 cm)

Acquired in 2004

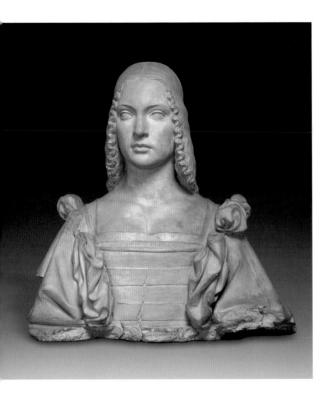

This rare terracotta portrait bust may represent Isabella d'Este, Marchioness of Mantua. The most celebrated woman of her day, Isabella d'Este (1474–1539) cultivated one of the most illustrious courts in Renaissance Italy. She was a passionate patron who invited the most

renowned artists in Italy to decorate her private quarters in the Ducal Palace of Mantua. The identity of the figure rests in part on its correspondence to Leonardo da Vinci's famous drawing of Isabella d'Este in profile (Musée du Louvre, Paris). It also bears comparison with a portrait medal of Isabella by Gian Cristoforo Romano, one of the leading sculptors of his time and an accomplished courtier, singer, poet, and antiquarian, who advised Isabella. As early as 1491, she commissioned him to make a marble portrait bust of her, although no such work by him is known. Isabella was not as attractive as she would have liked and often complained that her portraits were unflattering. In much Renaissance female portraiture, a faithful likeness was less desirable than an idealized beauty that represented the sitter's virtue. If the Kimbell bust indeed represents Isabella, it does so in a highly flattering way, presenting an ideal, classicized "likeness" that would have pleased the most discriminating of patrons. The bust was originally painted. As with almost all such terracottas, the colors were probably removed in the nineteenth century.

ATTRIBUTED TO TULLIO LOMBARDO

Italian, c. 1455-1532

Christ the Redeemer

c. 1500-1520

White marble relief; $13^{3}/_{16} \times 12^{3}/_{16} \times 3^{9}/_{16}$ in. $(33.5 \times 31 \times 9 \text{ cm})$

Acquired in 2005

This marble relief bears stylistic affinities with the Venetian sculptor Tullio Lombardo, although the attribution is uncertain. Tullio was well versed in both ancient art and the work of contemporary artists outside Venice, such as Mantegna and Leonardo da Vinci. As the prime Venetian sculptor of the High Renaissance, he received the lion's share of monumental commissions of the day; beyond the Veneto, his work is rare. The figure of Adam from the tomb of Doge Andrea Vendramin, originally in the church of Saints Giovanni e Paolo, Venice, and now in the Metropolitan Museum of Art, New York, is his only securely documented work in America.

Christ the Redeemer is sculpted in mezzo-rilievo (literally "half-relief"). The virtuosity of the carving is especially apparent in the deeply undercut, twisting tendrils and the crisp patterns of Christ's beard set against the smooth surface of his skin. The profile view of Christ has been traditionally associated with an emerald cameo engraved with the vera effigies ("true image") of Christ said to have been given to Pope Innocent VIII by the Sultan Bajazet II. Variants of this profile image circulated in medals, prints, and other media. The sculptor of the relief—whether Tullio or a close follower—has adapted the

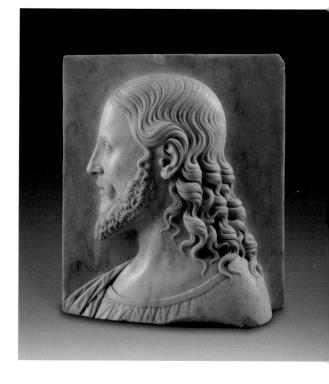

prototype to his own classical tendencies: Christ's archaic profile and blank eyes imbue him with an ideal beauty, which would have been understood to represent the Redeemer's divine nature. The relatively small size of the work suggests that it was a meditational object for a household altar or small chapel. It may originally have been painted.

GIOVANNI BELLINI

Italian, c. 1438–1516

Christ Blessing

c. 1500

Tempera, oil, and gold on panel; $23^{1/4}$ x $18^{1/2}$ in. (59 x 47 cm)

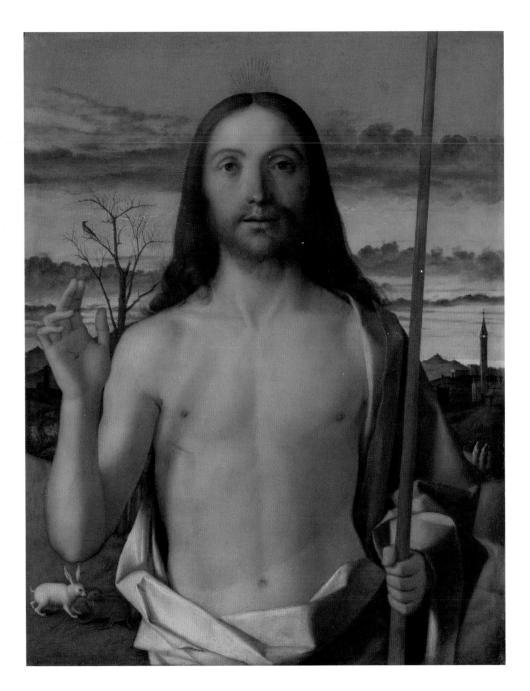

Bellini's Christ Blessing vividly portrays the central mystery of the Christian faith: the Incarnation, when Christ-fully human and fully divine—was sent to earth to redeem humankind. For greater immediacy, the devotional image is brought close to the picture plane as the Resurrected Savior faces the worshipper with a level gaze. He raises his right hand in blessing while his left grips the red staff of the banner of the Resurrection (the white flag with a red cross, denoting his triumph over death, is out of view). Golden rays of light emanate from his head, signaling his divinity. A cool, lavender-white drapery encircles his warm flesh, incandescent with a preternatural beauty. The message of Christian compassion is conveyed by the wounds visible on his hand and chest, while the shadow cast by his raised arm serves to confirm the reality of the Resurrection.

Various motifs in the landscape allude to the Resurrection. The withered tree with the solitary bird probably stands for the Old Covenant, out of which the New Covenant would grow. The pair of rabbits signify regeneration, while the shepherd tending his flock is a reminder that Christ is the Good Shepherd (John 10:14). The three robed figures at the picture's right edge are undoubtedly the three Marys hurrying to tell the disciples of the empty tomb. The distant bell tower denotes that salvation is found through Christ's sacrifice and the Church. Since the early Christian era, Christ had been identified with the sun god, Apollo. Like "Sol Invictus," the never-vanquished Sun, the risen Savior is victorious over death as he presides here like a classical hero over the landscape, dappled by the dawning light.

LUCAS CRANACH THE ELDER

German, 1472-1553

The Judgment of Paris

c. 1512–14 Oil on panel; $16^{15}/_{16}$ x $12^{11}/_{16}$ in. (43 x 32.2 cm)

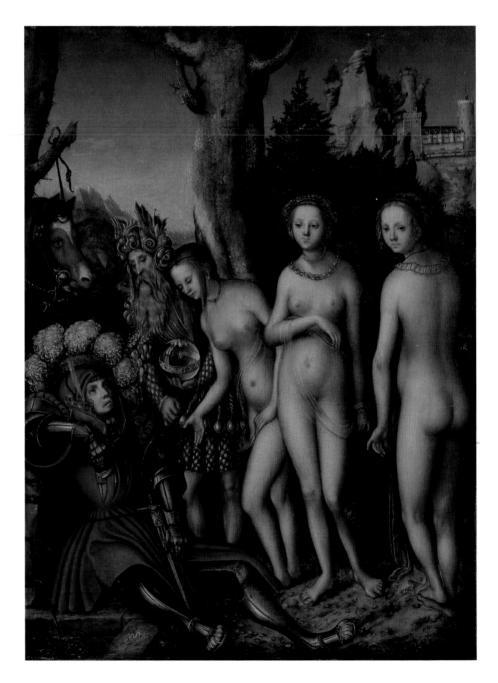

Lucas Cranach was one of the foremost artists of sixteenth-century Germany. From 1505, he spent almost his entire career in Wittenberg as the court artist to Frederick the Wise and his successors, the electors of Saxony.

This is the first of Cranach's several versions of *The Judgment of Paris*. According to Greek and Roman mythology, the goddess of discord tossed an apple labeled "to the fairest" among the Olympian gods. Jupiter sent the messenger-god Mercury to tell Paris, prince of Troy, to award the prize. The three goddesses who claimed the apple offered bribes. Juno promised wealth and power, Minerva military prowess, and Venus the love of the most

beautiful woman on earth. Paris's choice of Venus, and his abduction of the most beautiful woman—the Spartan queen, Helen—led to the Trojan War. Cranach's portrayal of this subject was influenced by Guido delle Colonne's Historia Destructionis Troiae, a fanciful medieval narrative of the Trojan War. In this version of the story, Paris tethers his horse and falls asleep after losing his way in a hunting expedition, and Mercury appears in his dream to present the three goddesses. In this painting, Cranach teases Paris—as well as the viewer-with an agonizing choice: the goddesses are nearly indistinguishable and equally enticing.

JAN GOSSART, CALLED MABUSE

Netherlandish, c. 1478–1532

Portrait of Hendrik III, Count of Nassau-Breda

c. 1516–17 Oil on panel; $22\frac{1}{2}$ x $18\frac{1}{16}$ in. (57.2 x 45.8 cm)

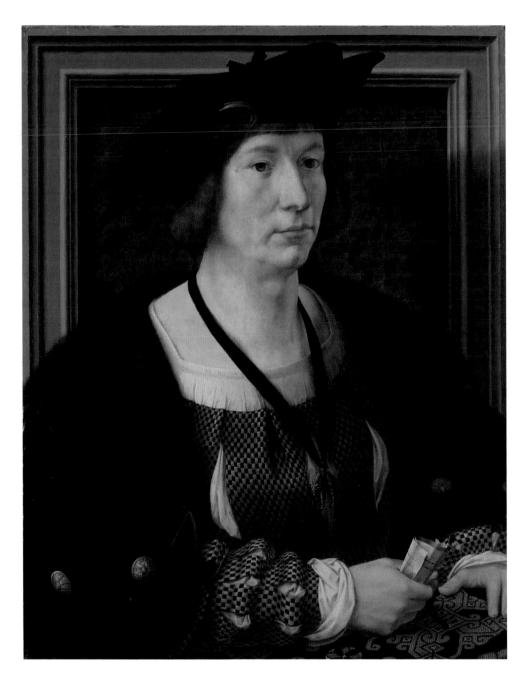

Having accompanied his patron Philip of Burgundy to Rome in 1508–9, Jan Gossart was one of the first artists to disseminate the Italian style in the Low Countries. The subject of this portrait is Hendrik III, Count of Nassau-Breda (1483–1538). An esteemed statesman and captain general, Hendrik was entrusted with the education of Emperor Maximilian's son, the future Emperor Charles V, who appointed him governor of Holland, Zeeland, and Friesland in 1515. Hendrik was also an adventuresome and noteworthy art patron whose collection included Hieronymus Bosch's *Garden of Earthly Delights* (Museo del Prado, Madrid).

In keeping with the meticulous attention to detail of the northern schools.

Gossart carefully renders the textures of the carpet, fur collar, buttons, and checkered doublet, creating an image of jewel-like intensity. The count wears the pendant of the Order of the Golden Fleece, the elite chivalric order dedicated to the defense of the church. The sitter's features are finely delineated (the underdrawing is visible around the lips, nose, and chin) to achieve a sympathetic likeness. The marked illusionism of the work, with the fictive frame and figure's shadow cast against the feigned green marble backplate, derives from the great Flemish master Jan van Eyck. Gossart's close study of Italian art is evident in the imposing bulk and balanced composition of the figure.

BAMBAIA (AGOSTINO BUSTI)

Italian. c. 1483-1548

Fortitude and Unidentified Virtue, Possibly Hope

c. 1520-25

Marble; $23^{13}/_{16} \times 9^{1}/_{2} \times 7^{5}/_{8}$ in. $(60.5 \times 24.2 \times 19.3 \text{ cm})$; $26^{3}/_{16} \times 12^{3}/_{8} \times 6^{1}/_{2}$ in. $(66.5 \times 31.5 \times 16.5 \text{ cm})$

Acquired in 1981

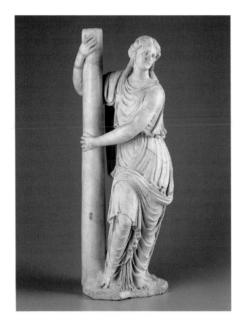

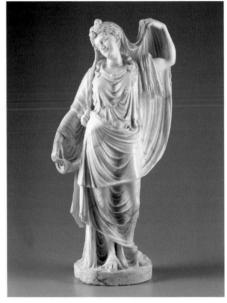

Agostino Busti, known as Bambaia, was an important Lombard sculptor, notable for his refined technique and innovative classicism. First mentioned in 1512 in the workshop of Milan Cathedral, Bambaia created a number of major tomb and altar commissions, often in collaboration with other sculptors such as Cristoforo Lombardo. The two marble sculptures in the Kimbell collection represent Virtues: one, wearing a classical robe draped over one shoulder, is identifiable as Fortitude by her attribute, the column; the other figure is without an attribute and may represent Hope. The exquisite sweep of her diaphanous drapery, with close pleats and rippling edges, exemplifies Bambaia's virtuoso

carving technique. Her pose derives from the ancient Venus Genetrix type, and the sweet and lyrical expression of the face was inspired by the work of Leonardo da Vinci, with whom Bambaia apparently traveled to Rome in 1513.

The *Virtues* may originally have adorned a tomb monument that was later dismantled and dispersed, most likely the funerary monument of a humanist in Pavia, parts of which were taken as war loot between 1527 and 1528 by the condottiere Mercurio Bua for his own tomb in the church of Santa Maria Maggiore in Treviso. However, the original configuration of Bambaia's tomb monuments remains difficult to reconstruct.

PARMIGIANINO (GIROLAMO FRANCESCO MARIA MAZZOLA)

Italian, 1503-1540

The Madonna and Child

c. 1527–30 Oil on panel; $17\% \times 13\%$ in. (44.8 \times 34 cm) Acquired in 1995

Hailed as the new Raphael, Parmigianino was one of the most influential artists of the sixteenth century, cultivating a mannered gracefulness of pose and physiognomy combined with new and dramatic coloristic effects that transformed the classicism of his Renaissance predecessors. In his *Lives of the Artists* (1568), Giorgio Vasari observed that Parmigianino "gave to his figures . . . a certain loveliness, sweetness, and charm in their attitudes which were particularly his own."

Parmigianino spent three years in Bologna (1527-30), where he produced a number of small devotional works in the swift, assured manner that typifies his mature style. In the Kimbell panel, he draws upon the work of Leonardo, Raphael, and Michelangelo in counterposing the serene, pensive Virgin with her active Son, who tugs at his mother's veil. But the compressed pose of the dimpled Christ Child and the tall, sweeping foreheads of mother and child introduce elements of Parmigianino's distinctive Mannerism. The Virgin's exquisite beauty is an outward sign of her inner grace, which Parmigianino reinforces through the golden strands of her ribboned hair and the fluid rhythms of her gossamer drapery.

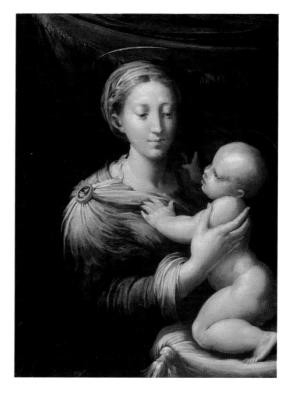

SEBASTIANO DEL PIOMBO (SEBASTIANO LUCIANI)

Italian, c. 1485-1547

Head of a Woman

Early 1530s
Oil on panel; diam. 10 in. (25.4 cm)

Acquired in 1985

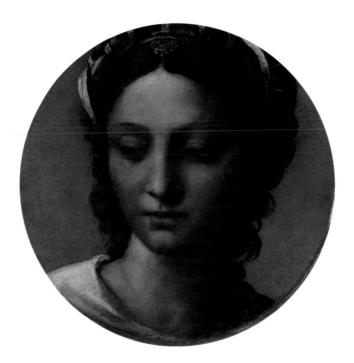

Notable for the monumental grandeur of his religious paintings and portraits, Sebastiano del Piombo became the preeminent painter in Rome following Raphael's death in 1520. Following his Venetian training with Giovanni Bellini and Giorgione, Sebastiano traveled to Rome in 1511 to fresco parts of the Villa Farnesina. An intense rivalry soon developed with Raphael. This was encouraged by Sebastiano's friend Michelangelo, who supplied him with drawings for some of his paintings. Sebastiano produced some of the finest portraits of his day, a number of which

were later mistakenly attributed to Raphael and Michelangelo. In 1531, Pope Clement VII rewarded him with an appointment as Keeper of the Papal Seal (*piombo*)—the name by which he came to be known.

This majestic head is an essay in ideal beauty of the type known as a *testa ideale* (ideal head). Sebastiano has emulated the smooth and abstracted facial structure found in classical sculpture—here reflected in the high, straight bridge of the nose and the downcast, half-moon eyes—and employed soft tonal transitions in the woman's skin to achieve a correspondingly three-dimensional effect.

TITIAN (TIZIANO VECELLIO)

Italian, c. 1488-1576

The Madonna and Child with a Female Saint and the Infant Saint John the Baptist

1530s Oil on panel; 41½ x 58¾ in. (105.4 x 148.3 cm)

Acquired in 1986

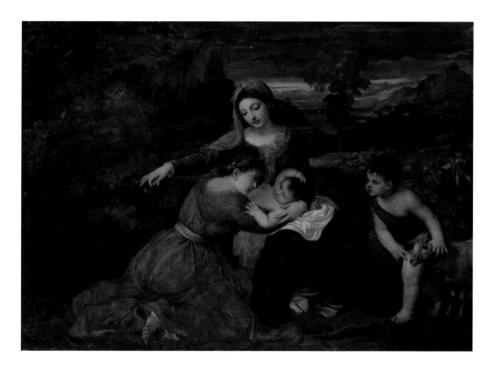

More than any other Renaissance master, Titian was acclaimed for his expressive handling of paint and rich use of color. Like his teachers Bellini and Giorgione, Titian set many of his religious subjects in a pastoral landscape. This painting is closely related to a version of the same composition in the National Gallery, London. In both works, Mary cradles the Christ Child, who is embraced by a kneeling female saint. Various aspects of the Kimbell painting underscore the theme of Christ's impending sacrifice. Christ's chubby arm is curled over his head in a pose used since antiquity to denote sleep as well as death. The white cloth that envelops

him foreshadows his shroud and also recalls the cloth used to protect the host during the Mass. X-radiography reveals that Titian initially included an angel at the left but later painted over this figure with a thicket and a finch, a symbol of Christ's Passion. Giving further emphasis to this sacrificial message, Titian also introduced the infant Saint John the Baptist gently leading a lamb.

Whereas the London version is on canvas, the Kimbell painting is on panel, which results in more deeply saturated color. Some areas—such as the sky, the Virgin's mantle, and the saint's dress—have darkened in color and become more transparent with age.

JACOPO BASSANO (JACOPO DAL PONTE)

Italian, c. 1510-1592

The Supper at Emmaus

c. 1538

Oil on canvas; $39\frac{5}{8} \times 50\frac{5}{8}$ in. (100.6 x 128.6 cm)

Acquired in 1989, with the generous assistance of a gift from Mildred Sterling Hedrick

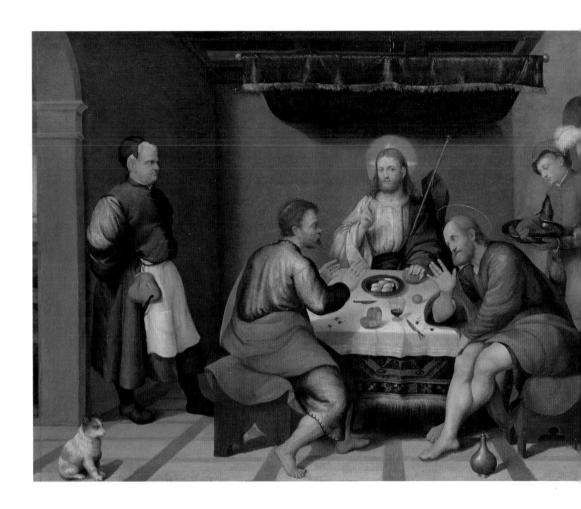

Jacopo Bassano was one of the most famous and influential masters of the late Renaissance in Italy, admired for his luminous color and sensitively observed incidents from everyday life. Trained by his father in the north Italian town of Bassano del Grappa, he worked in neighboring Venice in the early 1530s. His youthful works reflect the influence of Titian and other north Italian masters, along with artists ranging from Raphael to Dürer, whose compositions he knew through prints. Already by the late 1530s his powers of invention rivaled those of his contemporaries Tintoretto and Veronese. The Kimbell Supper at Emmaus depicts Christ's miraculous appearance after the

Resurrection (Luke 24:30-31). In the act of blessing and breaking bread at the inn. Christ reveals himself to two of his disciples, who failed to recognize him as they traveled on the road to Emmaus. Christ is seated beneath a splendid, green, velvet canopy that delimits the sacred space. The sacramental message is elucidated in the finely executed still life of bread, wine, and eggs—the latter a traditional symbol of resurrection and immortality. Distinguished by their contemporary dress, the wellfed innkeeper with a large purse and the plumed serving boy—along with their visual counterparts, a wary dog and menacing cat—attend to mundane affairs, unaware of the divine mystery unfolding before them.

JACOPO BASSANO (JACOPO DAL PONTE)

Italian, c. 1510-1592

Portrait of a Franciscan Friar

c. 1540-42

Oil on canvas; 3111/16 x 273/16 in. (80.5 x 69 cm)

Acquired in 1997

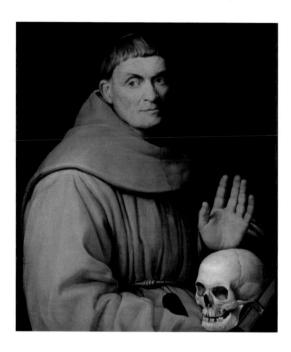

In this imposing portrait, Jacopo Bassano applies a vigorous and sharply focused naturalism to portray the distinctive features as well as the spiritual temperament and preoccupations of an unidentified Franciscan friar. The skull, a reminder of the vanity of earthly life, supports the contemplative aspect of the friar's piety, and the pen holder that hangs from the rope at his waist attests to his learning. A sensitive colorist, Jacopo creates a rich tonal range, contrasting the cool gray of the wool habit with the warm flesh areas, which derive luminosity from the reflection of the white ground through the glazes.

Portraits of Franciscans, who avow humility in a life devoted to prayer and penance, are not common. This early work is datable to around the time that Jacopo painted the Saint Anne altarpiece (1541, Gallerie dell'Accademia, Venice, on deposit in the Museo Civico, Bassano del Grappa) for the church of the reformed Franciscans in Asolo; possibly the sitter was one of its members.

JACOPO BASSANO (JACOPO DAL PONTE)

Italian, c. 1510-1592

The Adoration of the Magi

After 1555

Oil on jasper; 71/4 x 51/2 in. (18.4 x 14 cm)

Acquired in 1990, Bequest of Hedy Maria Allen, New York

The subject of the Adoration of the Magi, along with the Adoration of the Shepherds, occupies pride of place in Jacopo Bassano's repertory. There exist a number of variants of the composition of this miniature painting, both on canvas and stone, and their attribution to Jacopo remains the subject of scholarly debate. In the Kimbell painting, the yellow-veined, green jasper background that serves as the picture's support has been deftly integrated into the painted image to suggest an outcrop of rocks instead of the more traditional landscape setting with architectural ruins found in versions of the subject on canvas.

Small paintings on stone produced by Jacopo, or under his supervision in the prolific workshop he operated with his sons, reveal a little-known aspect of the family's output. Several of Jacopo's contemporaries praise his skill in painting night scenes on small black stones, and a painting on slate is listed in the inventory of the artist's studio after his death. Such supports became more common for miniature paintings during the Baroque period. In the Kimbell *Adoration*,

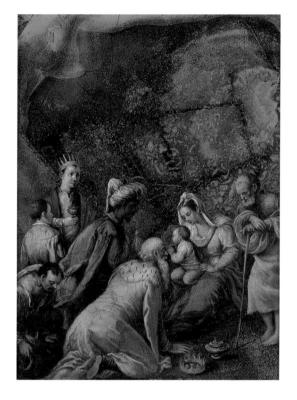

the rare stone would have been valued as a precious specimen of nature and for its smooth and durable surface, ideally suited for the detailed brushwork.

TINTORETTO (JACOPO ROBUSTI)

Italian, 1518-1594

Portrait of Doge Pietro Loredan

1567-70

Oil on canvas; 495/8 x 4115/16 in. (126 x 106.6 cm)

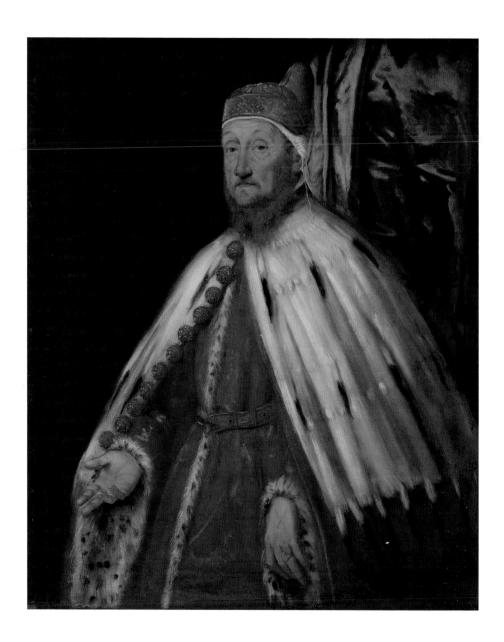

A prolific master of religious and historical works, as well as portraits, Tintoretto developed a rapid, often impetuous manner of painting that was both expressive and expedient. Here he captures the dignity and calm equanimity befitting "the most serene prince" of the Venetian Republic. In 1567, the eighty-five-year old Pietro Loredan (1482–1570) had been elected doge by his fellow councillors. Tintoretto portrays him in his ceremonial dress: the gold brocade, fur-trimmed robe; the ermine cape with golden harness-bell buttons; and the distinctive *como dogale* (doge's hat) worn over a white linen cap.

During his brief three-year reign, Loredan presided over famine, pestilence, a great fire at the Arsenal, and the onset of war with the Turks over the possession of Cyprus. Tintoretto shows his subject ruddyfaced and world-weary, giving physical expression to the weight of his obligations and tempering the formality of an official portrait.

Tintoretto's technical facility is evident, especially in the vigorously modeled face and the swift, sure strokes of the cape. This proficient style recommended Tintoretto to the Republic's officials, who typically commissioned a number of portraits upon their election. Another version of this portrait, now in the National Gallery of Victoria, Melbourne, is probably the first version, painted from life, from which was derived the official portrait displayed in the Doge's Palace and destroyed in a fire in 1577. The Kimbell version is possibly the painting that belonged to the Loredan family, mentioned in the will of the doge's son Alvise.

ANNIBALE CARRACCI

Italian, 1560-1609

The Butcher's Shop

Early 1580s

Oil on canvas; $23\frac{1}{2} \times 27\frac{15}{16}$ in. (59.7 x 71 cm)

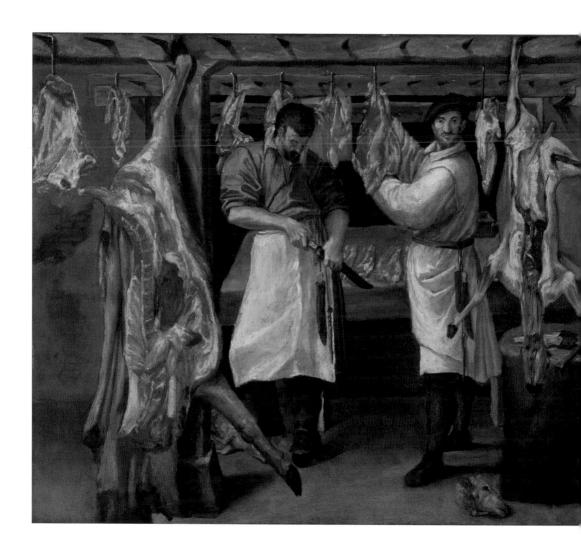

Around the time that he painted The Butcher's Shop, about 1582, Annibale Carracci, together with his cousin Ludovico and his brother Agostino, co-founded the Carracci Academy in Bologna, a teaching academy that would alter the future course of Italian art. Stressing the direct observation of nature. Annibale led a "reform" of painting that swept away the then-current Mannerism. Aiming at a more honest, emotional expression of reality, Annibale drew incessantly from life. In 1594, he went to Rome to work for the powerful Farnese family, developing a classicizing style that drew upon his study of antiquity and the Italian Renaissance masters.

In *The Butcher's Shop*, which was painted in the early, formative period of his career, Annibale employed a limited palette

of earthen colors to candidly describe the butchers and the cuts of meat. He applied the paint directly and spontaneously, developing the composition as he worked, so that some forms were painted on top of completed passages. Annibale's natural treatment of light lends a palpable sense of reality to the scene.

Also notable is Annibale's forthright portrayal of the tradesmen, with their sober, ceremonious demeanor and clean white aprons. Such sympathetic treatment distinguishes it from earlier, more humorous low-life subjects. Annibale's uncle and cousins were butchers, and he would have been intimately familiar with the trade. Annibale painted another larger picture of a butcher's shop that is now in Christ Church, Oxford.

CARAVAGGIO (MICHELANGELO MERISI)

Italian, 1571-1610

The Cardsharps

c. 1595

Oil on canvas; 37 1/16 x 51 9/16 in. (94.2 x 130.9 cm)

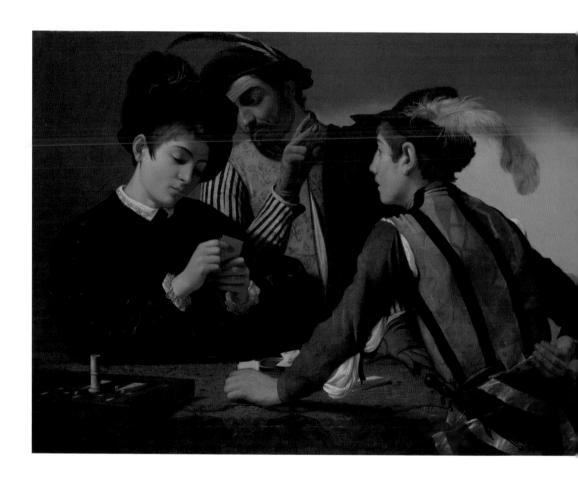

Caravaggio was one of the pivotal figures in the history of Western art. In his short lifetime, he created a new, theatrical style that shocked some and inspired others to probe their subject matter for the drama of psychological relationships. Apprenticed in Milan, Caravaggio came to Rome in the early 1590s. There, his early masterpiece The Cardsharps came to the attention of the influential Cardinal Francesco Maria del Monte, who not only purchased it but also offered the artist quarters in his palace and introduced him to the elite stratum of Roman ecclesiastical society, which would lead to his first significant large-scale public commissions.

In *The Cardsharps*, the players are engaged in a game of primero, a forerunner of poker. The dupe, engrossed in his cards, is unaware that the older cardsharp signals his accomplice with a raised, gloved hand (the fingertips exposed, better to feel

marked cards). The young cheat looks expectantly toward the boy and reaches behind his back to pull a hidden card from his breeches. Caravaggio structures the picture to allow us to witness everything, implicating us in the trickery. He has treated this subject not as a caricature of vice but in a novelistic way in which the interaction of gesture and glance evokes the drama of deception and lost innocence in the most human of terms. The Cardsharps spawned countless paintings on related themes by artists throughout Europe—not the least of which was Georges de La Tour's Cheat with the Ace of Clubs, in the Kimbell. The Cardsharps was stamped on the back with the seal of Cardinal del Monte and inventoried among his possessions after his death in 1627. Its location had been unknown for some ninety years when it was rediscovered in 1987 in a European private collection.

ADAM ELSHEIMER

German, 1578-1610

The Flight into Egypt

c. 1605 Oil on silvered copper; 3 1/8 x 3 in. (9.8 x 7.6 cm) (oval) Acquired in 1994

Having left his native Frankfurt for Venice at the age of twenty, Elsheimer arrived in Rome in 1600 and remained there until his premature death ten years later. His directness of vision placed him in the vanguard of reforming artists working in the Italian capital in the first decade of the seventeenth century. A pioneer in

the development of naturalistic landscape, his influence extended to Claude and Rembrandt. Here he portrays the Holy Family taking an arduous path through rocky terrain. Devotional literature interpreted their difficult and dangerous journey to Egypt as a pilgrimage of life toward salvation. This message is reinforced in the details of Elsheimer's miniature panel. The broad-brimmed hats are the traditional attributes of pilgrims, while the carpenter's tools, water gourd, cup, and rustic harness and saddle show the humility and poverty of the family. Singled out by a divine light, the oak suggests the Tree of Life—from whose wood the cross of Christ was made—which bestowed immortality on earthly sinners.

According to contemporary accounts, Elsheimer worked slowly and thoughtfully, producing a relatively small number of finished works. He died in poverty, although his works were coveted; according to his contemporary Giulio Mancini, they were "in the hands of princes and those persons who, in order that they should not be taken from them, keep them hidden." Only some thirty-five finished paintings on copper, all diminutive in size, have survived.

DOMENICHINO (DOMENICO ZAMPIERI)

Italian, 1581-1641

Abraham Leading Isaac to Sacrifice

1602

Oil on copper; 12 13/16 x 17 7/16 in. (32.5 x 44.3 cm)

Acquired in 1982

Domenichino, who is renowned for his large-scale frescoes, history paintings, and altarpieces, became Italy's leading classical painter in the first half of the seventeenth century. Trained at the Carracci Academy in his native Bologna, Domenichino came to Rome in 1602 to work under Annibale Carracci at the Farnese Palace. *Abraham Leading Isaac to Sacrifice*, which appears in the January 1603 inventory of the collection of Cardinal Pietro Aldobrandini, the powerful nephew of Pope Clement VIII, was inspired by the naturalistic and carefully constructed landscapes of Annibale. Its composition and

refined technique also recall the panoramic landscapes of Flemish artists like Paul Bril, who had settled in Rome a generation earlier, and anticipate the classical landscapes of masters like Claude Lorrain and Nicolas Poussin.

Domenichino depicts Abraham leading his beloved son Isaac to be sacrificed at God's command (Genesis 22:1–14)—a subject regarded as a prefiguration of God's own sacrifice of Christ. Later, when Abraham took up his sword to kill his son, an angel stopped him, indicating a ram as a substitute.

EL GRECO (DOMENIKOS THEOTOKOPOULOS)

Greek (active in Italy and Spain), 1541–1614

Portrait of Dr. Francisco de Pisa

c. 1610-14

Oil on canvas; 42 1/8 x 35 7/16 in. (107 x 90 cm)

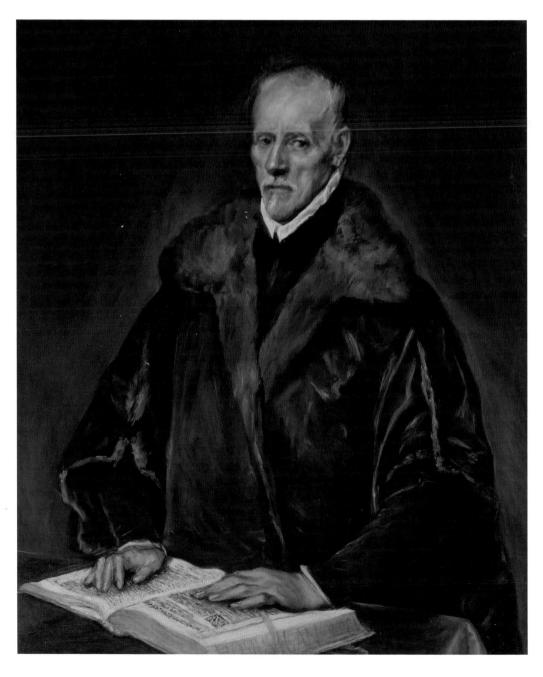

The painter known as El Greco ("the Greek") was born Domenikos Theotokopoulos in Crete, where he trained as an icon painter. Talented and ambitious, he left Crete around 1568 for Italy, where he studied the coloring of the Venetian masters, the figures of Michelangelo, and the grace and dynamism of the Emilian artists, all of which informed his own highly original style. In 1577, El Greco departed for Spain and settled in Toledo. There, he was patronized by the city's wealthy and educated elite. This painting, which dates from the last period of El Greco's career, attests to his profound gifts as a portraitist, which were praised since his years in Italy and remained undiminished in old age.

The sitter is Dr. Francisco de Pisa

(1534–1616), an important Toledan cleric and official historian of the city, who in 1610 expressed the intention to endow the Convent of the Purísima Concepción de Nuestra Señora. A portrait of Pisa probably identifiable as the Kimbell painting was bequeathed by him to the convent and recorded there in 1616 and 1623, along with other paintings by El Greco. Here, the rectitude of Pisa is aptly characterized: he appears absorbed in thought, his intensity of expression heightened by the deep hollows of his temples and cheeks. Despite the restricted palette, the bold white highlights over the dark mantle and the variegated brushstrokes over the reddish brown ground of the fur collar and lining render the entire canvas active.

JACQUES DE GHEYN II

Dutch, 1565-1629

Vase of Flowers with a Curtain

1615

Oil on panel; $43\frac{1}{4} \times 29\frac{5}{16}$ in. (109.8 x 74.5 cm)

Jacques de Gheyn II was one of the founders of the tradition of flower painting in the Netherlands. This exceptionally large panel is probably "the large vase of flowers surmounted by lilies" owned by De Gheyn's son. It was likely kept in the artist's studio as a showpiece to demonstrate his skills in a relatively novel artistic genre. A brilliant draftsman and printmaker, De Ghevn was admired for his invention and range of subjects. His paintings are rare, and only twenty-some survive. He began to paint flowers when working in Leiden in the 1590s, no doubt encouraged by his friend the French botanist Carolus Clusius. director of the Leiden University botanical gardens. His reputation as one of the foremost flower painters of his time was confirmed when the Dutch parliament gave one of his flower paintings to the French queen, Marie de' Medici.

The Kimbell painting is a lively and virtuoso performance. The flowers including precious varieties of tulips are painted with scientific exactitude, making use of preexisting studies or templates. Enhancing the sense of depth is the painted curtain—an illusionistic trick, since at this date paintings were sometimes protected behind actual curtains. To create a dramatic composition that showcases the various species, De Gheyn manipulated certain elements of reality in his towering arrangement. For him and his contemporaries, the ephemeral beauty of the blooms may have suggested the transience of life. Above all, however, his painting celebrates the wonders of nature.

GUERCINO (GIOVANNI FRANCESCO BARBIERI)

Italian, 1591–1666

Christ and the Woman of Samaria

c. 1619-20

Oil on canvas; 381/4 x 491/8 in. (97.2 x 124.8 cm)

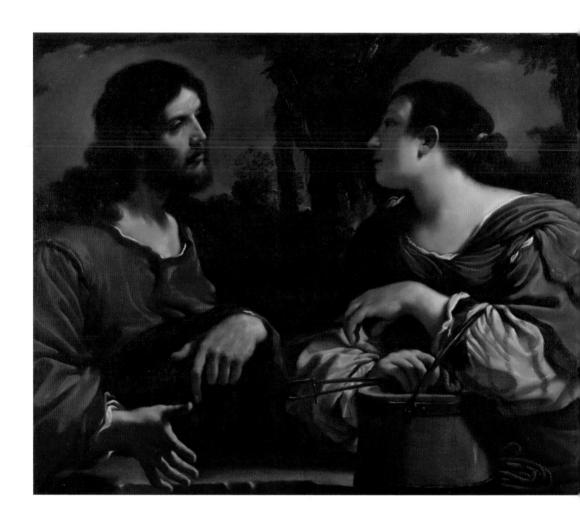

Guercino (literally "squinter," because he was cross-eved) was one of the foremost painters of the seventeenth century. Born in the northern Italian town of Cento, near Bologna, he was largely self-taught. The painter Ludovico Carracci praised the young Guercino for his remarkable powers of invention: "He is a great draftsman and a terrific colorist . . . even the top painters are awestruck." The Kimbell canvas was possibly painted for Cardinal Alessandro Ludovisi of Bologna, who was later Pope Gregory XV. Guercino followed him to Rome in 1621 and painted influential works that had a great impact on Roman Baroque art. He soon returned to Cento and later moved to Bologna, where he maintained a prolific career, producing paintings for an international clientele, including King Charles I of England.

This recently rediscovered work dates from the artist's early, rarest, and most desirable period, when he was acclaimed for the emotional power of his compositions, with lifelike figures intensified by a rich palette and strong effects of light. Guercino depicts an episode from the Gospel of John (4:5-42). Jesus, traveling through Samaria, sat down to rest beside Jacob's well. A woman came to draw water, and he asked her for a drink. She expressed her surprise that a Jew would even speak to a Samaritan, to which Jesus replied: "Everyone who drinks of this water will thirst again, but whoever drinks of the water that I shall give him will never thirst." Guercino presents this riveting moment, when the woman grapples to understand Christ's message that he is the living water, the source of eternal life.

FRANS HALS

Dutch, 1582/83-1666

The Rommel-Pot Player

c. 1618-22 Oil on canvas; $41\frac{3}{4} \times 31\frac{5}{6}$ in. $(106 \times 80.3 \text{ cm})$

Acquired in 1951

Frans Hals was the leading painter in the Dutch town of Haarlem, where he spent most of his life. He received many commissions from wealthy burghers for individual and group portraits and also produced religious paintings and genre scenes. He was especially famed in his lifetime, as today, for the spontaneity of his brushwork.

The smiling rommel-pot player in this painting by Hals has gathered around him an audience of amused children offering him coins. The children delight in the appalling sounds emitted by this lowly instrument, which is made of a pig's bladder stretched over an earthenware jug half-filled with water. A reed is bound in a small pocket in the middle of the bladder and moved up and down to produce a growling or rumbling sound. Played by impoverished street musicians, rommel pots were particularly associated with the pre-Lenten celebration of Shrovetide, here indicated by the fool's foxtail worn by the bearded man.

The Rommel-Pot Player is one of the earliest paintings to portray convincingly the vivacious and joyful expressions of children, here conveyed with Hals's distinctive brisk brushstrokes. This subject—associated with the idea of folly—was one of the artist's most popular compositions, and a number of versions and variants survive. The best of these is the Kimbell painting, a work with numerous revisions that apparently served as the prototype for the others.

GOFFREDO (GOTTFRIED) WALS

German, c. 1590/1595-1638/40

Country Road by a House

1620s

Oil on copper; diam. 91/4 in. (23.5 cm)

Acquired in 1991

Goffredo Wals, an early teacher of Claude Lorrain, was born in Cologne and joined the Roman studio of Agostino Tassi after an initial stay in Naples. He was influenced by the Flemish painter Paul Bril and his fellow countryman Adam Elsheimer, who produced jewel-like landscapes on copper. Wals's oeuvre has only recently been reconstructed: over thirty works have been identified to date. They show a radically fresh approach to nature and coloring; most are without prominent figures and employ strong contrasts of light and shade. The simplified settings, often painted in a round

format, with an emphasis on straight and circular forms, convey an impression of serenity.

An early example of pure landscape, without historical, religious, or literary content, this rare painting on copper records the effects of warm light bathing a country road at the close of day. Unlike most classical landscapes, it is devoid of framing elements to lead the viewer into the scene, and it features a daringly empty foreground. It was the first work by Wals to enter an American public collection.

PETER PAUL RUBENS

Flemish, 1577-1640

The Martyrdom of Saint Ursula and the Eleven Thousand Maidens

c. 1615-20

Oil on panel; $25\frac{3}{8} \times 19\frac{1}{2}$ in. (64.5 x 49.5 cm)

Peter Paul Rubens confessed that "my talent is such that no undertaking in size, or how varied in subject, has ever exceeded my confidence and courage." His monumental works exalting the Church and royal families of Europe are among the grandest accomplishments of the seventeenth century. As part of his preparatory process, it was Rubens's practice to make oil sketches for his compositions. With their inspired brushwork and fluid execution, the Flemish master's sketches have long been collected and acclaimed among the supreme masterpieces of this genre—not least for the process of creative genius that they reveal on such an intimate scale.

The Martyrdom of Saint Ursula and the Eleven Thousand Maidens is an oil sketch

for an unidentified altarpiece. The legend of Saint Ursula recounts how the virtuous daughter of a British Christian king, having reached Cologne on her return from a pilgrimage to Rome, was slaughtered by Huns along with her entourage of eleven thousand companions. Rubens orchestrates the throng of figures—maidens, soldiers, and angels—into a series of thrusting diagonals bridging heaven and earth. At the calm center of this maelstrom is Saint Ursula, portrayed as a princess with her tiara and pearl necklace. She stands on the brink of martyrdom, as her tormenters prepare to impale her with spear and sword. Above, a flight of angels ardently dispenses wreaths and palms as Ursula prepares to be united with the Madonna and Child in heaven.

PETER PAUL RUBENS

Flemish, 1577-1640

Equestrian Portrait of the Duke of Buckingham

1625

Oil on panel; $18^{3}/8 \times 20^{3}/8$ in. $(46.6 \times 51.7 \text{ cm})$

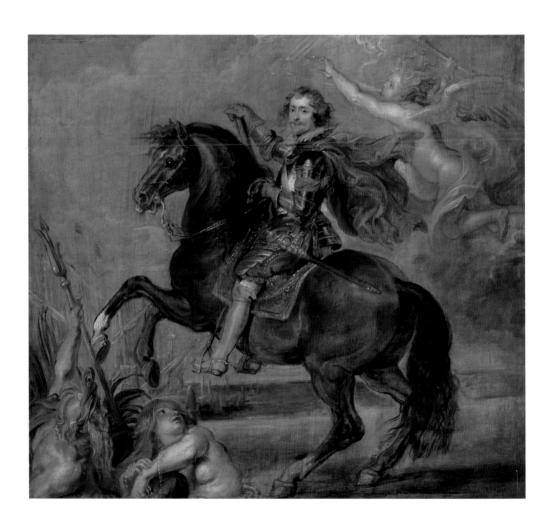

Rubens was a towering figure in the age of the Baroque, and his influence on later generations of artists was immense. His special position as both painter and diplomat brought him commissions from princely patrons, high-ranking statesmen, and noblemen. On a visit to Paris in 1625 for the marriage-by-proxy of England's King Charles I to Henrietta Maria, sister of the king of France, Rubens met George Villiers (1592–1628), the Duke of Buckingham, who commissioned the artist to paint a grand equestrian portrait. The Kimbell painting was the sketch for that work, which was destroyed by fire in 1949.

The elegance and bravura that captivated Buckingham's admirers—and

inspired Alexander Dumas's romantic depiction of him in *The Three Musketeers*—are evident in Rubens's portrait. As Lord High Admiral of the Navy, the duke lifts his baton, as his horse rears on command. Beneath him, the sea god Neptune and a naiad adorned with pearls indicate the duke's dominion over the sea. Overhead, a winged allegory of Fame signals victory with a trumpet in hand.

Privately, Rubens noted Buckingham's "arrogance and caprice" and predicted that he was "heading for the precipice." The duke's unsuccessful military campaigns against Spain and then France were much resented, and in 1628 he was assassinated.

NICOLAS POUSSIN

French (active in Italy), 1594–1665

Venus and Adonis

c. 1628-29

Oil on canvas; $38\frac{3}{4} \times 53$ in. $(98.5 \times 134.6 \text{ cm})$

Early in his career, Poussin traveled to Italy and was introduced to a circle of important Roman patrons, including the antiquarian Cassiano dal Pozzo. Poussin's classicism, nurtured by his knowledge of antique literature and art, was warmed by his study of Venetian painting. *Venus and Adonis* reveals the influence of Titian in composition, coloration, and mood. The composition is built in a series of opposing diagonals, highlighting Venus's shapely limbs and soft belly and casting the lovers into shadow, foreboding Adonis's imminent doom.

According to Ovid's *Metamorphoses*, Venus and her mortal lover Adonis sought the shade of a poplar tree during

an interlude from the hunt. The goddess mingled kisses and words, telling Adonis why she forbade him to pursue dangerous, wild animals—her mortal enemies. The lovers are attended by a host of putti who prepare Venus's golden chariot. A pair of reclining putti, along with a couple of doves, mimic the lovers' postures. Lance in hand and helical horn and dog nearby, Adonis is ready to disobey Venus and heed the call of the hunt. The tragic outcomefor Adonis is killed by a wild boar—is foreshadowed by the sleeping putto, unattended torch, and menacing clouds. Adonis wears a wreath of anemones, the flower that Venus would create in his memory by sprinkling his blood with nectar.

GEORGES DE LA TOUR

French, 1593-1652

The Cheat with the Ace of Clubs

c. 1630-34

Oil on canvas; $38^{1}/_{2} \times 61^{1}/_{2}$ in. (97.8 x 156.2 cm)

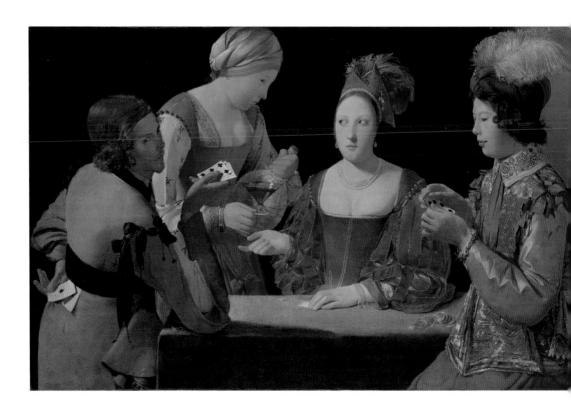

For most of his life, Georges de La Tour remained in his native duchy of Lorraine, remote from the art center of Paris.

Although he created some of the most visually compelling images of his age, soon after his death he fell into obscurity. It was only in the early twentieth century that La Tour's oeuvre began to be rediscovered.

One of the greatest masterpieces of seventeenth-century French art, *Cheat with the Ace of Clubs* takes as its subject the danger of indulgence in wine, women, and gambling. While the theme harks back to Caravaggio's influential *Cardsharps*, also in the Kimbell, the roots of this engaging morality play can be traced to earlier representations of the biblical subject of the prodigal son.

La Tour's dazzling colors and elaborate costumes create a brilliant decorative tableau. His characters enact a psychological drama that unfolds through the cues of their sidelong gazes and the measured gestures that signal their next moves. The cheat tips his cards toward the viewer, who thereby becomes complicit in the scheme, knowing that in the next moment, the conniving trio of cheat, maidservant, and courtesan (identified by her low-cut bodice) will prevail. Another autograph version of this subject, Cheat with the Ace of Diamonds (Musée du Louvre, Paris), displays abundant variations in details of color, clothing, and accessories.

ATTRIBUTED TO GEORGES DE LA TOUR

French, 1593-1652

Saint Sebastian Tended by Irene

Early 1630s

Oil on canvas; 411/4 x 541/8 in. (104.8 x 139.4 cm)

Acquired in 1993

Saint Sebastian—a Roman soldier who suffered martyrdom around AD 300— was nursed by the pious Irene, who, upon discovering him still alive, tenderly removed the arrows that pierced his body. Saint Sebastian was a protector against the epidemics that plagued La Tour's native Lorraine, and the artist's various versions of this scene were by far the most copied of his works in the seventeenth century.

Today, more than ten horizontal versions of the composition are known, differing widely in quality and condition. Opinion on the Kimbell painting is

divided: most scholars consider it to be a copy; others believe that it may be an autograph version. The painting has suffered damage from the transfer of the paint layer to a new canvas, rendering connoisseurship difficult. Nevertheless, it exhibits evidence of reworking during its creation, as well as the use of preliminary markings and incisions to establish the contours, a distinctive feature of La Tour's method. Most important, the palette, modeling, and brushwork in the better-preserved passages are of a quality approaching La Tour's autograph works.

JUSEPE DE RIBERA

Spanish, 1591-1652

Saint Matthew

1632

Oil on canvas; 50¹/₂ x 38¹/₂ in. (128.2 x 97.8 cm)

Acquired in 1966

Jusepe de Ribera left his native Spain for Italy as a young man. He is recorded living in Rome by 1612, one of many talented young artists who were held in thrall by Caravaggio's revolutionary paintings. Ribera's considerable talents caught the eye of both his fellow painters and well-connected patrons, and in 1616 he settled into a highly productive career in Naples. Ribera was soon employed by the Spanish viceroys who governed the city, and he also enjoyed the patronage of the most important religious houses.

In this devotional painting, Ribera has created a deeply affecting image that conveys the semblance both of a living being and of an apostle who knew the Lord and his Word. Although the identity of the saint is not certain, the book he holds accounts for his traditional identification as Matthew, author of the gospel. This painting formed part of an Apostolado, or series of portrait-like images of Christ's apostles. Here the influence of Caravaggio—the stark placement of the intensely lit figure against a dark background, the

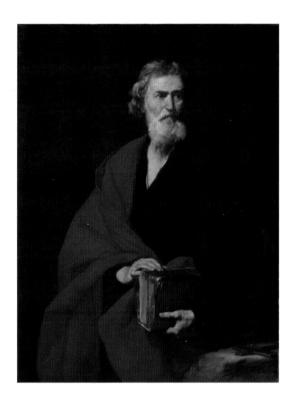

unrelenting naturalism, and the strength of characterization—is tempered by a classicism that reveals Ribera's study of the Renaissance masters and contemporary Bolognese painters.

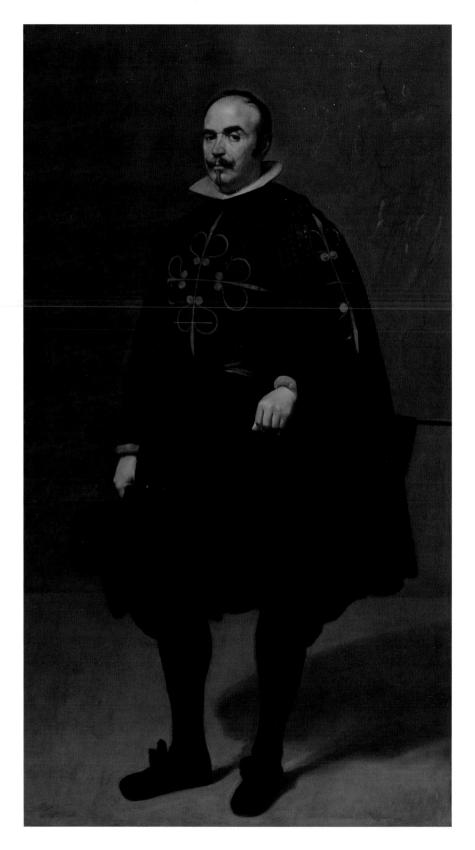

DIEGO VELÁZQUEZ

Spanish, 1599-1660

Portrait of Don Pedro de Barberana

c. 1631-33

Oil on canvas; 78 x 43 1/8 in. (198.1 x 111.4 cm)

Acquired in 1981

Born and trained in Seville, Velázquez moved to Madrid, where he served King Philip IV from 1623. As court painter, his main responsibility was to produce portraits of the royal family and their circle. These portraits, a major part of his legacy, remain unsurpassed in their depth of conception and extraordinary painterly technique.

Don Pedro de Barberana y Aparregui (1579–1649) was a member of Philip IV's privy council. He was named honorary postmaster of the realm and, by royal decree, governor of his native town of Briones. Prominently displayed on his doublet and cape is the red cross of the Order of Calatrava, founded in the Middle Ages as a defense against the Moors and subsequently a privilege of the aristocracy. Don Pedro was knighted in 1630, and Velázquez must have painted the portrait

soon after he returned from his first trip to Italy in 1631.

In his full-length portraits, Velázquez devised new ways of heightening the illusion of the sitter's physical presence. Don Pedro commands the entire pictorial space, which is stripped of architectural elements and enlivened by his cast shadow and the soft, ambient light of the background. His left brow raised, Don Pedro looks out with cool, confident aplomb, seeming to scrutinize and appraise the viewer, rather than the reverse. Much of the force of the portrait derives from the tension between the evocation of a forthright personality and the refinement and elegance of the knight's costume. Especially noteworthy is Velázquez's ability to create palpable volumes, particularly in the subtle gradations of blacks in the sitter's clothing.

CLAUDE LORRAIN

French, c. 1604/5-1682

Coast Scene with Europa and the Bull

1634

Oil on canvas; 67 1/4 x 78 5/8 in. (170.8 x 199.7 cm)

Claude Lorrain, the greatest artist of the classical school of European landscape painting, raised this previously secondary genre to a new level of sophistication and prestige. Characterized by the balanced arrangement of ideal landscape motifs and classical ruins, his works often introduce complementary mythological or pastoral elements that evoke a timeless, poetic world.

Claude left his native Lorraine as a young man and settled permanently in Rome. This majestic and important work, painted for the French ambassador to Rome, Charles de Créquy, helped to establish Claude as the city's most successful landscape painter. The story is from Ovid's *Metamorphoses*. Jupiter has taken the form of a divinely beautiful snow-white bull and in this guise has enticed the princess Europa onto his back. He edges toward the water, across which lies the isle of Crete, to which he will abduct her. Claude includes a ruin inspired by the ancient temple at Tivoli, which he had studied during frequent excursions to the Roman countryside. The enchanting atmosphere of the landscape depends on carefully modulated effects of light.

NICOLAS POUSSIN

French (active in Italy), 1594-1665

The Sacrament of Ordination (Christ Presenting the Keys to Saint Peter)

c. 1636-40

Oil on canvas; $37\frac{3}{4} \times 47\frac{7}{8}$ in. (95.9 x 121.6 cm)

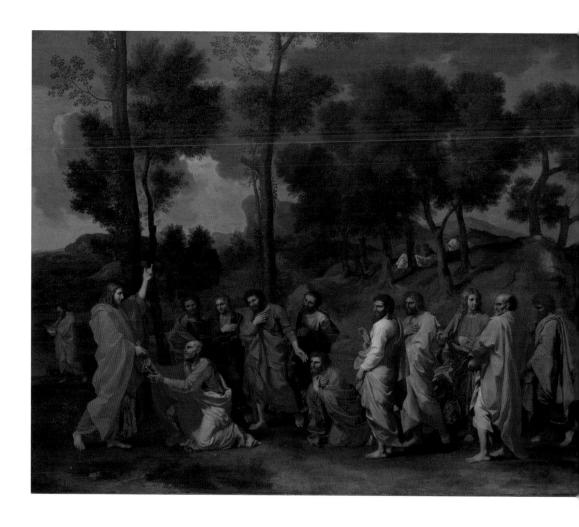

The Sacrament of Ordination is from one of the most celebrated groups of paintings in the entire history of art. The set depicting each of the Seven Sacraments was commissioned from Poussin by the antiquarian Cassiano dal Pozzo, secretary to Cardinal Francesco Barberini. To illustrate ordination—the taking of holy orders to become a priest—Poussin depicted the gospel account of Christ giving the keys of heaven and earth to the kneeling apostle Peter, showing the authority vested in him as head of the Roman church: "You are Peter, and on this rock I will build my church . . . I will give you the keys of the kingdom of heaven" (Matthew 16:18-19). Poussin infused the picture with emotional power, conveyed through the varied gestures and expressions of each apostle. The men discoursing in the distance may refer to the grove of ancient philosophers, recalling the old order that gives way to the new order instituted by Christ. The figure at the far left is almost certainly Paul, who will later preach Christ's message, while the figure at the far right, with his face obscured in shadow, is Judas Iscariot, who will betray Christ.

Charles Manners, 4th Duke of Rutland, purchased the Seven Sacraments from the heirs of Cassiano dal Pozzo in 1785 and installed them at Belvoir Castle. Leicestershire. The duke had consulted the English painter Sir Joshua Reynolds, who proclaimed the series to be "the greatest work of Poussin, who was certainly one of the greatest Painters that ever lived." Of the original seven paintings, the Duke of Rutland retains Confirmation, Eucharist, and Marriage. Penance was destroyed in a fire in 1816, and Baptism was acquired by the National Gallery of Art, Washington, in 1946 and Extreme Unction by the Fitzwilliam Museum, Cambridge, in 2012.

LOUIS (OR ANTOINE?) LE NAIN

French, c. 1600/1603-1648

Peasant Interior with an Old Flute Player

c. 1642

Oil on canvas; 215/16 x 247/16 in. (54.1 x 62.1 cm)

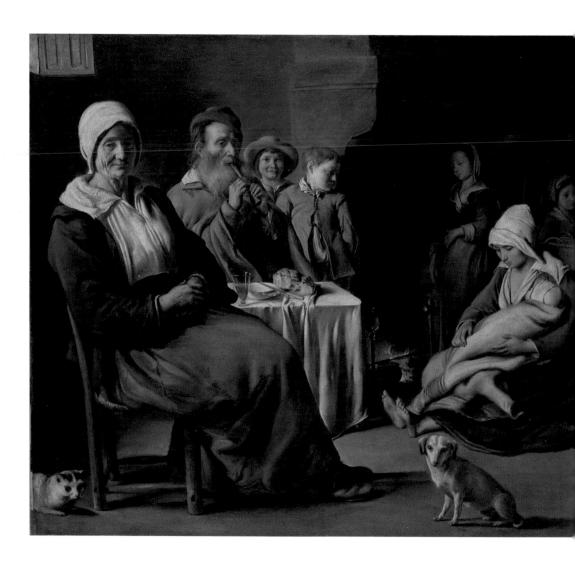

The Le Nain brothers—Antoine, Louis, and Mathieu—were born in Laon and settled in the artist's community of Saint-Germain-des-Prés, in Paris, by 1629. The brothers were founding members of the Royal Academy of Painting and Sculpture in 1648, but Antoine and Louis died that same year, presumably of the plague. The Le Nain studio produced portraits and religious works as well as mythological and genre scenes. A group of peasant scenes characterized by their sensitive, subdued palette and emotional solemnity has traditionally been assigned to Louis, who has been regarded as the genius of the family.

In Peasant Interior with an Old Flute Player, an air of serenity surrounds the dignified group, still and silent but for the sound of the flute. Despite the artist's clear sympathy with humble values, however, this scene is an idealized portrayal of peasant life. Wine in a crystal glass was not peasant fare. Together with the bread placed on the white tablecloth, the wine evidently alludes to the Eucharistic meal and Christian charity, exemplified by this humble household. Much remains to be learned about the Le Nains' patrons, who may have included members of the pious religious groups in Paris and the outlying regions. The reforming clergy encouraged the devout to emulate the virtues of the idealized poor, such as simplicity, humility, and patience.

PIETRO DA CORTONA

Italian, 1596-1669

The Madonna and Child with Saint Martina

c. 1645

Oil on canvas; $27^{9}/_{16}$ x $22^{13}/_{16}$ in. (70 x 58 cm)

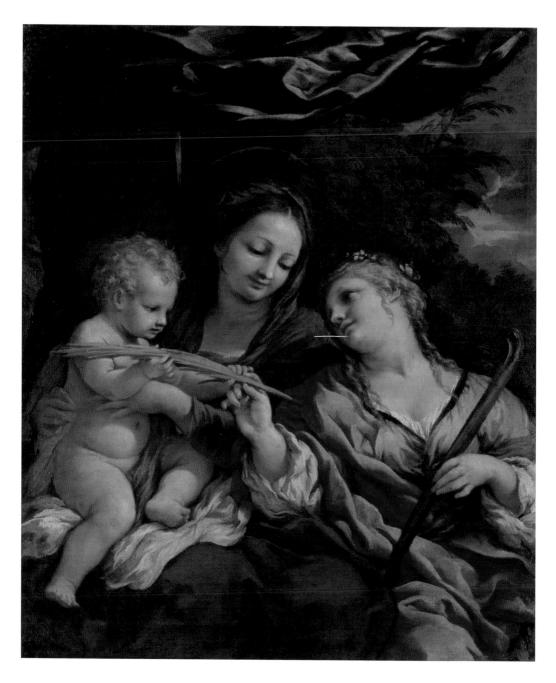

The preeminent painter in Rome of his day and an architect of considerable invention, Pietro da Cortona developed a robust style that was ideally suited to the glorification of the Church and prominent patrons. Cortona painted a number of grand frescoes for princely patrons in Rome and Florence, as well as altarpieces, history paintings, and designs for tombs and other projects.

In this devotional painting, Saint Martina, a third-century martyr who was put to death for refusing to worship idols, gazes fervently at the Christ Child while holding the forked iron hook with which she was tortured and accepting the palm of martyrdom. Cortona's strong colors, agitated drapery, and dynamic play of light and shadow enhance the image's spiritual intensity.

Saint Martina held great personal significance for Cortona, who painted her image numerous times. Elected president of the Academy of Saint Luke in 1634, Cortona proposed to rebuild the academy's church in the Roman Forum. Excavations in the crypt, where the artist planned to be buried, uncovered Saint Martina's remains. Pope Urban VIII came to view them, and his nephew Cardinal Francesco Barberini financed the rebuilding of the church now rededicated to Saints Luke and Martina—with Cortona as architect. The Kimbell canvas was likely owned by the cardinal; among Cortona's known versions of the subject, only the Kimbell's accords with the dimensions recorded in the Barberini inventories.

PIETER JANSZ. SAENREDAM

Dutch, 1597-1665

Interior of the Buurkerk, Utrecht

1645

Oil on panel; 22 1/8 x 20 in. (58.1 x 50.8 cm)

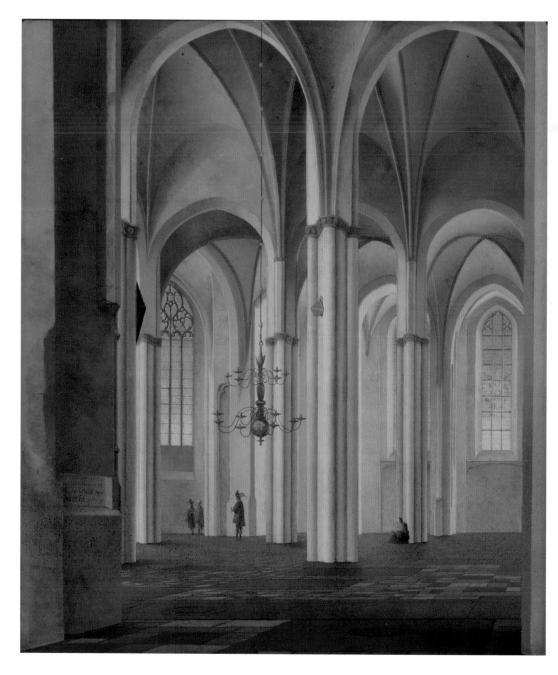

Following a lengthy apprenticeship with a Haarlem painter, Pieter Saenredam made a career specializing in what might be termed architectural portraiture. The clarity and harmony of his powerfully descriptive views of churches, stripped of Catholic furnishings by the Calvinists, are underscored by his subtle manipulation of line and color. In the Kimbell painting, a crisp light floods the interior, enlivening it with blue and pink tones as it strikes the vaults and floor tiles, the thinly painted figures providing a sense of scale. To the right of the delicate chandelier, an armorial tablet hangs on the cluster of pillars, marking gravesites in the pavings below. During Saenredam's five-month sojourn in Utrecht in 1636, the town was beset by an epidemic of the plague, and hundreds of victims were interred in the city churches. On the niche of the pillar at the left, the artist neatly inscribed his name and the date that he painted this view.

Saenredam's known oeuvre—fewer than sixty paintings—is small, owing to his meticulous working methods. His paintings of churches throughout the northern Netherlands are based on careful perspectival drawings derived from sketches and measurements taken in situ. The paintings themselves were executed in the studio, sometimes years later, as in the case of the Kimbell painting and the companion view of the same church, painted in 1644 and now in the National Gallery, London. The pen-and-chalk drawing that Saenredam made as the basis for the compositions, now in the Municipal Archives of Utrecht, bears the date August 16, 1636. He made subtle adjustments to this initial site drawing, heightening the elevation and maximizing the vertical thrust of the architecture to convey the church's lofty interior.

BERNARDO CAVALLINO

Italian, 1616-c. 1656

Mucius Scaevola Confronting King Porsenna

c. 1650

Oil on copper; 241% x 351% in. (61.2 x 89.2 cm)

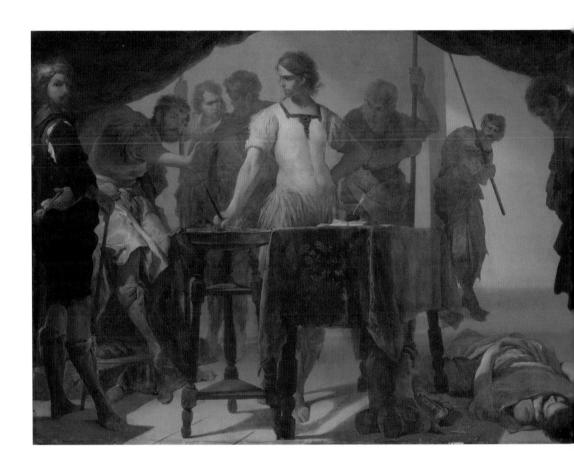

One of the leading painters of Baroque Naples, Bernardo Cavallino developed a distinctive manner marked by the dramatic play of light and action. The subject of this painting is taken from Livy's account of the Etruscan siege of Rome. Gaius Mucius, a young Roman nobleman, infiltrated the enemy camp in an attempt to slay the Etruscan king Porsenna but mistakenly killed the king's treasurer. At center stage, Gaius defiantly turns his head and dagger toward Porsenna, warning him that he is one of many youths sworn to assassinate him. Demonstrating his resolve, Gaius unflinchingly holds his hand in the hot embers until it is burned away. Porsenna was so impressed by this action that he freed the young hero and concluded peace with Rome. Gaius Mucius was

thereafter known as Mucius Scaevola (the left-handed).

The Kimbell painting comes from a Spanish collection that also included The Shade of Samuel Invoked by Saul by Cavallino (J. Paul Getty Museum, Los Angeles) and Jonah Preaching to the People at Nineveh by Andrea Vaccaro (Museo de Bellas Artes, Seville). All share narratives in which a king is threatened with death unless he withdraws from warfare against a virtuous people. Another Cavallino, The Expulsion of Heliodorus from the Temple (Pushkin State Museum of Fine Arts, Moscow), concerning a warning against taxation by foreign rulers, may also belong to the group. These themes were of topical interest in Naples, which witnessed revolts against Spanish domination during this period.

JACOB VAN RUISDAEL

Dutch, 1628/29-1682

Rough Sea at a Jetty

1650s

Oil on canvas; 383/4 x 513/4 in. (98.5 x 131.4 cm)

Acquired in 1989

Jacob van Ruisdael, the most influential and inventive landscape painter of the Dutch golden age, endowed the native tradition of realism with a newfound dramatic force. Recording the familiar wooded hills, flat farmlands, and coastal dunes of the Netherlands, his work went beyond the topographic accuracy of earlier generations to achieve a sense of the monumental grandeur of nature.

Among his most highly valued works, Ruisdael's rare marine paintings reveal the scope of his genius, as they convey the transitory and changeable face of nature. Rough Sea at a Jetty represents the approach of a violent storm. In the foreground, a jetty extends a considerable distance into the sea. At its end is a rustic beacon to guide distressed ships into harbor. Two men with long poles stand nearby, ready to come to the aid of a vessel striving to make port through the tempestuous winds and waves that threaten its approach. A dramatic light breaks through the clouds beyond the beacon, suggesting the power of nature and perhaps alluding to the salvation that greets those who steer the proper course.

Dentist by Candlelight

c. 1660–65 Oil on oak panel; 14 % x 10 % in. (37.2 x 27.7 cm) Acquired in 2002

A contemporary of Vermeer and Pieter de Hooch, Gerrit Dou was the founder of the so-called *fijnschilders* ("fine painters") of his native Leiden, admired for the miniaturistic detail and polished surface of their works.

In *Dentist by Candlelight*, Dou displays his legendary virtuosity in rendering still-life objects, the effects of artificial light, and the nuances of emotional states. The tooth-puller is a frequently depicted subject in Dutch and Flemish art of the seventeenth century. Dou incorporates the familiar components of the scene, including the long-suffering patient and concerned onlooker, here no doubt his wife. Dou's visual wit is evident as the anxious, openmouthed patient rolls his eyes upward to meet the sharp-toothed crocodile (often displayed on the premises of barbersurgeons) suspended above him.

By 1660, Dou's reputation surpassed those of all other Dutch painters, including that of his former teacher, Rembrandt van Rijn. After visiting Dou's studio in 1662, the Danish scholar Ole Borch proclaimed the painter to be "unequaled in the Netherlands and even in all other countries in the world."

BARTOLOMÉ ESTEBAN MURILLO

Spanish, 1617–1682

Four Figures on a Step

c. 1655-60

Oil on canvas; 43 1/4 x 56 1/2 in. (109.9 x 143.5 cm)

The leading religious painter of Seville and one of the great masters of Spain's golden age, Murillo was also for two centuries one of the most celebrated of all European artists, until his reputation was eclipsed by those of Velázquez and El Greco in the late nineteenth century. Murillo's rare and unusual genre scenes, which have always enjoyed great popularity, have no real precedent in Spain.

Four Figures on a Step accosts the viewer, who is insinuated into a scene with an unsettling cast of characters. The young woman beside the smiling man twists her face into a wink as she lifts up the scarf on her head. While this latter gesture had alluded to marital fidelity since classical times, in this context it may instead signal her availability. Some scholars have interpreted the Kimbell picture as a scene of procurement, with the older woman

identified as a procuress, the *celestina* of Spanish picaresque literature, who is often represented as a crone wearing glasses and a headscarf. She protectively cradles the head of a boy whose torn breeches reveal his backside—a detail that had twice been covered with repaint but is now restored to its original state.

On the other hand, the mature woman also resembles the bespectacled women in Dutch and Flemish genre paintings, among them virtuous women inspecting the heads of children for lice. In these works, which Murillo knew through prints, delousing a child served as a metaphor for cleansing the soul. If not simply a portrayal of the colorful characters to be found in the streets of Seville, *Four Figures on a Step* may carry an admonitory, moralizing message, urging the viewer to avoid the temptations of worldly pleasures.

SALVATOR ROSA

Italian, 1615-1673

Pythagoras Emerging from the Underworld

1662

Oil on canvas; 515/8 x 747/16 in. (131.2 x 189 cm)

Born and educated in Naples, Salvator Rosa was among the first artists to paint landscapes out of doors, adopting a bold, naturalistic manner. In Florence and in Rome, where he eventually settled, Rosa also gained a considerable reputation as a satirical poet and actor—and as an impetuous, individualistic personality. He was among the first artists to express a passionate appreciation for the aweinspiring beauty of untamed nature, and his landscapes were invoked by later generations of admirers as expressions of the "sublime." Here, Rosa's distinctive landscape—with its jagged rocks, bowed trees, and livid skies-lends the painting a dramatic, otherworldly mood.

Rosa was also fascinated by obscure subjects, particularly those featuring the

occult practices of ancient philosophers. Pythagoras Emerging from the Underworld, which follows the literary account of Diogenes Laertius, shows the Greek philosopher leaving his underground dwelling, where he had spent some time in isolation. Here, Pythagoras's stunned and credulous followers react to his claim that he witnessed the torture of the souls of Hesiod and Homer during his descent into Hades. In a letter of 1662, Rosa expressed great satisfaction with the Kimbell painting and its pendant, whose subjects had "never been touched by anyone." When the two works were purchased by the important Sicilian collector Antonio Ruffo, Rosa demanded a considerable sum, telling Ruffo's agent he "would rather die of hunger than reduce his price."

REMBRANDT VAN RIJN

Dutch, 1606-1669

Bust of a Young Jew

1663

Oil on canvas; 25 1/8 x 22 5/8 in. (65.8 x 57.5 cm)

Rembrandt van Rijn is recognized as the greatest Dutch painter of the seventeenth century, famed for his versatility in all genres: portraits, landscapes, and history painting, including secular, religious, and mythological subjects. In his maturity, he developed a loose, highly expressive brushwork, which, combined with a psychological intensity, sets his work apart from that of his contemporaries. Rembrandt was the most prolific portraitist of his time and produced an unrivaled series of self-portraits.

Bust of a Young Jew was painted as a character study (tronie), rather than as a commissioned portrait. The dramatic lighting, which focuses attention on the subtly characterized face, achieves nonetheless many of the effects of a true portrait. The work was doubtless painted from the live model. The sitter can be identified as a member of the Jewish community in Amsterdam by his modest apparel, full beard and curly hairstyle, and black skullcap—which was not, however, worn only by Jews at the time.

Rembrandt's penetration of outward likeness to suggest the temperament of the sitter is conveyed with his typically deft and economic brushwork. Animated by the strong light that casts one side of his face into deep shadow, the compelling figure is painted in the "rough manner" of Rembrandt's late style, with a limited palette of earth colors.

GIAN LORENZO BERNINI

Italian, 1598-1680

Modello for the Fountain of the Moor

1653

Terracotta; $31^{11}/_{16} \times 16^{3}/_{4} \times 16^{1}/_{2}$ in. (80.5 x 42.5 x 41.9 cm)

Acquired in 2003

Bernini made this dramatic image of a triton (a minor sea-deity of Greek mythology) grappling with a fish atop a gigantic shell as a presentation model for Pope Innocent X Pamphili, who in 1651 commissioned the artist to design a new centerpiece for the fountain at the southern end of the Piazza Navona in Rome. A few years earlier, Bernini had designed the spectacular Fountain of the Four Rivers as the focal point of the refurbished piazza. This second fountain, located opposite the Pamphili palace, would further beautify the site and glorify the Pamphili family. Modeled with the virtuosity and brio that characterize the work of the greatest sculptor of the Roman Baroque, the Kimbell model surpasses all other Bernini terracottas in scale, degree

of finish, and quality. The twisting stance of the figure was designed to engage the visitor from every vantage point. The primal-looking face (from which the figure takes its traditional name of "Moor") and waving hair place the triton in the realm of the elemental forces of nature. Bernini's fluid mastery of the human form is apparent in the well-muscled body, derived from life study and antique sculpture. The surface of the model is animated by the skillfully varied finishing of the clay—using a comb, stick, and brush to differentiate areas of flesh, hair, shell, and rock. The carving of the full-scale marble Fountain of the Moor was assigned to Gian Antonio Mari, working in Bernini's studio under the master's supervision.

GIAN LORENZO BERNINI

Italian, 1598-1680

Angel with the Superscription and Angel with the Crown of Thorns

1668

Terracotta: $11\frac{1}{2} \times 6\frac{3}{8} \times 5\frac{1}{8}$ in. (29.2 x 16.2 x 13 cm); $11\frac{7}{8} \times 6 \times 6$ in. (30.2 x 15.2 x 15.2 cm)

Acquired in 1987

More than any other artist, it was Gian Lorenzo Bernini, the leading sculptor of Baroque Italy, who reshaped the ancient city of Rome in a series of brilliant architectural and sculptural projects that affirmed its identity as the seat of the Roman Catholic Church. In 1667, Pope Clement IX appointed Bernini to supervise the renovation of the Ponte Sant'Angelo, the ancient bridge linking the city of Rome to the Vatican. Bernini designed ten angels, each carrying an instrument of Christ's Passion, to alight on the bridge's balustrades and guide the pilgrims' approach, physically and spiritually, toward Saint Peter's Basilica. Eight of the over-life-size angels were assigned to other sculptors, while the master himself made two: Angel with the Superscription and Angel with the Crown of Thoms. The pope deemed that the angels carved by Bernini with his own hand

were too beautiful to be exposed to the elements, and copies were created for the bridge, which was completed in 1672. The original pair of angels remained in Bernini's studio and was eventually bequeathed to Sant'Andrea delle Fratte, in Rome.

The lively terracotta angels in the Kimbell collection, conceived as a complementary pair, are among the surviving *bozzetti* (sketches) that trace Bernini's successive ideas for the compositions. Leaving the imprint of his fingertips and toolmarks in the clay, Bernini modeled the figures in a rough, highly expressive manner, pinching and smoothing the forms into place. He arranged the components—long legs, arched wings, and swirling drapery—into a dynamic series of curves and counter-curves about the central axis so that each angel could be viewed from several directions.

CLAUDE LORRAIN

French, c. 1604/5-1682

Pastoral Landscape

1677

Oil on canvas; 22½ x 32¾ in. (57.2 x 82.2 cm)

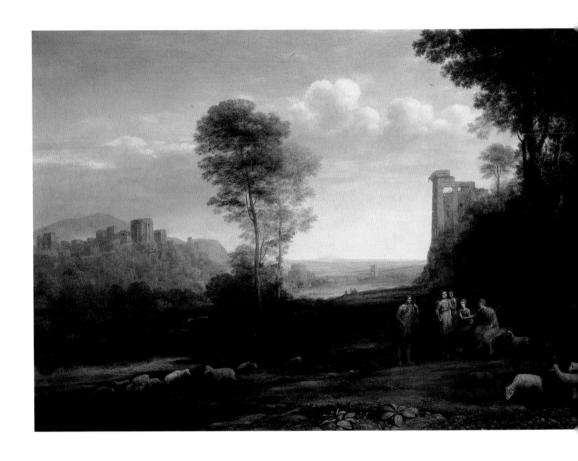

This is one of at least nine paintings that Claude created for Prince Lorenzo Onofrio Colonna, a great connoisseur and collector, between 1663 and 1682. The prince, whose family had its origins in the Roman countryside, undoubtedly shared Claude's pleasure in hilly sites such as Tivoli and Nemi, adorned with ancient temples, bridges, and other reminders of the Arcadian delights celebrated by Virgil in ancient times. Although the other works Claude painted for Colonna have mythological and literary subjects, the group of shepherds engaged in conversation in the Kimbell painting

cannot be associated with any particular narrative.

This ideal landscape view from late in Claude's career, when he often looked back to his earlier compositions, is pervaded by a sense of nostalgia. With its classical ruins and carefully calibrated landscape elements, it features many of the hallmarks for which the artist was celebrated and widely imitated. Claude developed the composition in a series of drawings in which he modulated tonalities and balanced proportions. The cool, blue-green palette and the clear articulation of spatial intervals are characteristic of his late work.

JEAN-ANTOINE WATTEAU

French, 1684-1721

Heureux age! Age d'or (Happy Age! Golden Age)

c. 1716-20

Oil on panel; 8 x 95/16 in. (20.3 x 23.6 cm)

As a young man, Watteau came to Paris from Valenciennes, a Flemish town that had recently come under French rule. In the French capital, he painted decorative and theatrical subjects and soon made his mark as the inventor of the fête galante, in which fashionable figures engaged in the rituals of love in a verdant parkland setting. Watteau continued to paint figures in theatrical dress throughout his short life. The little boy seated at the center of the Kimbell painting is dressed in the cream costume, bow-adorned shoes, and brimmed hat worn by Pierrot, the tragicomic clown of the commedia dell'arte. The boy's outward, unfocused gaze contrasts with the animated figures around him, who may all be girls,

although little boys also wore dresses during this period. Pierrot avoids the steady stare of the little girl with one arm akimbo who grips Harlequin's bat, known as a slapstick. Resting on the ground behind her is a ribboned tambourine, an instrument that connotes love and folly. The delicately painted scene is set in a misty landscape whose sky is streaked with the icy blue and rose hues of the children's costumes.

The title of this picture derives from the verses accompanying Nicolas Tardieu's engraving of the painting, published some years after Watteau's death, which begins "Happy Age! Golden Age, where without tribulation / The heart knows to surrender to innocent pleasures."

GIUSEPPE MARIA CRESPI

Italian, 1664-1747

Jupiter Among the Corybantes

c. 1730

Oil on copper; 26 1/4 x 26 1/4 in. (66.7 x 66.7 cm)

Acquired in 1984

Giuseppe Maria Crespi, the most innovative Bolognese painter of his day, was especially acclaimed for his intimate genre scenes. This fresh approach also infuses his paintings of classical subjects, like Jupiter Among the Corybantes, where Crespi paints a bevy of young women in graceful attitudes who attend to the infant god Jupiter. To avert the prophecy that a son would succeed him, Saturn habitually devoured his male children, and so his wife took the infant Jupiter to Crete to be reared by the Corybantes. In Crespi's own words, the nymphs, "thinking that his cries might reveal him, as is usual with babies, devised a plan to beat out a certain cadence, which they called Bactili, and so in unison they clanged little cymbals

made of bronze, so that the cries of the infant Jupiter could not reach the ears of Saturn."

The painting, executed on copper, retains its delicate, transparent glazes and vibrant colors, especially in the apricot and cherry draperies of the figures and the canopy billowing overhead, perhaps intended to shield Jupiter from Saturn's Olympian gaze. The infant god's good fortune to be entertained by lovely nymphs reminds the viewer that, as an adult, Jupiter would avail himself of the nubile beauties he henceforth considered his birthright. The melodious composition is arranged like musical notes, the dainty, ovoid heads of the maidens echoing the forms of the diminutive cymbals, vessels, and floral wreaths they hold.

JEAN SIMÉON CHARDIN

French. 1699-1779

Acquired in 1982

Young Student Drawing

c. 1738 Oil on panel; $8^{1}\!\!/_{\!4} \times 6^{3}\!\!/_{\!4}$ in. (21 x 17.1 cm)

Chardin's masterful depiction of a young man drawing comments upon the artist's own course of artistic study and hardwon success. His admirer Denis Diderot recorded the artist's recollection of his early training: "At age seven or eight, they put the crayon in our hand . . . Our back has been bent over the sketchbook for a long time . . . After spending days without end and lamplit nights before immobile and inanimate nature, we are presented with the living reality, and suddenly the work of all the preceding years seems to come to nothing."

After studying with the history painters Pierre-Jean Cazes and Noël-Nicolas Coypel, where he would have copied his instructors' académies (life drawings)—rather as the young draftsman is doing—Chardin was admitted as a member of the Academy of Saint Luke, the painter's guild. Such was his extraordinary talent as a still-life painter that in September 1728 he was made a full member of the more prestigious Royal Academy, into which he was received as a painter of "animals and fruits."

Chardin's works were avidly collected by European royalty, and were also engraved for a wider public. Another version of *Young Student Drawing* was

exhibited at the 1738 Salon with its pendant, *The Embroiderer*, featuring a young woman likewise industriously engaged in her work. The early versions may be identified with the panels now in the Nationalmuseum, Stockholm. The virtually identical Kimbell panel is one of numerous autograph repetitions, most of which have been lost, that Chardin made of these popular compositions.

CANALETTO (GIOVANNI ANTONIO CANALE)

Italian, 1697-1768

The Molo, Venice

c. 1735

Oil on canvas; $24\frac{1}{2} \times 39\frac{7}{8}$ in. (62.3 x 101.3 cm)

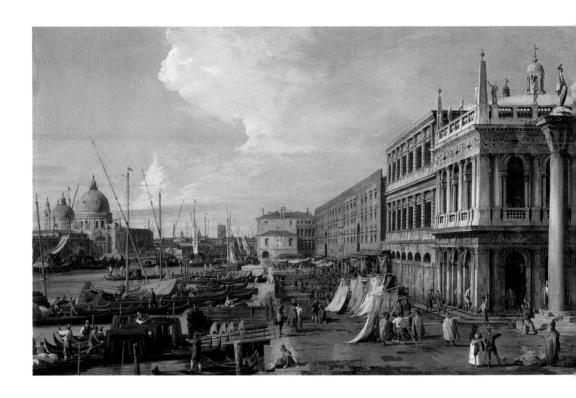

Trained by his father as a painter of theatrical scenery, Canaletto gained international renown painting scenes of his native Venice. These vivid and compelling cityscapes were much sought after by British aristocrats who traveled to Italy on the Grand Tour. In this painting from the collection of the Earl of Rosebery, Mentmore, Canaletto depicts one of his most popular views—the Molo, the wharf just west of the Doge's Palace. At the far right is the column of Saint Theodore, set before the ornate library, which is next to the Zecca (the mint where the Republic's gold ducats, or zecchini, were coined) and the terracottacolored public granaries. Across the water at the far left, marking the opening of the

Grand Canal, is the church of Santa Maria della Salute.

Canaletto imposes order and balance on the busy scene, observed from an ideally high viewpoint, omitting or adjusting architectural motifs and bringing them into alignment. The sun-drenched scene of crowded gondolas and market stalls against a grand architectural facade, with its sweeping perspective and linear precision, is enlivened with engaging details of the figures' costumes and gestures. Canaletto synchronizes the view with touches of sky blue, bright and dull red, and crisp whitefrom the sleeves of the gondoliers to the bell-shaped cloaks and skirts worn by the picturesque Venetians to the feathered hat of the figure in Eastern dress at the far right.

GIOVANNI BATTISTA TIEPOLO

Italian, 1696-1770

Apollo and the Continents

c. 1739

Oil on canvas; 39 x 25 in. (99.1 x 63.5 cm)

Acquired in 1985

This exquisitely prepared oil sketch served as Giovanni Battista Tiepolo's model for a frescoed vault in the Palazzo Clerici in Milan, commissioned by Antonio Giorgio Clerici. Clerici married Fulvia Visconti in 1741, uniting two of Milan's most powerful families; Tiepolo's sketch depicting *Apollo and the Continents* commemorates the impending nuptials. At the center of the

sketch, the sun god, Apollo, emanates a brilliant, yellow light. Nearby, nestled in the cloudbanks, are six planetary deities— Diana, Mercury, and Jupiter above Apollo, and Saturn, Venus, and Mars at his feet. In the four corners of the vault, whose fictive cornice is finished in gold, are personifications of the seasons and river gods, including Milan's river Po, identifiable by his bull's horns. Conspicuously silhouetted against the heavenly light are two embracing figures: Cupid, reunited with his beloved Psyche, bears her to Mount Olympus, where the gods will celebrate their marriage. The auspicious nuptial imagery of the sketch, with its allusions to abundance and fertility, speaks to the dynastic aspirations of Clerici and his new bride.

The figures are painted with the swift, seemingly effortless brushwork that has placed Tiepolo's sketches at the pinnacle of this genre. Here he modulates his technique from the lightly drawn gods to the thicker brushstrokes and darker colors of the corner groups representing earthly bounty. The Kimbell sketch differs significantly from the ceiling that Tiepolo ultimately painted in 1740 in the Palazzo Clerici, The Course of the Chariot of the Sun. To accommodate the proportions of the long gallery, Tiepolo was obliged to create a more complex program, with Apollo in his chariot at one end of the room, and Venus, Cupid, and Time at the other.

GIOVANNI BATTISTA TIEPOLO

Italian, 1696-1770

The Coronation of the Virgin

1754
Oil on canvas; 403/8 x 307/16 in. (102.6 x 77.3 cm)

Acquired in 1984

Giovanni Battista Tiepolo's talent for devising pictorial programs that infused older traditions with an animated and luminous grandeur earned him international repute as the greatest decorator of the age. In the spring of 1754, shortly after returning to Venice from Würzburg, where he painted an inspired series of frescoes for the archbishop's palace, Tiepolo won the commission to fresco the ceiling of the newly constructed church of Santa Maria della Visitazione, known as the Pietá. The Kimbell oil sketch served as the model for the frescoes. In this celestial vision, the Virgin, clothed in white to denote her purity and surmounting a blue globe, is escorted by a glory of angels as she rises toward the Trinity: Christ holding his cross, the dove of the Holy Spirit, and God the Father, who holds Mary's crown aloft as she is received into paradise, her eyes modestly cast down, mediating between heaven and earth. Along a curving balustrade marking the rim of the oval ceiling, angels lift their voices and play instruments in jubilation.

During Tiepolo's day, actual music would have accompanied this celestial chorus. The adjacent Foundling Hospital of the Pietá, which cared for orphaned

girls, was renowned for its school of music. Hidden behind several raised galleries, the choir and orchestra of young girls performed concerts written by eminent musicians, including Antonio Vivaldi, who also taught violin at the Pietá earlier in the century.

THOMAS GAINSBOROUGH

British, 1727-1788

Portrait of a Woman, Possibly of the Lloyd Family

c. 1750

Oil on canvas; 273/8 x 207/8 in. (69.6 x 53 cm)

Acquired in 1946

Along with Joshua Reynolds, Gainsborough was one of the leading figures in the glamorous golden age of British portraiture. This portrait is an early work, painted soon after Gainsborough's return to his native Suffolk from London, where he trained with the French engraver Hubert Gravelot. The sitter has traditionally been identified as a member of the Lloyd family of Ipswich.

Gainsborough's early, small-scale pictures of figures in a parkland setting with ornamental statuary show the influence of his mentor Francis Havman as well as of Jean-Antoine Watteau's fêtes galantes. In contrast to the rod-stiff posture of many of his early female sitters, here Gainsborough has adopted the informal cross-legged pose favored by Hayman. In a series of preliminary drawings, he worked out the relationship of the figure to the outdoor setting. The landscape accommodates the woman's gangling, languid form as she sits on a grassy bank, propped against a tree trunk, a branch offering a convenient armrest. The twined trees at the right mimic her crossed limbs and draw the eye to her blue silk dress with side hoops and the gauzy fabric surrounding the fashionable straw hat in her lap. The feathery brushwork and cool tonality of the background reflect the influence of French painting, while the more carefully delineated burdock plant in the foreground was a motif Gainsborough knew from Dutch landscapes and also sketched from life. The charm and unaffected elegance of this early portrait, with its dazzling costume, owes much to Gainsborough's mastery of fluidly applied paint and brilliant effects of light.

THOMAS GAINSBOROUGH

British, 1727-1788

Suffolk Landscape

Mid-1750s

Oil on canvas; 251/8 x 301/4 in. (63.8 x 76.9 cm)

Acquired in 1942

Gainsborough's passion for landscape dated from his earliest years. The canvases he painted in his native Suffolk show his admiration for Dutch seventeenth-century landscapes, which were increasingly available in the English market and which Gainsborough restored, copied, and later collected. The overall mood and massing of forms in this landscape derive from the compositions of Jacob van Ruisdael and other Dutch masters. Gainsborough's familiarity with the works of Jan Wijnants

is especially apparent in motifs such as the pollarded trees, travelers resting by a rutted road, and carefully observed plants. The degree to which these early landscapes represent specific sites has been debated, but clearly they express Gainsborough's genuine delight in the peaceful bounty of the English countryside. This fresh and sensitive outlook influenced later generations of landscape painters, including John Constable, who wrote, "I fancy I see a Gainsborough in every hedge and hollow tree."

JOSHUA REYNOLDS

British, 1723-1792

Portrait of a Woman, Possibly Elizabeth Warren

1759

Oil on canvas; 933/4 x 583/16 in. (238.1 x 147.8 cm)

Acquired in 1961

In 1749, Joshua Reynolds embarked on a journey to Italy, where he studied the artistic canon of the antique, Michelangelo, Raphael, and the great Venetian masters. Upon his return to London, he often cast his sitters in poses from these sources, creating a new historical or grand style based on "the simplicity of the antique air and attitude." As the first president of the Royal Academy of Arts, Reynolds was able to elevate the status of the painter in his native Britain to that of a man of learning. Through the exposure of his works at the Academy's annual exhibitions and the *Discourses on Art* he delivered to its members and students, Reynolds became the preeminent arbiter of style in his day and exerted tremendous influence on the arts.

The sitter in the Kimbell portrait may be Elizabeth Warren, sister of Sir George Warren, a wealthy member of parliament; according to Reynolds's records, a "Miss Warren" sat for him between January 1758 and May 1759. This portrait is one of Reynolds's earliest essays in the grand manner, in which beauty and grandeur are achieved by avoiding the particularities of local fashions. Miss Warren's simple, wrap-around morning gown displays the contours of her figure and lends the portrait a timeless, classical effect. Her idealized form has something of the quality and dignity of sculpture, with smooth, alabaster skin and graceful drapery folds. The proportions of the figure above the high waist are deliberately diminished, while her hips and thighs swell like the oversized urn beside her, perhaps alluding to her female role as a fecund vessel.

IFAN-RAPTISTE GREUZE

French. 1725-1805

La Simplicité (Simplicity)

1759

Oil on canvas; 28 x 231/2 in. (71.1 x 59.7 cm) (oval)

Acquired in 1985

Jean-Baptiste Greuze achieved fame for his morally uplifting narrative paintings influenced by seventeenth-century Dutch masters, but he was equally adept working in the pastoral, erotic mode brought to refinement by François Boucher. In 1756, while sojourning in Rome, Greuze was commissioned by the Marquis de Marigny to make two oval paintings for the Versailles apartment of his sister Madame de Pompadour, mistress of King Louis XV. The choice of subject was left to Greuze, and he chose Simplicity for one of the ovals. Despite the commission's importance, Greuze took three years to finish the painting, which depicts a girl pulling the petals off a daisy in a ritual of "he loves me, he loves me not." Its pendant, Young Shepherd Holding a Flower (Petit Palais, Paris), which shows a boy holding a dandelion and pensively making a wish for his love to be reciprocated, took even longer; it was not delivered until 1761.

The romantic sentiment and decorative style of *Simplicity* are typical of French court painting of the *ancien régime*. Skillfully capturing the nuances of emotion at the dawning prospect of love, Greuze works within the prescribed oval shape to lay stress upon the smooth curves of the girl's face, brows, and hair ribbons, her

straw hat, and her cupped hands. A critic at the Salon of 1759, where *Simplicity* was exhibited along with other paintings by the artist, noted: "M. Greuze seems to prefer dressing his figures in white; it is one of the greatest difficulties in painting, worthy of the efforts of a distinguished artist." The refinement of tones is seen in the transparency of the girl's porcelain flesh and the fluid brushwork of the creamy white costume, with its active play of delicate folds of fabric.

LUIS MELÉNDEZ

Spanish, 1716-1780

Still Life with Oranges, Jars, and Boxes of Sweets

c. 1760-65Oil on canvas; $19 \times 13\%$ in. $(48.3 \times 35.2 \text{ cm})$

Acquired in 1985

Luis Meléndez was the greatest Spanish still-life painter of his time. As the most gifted student admitted to the Royal Academy of Fine Arts in Madrid in 1745, he anticipated a prosperous career at the Spanish court. Such expectations were dashed, however, when he was expelled from the Academy because his father, honorary professor of painting,

had denounced its directors. Trained in portraiture and employed for some five years as a miniaturist, Meléndez eventually found his métier as a painter of still life upon his return from a trip to Italy.

In this tightly compressed composition, Meléndez scrupulously renders the textures and forms of the fruit and containers, highlighting the glazed curve of a honey jar of Manises pottery, one of his favorite motifs. The jar is rendered in white and green to match the color of the leaves and complement the oranges. A strong light enhances the sharper geometry of the sweet boxes—one bearing the artist's monogram—and throws a shadow from the honey jar across the receding boxes at the right.

In 1772, Meléndez appealed to the scientific interests of the prince and princess of Asturias (the future King Charles IV and his wife) and asked for their support in trying to depict "every variety of comestible which the Spanish clime produces." They agreed, but terminated the commission in 1776 due to a payment dispute. By then, Meléndez had delivered forty-four pictures to the royal couple, including some earlier still lifes. These later decorated the prince's country house at El Escorial. Despite his exceptional gifts, Meléndez died a pauper.

CLODION (CLAUDE MICHEL)

French, 1738-1814

The River Rhine Separating the Waters

1765

Terracotta; 11 x 18 x 12 in. (27.9 x 45.7 x 30.5 cm)

Acquired in 1984

One of the outstanding sculptors of his age, Clodion is today most admired for his small-scale terracottas. Though spirited and charming, his mythological scenes and putti are grounded in a solid academic training. He studied in the Parisian studio of his uncle Lambert-Sigisbert Adam, who created statuary for Versailles and other châteaux. In the autumn of 1762, Clodion departed for the French Academy in Rome, where he studied antique sculpture, Michelangelo, and especially Bernini.

Bernini's Four Rivers Fountain in the Piazza Navona in Rome, with its highly animated poses, was a primary source of inspiration for this terracotta, with its roiling, horizontally extended figure of the Rhine. The mighty river god's acrobatic feat is registered in his taut and rippled

muscles. With his beard undulating like the water he personifies, he grips the mouth of the urn, causing the water to flow in two separate streams. The unusual subject derives from the Roman historian Tacitus's *Germania* (AD 98) and alludes to the Rhine dividing the territory of the Gauls on the west bank from that of the Germans to the east.

During his years in Rome, Clodion's small terracottas were already highly sought after by collectors ranging from Catherine the Great of Russia to the artist François Boucher. The Kimbell terracotta, or one of the two similar versions now in the Victoria and Albert Museum, London, and the Fine Arts Museums of San Francisco, was exhibited at the Salon of 1773, two years after the artist's return to Paris.

GEORGE STUBBS

British, 1724-1806

Lord Grosvenor's Arabian Stallion with a Groom

c. 1765 Oil on canvas: 39½ x 32½ in. (99.3 x 83.5 cm)

Acquired in 1981

George Stubbs was the greatest painter of animals of his day. He was celebrated especially for his representation of horses, the forms and nature of which he captured with an unusual understanding and sensitivity. As the son of a Liverpool currier and leather-maker, he gained early exposure to animal carcasses, which no doubt inured him to the dissections he performed even as a boy. In 1754, he traveled to Rome, where his study of antiquity probably informed the classical design of many of his compositions,

with their elegant curves, pleasing profiles, and allusions to relief sculpture. Upon his return from Italy, for nearly two years, Stubbs single-mindedly carried out equine dissections and made exhaustive anatomical studies at an isolated Lincolnshire farm. Unable to find a printmaker to render his subtle drawings, Stubbs taught himself engraving and produced *The Anatomy of the Horse*, published in 1766. He established his artistic reputation in London during the 1760s, offering a newfound naturalism and artistry in his animal paintings.

Stubbs's characteristically uncompromising spirit and his quest for calibrated composition and balanced tones are clearly evident in this portrait of Lord Grosvenor's young Arabian stallion. He employs a low horizon, with rolling hills and soft foliage, to effectively display the warm tones of the chestnut Arabian. (A reproductive print of 1771 shows that the landscape was originally more extensive to the left; the canvas seems to have been cut down in the late eighteenth or early nineteenth century.) The sprightly mien of the colt, ears pricked and nostrils wide, is set in contrast with the reassuring demeanor of the groom. The artist meticulously portrays its genetic Sabino markings—the broad blaze, white stockings, and white spots on the belly and sides.

RICHARD WILSON

British, 1713/14-1782

Tivoli: The Temple of the Sybil and the Campagna

c. 1765

Oil on canvas: 29 x 381/2 in. (73.6 x 97.8 cm)

Acauired in 1979

Tivoli, in the Sabine hills to the east of Rome, was from the seventeenth century a favorite destination for artists and was also popular with foreign visitors on the Grand Tour. Like the artist seen sketching in this picture, Richard Wilson must have passed many hours drawing the dramatic site, with its distinctive round Temple of Vesta, known as the Temple of the Sibyl. Tivoli and the Campagna (countryside) had also figured in the works of Claude Lorrain and Gaspard Dughet. Wilson's composition derives unmistakably from their classical landscapes: a wedge of land framed by a tree, the hillside view of Tivoli, and the vista of

the low plain as it extends toward Rome.

The Kimbell painting—a variant of a composition painted in 1752—was made after Wilson's return to Britain. By introducing the ideal landscape to the next generation, he played a major role in establishing the British school of landscape painters. John Constable spoke of how Wilson's work "still swims in my brain like a delicious dream." The young J. M. W. Turner's debt was explicit: he copied the Kimbell painting (c. 1798, Tate, London) many years before he made his own trip to the Roman Campagna.

FRANÇOIS BOUCHER

French, 1703-1770

Juno Asking Aeolus to Release the Winds

1769

Oil on canvas; 109½ x 80 in. (278.2 x 203.2 cm)

FRANÇOIS BOUCHER

French. 1703-1770

Mercury Confiding the Infant Bacchus to the Nymphs of Nysa

1769

Oil on canvas; 1075/16 x 793/8 in. (272.5 x 201.6 cm)

Acquired in 1972

In 1769, Boucher painted six monumental mythologies for the Parisian residence of the cultivated financier Jean-François Bergeret de Frouville. Four of these are at the Kimbell: Juno Asking Aeolus to Release the Winds, Mercury Confiding the Infant Bacchus to the Nymphs of Nysa, Boreas Abducting Oreithyia, and Venus at Vulcan's Forge. Two of a narrower format (Venus on the Waves and Aurora and Cephalus) are in the J. Paul Getty Museum, Los Angeles. The Kimbell's canvases were enlarged at top and bottom when Baron Edmond de Rothschild acquired them at the end of the nineteenth century for his hôtel in the Faubourg Saint-Honoré.

Bridging heaven and earth by means of diagonally disposed, nubile bodies and pillowy putti in flight, Boucher's witty and dazzling compositions have come to typify the Rococo style at its most brilliant. In the present ensemble, painted in the penultimate year of his life, Boucher depicts with great inventiveness how passion, enflamed by beauty and susceptible to jealousy, finds expression in those unbridled forces of nature, the Elements—turbulent winds, torrential waters, molten fires, and the bounties of the vine.

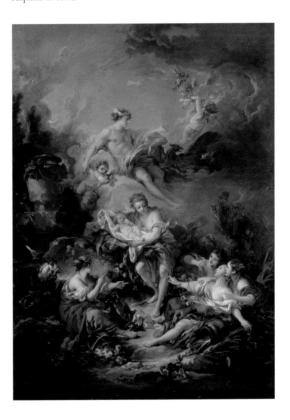

As related by the Roman author Virgil in the first book of the *Aeneid*, the goddess Juno, consumed by jealousy toward Venus, schemed to prevent her rival's son, Aeneas, from reaching shore and founding a Trojan colony in Italy. To thwart the Trojans, Juno entreated Aeolus, keeper of the winds, to

FRANÇOIS BOUCHER

French, 1703-1770

Venus at Vulcan's Forge

1769

Oil on canvas; 107¹¹/₁₆ x 80⁹/₁₆ in. (273.5 x 204.7 cm)

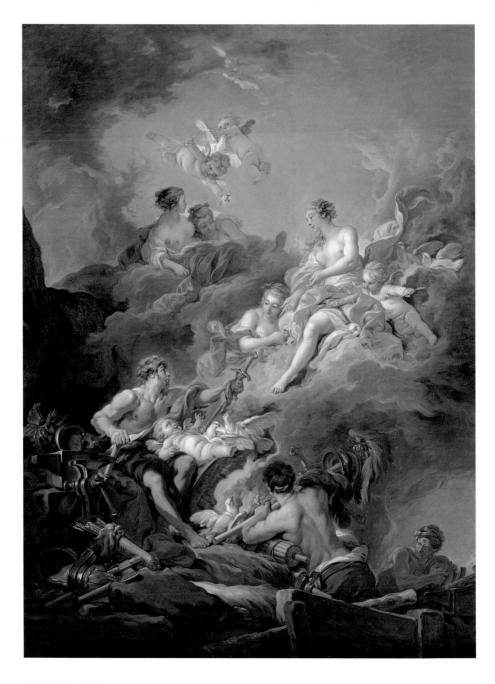

FRANCOIS BOUCHER

French, 1703-1770

Boreas Abducting Oreithyia

1769

Oil on canvas; $107\frac{5}{8} \times 80\frac{11}{16}$ in. (273.3 x 205 cm)

Acauired in 1972

provoke a violent storm that would destroy Aeneas's fleet. As enticement, Juno offered Aeolus her most beautiful nymph, Deiopea, in marriage. The presence of an alluring sea nymph reclining in the foreground reminds us that mighty Neptune, god of the sea, will prevail over the winds and calm the insurgent waters.

At the center of the second panel is the infant god Bacchus-born of Jupiter's illicit union with the princess Semele—who was transported by Mercury to Nysa for safe-keeping from Juno's jealous rage. The eagle bearing a lightning shaft, nestled in the clouds beside Mercury, alludes to Bacchus's fiery birth. As recounted in Ovid's Metamorphoses, Zeus had fallen in love with Semele. To punish her wayward consort, Juno tricked Semele into asking the god to appear to her in all his majesty. Powerless to deny her, Jupiter came to Semele, who was consumed by fire. However, the baby gestating in her womb was stitched into his father's thigh and spirited away to Nysa as soon as he was born.

Venus at Vulcan's Forge is drawn from the eighth book of the Aeneid. Succumbing to Venus's charms, Vulcan forges arms for her mortal son, Aeneas, champion of the Trojans against the Greeks. Another

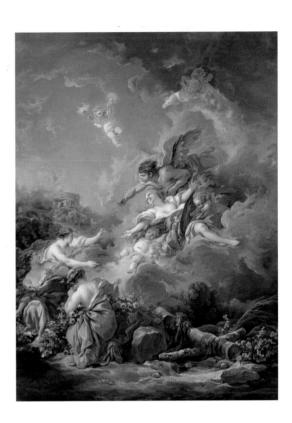

scene from Ovid's Metamorphoses, Boreas Abducting Oreithyia illustrates the cold north-wind god seizing the lovely Greek princess, who had earlier spurned his advances. Overhead, a putto brandishes two torches, an allusion to the twin sons that Oreithyia later bore the god.

JEAN-ANTOINE HOUDON

French, 1741-1828

Portrait of Aymard-Jean de Nicolay, Premier Président de la Chambre des Comptes

1779

Marble; 357/16 x 291/8 in. (90 x 74 cm)

Acquired in 1991

Houdon began sculpting at the age of nine and went on to receive an impeccable academic training in Paris and Rome. Between 1775 and 1789, he sculpted numerous portraits of the elite of French society—including members of the nobility and leading figures of the Enlightenment—in which he achieved a new spontaneity and informality of expression without

compromising his sitters' decorous and elevated presentation.

Houdon's portrait bust of Aymard-Jean de Nicolay, Marquis de Goussainville (1709–1785), was exhibited in the Salon of 1779, where it was described as "joining to the most perfect resemblance an elegance and nobility of form." As First President of the Chambre des Comptes, Nicolay was the senior official at the sovereign court responsible for the royal accounts and for the registration of all laws touching upon the Crown's domain, a position held by his family since 1506.

Although dressed in magistrate's robes, the sitter is portrayed without his wig, as if in a private moment. The attention lavished on the modeling of Nicolay's face and hair suggests the importance of this commission. The wrinkled forehead, fleshy chin, and sagging jowls, which convey Nicolay's acumen and experience, are testimony also to the sculptor's early and intense study of anatomy. The carving of the eyes is particularly masterful: Houdon first cuts out the entire iris, then bores a deeper hole for the pupil, taking care to leave a small fragment of marble to overhang the iris. The effect is a vivacity and mobility of expression that was praised even at the time, when Houdon was acclaimed as perhaps the first sculptor in the history of art to render eyes so convincingly.

FRANCESCO GUARDI

Italian, 1712-1793

Venice from the Bacino di San Marco

c. 1780

Oil on canvas; 243/8 x 371/2 in. (61.9 x 95.3 cm)

Acquired in 1970

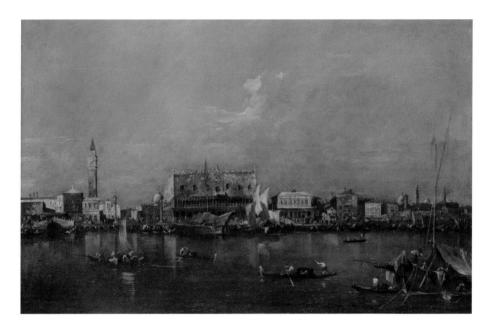

Little is known about Francesco Guardi, whose family included several artists. He initially worked with his older brother, Antonio, as a figure painter. Later, he was influenced as a view-painter by Canaletto, with whom he possibly trained; he may also have apprenticed in the studio of his brother-in-law, Giovanni Battista Tiepolo. Today, Guardi is remembered chiefly for his magical invocations of Venice.

Compared to the neatly delineated pictures of his predecessor Canaletto, Guardi's Venetian scenes are painted with great brio and atmosphere. In this panoramic view from the *bacino*, or bay, Guardi presents an evocative image of the city's most famous facade. Rising at left is the campanile, or bell tower, next to

the open space known as the Piazzetta, marked by the columns of Saint Theodore and the Lion of Saint Mark. At center is the imposing pink and white facade of the Doge's Palace, with the state galleon reserved for the doge moored at the quay, oars raised in waiting. The neighboring vessel with bright, unfurled sails docks adjacent to the dazzling white prisons. Under the light, fleecy sky, gondolas and cargo boats ply water the color of slate, with reflections that enhance its glassy surface. Guardi's agile brush leaves traces of paint that glide on the surface of the canvas to create a mirage-like image of the city on a lagoon, the forms quivering and dissolving in the sunlight.

ELISABETH LOUISE VIGÉE LE BRUN

French, 1755-1842

Self-Portrait

c. 1781

Oil on canvas; $25^{1}/_{2} \times 21^{1}/_{4}$ in. (64.8 x 54 cm)

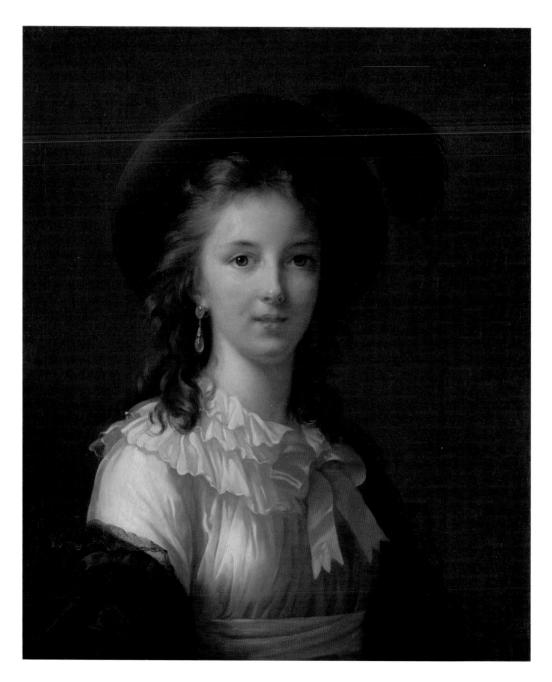

This youthful self-portrait depicts Elisabeth Louise Vigée Le Brun at about age twenty-six, by which time she had already worked some ten years as a professional painter. Here she presents herself not as an artist, but as a charming and attractive lady of society—indistinguishable from her own aristocratic patrons, whom she sometimes painted in similar informal attire. Largely self-taught, Vigée Le Brun copied old master and modern paintings, including works owned by the painter and art dealer who became her husband, Jean-Baptiste-Pierre Le Brun. Recommended by the queen for membership in the Royal Academy in 1783, despite being disqualified by her husband's profession academicians could not be connected to the picture trade-Vigée Le Brun soon acquired considerable fame and renown. Her paintings shown at the Salon were "the most highly praised . . . the topics

of conversation at court and in Paris, in suppers, in literary circles."

This radiant self-portrait, which highlights Vigée Le Brun's healthy good looks and creamy complexion, also bears witness to her absorption of seventeenthcentury Flemish art. Having visited Flanders and the Netherlands in the spring of 1781, Vigée Le Brun made good use of her study of Rubens—particularly in the delicate glazes used to render her translucent skin and the sparkling light catching her eyes and crystal earrings. Attentive to the latest fashions, Vigée Le Brun often showed her sitters in graceful poses and outfitted in comfortable Grecian gowns and scarves. Here her simple muslin gown and elegant scheme of white, black, and cherry, along with her loose curls of hair, offer a refreshingly unfettered contrast to the towering, powdered coiffures and swathes of brocaded silk favored by more formal portraitists.

JOSHUA REYNOLDS

British, 1723-1792

Portrait of Miss Anna Ward with Her Dog

1787

Oil on canvas; 55 3/4 x 44 3/4 in. (141.6 x 113.7 cm)

Acquired in 1948

The portrait represents Anna Ward, the eight-year-old illegitimate daughter of John, second Viscount Dudley and Ward, and Mrs. Mary Baker, whom Lord Dudley later married. This was one of thirteen paintings that Reynolds exhibited in 1787 at the annual exhibition of the Royal Academy of Arts in London; six of these paintings represented children. Portraits of children were increasingly common during the eighteenth century, and Reynolds was particularly gifted at capturing his young subjects' innocence and grace, as he does here. Reynolds painted this portrait nearly two decades after becoming president of the Royal Academy of Arts and only two years before losing his sight and being forced to retire from painting.

The Allen Brothers (Portrait of James and John Lee Allen)

Early 1790s $\label{eq:continuous} \mbox{Oil on canvas; } 60 \times 45 \, \mbox{$^{1}\!/_{\!2}$ in. (152.4 \times 115.6 cm) }$

Acquired in 2002

Henry Raeburn was the leading portraitist in Edinburgh, Scotland, a center of the Enlightenment, from about 1790 until his death in 1823. *The Allen Brothers* dates from early in his career, when his portraits show a remarkably experimental approach to composition, poses, and lighting effects, as well as the free, virtuoso brushwork for which he is best known.

Like many of Raeburn's patrons, the Allen brothers came from the Scottish landowning elite. John Lee Allen (born in 1781) and James Allen (born in 1783), the sons of John Allen of Inchmartine. were heirs to the considerable estates of Inchmartine and Errol on the north bank of the Tay estuary, near Perth. Despite their social status, the boys appear in an informal scenario, playing a game with a hat and a stick—presumably some form of mock fighting, perhaps a bovish version of jousting. The activity allows Raeburn to set off one against the other in a series of contrasts: the older boy standing and active, the younger seated (after a fashion) and passive; the older boy in profile and intent on his play, the younger in full face and apparently responding to the presence of the viewer.

FRANCISCO DE GOYA

Spanish, 1746–1828

Portrait of the Matador Pedro Romero

c. 1795-98

Oil on canvas; $33\frac{1}{8} \times 25\frac{9}{16}$ in. (84.1 x 65 cm)

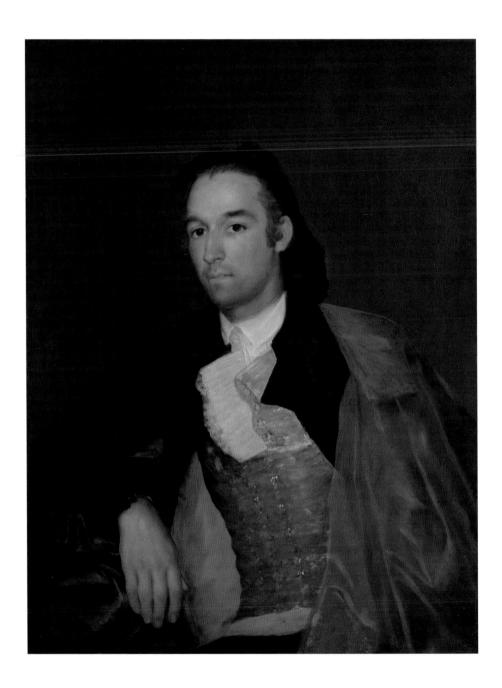

Francisco de Goya, the most important Spanish painter after Velázquez, was a master portraitist, unrivaled for his capacity to explore the depth and range of human passions. This portrait depicts Pedro Romero (1754-1839), one of the greatest toreadors of all time, idolized for his courage and control, as well as his handsome appearance. He was the foremost exponent of the classical school of bullfighting established by his family in Ronda, Andalusia. Romero was painted shortly before he retired from the bullring in 1799, at age forty-five, and several years after Goya had become completely deaf as the result of illness.

The finery of Romero's costume does not upstage his charismatic good looks. Goya's study of Velázquez is apparent in the deft brushwork defining the rich fabric of Romero's black jacket and the silver and pearl tones of his waistcoat—painted wet-

in-wet-against the bright white of his shirt. The chromatic refinement extends to the mauve cape and the crimsons of the jacket lining and sash. The composure of the figure is in keeping with Romero's style of bull-fighting; in contrast to the recklessness of his Sevillian rivals, Romero-who was said to have killed over 5,000 bulls without suffering injury—relied on skill and agility. He was especially admired for subduing the bull with his elegant use of the cape and for killing the animal with a single sword-thrust. Romero asserted that "the bullfighter should rely not on his feet but on his hands, and in the ring when confronting the bulls he must kill or be killed before running or showing fear." Here, Goya enlarged the initial expanse of the cape over Romero's black jacket, thereby balancing the prominent display of the matador's right hand and magnifying the attributes of Romero's skill.

LOUIS-LÉOPOLD BOILLY

French, 1761-1845

The Geography Lesson (Portrait of Monsieur Gaudry and His Daughter)

1812

Oil on canvas; 29 x 231/4 in. (73.6 x 59 cm)

Arriving in Paris in 1785, Louis-Léopold Boilly witnessed the collapse of the French monarchy, the struggle for modern republicanism, and the rise and fall of Napoleon's empire. Although he was denounced for the allegedly corrupt morality of his works in 1794, he survived the Revolution and went on to become a prolific portraitist and the most gifted genre painter in France during the late eighteenth and early nineteenth centuries.

This portrait was shown in 1812 and 1814 at the Paris Salon, the highly publicized, state-sponsored exhibition of contemporary art. It depicts a paymaster in the French administration, Monsieur Gaudry, instructing his daughter in geography. Boilly, as an intimate of the family, was said to have been a frequent witness to such scenes. The little dog,

whose face and paws are mimicked by the ornamentation of the chair, has been identified as "Brusquet," much admired because his constant barking had once succeeded in scaring away a band of thieves who had broken into the finance ministry.

Historical geography was promoted as a field of study for both boys and girls in Napoleonic France, whose maps were subject to frequent revision with each new conquest. Here the sphinx and pyramid in the cartouche of the map no doubt refer to Napoleon's Egyptian expedition of 1798–1801; the globe shows Europe and Africa. The fine detail of *The Geography Lesson* is indebted to Dutch domestic genre paintings of the seventeenth century, many incorporating maps and books into middle-class homes.

ANTONIO CANOVA

Italian, 1757-1822

Ideal Head of a Woman

c. 1817

Marble; $22^{3}/_{16} \times 9^{7}/_{16} \times 9^{3}/_{4}$ in. (56.3 x 24 x 24.7 cm)

Acquired in 1981

The Venetian artist Antonio Canova was the leading sculptor of the Neoclassical movement. Traveling to Rome in late 1779, his stylistic innovation soon won him papal commissions and acclaim. Along with the painter Jacques-Louis David, Canova set the standard for a new aesthetic based on the noble simplicity, grandeur, and ideal beauty of ancient art.

With its elegant profile, smooth skin, and elaborately arranged hair, all inspired by the sculpture of ancient Greece and Rome, Canova's head in pure white marble is a stunning example of his technical virtuosity as a carver.

This work is not a portrait, but instead an "ideal head," which Canova developed as a sculptural type and sometimes named after ancient muses, such as Clio and Calliope. The exquisite heads of the lifesize figures in his greatest masterpiece, *The Three Graces*, a commission from Empress Josephine, were arguably the culmination of Canova's efforts to revitalize the ideals of classical female beauty. The Kimbell bust, in turn, relates to a statue of Polyhymnia, the muse of heroic verse, made for Elisa Baciocchi Bonaparte.

Despite the fact that members of Napoleon's family had been among Canova's most important clients, the sculptor was appointed by Pope Pius VII after the Battle of Waterloo to negotiate the restitution of famous paintings and antique statues that the emperor had looted from Italy. At the Allied Conference in Paris in 1815, Canova was aided by several British diplomats, including Charles Long. Canova presented this exquisite head to Long in gratitude. Similar heads were given to the Duke of Wellington, the foreign secretary Lord Castlereagh, and the diplomat William Richard Hamilton.

THÉODORE GÉRICAULT

French (1791-1824)

Portrait Study of a Youth

c. 1818-20

Oil on canvas; 18½ x 15 in. (47 x 38.1 cm)

Acquired in 1969

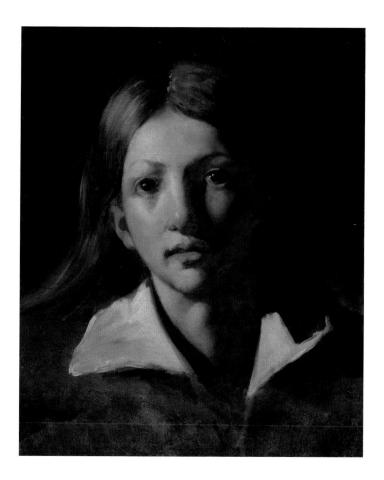

In the Salon of 1819, Géricault showed his celebrated *Raft of the Medusa*. During a period of illness and convalescence in the seven months between the completion of the Medusa and the artist's departure for England in April of 1820, he turned to small works, among them portraits of adolescents. *Portrait Study of a Youth* may have been executed in this period.

The effects of light in the boy's flushed cheek, glossy hair, and gleaming eyes lend the work a liveliness and intimacy of characterization. Géricault's influence on the development of the Romantic movement was enormous, exceeding what might have been expected from the few works he exhibited. His art was a starting point for the young Delacroix, who admired him deeply.

JACQUES-LOUIS DAVID

French, 1748-1825

The Anger of Achilles

1819

Oil on canvas; $41\%6 \times 57\%6$ in. (105.3 x 145 cm)

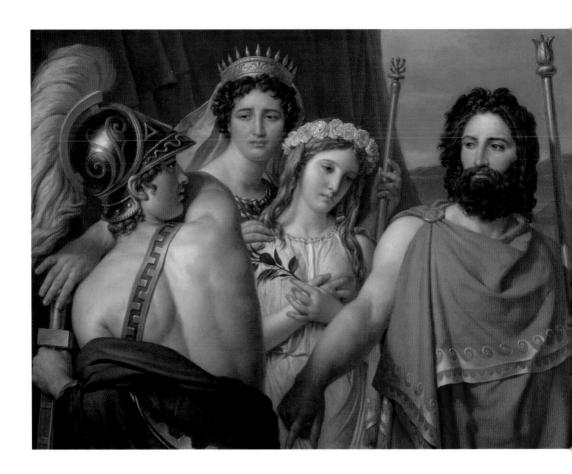

The leading Neoclassical painter in Europe during the French Revolution and under Napoleon, David went into exile in Brussels after the Battle of Waterloo, in 1815. There, he painted and exhibited *The Anger of Adrilles*, which he prized as the culmination of his career-long effort to recapture the perfection of ancient Greek art.

The complex episode, from the events that preceded the Trojan War, challenged David to render a spectrum of emotions, from stoic courage and heroic resolve to grief and anger. The subject is drawn from Euripides's *Iphigenia in Aulis* and Racine's seventeenth-century dramatic version of the same story. Agamemnon, king of the Greeks, has just revealed that his daughter Iphigenia is not to be married to the youthful Achilles but sacrificed in order to

appease the goddess Diana and so allow the Greek fleet to set sail for Troy.

Observed from close up and cropped at waist level, David's seemingly speechless figures have scarcely enough room to act out the drama. Achilles angrily reaches for his sword, but Agamemnon's magnetic gaze and his authoritative gesture appear to freeze Achilles's outburst. Dressed as a bride, Iphigenia, who is portrayed like a Renaissance angel, clutches her heart, oblivious to this display of male confrontation. The reaction of her mother, Clytemnestra, mingling disappointment at Achilles's inability to act with grief for her daughter, is apparently intended to mirror the mixed reactions that any spectator must feel as filial, spousal, and civic duties compete with one another.

THOMAS LAWRENCE

British, 1769-1830

Portrait of Frederick H. Hemming

c. 1824-25

Oil on canvas; 30 x 253/8 in. (76.2 x 64.5 cm)

Acquired in 1963

After the death of Sir Joshua Reynolds in 1792, Thomas Lawrence was appointed Painter in Ordinary to King George III. Drawing inspiration from Reynolds's style, with its allusions to the old masters, Lawrence dominated society portraiture in England. He was knighted in 1815 and elected president of the Royal Academy in 1820.

Lawrence's accession to this office bears an intriguing relationship to the pair of portraits by him in the Kimbell. The new president of the Academy wanted to own the original design by Giovanni Cipriani for the diploma awarded to new Royal Academicians. Cipriani's drawing then belonged to Richard Baker, who offered to give it to the painter. In return,

THOMAS LAWRENCE

British, 1769-1830

Portrait of Mary Ann Bloxam, Later Mrs. Frederick H. Hemming

c. 1824-25

Oil on panel; 30 x 24½ in. (76.2 x 62.2 cm)

Acquired in 1963

Lawrence volunteered to paint a portrait of Baker's great-nephew, Frederick Hemming. Sittings for the portrait were underway when Baker died and his great-nephew, Lawrence's sitter, inherited his collection. It happened that Lawrence also coveted Baker's drawings by Raphael and offered Hemming a companion portrait of his fiancée, Mary Anne Bloxam, in

exchange for them. Lawrence lived up to his side of the bargains, for Hemming is portrayed as a handsome and sensitive young man, and his fiancée as a cultivated beauty. Miss Bloxam was reputedly an accomplished porcelain painter, and in her portrait holds a brush as if busy at work; she is depicted in a modish white Grecian dress.

RICHARD PARKES BONINGTON

British, 1802-1828

The Grand Canal, Venice, Looking toward the Rialto

1826

Oil on millboard; 137/8 x 177/8 in. (35.2 x 45.4 cm)

Acquired in 2009

Bonington was one of the most gifted landscape painters Britain has produced, comparable in artistic stature to Turner and Constable. He is less familiar to modern audiences, probably because when he died at twenty-six he left behind a comparatively small body of works, most of them on a modest scale. His on-the-spot oil sketches of Venice demonstrate the subtle effects of light and atmosphere that he had mastered as a watercolorist, bearing out his friend Eugène Delacroix's observation that he possessed "a lightness of touch . . . that makes his works a type of diamond that flatters and ravishes the eye."

Here the view looks along the Grand Canal, the city's busy main thoroughfare, toward the Rialto Bridge. At this date, Venice was not yet a popular attraction for artists from other parts of Europe. Indeed, Bonington played a leading role in the creation of a modern vision of its beauties—an atmospheric, even ethereal vision that is quite distinct from that of the native Italian view painters who preceded him, notably Canaletto and Guardi. Contemporaries found in his views the poignant, evanescent Venice described in Romantic literature, especially the poems of Lord Byron.

JEAN-BAPTISTE-CAMILLE COROT

French. 1796-1875

View of Olevano

1827

Oil on paper affixed to canvas; $10\% \times 17\%$ in. (27.6 x 45.4 cm)

Acquired in 1980, with the assistance of a gift from Colonel C. Michael Paul

As the final stage in his artistic education, Corot went to Italy in the fall of 1825. During his nearly three-year-long stay, he toured the countryside, painting landscape studies as preliminaries for more traditional large landscapes with figures composed in the studio. But many modern viewers prefer Corot's oil sketches to the less spontaneous studio works developed from them. Figures, even secondary ones, are rare in these studies, with the implication that Corot recorded nature for its own sake rather than to provide background décor to some historical or literary narrative.

Working out-of-doors, Corot made around 150 oil studies in Italy. Taken as a group, these works constitute one of the earliest important manifestations of modernart values, including a meteorological (rather than poetic) concern for light, a preference for unexpected points of view with a disregard for symmetry in composition, and a willingness to leave brush marks visible for their own inherent beauty. Corot visited Olevano, about twenty-five miles east of Rome, toward the end of his Italian sojourn, in April and again during the summer of 1827.

Corot himself did not intend his Italian studies for public exhibition and left most of them unsigned. The red stamp at the lower-right corner of the Kimbell painting, which reads *Vente Corot* (Corot Sale), was applied at the time of the auction of the contents of the artist's studio after his death in 1875.

CASPAR DAVID FRIEDRICH

German, 1774-1840

A Mountain Peak with Drifting Clouds

c. 1835

Oil on canvas; 913/16 x 121/16 in. (25.1 x 30.6 cm)

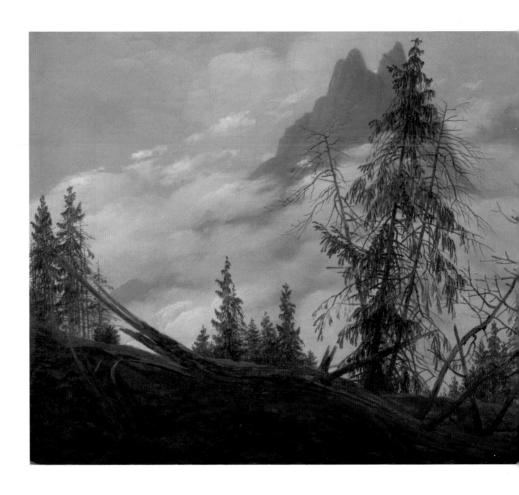

Friedrich is among the greatest of those Romantic artists in whose work spiritual yearning is the dominant theme. A close literary counterpart to his detailed, metaphorical landscapes is the work of the English nature-poet William Wordsworth. Both epitomized an international trend in the years around 1800 to contemplate the state of nature, as opposed to the "civilized" states of humankind, for revelations about basic and eternal truths.

Near the end of his career, the artist here observed a mountain wilderness with what appears to be photographic precision. Yet, like all Friedrich's works, this ostensibly ordinary scene is also open to interpretation as a spiritual text. While the rendition of the drifting clouds suggests a naturalist's awareness of meteorology, Friedrich almost certainly saw in them a symbol of the shifting, imperfect conditions that nature provides for the illumination of

the spirit. In the foreground, a toppled tree is portrayed in matter-of-fact detail. It may symbolize mortality as a barrier to spiritual progress: according to some interpretations of Scripture, nature only became subject to death when the Fall of humankind corrupted the originally blissful landscape of Eden. Even the trees in the middle distance bear witness to death: though often understood as premonitions of eternity, given their relative immunity to seasonal change, these evergreens are leafless. Finally, far off in the distance, as if all but inaccessible to human striving, Friedrich includes a fortresslike mountain peak—a revelation, perhaps, of the possibility of salvation.

When the Kimbell Art Museum acquired A Mountain Peak with Drifting Clouds in 1984, it became the first public collection outside Europe to own a painting by Friedrich.

JOSEPH MALLORD WILLIAM TURNER

British, 1775–1851

Glaucus and Scylla

1841

Oil on panel; $30^{13}/_{16} \times 30^{1}/_{2}$ in. (78.3 x 77.5 cm) (oval)

J. M. W. Turner dominated British landscape painting throughout the first half of the nineteenth century. During Turner's lifetime and ever since, his paintings have been most admired for his virtuoso renditions of natural appearances, especially dramatic effects of light and weather. Emulating the seventeenth-century French painter Claude Lorrain, however, Turner frequently included momentous events from the past within his landscapes, as moral lessons.

Glaucus and Scylla tells a complicated mythological tale from the Metamorphoses of the Latin writer Ovid. The beautiful sea nymph Scylla flees from the outstretched arms of her would-be lover, the sea god Glaucus, transformed into a frightening

monster by the jealous and vengeful Circe, daughter of the Sun, who herself loved Glaucus. Later, Circe changed Scylla into a rock; Turner possibly meant to indicate Scylla's fate with the two red outcroppings on the distant horizon. As for Circe, Turner apparently visualized her as the explosion of sunset light.

Various explanations, including a preference for centralized compositions, have been forwarded for Turner's decision in the last decade of his life to paint circularformat works, almost always in pairs.

Glaucus and Scylla was exhibited as a pair to The Dawn of Christianity/Flight into Egypt (Ulster Museum, Belfast) at the Royal Academy, London, in 1841.

GUSTAVE COURBET

French. 1819-1877

Portrait of H. J. van Wisselingh

1846

Oil on panel; 22½ x 18½ in. (57.2 x 46 cm)

Acquired in 1984

Born at Ornans, near the Swiss border of France, Courbet came to Paris in 1840 to study law but quickly decided that his true calling was art. He at first specialized in swashbuckling self-portraits, reclining female nudes, and somber portraits of men. The Dutch contemporary art dealer H. J. van Wisselingh (1816–1884) noticed Courbet's work at the Salon of 1846 and invited the

artist to visit Holland that summer. Holland, Courbet wrote to his family, "is the only country where I can earn money right away. That is why I have to go and see what they like . . . and get to know their art dealers. I already know one who will be most useful to me." While in Amsterdam, he painted a portrait of Van Wisselingh to present at a contemporary art exhibition. "I had a unanimous ovation from the artists, all of whom by now I know," Courbet explained, "and many art lovers have come to see it and paid me the greatest compliments."

The Dutch seventeenth-century paintings that Courbet saw in the Rijksmuseum in 1846, especially those by the master Rembrandt, made a lasting impression on the French painter. The deep Rembrandtesque shadows in this portrait, while they obscure physical detail, suggest keen insights into the mood and character of the sitter and his world. The anticlassical and widely influential art of the common people—the Realist art advocated by Courbet and his friend the poet Charles Baudelaire—owed a considerable debt to the model of Rembrandt and his contemporaries.

EUGÈNE DELACROIX

French. 1798-1863

Selim and Zuleika

1857

Oil on canvas; 18 3/4 x 15 3/4 in. (47.6 x 40 cm)

Acquired in 1986

Like many of his contemporaries, including Théodore Géricault, Delacroix proudly took inspiration from the best-selling Romantic poetry of Lord Byron. This painting is the last and most developed of the four canvases that the artist devoted to Byron's *The Bride of Abydos*, first published in 1813 and available in French translation by 1821.

Set in Turkey, Byron's poem relates the tragic fate of Zuleika, the daughter of the Pasha Giaffir, and her lover, the pirate Selim. In order to avoid a loveless marriage arranged by her father, the young woman escapes at night from the harem tower in which she has been held. In Delacroix's painting the lovers await rescue in a grotto by the sea, pursued by Giaffir and his men, armed and bearing torches. When Selim fires his pistol to summon his comrades offshore, the shot signals the couple's position to her father. Sensing the approach of the pursuers, Zuleika tries to restrain Selim. In the tragic climax of the tale, Selim is shot dead by Giaffir, and his body washed out to sea; Zuleika dies of grief.

Delacroix, a master of pose and gesture, portrays the lovers in a dancelike embrace. Their story's mix of tragedy and romance is mirrored in the fluttering sweep of drapery, as Zuleika holds Selim back from the futility

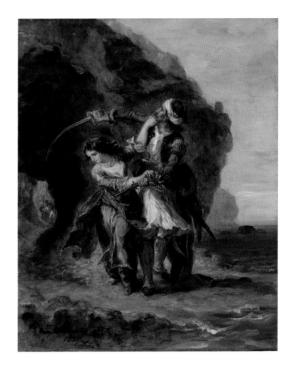

of confrontation and gently takes hold of him for a final embrace. The dawning light reveals the rocky silhouettes characteristic of the Normandy coast, where Delacroix often sketched during the late 1840s and 1850s. The colorful, freely brushed rendition of the rocks, water, and drifting clouds are precisely the qualities that made Delacroix's art so inspirational to the next generation of French artists, in particular the Impressionists.

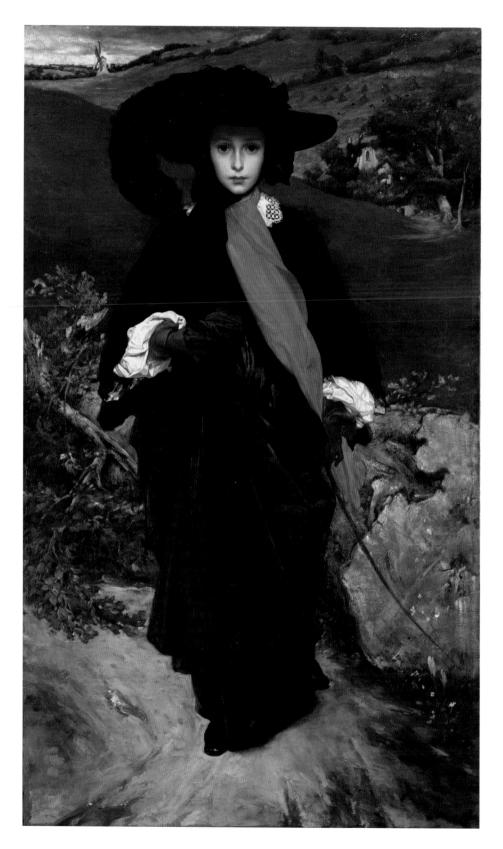

FREDERIC LEIGHTON

British, 1830-1896

Portrait of May Sartoris

c. 1860

Oil on canvas; 59 % x 35 1/2 in. (152.1 x 90.2 cm)

Acquired in 1964

This striking portrait represents Mary Theodosia (May) Sartoris around age fifteen. Carrying a riding crop and gathering up her dark blue riding habit, the horseless equestrienne looks out of the painting with inscrutable wide eyes. As much as the sitter herself, however, the subject of the painting seems to be her extraordinary costume. Her hair is hidden under a broad-brimmed black hat tied at her chin in a bow and topped with an ostrich feather. Her black jacket with its white lace collar is boldly accented with a long, scarlet scarf.

Leighton's close friendship with May's mother, the opera singer Adelaide Sartoris, began in Rome in 1853. Leighton had spent most of his childhood in Germany and Italy, where he became committed to the revival of the Renaissance style. Indeed, he made his reputation in 1855 when Queen Victoria purchased his history painting depicting Cimabue, Giotto, and other

Renaissance art pioneers. Leighton would go on to be knighted by the queen in 1878; he was elevated to the peerage in 1896, only a day before his death.

This portrait owes a debt to the art of the past—to British royal portraits by Anthony van Dyck, for example—but has numerous counterparts among the images of pensive females painted in the 1850s by leading English Pre-Raphaelite painters like John Everett Millais. The background landscape, presumably the Sartoris family properties in Hampshire, includes a windmill, a field with rows of stacked wheat, and a country church. The dark tonality of the broad rolling lawn in the middle ground suggests an overcast day. The tree allows Leighton to indulge in varied painterly effects, while the invocation of autumn invites meditation on the seasons and the passage of time, accentuating the fragile beauty of the young girl.

JEAN-BAPTISTE-CAMILLE COROT

French, 1796-1875

Orpheus Lamenting Eurydice

c. 1861-65

Oil on canvas; 16½ x 24 in. (41.9 x 61 cm)

Acquired in 1961

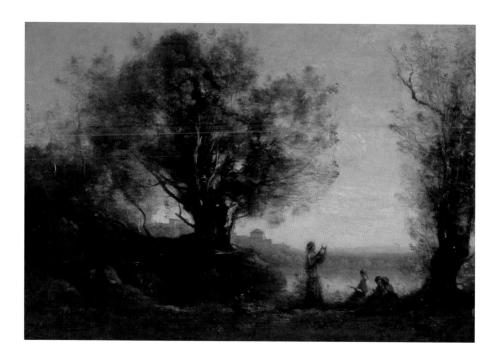

The celebrated landscape painter Corot was among the leading members of the so-called Barbizon school, which placed a premium on working directly from nature, but he was simultaneously active as a painter of dreamlike fantasy landscapes. He undertook several works in response to the 1859 Berlioz production of Glück's celebrated opera *Orfeo*, about the musician of Greek mythology who enchanted all his listeners, even the animals. In the first act of the opera, Orpheus's beautiful bride has just died from the bite of a serpent. The Kimbell painting shows the mournful Orpheus, dressed in ancient fashion,

playing his lyre for three seated women, who appear more contemporary, dressed in Italian folk costumes.

By the early 1860s, critics accused Corot of repeating more or less the same pastoral painting—a misty-morning landscape with a literary theme in the style of Claude Lorrain, the great seventeenth-century master. But Corot's contemporaries appreciated his ability to conjure the poetic past through exquisite, silvery harmonies of paint and admired these imaginative paintings just as much as the studies he made in the open air.

JEAN-BAPTISTE CARPEAUX

French, 1827-1875

Portrait of Charles Carpeaux, the Sculptor's Brother

1874

Terracotta; $27 \times 19^{1/2} \times 15$ in. (68.6 x 49.5 x 38.1 cm)

Acquired in 1984

Jean-Baptiste Carpeaux was much sought after as a portraitist by prominent sitters, including members of the imperial household. Among his finest busts is this posthumous portrait of his older brother, Charles, a musician. Carpeaux made an initial, rapid sketch in clay, which the sculptor's earliest biographers claimed was made entirely for himself as his brother lay sick and dying. (The sketch is preserved in a plaster copy in the Musée du Petit Palais, Paris.) The Kimbell's portrait began as a terracotta cast, but Carpeaux added more clay to it, reworking the textured jacket and tousled hair to enliven the likeness and to assert his own touch. The back and side of the figure's coat show traces of the artist's fingers in the clay, whereas the parallel lines along the sleeves, apparently scraped with a stylus, are comparable to chisel marks still visible on a marble work in process.

The artist's decision to create a work that is not "finished" by conventional standards is richly suggestive, inviting comparison with the expressive power of the unfinished sculptures of Carpeaux's hero, Michelangelo. The hand and tool marks provide a sense of intimacy, suggesting that the viewer is watching over the shoulder of the sculptor at work in his studio. These same marks might point

to a deeper, elegiac meaning: the rough, unfinished look seems in keeping with the subject's "unfinished" life. This probing, stirring portrait is among Carpeaux's most modern works, anticipating the similarly modern-minded experimentation of Rodin.

CLAUDE MONET

French, 1840-1926

La Pointe de la Hève at Low Tide

1865

Oil on canvas; 35½ x 59¼ in. (90.2 x 150.5 cm)

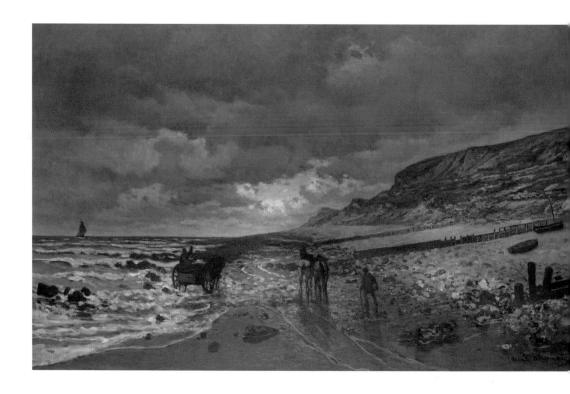

This magnificent beach scene near Le Havre, where Monet grew up, was one of two landscapes that launched his career when exhibited in Paris at the 1865 Salon, Monet developed this large showpiece in direct response to similar compositions submitted to the Salon of 1864 by Charles-François Daubigny and his son Karl. Daubigny had attempted to execute his Salon painting entirely on the spot, in what would soon become orthodox practice for Impressionist landscapes. But in 1864, Monet still worked in more traditional fashion: he first painted La Pointe de la Hève at the site as a portablescale work then enlarged it at his Paris studio in early 1865. Most impressive in

this large version is Monet's rendition of the beach at low tide, the muted silvery tones of the foreground reflecting the lowhanging clouds stretching far away. The rocks at the right, described with brisk, creative brushwork, are especially indicative of Monet's unique talents, which were increasingly evident as he emerged as the leading Impressionist landscape artist.

Monet insisted that an old black-and-white photograph of *La Pointe de la Hève* be included in a 1921 book about him. Perhaps as a result, this work from his youth was traced, and in 1923 a dealer friend brought it to Giverny to keep the elderly artist company as he recovered from eye surgery.

GUSTAVE COURBET

French, 1819-1877

Roe Deer at a Stream

1868

Oil on canvas; $38\frac{3}{8} \times 51\frac{1}{8}$ in. (97.5 x 129.8 cm)

Courbet was an avid hunter and painted such works as *Roe Deer at a Stream* to appeal to patrons who shared his sporting interests. By depicting such swift creatures, he also demonstrates his talent for lightning-fast observation and his ability to render what he has seen in a studio painting. In this respect, Courbet challenged the efforts of his young admirers—including Manet, Degas, Monet, and Renoir—who were determined to depict the fast pace of modern life on Paris streets or at the racetrack.

Courbet boasted about painting directly from nature, but the fact that many of the

animals in this painting are identical in pose to those in a landscape of 1866 reveals such claims to be exaggerated. In a letter written in 1866, Courbet explained that he had rented some deer from a Paris game butcher to serve as models. His tricks of the trade notwithstanding, Courbet's originality is evident in his confident brushwork, which, in tandem with his use of a palette knife, suggests delicate textures like grass and rough ones like stone strata. With such emphasis on the physical qualities of paint, works like this inspired several generations of modern landscape artists, from Cézanne to Picasso.

CAMILLE PISSARRO

French, 1830-1903

Near Sydenham Hill

1871

Oil on canvas; $17\frac{1}{8} \times 21\frac{1}{16}$ in. (43.5 x 53.5 cm)

Camille Pissarro was one of the leading figures of the French Impressionist movement. He took part in the first Impressionist show in 1874 and was the only member to show his work in all eight exhibitions organized by the group. Pissarro was a modest and generous man who exerted a strong influence on the next generation of painters. He was, in Cézanne's opinion, "a man to consult, and something like the good Lord."

This crisply observed landscape, with a commuter train puffing along in the middle distance, depicts the suburban neighborhood near Lower Norwood (West Dulwich), south of London, from just north of Sydenham Hill Station, looking toward West Norwood Cemetery. The forty-year-old Pissarro, his companion Julie Vellay,

and their two children came to live in this part of London in December 1870 to escape the chaos resulting from the Prussian army's ongoing siege of Paris. Their friends the Monets had been in London since early October, part of a colony of French exiles. In London, Pissarro and Monet went to the museums and studied works by Constable and Turner, whose pioneering, freshly observed landscape paintings had paved the way for French Impressionism.

Judging from the absence of green foliage, the Kimbell painting was executed in early spring. An inscription on the stretcher reads: "to my wife . . . C. Pissarro," suggesting that it was a wedding gift. Pissarro and Julie Vellay married on June 14, 1871, just before returning to France.

GUSTAVE CAILLEBOTTE

French, 1848-1894

On the Pont de l'Europe

1876-77

Oil on canvas; 41% x 51½ in. (105.7 x 130.8 cm)

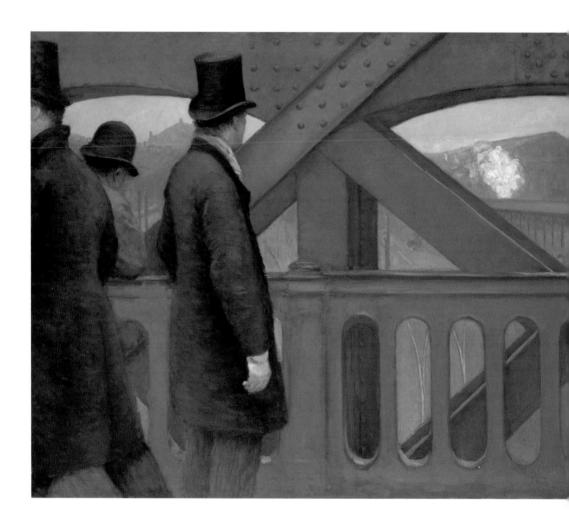

In the second half of the nineteenth century, the city of Paris underwent a massive architectural revolution. New avenues and boulevards were constructed, whole new neighborhoods rose up, and vast new train stations were erected to link the capital with the suburbs and with the world beyond. Artists and writers took note of these transformations and the effect that the new patterns of urban life had on the citizens of Paris.

In a series of paintings from the years around 1875, Gustave Caillebotte explored the new spaces of the city, showing men and women walking along rain-soaked pavements, crossing bridges, staring out of windows, or standing on balconies above busy streets. The most radical of all these paintings is the Kimbell's *On the Pont de l'Europe*, which shows three men on a massive bridge that spanned the rail

yards of the Gare Saint-Lazare, one of the principal train stations of Paris. Huge girders of iron crisscross the composition, just beyond a cast-metal balustrade that separates the space of the street from the activity below. Through its openings, Caillebotte offers glimpses of the station roof at right, the curving network of steel rails, and the rooftop of the newly opened Opera to the left.

The subject of the painting is the action of the public space—the interaction of pedestrians on a street, the views of each other and their surroundings that city life affords. But Caillebotte, to underscore the anonymity of the industrialized city, deliberately thwarts that interaction. None of the figures looks at the other, nor at the viewer, and their view of the station is only a series of vignettes, broken and reorganized to stress the fragmentation of modern life.

ÉDOUARD MANET

French, 1832-1883

Portrait of Georges Clemenceau

1879-80

Oil on canvas; 455/8 x 343/4 in. (115.9 x 88.2 cm)

Two radicals—one of art and the other of politics—are linked in this forceful portrait. It is not known when Georges Clemenceau (1841–1929) met Manet: the future politician left for America as a newspaper correspondent in 1865, the year in which Manet first exhibited his shocking nude Olympia in Paris. Following his return in 1869. Clemenceau entered the tumultuous French political world as a radical leftist. Manet, who often painted his friends as themselves, seems to have sought out political figures around 1879, when he initiated this portrait of Clemenceau. who had visited his studio. The rostrum at the bottom of the Kimbell painting was probably intended to indicate Clemenceau's incumbency at the time in the Chamber of Deputies.

Manet typically exasperated models with his insatiable need to revise, and he

never finished the portrait of Clemenceau, begun on two different canvases of identical size. Closely related photographs of Clemenceau, found among the papers of both artist and sitter, suggest that the deputy was seldom available to pose in person.

Manet's widow gave both incompletely realized portraits to the politician as keepsakes. Later, in 1905, Clemenceau sold one of the versions to an American collector, Louisine Havemeyer of New York, who later gave the painting to France; shortly afterwards he sold the other (now the Kimbell version) to the Parisian dealer Ambroise Vollard. When he became prime minister of France in 1906, Clemenceau ordered Manet's *Olympia* to be transferred from the Musée du Luxembourg (where contemporary art was displayed) to the Louvre, thus granting old master status to the controversial painter of modern life.

JAMES ENSOR

Belgian, 1860-1949

Skeletons Warming Themselves

1889

Oil on canvas; 29½6 x 235/8 in. (74.8 x 60 cm)

James Ensor was one of the most original painters of the late nineteenth century. Populated with masks and skeletons, his macabre images are morbid commentaries on the human condition, on his hometown of Ostend on the North Sea, on Belgian history, and on his own mortality.

This enigmatic work is among the artist's masterpieces. Three dressedup skeletons huddle around a stove on which is written "Pas de feu" and under it "en trouverez vous demain?"—"No fire. Will you find any tomorrow?" Ensor presumably intended the palette and brush, violin, and lamp accompanying the skeletons to symbolize art, music, and literature, implying that artistic inspiration, or patronage to support it, has expired in Ensor's world. The surreal subject has its roots in reality: human bones were regularly uncovered in Ostend, residue of seventeenth-century warfare, and Ensor retained childhood memories of their

exhumation, later casting the bones into scenes of ordinary life, as in 1888, when he made an etching of himself as a reclining skeleton in slippers entitled *My Portrait in* 1960.

Understood as a scene in an artist's studio, Skeletons Warming Themselves resembles a vignette from the popular medieval and early Renaissance print cycles of the Dance of Death, in which skeletons represented the vanities of various professions. In this tradition, Ensor may be satirizing the idea that painters can bring life to canvas. Rather than immortalizing his models, this painter has a studio littered with skulls from previous failed efforts. While the models in absurd costumes warm themselves between posing sessions, a skeleton peers in from the left, possibly the artist, himself too dead to perceive anything wrong. The long vertical stripe of white paint at left, behind his neck—too tall for a door—is probably the edge of the ambitious canvas under way.

EDGAR DEGAS

French. 1834-1917

Dancer Stretching

c. 1882-85

Pastel on pale blue-gray paper; 18 3/8 x 11 11/16 in. (46.7 x 29.7 cm)

Acquired in 1968

Edgar Degas, born in Paris, spent most of his life there and became one of the great chroniclers of its urban life in the last half of the nineteenth century. Seeking out a subject that would give full scope to his

desire to draw, paint, and sculpt the human figure—while at the same time giving rein to his fascination for contemporary manners and mores—he settled on the ballet of the Paris Opera. At the beginning of the 1880s, as Degas became increasingly famous for such subjects, he evolved a series of paintings depicting dancers in large rehearsal rooms, loosely based on the actual rooms they used for classes. The source of light for these rooms were large windows looking out on Parisian rooftops. In his own studio, he would pose models against the light of a window or skylight to study the effect of light falling over a body seen partly in shadow.

Dancer Stretching is among the most beautiful of these studio studies in pastel of a dancer or a model posed as a dancer. On the cool tone of a blue-gray paper, the artist worked his soft pastel with apparent ease, taking such pleasure in the medium that the viewer now marvels at his skill. Rich strokes of blue-black pastel define the contours of the girl's bent elbow; softer strokes of gray and white, with passages of turquoise, describe the fabric of her costume; reddish-brown pastel, mixed with white, conveys the tones of her skin; and a few strokes of orange suggest the play of light on her red hair.

PAUL GAUGUIN

French, 1848-1903

Self-Portrait

1885

Oil on canvas; 25¹¹/₁₆ x 21³/₈ in. (65.2 x 54.3 cm)

Acquired in 1997

Gauguin assumed his role as renegade artist in 1885, the year in which he undertook this portrait. Rather than remain jobless in Copenhagen with his Danish wife and their five children, the former Parisian stockbroker decided to return to the French capital to follow his restless artistic conscience. Whether painted in Denmark, on the eve of his separation from his family, or in Paris, embarking on a new phase of his career, this painting is the first of the many self-portraits in which Gauguin sought to explore his dark inner psyche.

Scientific examination of the painting has revealed that at first Gauguin portrayed himself in profile and included reproductions of his own paintings in the background. Turned to confront the viewer in the final work, he paints the left-handed image seen in a mirror. His body seems crowded in an attic space with a slanted beam, and cold, with the lapels of his heavy jacket wrapped together. Only his piercing eye escapes the bleak atmosphere.

Gauguin, who regularly assumed roles in his self-portaits, may indeed have intended to present himself here as a prisoner. When he later made a self-portrait for his new friend Vincent van

Gogh in 1888, he explained: "It is the face of an outlaw, ill-clad and powerful like Jean Valjean [the criminal hero of Victor Hugo's *Les Miserables*], with an inner nobility and gentleness . . . As for this Jean Valjean, whom society has oppressed, cast out—for all his love and vigor—is he not equally a symbol of the contemporary Impressionist painter?"

PAUL CÉZANNE

French, 1839-1906

Man in a Blue Smock

c. 1896-97

Oil on canvas; $32^{1}/_{16}$ x $25^{1}/_{2}$ in. (81.5 x 64.8 cm)

Acquired in 1980, in memory of Richard F. Brown, the Kimbell Art Museum's first director, by the Kimbell Board of Directors, assisted by the gifts of many friends

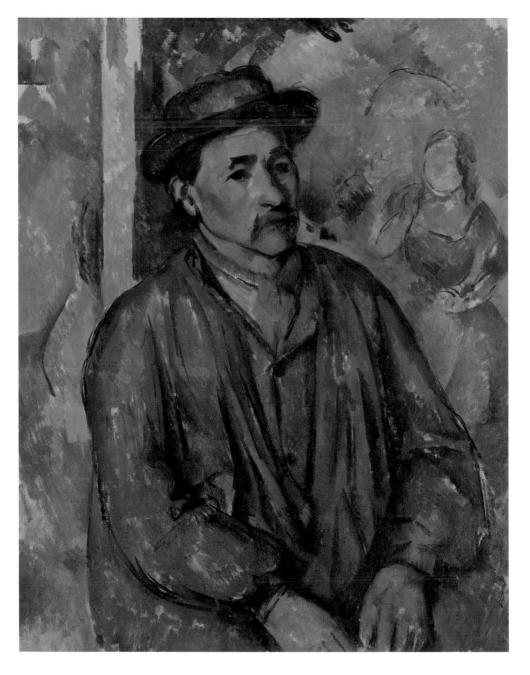

Portraiture occupied an important place in Cézanne's art in the 1860s and 1870s, when he typically produced experimental, sometimes ironic, representations of family and friends. Starting again around 1887, first using his wife and son as models, Cézanne began to accord the portrait a greater significance, painting single figures with the same gravity he had displayed in his landscapes and still lifes. Around 1890, he began enlisting workers from his family's estate. For the remainder of his career. Cézanne maintained his interest in making portraits of rural workers: the man who posed for Man in a Blue Smock also posed for the famous Cardplayers compositions of the early 1890s.

The majority of Cézanne's portraits are set in the studio. In the background of *Man in a Blue Smock*, Cézanne represented the right-hand section of an 1859 folding

screen that was his very first work of art, featuring elegant figures rendered in a pastoral spirit. Juxtaposed in an ambiguous way next to the worker in the Kimbell portrait, a woman with a parasol may suggest some mute dialogue between opposite sexes, differing social classes, or even between the artist's earliest and most fully evolved efforts as a painter.

The portrait is enlivened by tiny patches of white canvas. Although the artist sometimes suggested the flicker of light with such small, unpainted zones, the blank patches in his paintings might be understood on a more philosophical level. Among Cézanne's most important legacies was his pioneering demonstration, by leaving areas of canvas unpainted, that a painting could suggest not only what the artist saw, but also the pauses and hesitations that accompanied the exacting realization of his observations.

PAUL CÉZANNE

French, 1839-1906

Maison Maria with a View of Château Noir

c. 1895

Oil on canvas; 25% x 31% in. (65 x 81 cm)

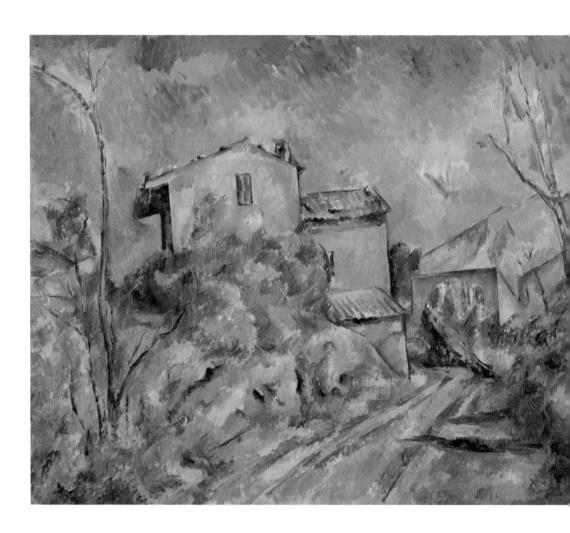

Paul Cézanne, born in Aix-en-Provence, often painted the characteristic buildings of his native countryside—houses with stucco walls and red-tiled roofs, frequently, as here, observed from a road turning into the picture. Several seem to have appealed to him as portraits-by-proxy of their owners, but the identity of "Maria," after whom the primary building in this work is named, remains a mystery.

By the late 1870s, Cézanne had devised his hallmark manner of applying color in short parallel strokes, no differently for objects than for empty space. Here trees are rendered with jagged broken lines against a sky painted with energetic strokes of light- and dark-blue paint, relating stylistically to paintings that the artist made

in 1895 at a quarry near Château Noir, an unfinished and abandoned nineteenth-century building complex in the Gothic style. It was at that site, visible in the right background of the Kimbell canvas, that Cézanne stored his art supplies for outdoor painting beginning in 1887. Indeed, Cézanne's melancholy late views of Château Noir were painted from the path in front of the Maison Maria.

This and other landscapes by Cézanne, in which the geometric solids of man's architecture are juxtaposed with the forms of nature—both organic and geological—were a major source of inspiration for the Cubist landscapes of Braque and Picasso and, by extension, for much of early twentieth-century art.

PABLO PICASSO

Spanish, 1881–1973

Nude Combing Her Hair

1906

Oil on canvas; 41½ x 32 in. (105.4 x 81.3 cm)

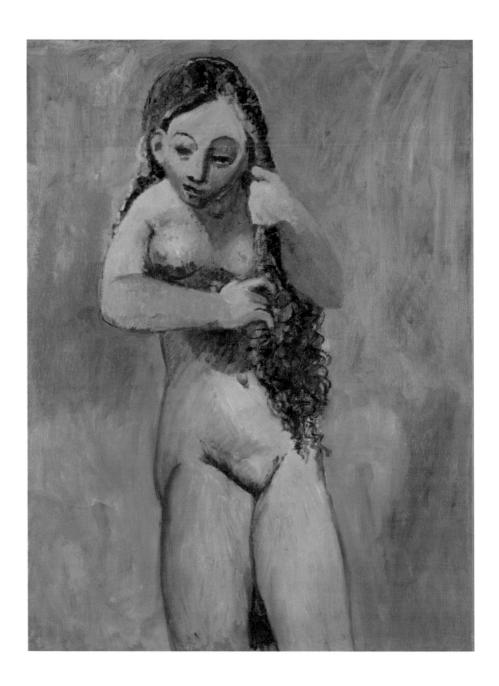

Based on the classical Venus Anadyomene—in which the water-born goddess of love, rising from the sea, wrings out her hair—Nude Combing Her Hair attests to the engagement with classicism that preoccupied Picasso throughout his career. This was, however, always a process of selective and critical adaptation: here, the woman's masklike features exemplify his habit of stylizing the classical prototype, and the intentionally crude brushwork marks a deliberate gesture against the idealism of classical art.

The model for *Nude Combing Her Hair* was Fernande Olivier (born Amélie Lang), who entered Picasso's life in 1904. Her presence helped motivate him to abandon his somber Blue Period subjects in favor of the female nudes so successful with Edgar Degas, Auguste Renoir, and other

vanguard artists. *Nude Combing Her Hair* may be understood as Picasso's response to a powerful artistic rival, Henri Matisse, to whom Picasso was introduced in 1906, when the older artist had begun to stress female nude themes.

Picasso created many works with similar subjects in 1905–6, for the most part fragmentary or sketchy in appearance. Judging from X-radiographs of the Kimbell painting, Picasso first showed the figure in a kneeling pose (compare the Kimbell's *Crouching Aphrodite*, page 17), afterwards repainting the lower part of the figure as a standing, adolescent nude. Like so many of Picasso's dramatically reworked canvases of this time, with boldly modern disjunctions between adjacent parts, *Nude Combing Her Hair* represents both its obvious subject and the artistic act in the process of realization.

PABLO PICASSO

Spanish, 1881-1973

Man with a Pipe

Oil on canvas; $35^{11}/_{16}$ x $27^{15}/_{16}$ in. (90.7 x 71 cm) (oval)

In July 1911, Picasso left Paris for Céret, a small town in southwestern France. Braque joined him there in August and the two painted together in intense dialogue. The style that came to its apogee in these months, called "Analytical Cubism," is characterized by complex linear underpinnings and by scores of small brush marks, interlocking and overlapping like pieces of an unsolved jigsaw puzzle.

While most of the marks in *Man* with a Pipe are baffling in terms of representation and serve primarily to establish visual rhythms, a few fragments of graphic information are legible. Above the middle of the painting, the white clay pipe helps locate the man's head, with its half-lightened mustache, suggesting that one side of his face is turned toward a light. The eye and nose can be discerned above the mustache. A white rectangular shape at the bottom, perhaps a piece of paper,

indicates where to look for the man's hands. *Man with a Pipe* may represent the interior of a dimly lit café—hence the letters *est* excerpted from the word "restaurant" and the letters *AL* suggesting *journal* ("newspaper" in French).

Two features of the painting are remarkable—its dark palette and oval composition. Around 1910, both Picasso and Braque began to work with particularly dark tones, possibly to invite viewers to strain their eyes to experience a difficult new way of looking. The oval format of the dark Analytical Cubist works, introduced by Braque in early 1910, offered a formal resolution to the tendency of their compositions to cluster marks at the center of the rectangle. Picasso painted nearly three dozen compositions in this format by the end of 1913. This example, once on an oval stretcher, was later remounted onto a rectangular canvas.

GEORGES BRAOUE

French, 1882-1963

Girl with a Cross

1911

Oil on canvas; 215/8 x 1615/16 in. (55 x 43 cm)

Acquired in 1989

Beginning in late 1907, Braque and his new acquaintance Pablo Picasso began to paint objects as highly simplified geometric forms, expressing solidarity with the most idiosyncratic tendencies in the art of Cézanne—especially that of juxtaposing unaligned observations of adjacent parts of a single object—a house, bottle, or face.

Matisse, whose own works at this time emphasized rich color, is generally credited with coining the term "Cubism"—and he used it to describe Braque's overcast landscapes and shadowy still lifes. By late 1909, however, Braque and Picasso had extended the Cubist premise to such a degree of analysis by fragmentation that their somber gray and ocher paintings appeared mostly abstract, except for scattered, geometric-shaped vestiges of recognizable imagery, such as an eye, the bridge of a nose, a cascade of hair in curls, or a necklace with a cross. The implication was that solid matter and the space surrounding it had interpenetrated one another, resulting in a new visual order.

In *Girl with a Cross*, the head (or rather its disembodied details) emerges like an apparition amid a rich interplay of highlighted and shaded facets, thinly and patchily applied and atmospheric in mood. What appears to be a round, white, ceramic pot at the right, more solidly painted than the woman, mysteriously occupies the space where her shoulder should be. Orchestrating details in this way, Braque creates an unprecedented visual impression of powerful opposites: presence and absence, stasis and movement.

FERNAND LÉGER

French, 1881-1955

Composition

c. 1920

Oil on canvas; 233/4 x 287/8 in. (60.3 x 73.4 cm)

Acquired in 1985

Léger usually painted several variations of each of his pictorial ideas, and many of the same elements in the Kimbell painting appear in four other paintings, all dated 1920. Aside from what appear to be rods, wires, and the stenciled letters P, U, and V (presumably taken from some poster or sign on the street), it is impossible to identify specific objects in this highly abstract composition. But judging from Léger's more explicitly representational works of the immediate post-World War I era, the colorful fragmented and segmented geometric forms are most likely related to elements of modern machinery and architecture. Already before World War I, Léger stressed that condensation, variety, and fragmentation were the essential visual qualities of motorized, commercialized, twentieth-century experience and hence of modern painting.

Léger gave the Kimbell painting to his lifelong friend, the poet and art critic Blaise Cendrars (1887–1961), who favored the rhythms of just such fractured and fragmentary observations in his influential writings. After the war, in which they both saw combat, Léger provided illustrations for Cendrars's book *I Have Killed* (1918). Their

close relationship is apparent in a poem entitled *Construction*, which Cendrars wrote in 1919: "Color, color, and more colors . . . / Here's Léger who grows like the sun in the tertiary epoch. . . . Painting becomes this great thing that moves / The wheel / Life / The machine / The human soul / A 75 mm breech / My portrait."

The work remained in Cendrars's collection until acquired by the Kimbell in 1985. As a result, its condition remains pristine; never varnished or relined, it provides a benchmark for understanding the delicate textures and matte surfaces essential to Léger's aesthetic.

Tableau No. 1/Composition No. 1/ Compositie 7, 1914

1914

Oil on canvas; 47½ x 39% in. (120.6 x 101.3 cm)

Acquired in 1983, Gift of The Burnett Foundation of Fort Worth in memory of Anne Burnett Tandy

© 2013 Mondrian/Holtzman Trust c/o HCR International USA

After experimenting with the bright colors of Fauvism, Mondrian's exposure to Cubism in 1911 quickly converted him to ever-deeper abstraction and brought him back to the coloration of his poetic early works. The atmospheric tones of ocher, blue gray, and pink in Tableau No. 1 are typical of this development. The artist had moved to Paris in 1912 and based a series of compositions, including the Kimbell painting, on the complicated geometry of the streetscape near his studio in Montparnasse. In these Cubist-inspired works, Mondrian "drew" his subject with a scaffold of black lines within, across, and around which he delicately added color as if orchestrating atmospheric effects.

"The masses generally find my work rather vague," he wrote in January 1914, around the time he painted *Tableau No. 1*. "I construct lines and color combinations

on a flat surface, in order to express general beauty . . . I believe it is possible that, through horizontal and vertical lines constructed with awareness, but not with calculation, led by high intuition, and brought to harmony and rhythm, these basic forms of beauty, supplemented if necessary by other direct lines or curves, can become a work of art, as strong as it is true."

If such paintings took their inspiration from nature, the artist was at pains to hide his sources. Mondrian first exhibited the Kimbell painting at the 1914 Salon des Indépendants in Paris, listed in the catalogue simply as *Tableau* ("Picture"). Later that same year, he revised the work prior to an exhibition in The Hague, for which he titled it *Composition I*. The next year, he exhibited the painting twice more, each time with a different title: *Composition H* and then *Composition VII in Color*.

JOAN MIRÓ

Spanish, 1893-1983

Portrait of Heriberto Casany

1918

Oil on canvas; 275/8 x 247/16 in. (70.2 x 62 cm)

Acquired in 1984

"Here in Barcelona, we lack courage," Miró wrote in late 1917 to his studio-mate Enric Ricart. "We, the younger generation, could get together and exhibit every year . . . and pronounce virile manifestos . . . We have to be men of action." Miró and his friends eventually banded together as the "Courbets," in honor of the controversial French Realist. Their devotion to modern French painting notwithstanding, the Courbets were committed both to radical

pictorial innovation and to Catalan tradition. Among the three works that Miró presented when the Courbets first showed together in 1918, this portrait of his art-school friend Heriberto Casany, with his spindly fingers and the undulating folds in his tweed suit jacket, resembles saints depicted in medieval Catalan frescoes with gold backgrounds. Casany's attribute is quintessentially modern: a framed cartoonlike image of an automobile, which apparently refers to his father's cab-rental business.

Treated in Fauvist fashion, with disconcerting green, yellow, and violet shadows, Casany's schematized features appear animated with a life force. As Miró explained later, "even in my portraits, where I tried to capture the immobility of presence . . . I tried to get the vibration of the creative spirit into my work." Miró's treatment of his friend's fine haberdashery, his rendering of the stripes and texture with undulating lines and white specks, makes the inanimate tweed as vividly "alive" as the sitter. Just such attention to minute details would become the basis for the highly poetic, pulsating pictorial language Miró developed in the following decades to evoke tilled fields, starry nights, and nature in all its abundance.

EDVARD MUNCH

Norwegian, 1863-1944

Girls on a Bridge

c. 1904 or 1933-35

Oil on canvas; $31^{11}/_{16} \times 27^{5}/_{16}$ in. (80.5 x 69.3 cm)

Acauired in 1966

In 1889, Munch started spending periods at the Norwegian resort of Åsgårdstrand, popular at that time with many artists and writers. In 1901, Munch used a pier as the foreground in a painting of a group of women with the houses of Åsgårdstrand in the background, resulting in the first version of *Girls on a Bridge* (National Gallery, Oslo).

Here, exaggerating line and color to create haunting, even ominous, moods, Munch portrays a world charged with emotions and anxieties. It is the setting, rather than the girls' poses and expressions, that suggests they may be brooding about their identities or desires. They appear absorbed, like the painter, in their observations of the townscape under a full moon. The foremost girl turns away from her friends toward the viewer, but her face is blank, an emotional riddle.

Following the lead of modern artists such as Monet and Renoir, who in the early 1890s began to play multiple variations on a single compositional idea, Munch painted many versions of *Girls on a Bridge* over the course of several decades, as well as half a dozen closely related works with older female figures in the same setting. In all these, Munch depicted the pier with slanting lines receding dramatically into

the background space. Among the *Girls* on a *Bridge* variations, the Kimbell's is one of the most freely painted. When it was acquired by the Kimbell in 1966, as one of the first twentieth-century paintings in the collection, it was thought to be one of the earliest variants in the series; recent authors have suggested that it was painted in the first half of the 1930s. It was first exhibited, and sold, in 1936.

CLAUDE MONET

French, 1840-1926

Weeping Willow

1918-19

Oil on canvas; 391/4 x 471/4 in. (99.7 x 120 cm)

Monet had painted ten *Weeping Willow* paintings by 1919, apparently in mournful response to the mass tragedy of World War I. Due to the war, Monet's luxurious compound at Giverny was for the most part emptied of his children's families and his household staff, who were either called into service or moved away from the advancing German army. His only surviving son was in constant danger at the front. At times, Monet could hear artillery fire, but he refused to leave, preferring to share the fate of his gardens.

As a group, the Weeping Willow paintings are characterized by shadowy colors and writhing forms, as if Monet intended to express the grieving mood not simply with the subject, but also through an expressionist style of painting. They were among the very few easel-scale paintings

that Monet made after 1914, when he claimed his failing eyesight was best suited for working in larger formats. The particular tree portrayed in *Weeping Willow* had pride of place on the bank of Monet's water garden, with its exotic water lilies. The tree's trunk, its cascading branches, and its reflection are all incorporated into his greatest artistic legacy, the mural-scale Nymphéas canvases, which were his preoccupation from 1914 until his death.

Most of Monet's works from the late teens were never finished and were retained in his studio at the time of his death. The Kimbell *Weeping Willow*, on the other hand, was signed and dated, and passed by 1924 into the collection of the Japanese Baron Kojiro Matsukata, one of the first collectors to recognize the genius of Monet's last, expressionistic canvases.

ANTOINE BOURDELLE

French. 1861-1929

Penelope

1909

Cast bronze, dark green patina; $47\frac{1}{8} \times 17\frac{1}{4} \times 14\frac{3}{4}$ in. (119.7 x 43.8 x 37.5 cm)

Acquired in 1969

Bourdelle is generally acclaimed as the most important heir to the sculptor Auguste Rodin, in whose studio he was an assistant from 1893 until 1908. Upon his separation from Rodin, however, Bourdelle sought direct inspiration in the work of the famous Neoclassical painter Ingres, a native of the sculptor's own hometown, Montauban. Bourdelle sculpted a portrait of Ingres in 1908 while developing *Penelope*, the pose for which, based on ancient Roman models, was among Ingres's favorites.

In Bourdelle's earliest treatments of the theme, Penelope held a spindle to identify her as the steadfast wife of Odysseus, who, in Homer's epic account of the Trojan War, endures the long absence of her warrior husband by weaving a shroud. In the fully evolved Kimbell model, the figure's identity as Penelope is manifest only from the ancient Greek costume and meditative pose. By eliminating the spindle prop and bringing the woman's arms close to her body, the artist made her form more architectural: the heavy woolen pleats of Penelope's chiton are like the fluting on a Doric column. Such monolithic simplicity was an ideal in early twentieth-century sculpture, from Rodin to Aristide Maillol and Constantin Brancusi.

ARISTIDE MAILLOL

French, 1861-1944

L'Air

Designed in 1938; cast in 1962

Bronze; $50^{13}/_{16} \times 92^{11}/_{16} \times 38$ in. (129 x 235.5 x 96.5 cm)

Acquired in 1967

The city of Toulouse, in southwest France, commissioned a statue from Maillol in 1937 to honor the memory of the crew of the hydroplane Croix du Sud. The plane had left on December 7, 1936, for a transatlantic crossing of a newly established mail service between France and South America and disappeared after take-off. The monument's stone figure, balanced on its right hip, is positioned on an undulating drapery, perhaps to suggest wind or waves as well as to give support to the horizontal form. Versions of the model cast in metal—in lead or, as here, in bronze—did not need the extended support and seem to float, as it were, on air itself.

The historian John Rewald visited Maillol at his studio while the sculpture was under way and recorded that Maillol based his idea on a small terracotta he had made around 1900 showing a woman reclining on billowing drapery, as if to represent a Greek goddess in the clouds or on the sea. Since classical antiquity, the image of the healthy nude woman has symbolized beauty, truth, and innocence. Maillol's own interest in the general pose first appears in his paintings of bathers around 1895, derived from works by Gauguin and Renoir.

Maillol's first work in the form of a recumbent female nude evolved from his commission to create a monument to Cézanne (finished 1925, Musée d'Orsay, Paris). According to Rewald's account, Maillol developed the pose for *L'Air* by cutting up a version of the figure he had already developed for the Cézanne monument and subtly rearranging the parts. "Nevertheless," Rewald concluded, "the artist thus created an altogether original work which appears still more beautiful than the initial statue."

PIET MONDRIAN

Dutch, 1872-1944

Composition No. 8, with Red, Blue, and Yellow, 1939-42

1939-42

Oil on canvas; 29½ x 26¾ in. (74.9 x 67.9 cm)

Acquired in 1994

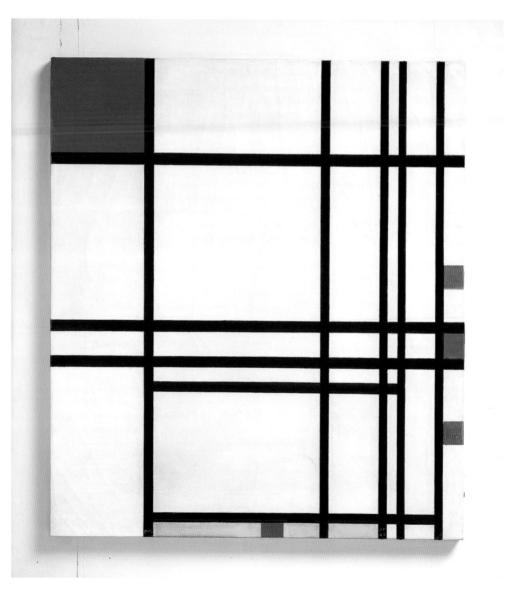

© 2013 Mondrian/Holtzman Trust c/o HCR International USA

The austerely abstract style of Mondrian's grid paintings restricts itself to straight horizontal and vertical lines and the rectangular shapes resulting from their crossing; their palette is deceptively simple: black, white, and the primaries—red, yellow, and blue. The artist's intuitive arrangement of these elementary pictorial means in balance and harmony, together with his subtly nuanced variations in the simple means he allowed himself, expressed the concept he called "dynamic equilibrium."

From 1919 until 1938, Mondrian made his home in Paris. He left the Continent, in the face of growing fascism to the east, for London, where he began work on *Composition No. 8* in 1939. The painting was completed in New York, where he arrived in 1940 to escape the quickly spreading dangers of World War II. The Axis attack on Pearl Harbor in December

1941 took place just as he put the finishing touches to the work for a January 1942 exhibition. In most respects, *Composition No. 8* is one of the culminating paintings in a stark, hallmark mode that Mondrian had developed by 1921 in dialogue with his fellow Dutch artists of the De Stijl movement. But a new sense of adventure, characteristic of Mondrian's final New York works, is expressed in such details as the absence of black bordering lines for the red rectangles located along the right and bottom edges.

Composition No. 8 retains its vibrant, unvarnished surface and also its original frame. Mondrian himself claimed, as far as he knew, to be the first artist to bring the painting forward from the frame rather than setting it within; in so doing, he eliminated the tendency of the traditional frame to lend an illusionistic depth to the painting.

JOAN MIRÓ

Spanish, 1893-1983

Constellation: Awakening in the Early Morning

1941

Gouache and oil wash on paper; $18^{1}/_{8}$ x $14^{15}/_{16}$ in. (46 x 38 cm)

Acquired in 1993, with the generous assistance of a grant from Mr. and Mrs. Perry R. Bass

Miró's Awakening in the Early Morning is one of twenty-three small gouache and oil wash paintings on paper known as Constellations. Teeming with weird, doodled creatures afloat in fluid fields of color, the Constellations evolved, surprisingly enough, from Miró's aspirations to work on a mural scale. After writing a brief article in May 1938 called "I Dream of a Large Studio," Miró was invited by his neighbor in Paris, the American architect Paul Nelson, to spend that summer painting a mural in his home in Normandy. Miró returned the following summer and chose to remain there after France declared war on Germany in September 1939. Miró described the Constellations as "very elaborate paintings ... [with] a high degree of poetry" and claimed, with fifteen to twenty under way, that they were among "the most

important things I have done, and even though the formats are small, they give the impression of large frescoes." He insisted on keeping them all with him "to maintain the momentum and mental state I need in order to do the entire group."

In May 1940 the Nazi offensive into Normandy forced the Miró family to flee south. They reached Majorca in July, and it was there that the Kimbell *Constellation* was finished. At this time, Miró later explained, "The night, music, and stars began to play a major role in suggesting my paintings." The series was first shown in 1945, in New York. Symbolic of the survival of great art in the face of the ongoing war, these small works had important implications for American painters such as Jackson Pollock as they created abstract compositions permeated with free-floating lines and forms.

HENRI MATISSE

French, 1869-1954

L'Asie (Asia)

1946

Oil on canvas; 453/4 x 32 in. (116.2 x 81.3 cm)

Acquired in 1993

Painted near the end of Matisse's long career, *L'Asie* culminates his obsession with single female figures, richly costumed, in exotic settings. The work's title may allude to the European tradition in which a woman would represent a continent, or it may have been suggested by one of Matisse's favorite costumes, a Chinese coat lined with Siberian tiger fur, here rendered in violet and blue. While the contrasting golden skin of the model is emblematic of Asian peoples, the model apparently came from the Congo. Moreover, her eyes are blue and green, as if chosen to reflect the colored beads of her necklace.

L'Asie was painted in Matisse's studio at the Villa Le Rêve, in Vence, to which he had withdrawn in June 1943 to escape the Allied bombardment of nearby Nice. Matisse worked on L'Asie between late

November 1945 and his departure for Paris in June 1946. The apparent effortlessness of L'Asie's thinly painted surface and fluid drawing masks the painstaking efforts Matisse put into its creation. In an earlier state—perhaps one of several—the composition featured a black quadrant enlivened by arabesque lines in the lower left and a signature and date of 1946 scratched into the paint. In L'Asie's finished state, Matisse converted the black quadrant to a flaming red, unifying the background as a decorative space, and redrew the arabesque lines, as well as his signature and the date, with black crayon. He wrote in 1948: "I have always tried to hide my own efforts and wanted my work to have the lightness and joyousness of a springtime which never lets anyone suspect the labors it has cost."

FERNAND LÉGER

French, 1881-1955

Walking Flower (La fleur qui marche)

1952

Ceramic; 123 x 96 x 55 in. (312.4 x 243.8 x 139.7 cm)

Acquired in 2011, Gift of the Burnett Foundation

After his groundbreaking investigations of complex forms and patterns in the paintings of his Cubist years—paintings such as the 1920 *Composition* (page 188)—Léger moved towards a style of greater generalization and simplicity. In the 1920s and 1930s, he experimented with painting large-scale images of the human body, as well as

almost abstract still lifes and architectural compositions. Profoundly interested in modern technology, Léger sought to bring art to the masses through whatever means he could, including the production of films. By the end of the 1930s, he had undertaken a number of important projects for public art, including a mural for an important exhibition of modern art and industry held in Paris in 1937.

Léger spent the years of World War II in the United States, where his paintings took on a new character. Bold patches of color were suspended within a framework of black and white imagery, the colors deliberately flat and bright: yellow, red, and blue, plus orange and green. Back in France after the war, the artist expanded his interest in public art, embracing new media—mosaics, textiles, and stained glass among them.

He visited the town of Biot, near Nice, where a former student was in charge of ceramic works. Léger began to work in ceramic sculpture, first creating murals in low relief but soon embracing the idea of a fully round sculptural form. *Walking Flower* was one of the products of this burst of creativity, boldly colored on one face, black and white on the other, a form from nature imbued with a human spirit, a spirit of humor, of play, and of joyfulness.

Woman Addressing the Public: Project for a Monument

1980-81

Bronze; 146½ x 96 in. (372.1 x 243.8 cm)

Acquired in 1996

With its peculiar proportions and anatomy, Miró's huge, fantasy Woman Addressing the Public is indebted to the artist's lifelong study of the imaginative and expressive powers of the art of children. He first realized its design in 1971 as a twenty-inch plaster maquette painted white, with color accents for the eyes, arms, and sexual organs. He planned to place the as-yet-unfinished statue at the entrance to the Los Angeles County Museum of Art, then in New York City's Central Park or at the Hirshhorn Museum and Sculpture Garden in Washington, but none of these projects materialized. It would be nearly a quarter of a century before his playful "monster" would finally have a place of honor outside an important museum, the Kimbell. The final work, cast in an edition of four when the artist was eighty-seven, weighs roughly three tons.

The art of children was indeed a major source of inspiration for Miró, and whimsical creatures related in appearance to *Woman Addressing the Public* began to appear in his paintings and drawings in the 1920s. It was only after World War II, however, that he began to fashion little statuettes of similar figures, perhaps inspired by the surreal sculptures of his fellow countryman Picasso. Miró began to develop his ideas as sculpture at full scale in

the 1950s and 1960s, in effect embarking on a second career as a sculptor expressly interested in art for public spaces. The female creature with arms outspread was his favorite sculptural subject, and *Woman Addressing the Public* is his grandest and ultimate statement of the theme.

HENRY MOORE

British, 1898-1986

Figure in a Shelter

1983

Bronze; 72 x 80 x 90 in. (182.9 x 203.2 x 228.6 cm)

Acquired in 2011, Gift of the Burnett Foundation

Henry Moore is one of the most important sculptors of the twentieth century.

Beginning as a carver in wood and stone,
Moore moved to modeling sculpture to
be cast in bronze, taking the human form
as his constant theme. A major figure
in British art, he achieved greatest fame
with large-scale commissions for public

sculpture in civic spaces and in gardens across the world.

Figure in a Shelter is a work from the artist's last creative phase, produced just three years before his death. Its forms, however, go back to sculptural ideas Moore first explored in the 1930s. The "shelter" that surrounds the figure within has its origins in a helmet-like head that Moore conceived about 1939–40, a shape in turn based on ancient armor. Greatly expanded, the two halves of the "helmet" become an enfolding architectural protection for the small, upright form, whose expanding and contracting columnar shape suggests a human body.

Shelter and protection are abiding themes in Moore's art. Many of his best-known early sculptures show mothers and fathers holding their children. During the air attacks on London during the Second World War, Moore created hundreds of moving sketches and finished drawings of figures sleeping and waiting in underground shelters. *Figure in a Shelter*, a large-scale bronze that is both ominous and comforting, takes the theme to its most abstract end.

ISAMU NOGUCHI

American, 1904-1988

Constellation (for Louis Kahn)

1980-83

Basalt; left to right: $26\frac{1}{2} \times 96\frac{1}{2} \times 34$ in. $(67.3 \times 245.1 \times 86.3 \text{ cm})$; $24 \times 27 \times 24$ in. $(61 \times 68.6 \times 62 \text{ cm})$; $40 \times 58 \times 43$ in. $(101.6 \times 147.3 \times 109.2 \text{ cm})$; $84 \times 33 \times 29$ in. $(213.4 \times 83.8 \times 73.7 \text{ cm})$

Acquired in 1983, Gift of the Isamu Noguchi Foundation in honor of Louis I. Kahn and the Kimbell Art Museum. With thanks and goodbye to Shaindy Fenton

Around 1980, the great twentieth-century sculptor, stage designer, and furniture maker Isamu Noguchi was inspired to create a sculptural ensemble in honor of the architect Louis Kahn for the grass courtyard on the south side of the Kimbell. The two men had been friends-they worked together in the early 1960s on a never-realized playground for Manhattan's Riverside Park. Arranged on the Kimbell site in August 1983, Constellation makes a most successful addition to the spirit of the building through allusion to one of Kahn's favorite topics, the prehistory of architecture. In particular, it recalls the mysterious menhirs that are among the earliest structures made by humankind. Drawing upon his American-Japanese heritage, Noguchi helped

introduce into Western sculpture the spirit of Japanese garden design, with carefully chosen rocks placed to create a setting of intuitive harmony. His first major project of this kind was the garden for the UNESCO headquarters in Paris, finished in 1958.

Given his longstanding interest in lunar themes, it was perhaps the basalt-like moon rocks brought back to earth in 1969 that encouraged Noguchi to use basalt monoliths as a primary material in the 1970s. Carved in his studio on the island of Shikoku, Japan, the igneous rocks, rich in iron and black augite, weather brown; by leaving them untouched on some sides while chiseling and polishing them on others, Noguchi made his material yield a palette of different colors.

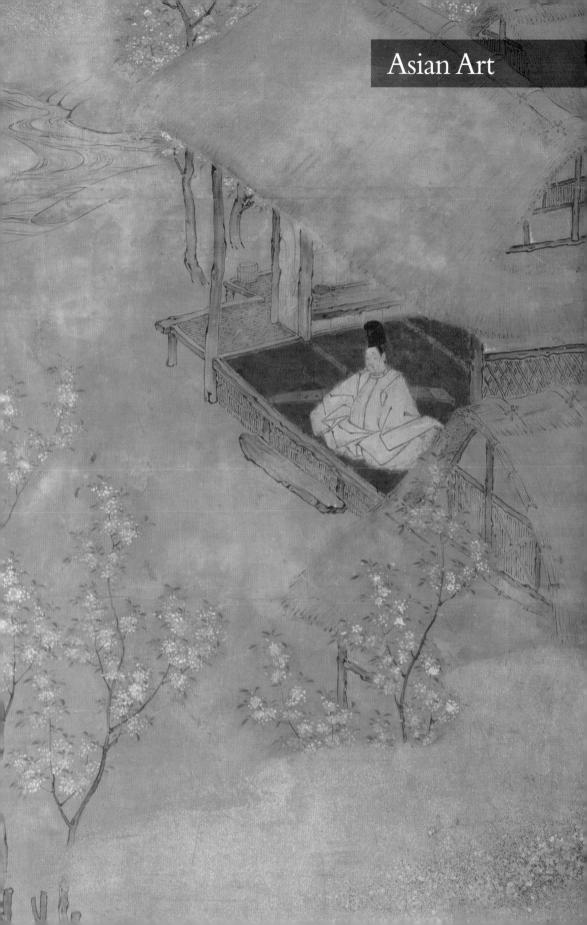

Seated Buddha with Two Attendants

Mathura, Uttar Pradesh, India; Kushan period, AD 82 Red sandstone; $36\frac{5}{8} \times 33\frac{5}{8} \times 6\frac{5}{16}$ in. ($93 \times 85.4 \times 16$ cm)

Acquired in 1986

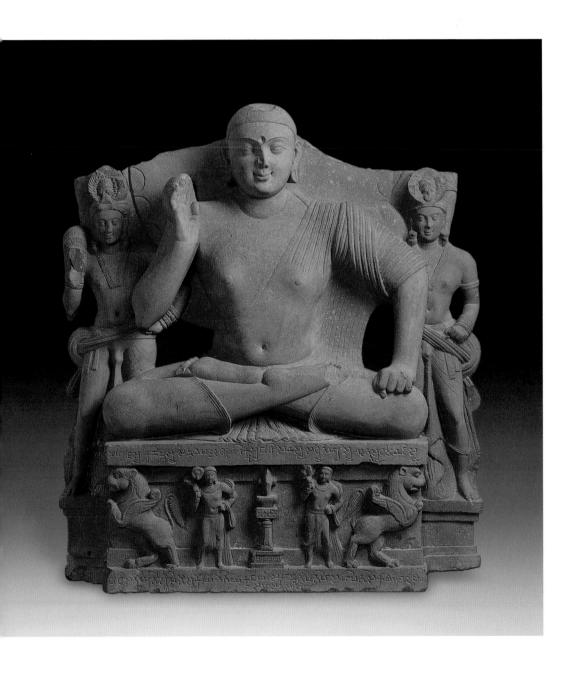

The Kushans ruled from the second century BC to third century AD in much of northwestern India and the ancient region of Gandhara (parts of present-day Pakistan and Afghanistan). Mathura was the second capital of the Kushans and a major center of art production that incorporated indigenous Indian traditions and made much use of the local mottled red sandstone.

This sculpture conforms to a standard early Mathura type. The Buddha is personified as Shakyamuni, the teacher. He is portrayed as a traditional yogi, seated on a throne, and dressed in the guise of a monk, with a diaphanous robe worn over the left shoulder. The sensitive modeling of the soft, plump flesh gives little hint of musculature but endows the body with a sense of solidity and mass. The hair is smooth like a cap, and the cranial bump (ushnisha), now

missing, would have appeared as a twisted bun or coil of hair (kapardin). The right hand is raised in the gesture of reassurance (abhayamudra). The palms of the hands and soles of the Buddha's feet are marked with the lotus and the wheel, symbols of his divinity and teaching. The generously modeled and sensuous royal attendants flanking the Buddha have stylized features and archaic smiles similar to their lord's. The sculpture includes other references to the Buddha's life and exalted status as a universal monarch. The large halo behind his head represents the sun and proclaims his divinity. The pillar topped by a wheel, centered in the relief panel of the throne, is symbolic of preaching and refers to the Buddha's first sermon at Sarnath. The two figures holding flywhisks and the rampant lions signify the Buddha's royal heritage.

Standing Bodhisattva

Pakistan (ancient region of Gandhara); Kushan period, 2nd–3rd century AD Gray schist; $59\frac{1}{8} \times 30 \times 10$ in. (150.2 \times 76.2 \times 25.4 cm)

Acquired in 1997

Representations of bodhisattvas emerge at the same time as images of the Buddha in Gandharan art, in the first century AD. Enlightened beings who voluntarily postpone their own achievement of nirvana to assist mankind on the path to salvation. bodhisattvas are sometimes shown as attendants to the Buddha and sometimes stand alone. They possess some of the same superhuman traits as the Buddha, having elongated earlobes and the tuft of hair between the eyebrows (uma), and display similar gestures (mudras), but bodhisattvas lack the cranial protuberance (ushnisha). At first, their images were distinguished from those of the Buddha primarily by their secular attire, such as a turban, a sophisticated coiffure and mustache, or noble robes and jewelry, all alluding to the Buddha's life as a prince before attaining enlightenment. Eventually, individual bodhisattvas were also identified by attributes held in their hands or symbols worn in their hair.

This majestic figure of a Standing Bodhisattva is lavishly attired in the rich dress and jewelry of a Kushana prince or nobleman from Gandhara. The powerful, fleshy torso, the rounded musculature of the chest and abdomen, and the long, flowing hair further emphasize the figure's regal bearing. The strong, round chin, straight nose, and smooth oval face adorned by an elegantly twirling mustache reflect the mixture of races and cosmopolitan nature of first millennium Gandharan art and culture. Although strongly Hellenizing in profile, the figure is dressed as a thoroughly Indian ruler, wearing the dhoti, bare-chested, with a sash casually slung over the shoulder and draped over the forearm. The juxtaposition of distinctly Western classical features, particularly the realistically rendered drapery and musculature, with the indigenous elements of dress and attributes typifies Gandharan Buddhist sculpture.

Standing Buddha

Pakistan (ancient region of Gandhara); Kushan period, c. 2nd–3rd century AD Gray schist; $51\frac{1}{2} \times 20\frac{3}{4} \times 8\frac{1}{2}$ in. (130.8 x 52.7 x 21.6 cm)

Acquired in 1967

During the rule of the Kushans in India, the image of the Buddha was first realized in human form, and the basic repertoire of Buddhist iconography was established in the first century AD. Among the elements specified in the early literature are the *lakshana*, auspicious physical attributes or marks on the Buddha's body indicating his status as a supernatural being. The most important were the *ushnisha*—the cranial bump—and the *uma*—the tuft of hair between the eyebrows—both signs of the Buddha's superior wisdom; webbed fingers and toes; and wheel markings on the palms of the hands and soles of the feet.

One of the two distinct styles of sculpture that emerged during the Kushan period was produced in Gandhara (parts of present-day Pakistan and Afghanistan), which was heavily influenced by contact with the Greek and Roman traditions of the Mediterranean world. In this image, monastic robes cover the Buddha's shoulders in heavy folds of naturalistic drapery deriving from classical models. The serene, idealized face, blending classical and Indian types, is smooth and oval-shaped with a straight nose and well-defined eyes, shown half-closed as if in a state of meditation. The hair is rendered in wavy lines, culminating in the ushnisha, here depicted as a wavy topknot. The urna is conceived as a raised circle between the brows. The arms would have been raised in one of the five standard gestures (mudras) of the Buddha.

Four-Armed Ganesha

Uttar Pradesh, India; Gupta period, 5th–6th century AD Terracotta relief; $19^5/_{16} \times 26^3/_4 \times 8^1/_8$ in. (49.1 x 67.9 x 20.6 cm)

Acquired in 1981

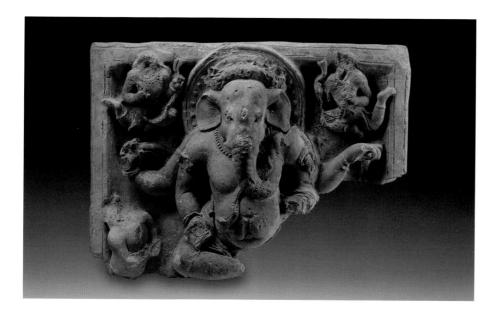

The forms of many Hindu deities became standardized in the Gupta period (c. 321–500 AD), which is therefore considered India's classical age. Sensuously modeled figures with softly rounded contours and lively, elegant silhouettes characterize the period's highly sophisticated style of sculpture. Niches in the exterior walls of Hindu brick temples were often decorated with terracotta plaques such as this one.

Ganesha is the elephant-headed son of Shiva, one of the three most important deities of the Hindu pantheon, and his consort, the goddess Parvati. He is widely worshipped as the remover of obstacles and the bestower of good fortune, prosperity, and health. The origin of his hybrid body—consisting of an elephant's head with one tusk and an infant's torso with distended

belly—is related in Hindu legends. Parvati is said to have created Ganesha in human form to act as her door guardian. When he refused to admit Shiva to Parvati's chamber, the god cut off the child's head. To placate the distressed Parvati, Shiva replaced the head with that of the first living thing he could find—an elephant. Hindu deities are often depicted with multiple heads and arms, an expression of the multiplicity of their superhuman powers. Due to the damaged condition of this superb terracotta relief, it is no longer possible to identify the deity's usual attributes—an axe, a rosary, and a bowl of sweetmeats—which he would have held in his hands. The serpent hanging across his torso signifies his relationship to Shiva, who also bears this attribute.

Standing Female Deity

Rajasthan or Madhya Pradesh, India; Medieval period, 10th or 11th century Pinkish tan sandstone; $56\frac{3}{4} \times 22\frac{1}{4} \times 11\frac{1}{4}$ in. $(144.2 \times 56.5 \times 28.6 \text{ cm})$

Acquired in 1968

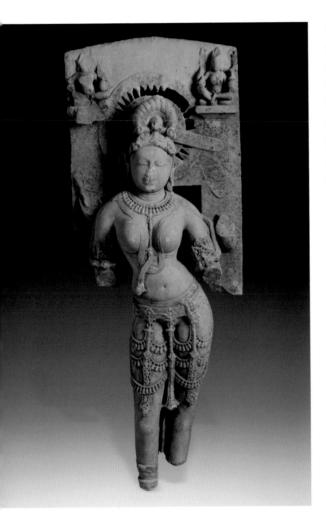

The medieval period (c. AD 600–1200) in India witnessed an unprecedented growth in the building of temples, which were copiously decorated with exquisitely carved stone sculptures. In both the Hindu and Jain religions, building temples and

consecrating images are the surest means of gaining liberation (*moksha*) from the endless cycle of rebirth. The interior shrines of the temples are generally reserved for images of the primary deities to which the temples are dedicated, while the sculptural programs include a vast array of gods, goddesses, dancers, and musicians, as well as mythological and other narrative scenes.

Fertility goddesses were an important component of early Indian nature cults and were eventually assimilated into the symbolic repertoire of later Indian religious art. These youthful, sensuous figures personify fertility, maternity, and Indian ideals of feminine beauty, various guises expressing different aspects of the female character—triumphant and fierce, as well as passive and dependent.

This delicately carved figure of a goddess, with its softly rounded forms and crisply delineated ornamentation, is typical of temple sculpture from the western Indian state of Rajasthan. The large size of the figure and attendants attest to her importance, and the halo and sword behind her head signify her power. However, since two of the original four arms, and the attributes they held, are missing, her identity cannot be firmly established. She may represent one of the sixteen Jain Vidyadevis (goddesses of learning); Mahamanasi, the sixteenth Vidyadevi, bears a sword as one of her attributes.

Bodhisattva Khasarpana Lokeshvara

Bengal, India; Pala period, c. 11th–12th century Gray schist; $49^3/_{16} \times 31^5/_{8} \times 14^1/_{8}$ in. (124.9 x 80.3 x 35.9 cm)

Acquired in 1970

The last significant phase of Buddhism as a dominant religion in India occurred under the Pala and Sena dynasties (c. AD 700–1200), which ruled eastern India. A prodigious amount of art was produced during the Pala period, but, with the destruction of many Buddhist monuments and sculptures during the twelfth-century Muslim invasions and the subsequent rise of Hinduism, little of its architectural context survives.

The increasing complexity of imagery in late Pala art paralleled the growing popularity of Esoteric Buddhism in eastern India. Khasarpana Lokeshvara, the Esoteric form of the immensely popular bodhisattva of compassion, was created by the absorption of Hindu elements into Buddhism and appears frequently in Pala art. In this stela, the youthful, bejeweled figure is seated on a doublelotus throne, surrounded by lotus blossoms and the deity's four standard attendants: the goddesses Tara and Bhrikuti at the bodhisattva's knees and, on the base, the needle-nosed Sucimukha, who imbibes the nectar of grace, and the plump, fearsome Hayagriva. In addition, the princely Sudhanakumara, who carries a book, is shown at the front left of the base, while two tiny figures of the donor couple are shown kneeling behind Hayagriva. Due to damage to the upper part of the stela, only one out of five jina Buddhas, the rulers

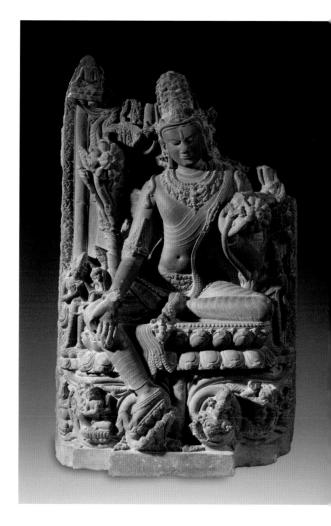

of the Buddhist universe, remains. The elegant proportions, attenuated waistline, richly carved surface decoration, complex iconography, and almost feminine poise of the bodhisattva are hallmarks of the mature Pala style.

Vishnu

India; Chola period, 13th century Bronze; $33\frac{3}{4} \times 13\frac{3}{8} \times 12\frac{7}{8}$ in. (85.7 x 34 x 32.7 cm)

Acquired in 1970

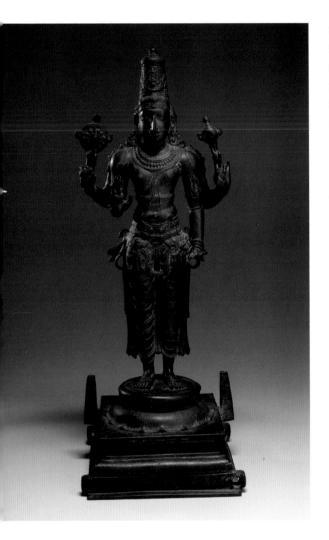

The Cholas originated a tradition of large-scale, cast-metal Hindu sculpture in the round. These sculptures were carried in ritual processions through temples and adjoining precincts, with poles inserted in

the lugs and holes on the base to support the image. As icons of worship, Hindu sculptures were believed to be concrete forms in which the gods temporarily resided. Because of their religious function, every feature of these sacred images was carefully regulated. Specific attributes, hand gestures (*mudras*), and postures (*asanas*) were assigned to each deity; they revealed his various powers and helped a devotee to identify him.

In the Hindu pantheon, Vishnu is the Preserver, a benevolent god who keeps the world safe from natural calamities and protects the righteous. He is a martial deity who, in his role as preserver of the universe, conquers various personifications of evil. His attributes are mainly weapons or objects related to battle. In this image, Vishnu stands rigidly in his traditional frontal pose, called samabhanga. He is magnificently attired in a richly draped and elaborately fastened skirt (dhoti), ornate jewelry, and a tall regal crown. His multiple arms symbolize his manifold powers. The lower right hand makes the gesture of reassurance (abhayamudra), the lower left the boon-giving gesture (ahuyavaramudra). The other two arms hold his attributes—in the upper right, a wheelshaped discus thrown in war to cut down foes, and in the upper left, a conch shell battle trumpet used to strike terror into the heart of the enemy.

Parvati

India; Vijayanagar period, 15th century Bronze; 35¹¹/₁₆ x 10¹⁵/₁₆ x 9⁵/₈ in. (90.7 x 27.8 x 24.5 cm)

Acquired in 1969

One of the most striking characteristics of Hinduism is the importance of goddesses. Fertility goddesses were an important component of early Indian nature cults and were eventually assimilated into the symbolic repertoire of late Indian religious art. The prototype for the female torso was the damaru, the waisted hourglass-shaped drum held by the god Shiva. Following such models specified in ancient texts, sculptors produced an idealized female form with narrow waist, broad hips, high, rounded breasts, shapely arms elongated to resemble the slender, pliant bamboo shoot, and eyes modeled on the lotus petal or the fish. These young, beautiful, sensuous figures personify fertility, maternity, and Indian ideals of feminine beauty.

In the Hindu religion, Parvati, goddess of the Himalayas, is the archetypal mother goddess and fertility image. She is the consort of the great god Shiva and mother to Ganesha and Skanda. In this role, she benevolently mediates between the worshipper and the divine. Standing in *tribhanga* (thrice-bent) pose, the graceful divinity is represented as an ideal beauty. She wears a tall conical headdress with a *dhakra* (wheel of light) in the back that functions as a halo. Her diaphanous skirt with jeweled belt emphasizes her shapeliness. This delicate bronze would have been placed inside a temple, probably

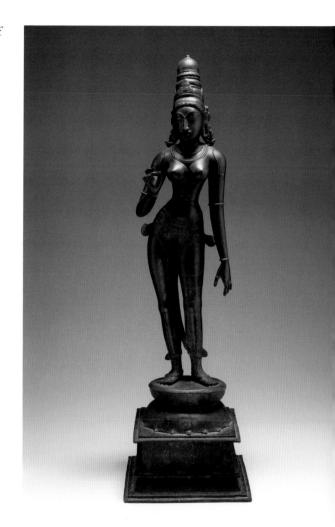

alongside an image of Shiva. During temple festivals, the sculpture's relatively small size permitted it to be carried in a religious procession so that devotees could see and enagage with the deity.

Ragamala Painting of Dhanasri Ragini

Rajasthan, India; Rajput period, c. 1690 Gouache on paper; $10\frac{1}{8} \times 8\frac{1}{2}$ in. (25.7 x 21.6 cm)

Acquired in 1975, Gift of Mr. and Mrs. Edward Wiener

Ragamala paintings represent a confluence of three Indian artistic traditions—classical music, poetry, and miniature painting.

Consisting of an album of between thirty-six and forty-two painted folio sheets,
Ragamalas are organized according to families. Six male Ragas, who personify the six principal musical modes, each possess a harem of five Raginis (wives), or secondary musical modes, and often head a family of several Ragaputras (sons) and Ragaputris (daughters). In this folio from a Ragamala album, a Ragini, longing for her lover, paints his portrait in the belief that the image

of something real can conjure up the subject of the image. The floating moon and fiery red background suggest the intensity of her passion. Many such miniatures were contained in Ragamala albums that followed Indian music in its organization into several modes. Each mode had a special mood and time of day associated with it, at which time its related music and paintings would have been experienced simultaneously. The bright, saturated color of this nocturnal scene is typical of the indigenous folk art of the Mewar.

Standing Buddha Shakyamuni

Nepal; Licchavi period, 7th century AD Gilded copper; 19^3 /4 x 8 x 3^3 /6 in. (50.2 x 20.3 x 8.6 cm)

Acquired in 1979

Nepal derived much of the inspiration for its art and culture from India. The early Buddhist sculpture of Nepal is nearly indistinguishable in style from Indian work of the Gupta period (AD 320–600). Much of Nepalese art was created by a minority community known as the Newars, highly skilled and creative metalsmiths who were concentrated in the Kathmandu Valley.

This slim, richly gilded figure represents the historical Buddha, Shakyamuni, Sage of the Shakya clan. He displays a number of the physical signs that represent the Buddha's divinity—the cranial protuberance (ushnisha), elongated earlobes, three parallel folds in the neck, webbed fingers and toes, and palms marked by a wheel. He stands in a graceful pose with the weight on the right leg. The smooth, fleshy contours of the body are revealed by a thin, clinging garment with cascading pleats. The upper end of the robe is gathered in the left hand, the right bestowing the gesture of charity (varadamudra). While the clearly delineated striations of the garment completely covering the body show the influence of Mathura Buddhas, the transparency and flaring hem of the robe are more typical of images from Sarnath. The "snail-shell" pattern of curled hair, half-closed eyes, and lack of an uma between the eyebrows are typical Gupta features. The Nepalese origin

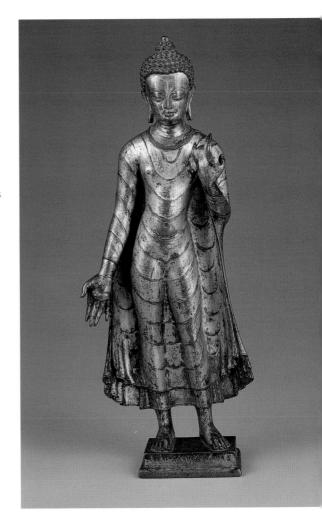

of the sculpture is most evident in the facial expression. The inscription on the base is in a script that was in use in Nepal during the Licchavi period (c. AD 400–750).

Four Mandalas of the Vajravali Series

Sakya order, Tsang (Ngor Monastery), Central Tibet; c. 1429–56 Thangka, gouache on cotton; 35 x 29 in. (88.9 x 73.7 cm)

Acquired in 2000

Most Tibetan art was created in connection with the complex rituals of Vajrayana Buddhism (the Diamond Path), in which mandalas (cosmic diagrams) are employed as visual representations of the sacred realms inhabited by deities. Used as aids in the process of enlightenment, thangkas are painted portable scrolls that depict sacred icons or mandalas. This extraordinary thangka is from a series that illustrates mandalas from the Vajravali (Diamond Garland) text, commissioned by the monk Ngorchen Kunga Sangpo (1382–1456), founder of the Ngor monastery, in honor of his late teacher Lama Sasang Pakpa.

In this highly elaborate work, four individual mandalas have been incorporated into an all-encompassing mandala of the Five Pancharaksha Goddesses. The upperleft mandala depicts these goddesses, popular deities for protection against sickness, misfortune, and calamity, with

the golden goddess Mahapratisara in the center. The upper-right mandala depicts the golden goddess of wealth, Vasudhara, accompanied by eighteen deities associated with prosperity. The lower-right mandala portrays the white goddess of long life, Ushnishavijaya, surrounded by eight Ushnisha deities. In the mandala at the lower left, which is associated with protecting the initiate from negative planetary influences, Bhagvati Mahavidya sits in the upper-right corner.

Interwoven around the four mandalas is another floating mandala scheme consisting of the Five Pancharaksha Goddesses, who appear at the four cardinal directions and in the center, surrounded by thirty-five small Buddhas of Confession. Along the top border are sixteen seated Buddhas in niches. At the bottom are fifteen Buddhist forms of the World Gods and the donor lama, Kunga Sangpo, the last figure on the right.

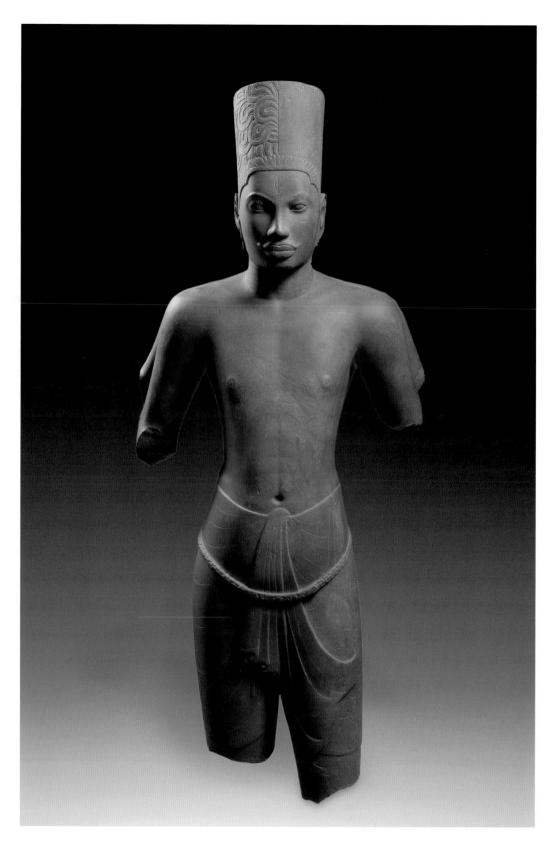

Harihara

Style of Prasat Andet, Kompong Cham, Cambodia; Pre-Angkor period, c. AD 675–700 Sandstone, $45^{1}/_{2} \times 20\% \times 11$ in. ($115.6 \times 53 \times 28$ cm)

Acquired in 1988

Before the emergence in the early ninth century of the powerful Angkor kingdom, Cambodia, along with areas of Vietnam, Thailand, and Laos, was divided into a number of early Khmer cultures. Though influenced by contact with India, by the sixth century Khmer sculpture clearly demonstrates the naturalism and mastery of sculpture in the round that was to distinguish future Cambodian art. This image of the Hindu deity Harihara, with its delicately modeled musculature, supple articulation of limbs, and slender torso draped in a simple *sampot*, is characteristic of the finest pre-Angkor style.

The cult of Harihara was of great importance in early Cambodia, combining the potency of two of the most powerful Hindu gods, Shiva and Vishnu. Shiva (Hara), embodiment of the forces of destruction and fertility, is

indicated on the sculpture's proper right by the matted and twisted locks forming his characteristic headdress (*jakamukata*) and by half of his potent third eye. Vishnu (Hari), preserver of the world, who will give rise to Brahma, the creator, after a cosmic sleep following the end of the current cycle of existence, is implied in the tall miter on the left. Harihara embodies the equilibrium between these two irreconcilable forces that is necessary for cosmic balance.

Some Harihara images are distinguished by garments and attributes, but this one is identifiable only from its head details. The almond-shaped eyes, delicately traced brows, and subtly molded lips and nose have the particularity of portraiture, an individualized treatment that may represent the royal patron who commissioned the sculpture.

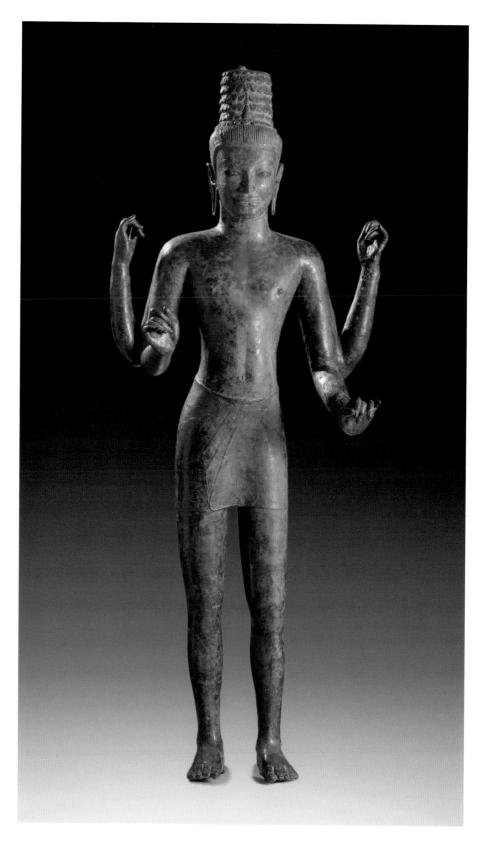

The Bodhisattva Maitreya

Prakhon Chai, Buriram province, Thailand; Pre-Angkor period, late 8th century AD Bronze; $48^{1/4} \times 20^{1}/_{16} \times 12^{3}/_{8}$ in. $(122.5 \times 51 \times 31.5 \text{ cm})$

Acquired in 1965

The earliest Buddhist images in Southeast Asia were probably brought from India, but by AD 600, regional characteristics had developed that clearly distinguish Southeast Asian sculptures from their Indian models. Among the most distinguished pre-Angkor bronzes are those unearthed in 1964 in Prakhon Chai, in northeastern Thailand. This Maitreya, one of the largest bronzes found in the horde, is remarkable for its naturalistic representation of musculature, slenderness of torso and limbs, and iconic spirituality of facial expression—features that characterize pre-Angkor sculpture at its finest.

Maitreya is unique in the Buddhist pantheon, being simultaneously a Buddha and a bodhisattva, a being who postpones nirvana to help others. He is the Buddha of the Future, who will inaugurate the new Buddhist era after the era introduced by the historical Buddha (Shakyamuni) ends. The identity of the Kimbell sculpture as Maitreya is established by the stupa—a venerated structure housing Buddhist relics—in his coiffure, which may symbolize his role as the guardian of the future. The four arms indicate his divinity and represent a multiplicity of powers. Very different from the typical Indian bodhisattva images, which are dressed in skirts, flowing scarves, and abundant jewelry, this figure has a slender, bare body, clothed only in a short garment covering the loins, in a manner more characteristic of Cambodian art. The scanty clothing, lack of jewelry, and unkempt hair indicate that this sculpture represents a bodhisattva-ascetic, one who practices austerities in order to attain spiritual enlightenment.

Buddha Enthroned

Chaiyaphun province, Thailand; Angkor period, c. 1180–1220 Bronze; $69\frac{3}{16} \times 25\frac{7}{8} \times 16\frac{1}{4}$ in. (175.7 x 65.7 x 41.3 cm)

Acquired in 1966

The identification of Buddhist monarchs with overt symbols of worldly wealth and power was characteristic of the reign of the Angkor king Jayavarman VII (1181–c. 1218), when the Khmer empire reached its greatest extent, centered on the city of Angkor Thom. Although Buddhism rejects worldly possessions, the association of Cambodian kings with gods was frequently expressed in sculpture decorated with royal regalia. By presenting the Buddha as possessing material wealth and power, Jayavarman VII may have sought to identify himself with divine authority.

Instead of being represented as a monk meditating on a lotus pad, the Buddha is here depicted on an elaborate throne. The intricate superstructure, whose steepness and lavish decoration are specifically Thai, is surmounted by a flame pattern and invokes the mountain-shaped pediments of Khmer temples with entwined foliate motifs and nagas, the serpent symbols of the power of the underworld: water and fertility. The Buddha is adorned with an elaborate diadem, ear pendants, and jeweled necklaces, bracelets, and anklets. His gaze, instead of expressing humility and spirituality, exudes an imperious self-confidence. His right hand reaches down with extended fingers to make the earth-touching gesture (mudra) known as Maravijaya, meaning "victory over Mara." In this mode, the most frequently encountered gesture in Thai sculpture, the Buddha is calling on the earth to witness his victory over the evil power of Mara, who tried to distract him from the meditation that would lead to his enlightenment. This sculpture perfectly integrates the iconic potency of the Angkor style with the joyful inventiveness of Thai decoration.

Storage Jar

Yangshao culture, Banshan phase; Gansu province, China; Neolithic period, c. 2500 BC

Low-fired earthenware painted with iron oxide and manganese pigments; h. 14 in. (35.6 cm); diam. 14 ³/₄ in. (37.5 cm)

Acquired in 1987, Gift of Mr. and Mrs. Roger Horchow

Storage Jar

Yangshao culture, Machang phase; Gansu province, China; Neolithic period, c. 2200 BC Low-fired earthenware painted with iron oxide and manganese pigments; h. 15 in. (38.1 cm); diam. 16 in. (40.7 cm)

Acquired in 1985

One of three principal Neolithic cultures of China, the Yangshao (c. 5000–1500 BC) extended across the central plain of north China. Yangshao culture is identified primarily by buff or reddish clay pottery vibrantly painted with black and crimson patterns of parallel, curving, or cross-hatched lines and is divided into several chronological and regional phases. The Banshan (c. 2600–2300 BC) and Machang (c. 2300–2000 BC) phases, to which the Kimbell vessels belong, were centered in Gansu and Qinghai provinces, in the west.

Painted pottery was commonly included as part of Neolithic tomb furnishings. These jars, hand coiled and

burnished on a slow-turning wheel before being painted with a free hand in imaginative geometric designs, probably held food or liquids buried with the dead. The bold, abstract decoration, dominated by round medallions, checkerboards, crosshatching, and concentric bands, together with the swelling forms of the vessels, illustrates the creativity that has made early Chinese pottery so appealing to modern sensibilities. Predating the development of bronze technology, they are testament to the remarkable skill in firing and decorating ceramics in Neolithic China and were fundamental to the extraordinary development in Chinese ceramic art that followed.

Nao Bell

Possibly Hunan province, China; Western Zhou dynasty, c. 10th century BC Bronze; $19 \times 13\frac{1}{2} \times 10$ in. (48.3 \times 34.3 \times 25.4 cm)

Acquired in 1995

During their manufacture in the second and first millennia BC, ritual chime bells embodied some of the highest technical skills of Chinese civilization and bore a political and intellectual significance hardly suggested by their function as musical instruments. The *nao* bell represents the earliest form of chime bell from any culture. It has no clapper, but produced a single tone upon being struck on the outside with a T-shaped wooden mallet after being mounted on a wooden stand with its mouth pointing upwards.

This *nao* is an exceptionally fine example of the southern type produced in Hunan province in the early Western Zhou dynasty (c. 1046–771 BC). While northern *nao* bells were produced in sets of three and formed part of a ritual orchestra, southern *nao* bells are all single specimens and never form part of a chimed set. They are also much larger, heavier, and more elaborately decorated, and may have functioned more like Buddhist temple bells or later European church bells than orchestral instruments.

This *nao* bell is ornamented on each side with eighteen conical studs arranged in three rows, separated by bands of scrolling thunder-pattern (*leiven*) decoration, and

surrounded by borders of fine thread-relief. The flat underside is embellished with deeply cast scrolling volutes. The tubular shank bears a raised collar decorated with two highly stylized animal masks (*taotie*), constituted by large, rounded "eyes" amid a scroll pattern.

Jar with Stamped Decoration

Probably Jiangxi province, China; Eastern Zhou dynasty, 7th–4th century BC High-fired earthenware; h. 10 % in. (26.4 cm); diam. 15 ¾ in. (40 cm)

Acquired in 1996

The ceramics of the early first millennium BC from Jiangxi province in central China are characterized by stamped or impressed geometric designs on high-fired earthenwares, predominantly on vessels of simple forms with high shoulders, short necks, and broad mouths. This jar has an unusually wide, buoyant form and is decorated with three bands of delicately stamped designs: a wave pattern of fine, closely spaced lines around the mouth; a "waffle" pattern where double parallel lines crisscross to form multiple squares on the shoulder; and hatched squares aligned diagonally on the body. On opposite sides of the shoulders are two pairs of applied handles: one set of rings (one lost)

attached by lugs, and one pair of horizontal twisted cords.

Despite the freedom with which the pot was thrown and decorated, there is considerable refinement in its simplicity of shape and crispness of design. During the Eastern Zhou dynasty (771–256 BC), one extreme within the ceramic tradition was distinguished by its magnificent imitations of the ornate bronzes of the period. This jar represents the other extreme—simple, elegant, "true" ceramic forms decorated with integrated surface designs based largely on contemporary fabric and textile patterns. Its comparatively large size and varied decorative patterns indicate that it may have been used for ritual as well as utilitarian purposes.

Jar with Ribbed Decoration

Probably Zhejiang province, China; Warring States period, 4th century BC Stoneware with yellowish green glaze; h. 95% in. (24.5 cm); diam. 141/4 (36.2 cm)

Acquired in 1995

From the end of the Warring States period (c. 475–221 BC) through the Han dynasty (206 BC–AD 220), glazed stoneware vessels were routinely produced in northern Zhejiang and southern Jiangsu provinces to serve as funerary storage jars. These vessels, many of which derive their shapes from bronze *guan* (ritual jar) or *hu* (ritual wine vessel) prototypes, are typically decorated in an overall stamped pattern or with a combination of incised lines and raised bands or ribs. Their glaze, restricted to the upper surfaces, was probably produced by sifting dry woodash, or a mixture of dry clay and ash, over

the damp pots before firing. These protoporcelaneous wares are the predecessors of the finer kaolin-clay, high-fire wares developed toward the end of the Tang dynasty (AD 618–907).

The shape of this jar, as well as its lug handles, imitates bronze *jian* vessels (ritual water vessels), but in the process of simulation, the potter has adapted the form and decoration to this older and more venerable art form. The smooth, regular profile is evidence of being worked on a potter's wheel. It was probably placed in a tomb burial and would have contained foodstuffs for the deceased.

Horse and Rider

Probably Shaanxi province, China; Western Han dynasty, 2nd–1st century BC Earthenware with painted polychrome decoration; $22\% \times 21\% \times 6\%$ in. (57.5 x 54.6 x 16.8 cm)

Acquired in 1994

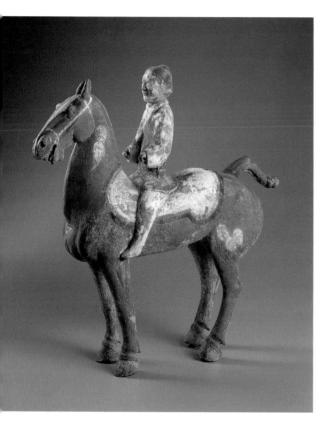

Tombs of the Han dynasty (206 BC–AD 220) were typically furnished with model figures and other objects believed to be necessary for a safe journey to the afterlife. Records indicate that when important military officials died, the imperial Han court would give them elaborate funerals, including a full military cortege. This figure of a horse and rider was likely part

of a model funerary retinue comprised of soldiers and cavalrymen that would have been placed in such a tomb. It is closely related stylistically to a group of military figures excavated in a Western Han tomb in Yangjiawan village, Shaanxi province.

To meet the increased demand for burial goods during the Han dynasty, these figures were produced in great numbers. Despite their standardized types and simple sculptural techniques, however, the Kimbell group displays great vitality of form and considerable descriptive and expressive power.

As with much Western Han sculpture, the artist has here focused attention on the figures' heads. That of the horse is boldly sculpted and precisely rendered, suggesting the physical attributes of the Samanthian breed from Xinjiang province in Central Asia, prized by the Chinese for its superior strength and speed. The rider's face is characteristic of the period, with simple, yet naturally modeled, features. In both figures, the strong contours help to define a sense of volume, enhanced by the addition of colorful pigments, which delineate the rider's costume and the horse's saddle and harness. Despite their relatively modest size, the pair possess a monumental quality normally associated with more massive Han stone sculptures.

Cocoon-Shaped Jar with Cloud-Scroll Design

Possibly Luoyang, Henan province, China; Western Han dynasty, late 2nd or early 1st century BC Earthenware with painted polychrome decoration; $11^{1/2} \times 13^{1/8} \times 9^{1/4}$ in. (29.2 \times 33.3 \times 23.5 cm)

Acquired in 1995

This handsome jar, dating from the Western Han dynasty, would have served as a mortuary object (*mingqi*), placed in a tomb as a substitute for the more valuable bronze and lacquer vessels used in daily life. Along with other funerary earthenware objects, attendant figures, and animals, richly decorated vessels of this kind were intended to serve the spirit of the deceased in the afterlife.

The silk industry was a principal source of wealth for the Chinese economy during the Han dynasty. The distinctive, plump, ovoid form of this jar imitates the silkworm's cocoon, a shape that appears to have been produced only from the end of the Zhou dynasty (c. 1100–221

BC) through the Western Han period. In these later examples, the surface of the jar was either burnished before firing to a glossy black or painted after firing with designs in white, green, red, and lavender. On this painted example, the drifting cloud-scroll (yunwen) motif, which flanks a central vertical panel of diamond-shaped lozenges, is evocative of the celestial realms of a Taoist immortal paradise. During the reign of the Han emperor Wudi (140-87 BC), fascination with the idea of the celestial journey and the Taoist search for immortality reached a climax and gave tangible definition to the ethereal decoration of painted earthenware vessels like this.

Standing Dog

China; Eastern Han dynasty, c. 1st century AD Earthenware with lead-fluxed glaze; $12\frac{1}{4} \times 13\frac{1}{2} \times 5\frac{1}{2}$ in. (31.1 x 34.3 x 14 cm)

Acquired in 1995

During the Eastern Han dynasty (AD 25–220), sculptors produced images of various dog types—among them mastiffs and chows—to be included with the human and other animal figures placed in tombs. Dogs were generally fashioned standing

on all fours or in recumbent attitudes. Chow dogs are usually shown in harness, sometimes with a bell hanging from the collar, reflecting their use for pulling small sleighs. This animated figure of a chow was made from red earthenware covered in a dark green glaze. The dog's sturdy, compact body stands firmly planted, his head slightly raised in an alert expression with snarling mouth, cocked ears, and tightly curled tail—a fine illustration of the Han artist's ability to embody the spirit of the animal in sculpted form.

The technique of glazing pottery was brought to new levels of sophistication during the Western Han dynasty. The earthenware surface was covered with a lead-fluxed glaze, containing copper or iron as a colorant, and fired to earthenware temperatures (600-800 degrees Celsius) in an oxidizing kiln. Copper green and iron yellow/brown make up the normal palette of Han glazed pottery, which provided the foundation for the development of the three-color (sancai) glazes of the Tang dynasty (AD 618-907). Most Han dogs are covered with a green glaze; however, there are also reddish brown examples, the result of a high content of iron in the lead.

Mirror with Animals and Figure

China; Eastern Han dynasty, c. AD 100 Cast bronze: diam, 6½ in, (16.5 cm)

Acquired in 1984

Produced in ancient China from at least the Shang dynasty (c. 1600–1100 BC), mirrors served both as functional articles and as powerful sacred objects. By the fourth century BC, the custom had developed of placing mirrors in tombs. The Chinese believed that mirrors had the ability not only to reflect the truth, and thus ward off evil demons who could not bear to look upon themselves, but also to radiate light, illuminating the tomb for eternity. Often multiple mirrors were placed in the tomb, not with the other funerary objects, but close to the body of the deceased.

In characteristic Chinese fashion, both the geometric motifs and naturalistic forms used to decorate this mirror have symbolic meaning. The four prominent, raised bosses

that divide the field into quarters refer to the four cardinal directions and quadrants of the universe. Seven real and fantastic animals follow each other around the band. As is typical in such contexts, the group includes three of the traditional "spirit animals" of the four directions: the Green Dragon of the East, the White Tiger of the West, and the Red Bird of the South. The Black Tortoise of the North is here replaced by a pair of rodent-like quadrupeds. The two remaining animals cannot be identified. The eighth figure is a creeping human with fringes on his arms and legs, possibly one of the Taoist immortal "feathered men." Tiny bosses scattered seemingly at random over the surface represent stars grouped as constellations.

Jar in the Shape of a Stupa

Shaanxi, Shandong, or Henan province, China; Northern Qi period or Sui dynasty, late 6th or early 7th century AD Earthenware with traces of painted polychrome pigment; h. 19 1/4 in. (48.9 cm); diam. 10 7/8 in. (27.6 cm)

Acquired in 1994

This unusual pottery jar illustrates the early assimilation of Buddhist motifs into the decoration of Chinese mortuary objects. The swelling, ovoid body resembles the shape of a stupa (in China, a pagoda), a traditional Indian structure that houses relics of the Buddha and marks

the site of a sanctuary. The shoulder of the vase is decorated with bands of lotus roundels above monster masks, both in relief. The cover, which imitates the top of the stupa, consists of a series of simplified "umbrellas" crowned by a jewel and a band of relief monster masks. The body is supported by a separate flared stand that echoes the design of lotus roundels. Traces of the original white, red, and black pigment decoration are evident on the jar's surface.

With the introduction of Buddhism into China in the third century AD, the lotus became a pervasive motif in secular as well as religious art, symbolizing both the Buddha himself and Buddhist purity. The lotus roundels on this piece are based on pedestals found in early Chinese Buddhist sculpture. The fantastic monster masks may have been borrowed from the Gorgon mask of Greek mythology. In Chinese Buddhist iconography these masks assume the role of guardians of the Buddhist law. Here they may have served to expel evil influences from the grave, as this jar would have been among the objects included in a Chinese tomb of the late sixth or early seventh century. In this capacity, it may also have functioned as a container for some relic or sacred token belonging to the deceased.

Amphora-Shaped Vase

Probably Hebei province, China; Tang dynasty, 7th or 8th century AD White stoneware with transparent glaze; $14\% \times 7\%$ in, $(37.8 \times 19.4 \text{ cm})$

Acquired in 1969

The first high-fired stonewares with a white body and a transparent glaze were made in Hebei province at the end of the sixth century. Around the same, the first three-color (*sancai*) glazes appear. The three colors that made up the *sancai* palette were amber, green, and cream, the latter composed of a transparent glaze over a white slip. Throughout the Tang dynasty (AD 618–907) these colors were used both individually and in various combinations.

At this time, foreign goods and ideas were making their way along the silk route to the capital at Chang'an (modern-day Xi'an), impacting cosmopolitan Tang society and art. The influence of Central Asian, Hellenistic, and Persian models can be seen in the shapes and designs of many Tang vessels. This amphora-shaped vase, typical of the Tang period, was modeled after Hellenistic Greek prototypes. It has been translated into a Chinese idiom through the substitution of double-stranded loop handles-ending in dragon's heads biting the rim—for the ordinary loop variety, and through the use of a singlecolor glaze. The finely crackled, barely tinted glaze falls in a graceful swag that separates the glossy upper body from the unglazed portion below.

Court Lady

Probably Shaanxi province, China; Tang dynasty, first half of the 8th century AD Gray earthenware with painted polychrome decoration; $16^5/_{16} \times 7^1/_{16} \times 6^3/_{16}$ in. (41.5 x 18 x 16.2 cm)

Acquired in 2001

The Tang dynasty (618–907 AD) practice of sumptuous burials has left a rich legacy of Tang funerary sculpture. One of the most engaging and distinctive groups of such

figures are representations of court ladies. This animated and charming example stands in a gracefully swayed pose, her petite hands held in a conversational gesture in front of her swelling form. She wears a long scarf draped over her shoulder and a white, long-sleeved jacket tucked into a full-length red robe, which is belted above her bosom and falls in looping folds to her feet, leaving her upturned, ruyi-shaped, triple-cloud shoes visible. Her hairstyle, known as a gaoji (upswept topknot), is stiffly lacquered and folded, with a clump of hair bound into a fan shape in the front, all held in place by two crescent-shaped combs. Her plump, heavily made-up cheeks are offset by exquisitely delicate eyes, nose, and slightly parted lips, reflecting the contemporary ideal of voluptuous beauty.

The Tang sculptors' careful attention to details of fashion and physiognomy allows us to trace in their works the changing fashions of ladies at court. In the early eighth century, a new aesthetic favored a fuller and more rotund physique and loose, billowing robes. This new trend was probably set by Yang Guifei, the imperial consort of the emperor Xuanzong (reigned AD 712–56). Dressed in elegant clothes with their hair arranged in elaborate coiffures and their faces beautified with cosmetics, these figures of aristocratic Tang women possess a singular grace and charm.

Earth Spirit

Probably Shaanxi province, China; Tang dynasty, first half of the 8th century AD Gray earthenware with painted polychrome decoration; 31½ x 7½ x 11½ in, (79.1 x 19.2 x 28.5 cm)

Acquired in 2001

The inclusion of fantastic animal guardians among the retinue of Chinese tomb figures began in the Northern Wei dynasty (AD 386–534) and continued into the Tang dynasty (AD 618–907). Also called earth spirits, or *zhenmushou* (grave-quelling beasts), these guardians took the form of fantastic hybrid creatures composed of various animal and, in some cases, human elements. They were placed in tombs in pairs to ward off malevolent beings.

Brilliantly painted in pink, red, orange, and black and highlighted with gilding, the Kimbell's fierce figure stands in a rampant posture of conquest as it subdues a snarling beast upon a rockwork base, its left arm entwined with a serpent. The spirit's triple horns, bulging eyes, bareteethed grimace, and sharp claws add to its ferocious appearance. Undulating flames emerge from its head, shoulders, and right leg. A gilded tondo, finely painted with a group of figures (possibly musicians, who may also be foreigners) and set against a luxuriant floral panel, embellishes the creature's chest.

The composite elements of the *Earth Spirit*, such as the large horns, claws, fangs, and tiger stripes, presumably conferred upon it the fearsome qualities of these animals. The guardian is quelling evil in the form of the horned, hoofed beast that he tramples underfoot. The eye on the

side of the beast's belly may represent the "third eye," an indication of the influence of Esoteric Buddhism prevalent during the early Tang period.

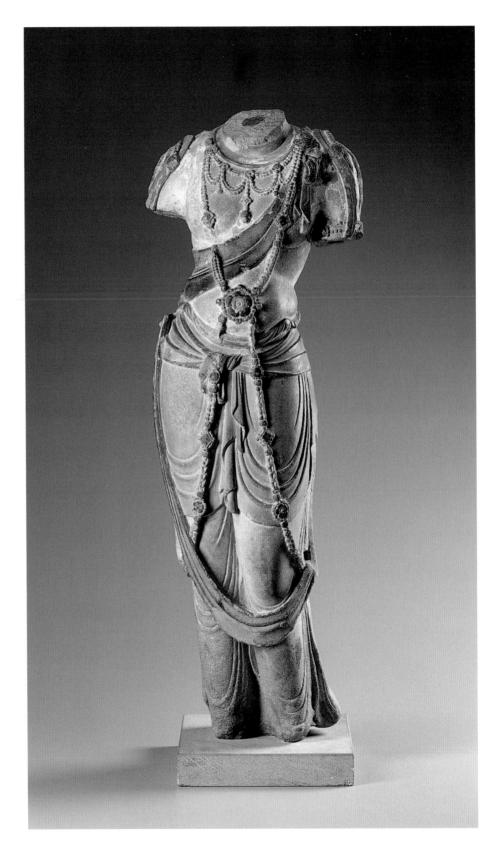

Bodhisattva Torso

Probably Shanxi province, China; Tang dynasty, c. AD 775–800 Stone, traces of gesso and pigment; $39 \times 12^{15/16} \times 8$ in. $(99 \times 32.8 \times 20.3$ cm)

Acquired in 1987

The evolution of Chinese Buddhist sculpture from archaic and columnar to fleshy and sensuous reached its culmination in the Tang dynasty (AD 618-907), by which time Chinese Buddhist sculpture in the round shows a masterful adaptation of foreign Indian style to indigenous traditions. The finest Tang sculptures are voluptuous and tactile, their sumptuous garments carved to accentuate the contours of the body. with flowing scarves and clinging ropes of beads to emphasize its curves. This Tang International style became the model for the transmission of Buddhist sculpture to the rest of East Asia.

This torso, adorned in a simple skirt with a scarf across the chest and a long, elaborate necklace, represents a bodhisattva attendant to the Buddha, a divine being who delays their own final nirvana to help

humankind on the path to enlightenment. The complex decorative treatment of the garments combines with a sense of confident repose to make this one of the most successful creations of Tang sculpture. The pronounced tribhanga pose, with the left knee slightly bent; the fleshy, volumetric treatment of the body; and the thin drapery reflect continuing Indian influence, here of the Gupta period (AD 321-500). The skirt, or dhoti, gathered and loosely tied at the waist, is sculpted into graceful folds and naturalistic curves that reinforce the sense of movement in the body. The necklace, crossed in front and looped around the sides to the back, is crisply carved with individual beads and studded with medallions. The torso is distinguished by its remarkably thick, full body when viewed from the side and by the sharp, precise quality of the carving.

Mirror with Dragons

China; Song dynasty, 11th–13th century Bronze; diam. 9¹/₄ in. (23.5 cm)

Acquired in 1973

Bronze mirrors were essential items in the toilet sets of aristocratic ladies. A significant number of them survive through the East Asian custom of placing such luxury objects in tombs to be used by the dead in the spirit world. The ability of mirrors to reflect images and light led to the belief that they had the power to radiate light for eternity, thus magically illuminating the interior of the tomb. This custom originated in China as early as the fourth century BC and continued into the Song dynasty (960–1279).

On this mirror, two lively dragons

chasing pearls or flaming jewels decorate the primary field around a central lotuspetal medallion. In the East, dragons are connected with water, rain, and thunder, and thus symbolize the spring season and fertility. The significance of the pearl or jewel is not known. The reverse side would have been highly polished, forming an excellent reflecting surface. The boss in the center has a transverse opening for the loop of a braided silk tassel that would have served as the mirror's handle, while the mirror was supported by a lacquered wood stand.

Manjushri on a Lion

China; Southern Song or Jin dynasty, c. 1150–1300 Gilt bronze; $23 \times 15\frac{1}{2}$ in. (58.4 x 39.3 cm)

Acquired in 1987

Of the many deities that played a role in Chinese Buddhism, Manjushri (in Chinese, Wenshu), the bodhisattva of wisdom, is among the most appealing. One of the three most important bodhisattvas in East Asia, Manjushri is said to have originated in China from the mountains associated with Mount Wutai, a famous Buddhist monastic center. He was worshipped in China as the embodiment of knowledge and the guardian of sacred doctrines. Usually presented as a youthful, bejeweled prince, he is often shown seated on the back of a lion, carrying a book of truth and a sword that cuts through the darkness of ignorance. Depictions of Manjushri on a lion were popular from the Tang dynasty (AD 618-907) onward. In this form, he was most frequently paired with the bodhisattva Samantabhadhra, these two figures flanking the historical Buddha Shakyamuni in a triad.

Among the Buddhist sculptures of China, bronze images occupy a very prominent place. Some of the finest religious works, especially during the Song dynasty (960–1279), were executed in this medium. Although paintings of Manjushri dating from the thirteenth to the fifteenth century are still extant, sculptures—particularly gilt-bronzes of this size—are extremely rare. This beautifully proportioned and superbly detailed example

is a very rare complete image of the divinity. Its precise dating remains problematic due to the paucity of related material.

Bowl Carved with Design of Boys among Peonies

Jiangxi province, China; Southern Song dynasty, 12th century Porcelain with pale blue glaze (*qingbai* ware); h. 3 in. (7.6 cm); diam. 7³/₄ in. (19.7 cm)

Acquired in 1995

Among the finest porcelain wares ever produced, *qingbai* (bluish white) constitutes one of the main groups of porcelain manufactured during the Song dynasty (960–1279). It is characterized by a fine, white, pure clay body of sugary structure, surprisingly thin and highly translucent potting, and a glaze that varies from

strong bluish green to pale blue or almost white. Designs were incised, carved, and molded; incised wares were often worked with a thin, pointed tool and a comblike instrument.

The extremely fine *Bowl Carved with Design of Boys among Peonies* bears an almost transparent icy blue glaze. The swirling

Meiping Vase

Jiangxi province, China; Yuan dynasty, first half of the 14th century

Porcelain with pale greenish blue glaze (qingbai ware); $12^{1}/_{2} \times 7^{1}/_{8}$ in. (31.8 x 18.1 cm)

Acquired in 1968

decoration of two bald-headed boys and peony scrolls is incised in fluid forms of great vigor and movement. Designs showing two or three small boys climbing among flowers are very common in *qingbai* wares. The peony symbolizes spring and is an omen of good fortune. The cherubic boys crawling on all fours probably allude to the wish for male progeny. An unusual feature is the Chinese character *zhang* carved in the center of the bowl, which probably denotes the surname of the family workshop that produced the piece.

Qingbai wares of the Yuan dynasty (1279–1368) continue the tradition of Song qingbai wares, although the porcelain body is generally heavier. The term meiping (plum blossom vase) describes a tall vase with a wide shoulder and small mouth. The decoration on this Meiping Vase is arranged in three registers: carved floral scrolls on the shoulder, a carved dragon twisting through combed pattern clouds in the center register, and an upright band of incised, stylized petal motifs on the bottom register.

Vase with Fish and Foliate Scroll Design

China; Yuan dynasty, 14th century Stoneware with brown slip and green glaze (Cizhou ware); $15^3/4 \times 11^{13}/16$ in. (40 x 30 cm)

Acquired in 1970

Cizhou is the designation for a large and varied group of cream-colored stonewares decorated by painting designs under a transparent glaze or by incising, stamping, or carving into a colored slip. First developed in the Song period (960–1279) and named for the kilns in the Cizhou area of Hebei province, they were made throughout north China from the tenth to the fifteenth century. Cizhou wares share a distinctive decoration in which large-scale motifs play on the contrast of light and dark tones. They are somewhat unrefined and were generally made for everyday utilitarian use in middle-class homes.

This vase's bold design of large foliate scrolls and fish was achieved by incising and removing areas of a dark brown slip that had been applied to the whole vase. Initially, the slip was cut away from the lower third of the jar to reveal the cream-colored body of the stoneware. The deeply incised outlines of the floral design and some details, most notably the eyes and the scale pattern of the fish, were then cut through the remaining slip. Finally, the background area of the floral design was scraped away. The result is a striking design that exploits the juxtaposed contrast of light and dark tones and the differing textures of the glossy slip and matte stoneware.

ATTRIBUTED TO TAN ZHIRUI

Chinese, active late 13th to early 14th century

Bamboo and Rocks

c. 1275

Hanging scroll; ink on paper; $39^{1/2} \times 14^{15}/_{16}$ in.

Acquired in 2002

This delicate ink painting of bamboo and rocks is attributed to the Yuan-dynasty painter Tan Zhirui, who originated this classic subject. The elegantly inscribed poem was added by one of his famous contemporaries, the Buddhist priest Yishan Yining (1247–1317).

The technique of applying modulated tones of ink on paper was closely associated with Chan (Zen) painting in both China and Japan. A major stream of this tradition celebrated the simple beauty of the natural world. The symbolism of bamboo and rocks was very ancient in Chinese culture; bamboo was admired for its strength, resilience, and beautiful green color, while rocks symbolized strength, solidity, and endurance. Here, the thrusting framework and smooth texture of the bamboo provide a pleasing contrast to the solid, twisting forms of the rocks.

Metaphorically, this subject also constitutes a commentary on the political climate of the Yuan period, when the Mongols ruled China. The collapse of native Chinese imperial power was a bitter blow to the scholar-official class from which painters and men of letters emerged. Many of them were unwilling to serve their new barbarian rulers and consequently languished in poverty or sought a livelihood in Japan. In the Chinese tradition, bamboo, which may bend with the wind but does not break, was regarded as symbolic of the *junzi* (gentleman) and was a suitable metaphor

for the predicament of loyalist scholars under alien rule. The accompanying poem, describing the tangled bamboo growing among ancient rocks, reinforces the allusion to an uncertain future.

ZHU DERUN

Chinese, 1294-1365

Returning from a Visit

c. mid-14th century Handscroll; ink on paper; 11½ x 46½ in. (28.2 x 119.3 cm)

Acquired in 1972

The Yuan dynasty (1279–1368), during which time the Mongols dominated China, was one of great distress for the Chinese. For the first time in their history, the entire country was under foreign control. With the abolishment of the traditional government careers of the scholar-gentry class, the literati retreated to their homes and supported themselves through painting. The Yuan dynasty thus represents a break in the continuity of Chinese landscape painting.

A time of nostalgic return to the past, it also saw the emergence of new directions in the function of painting, which became not just representational, but a means of self-expression.

Zhu's conservative style of rendering rocks and trees, as seen in this handscroll, is drawn from the early landscape masters of the tenth century. Starting at the right, the composition begins with a thatched house in a clearing among mountains and

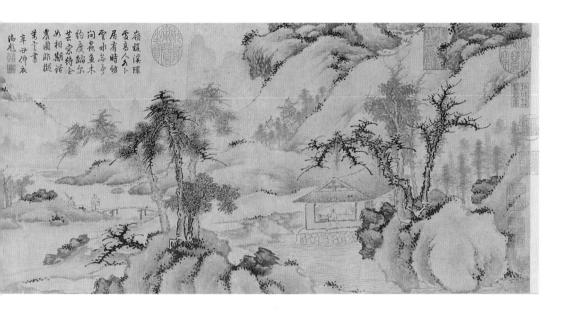

trees; inside a man sits reading, the head of a woman visible through a window. Continuing left, a path leads across a bridge to a village and then to distant mountains, which recede into the mist. A traveler and his servant approach the bridge, returning home. In keeping with the innovative character of Yuan-period works, Zhu has skillfully combined two earlier tenth-century modes of landscape painting. The sharp, spiky depiction of the gnarled trees

follows the manner of Li Cheng and Guo Xi, while the soft, round forms of the rocks spotted with rich, black dots of vegetation are painted in the manner of Dong Yuan and Ju Ran. The theme of the scholar-official returning home to withdraw from the troubles of the world is common in Yuan painting, a reaction to the traumatic mood of the period.

The grandeur of this depiction of lotus blossoms, leaves, and seedpods is eloquent testimony to the considerable position accorded the genre of flower painting in China. Produced for the court, far more flower paintings are recorded in

Pink and White Lotus

China; Yuan dynasty, 14th century
Hanging scroll; mineral pigments on silk;
53\% is x 23\% in. (136 x 60.7 cm)

Acquired in 1984

imperial collections than paintings of any other subject. Practiced since the tenth century, the genre reached its apogee in the late Song and Yuan dynasties. The rare surviving thirteenth-century paintings of lotuses or peonies are vibrant and lifelike; their brilliant decorative qualities foreshadow the finest Yuan works.

This composition depicts the lotus at a moment just past its peak, when the blossoms are fully opened and some petals have begun to fall. The flowers retain their full colors, showing a gentle gradation from deep pink to nearly transparent lighter shades and white. The large, bowl-shaped leaves with lobed and curled edges are turned up to reveal a lighter shade of green on the underside. In Asian art, the lotus is never merely decorative but also has deep religious meaning. In Buddhism, the muddy pond in which the lotus grows represents the mundane world; the beautiful blossoms, which rise high out of the water, represent the purity of salvation and rebirth in a heavenly paradise.

Large-scale compositions of lotus flowers were usually produced in pairs to decorate Buddhist temples or palace halls. This scroll was probably originally part of a pair and, as is typical of lotus paintings of this type, bears neither the signature nor seals of the artist.

Arhat Taming the Dragon

China; Yuan dynasty, early 14th century Hanging scroll; ink and mineral pigments on silk; $48^{1/4} \times 20^{3/4} \text{ in.} (122.5 \times 52.7 \text{ cm})$

Acquired in 1987

Arhats (in Chinese, lohans), as the original disciples of the Buddha, were enlightened beings of exceptional wisdom, endowed with supernatural powers. One of the primary roles of an arhat (which means "worthy one" or "perfected saint") is to serve as guardian and advocate of the Buddhist Law (dharma). In China, certain arhats became the focus of religious devotion, including of a group of sixteen arhats whose worship was set forth in an Indian sutra that was translated into Chinese in the mid-seventh century. By the end of the tenth century, two additional arhats were added, one paired with a tiger and the other with a dragon. The dragon, regarded as a divine animal in China long before the advent of Buddhism, personified potentially fearsome natural phenomena associated with water, thunder, and rain.

In this dramatic composition, a seated arhat—accompanied by a guardian king, a monk, and a child—confronts a dragon as it emerges from a body of water. The figures are rendered in a fine, linear ink technique, their outlines almost obscured by the colors applied to the garments. The landscape setting is painted with bolder, more expressive brushwork. The turbulent water, fluttering robes, and wide-eyed expressions of the figures imbue the scene with considerable movement and tension. The arhat, depicted with an intense and

slightly malevolent expression, appears to be subduing the dragon with his gaze, drawing the beast into his magic alms bowl, which sits on a rock between them. The dragon's act of submission to the arhat glorifies the supernatural power of the Buddhist saint.

Seated Arhat

Shanxi province, China; late Yuan to early Ming dynasty, c. 1300-1450 Cast iron, traces of pigment; $30^{11}/16 \times 19^{19} \times 16$ in, $(78 \times 50.5 \times 40.7 \text{ cm})$

Acquired in 1984

This engaging portrait represents an arhat (in Chinese, lohan), one of a group of enlightened beings with superhuman capabilities who were the original disciples of the Buddha. Like bodhisattvas, arhats have attained perfection but have delayed entering nirvana and becoming buddhas so that they may aid others in seeking enlightenment. Usually appearing in groups of four, sixteen, eighteen, or even as many as a thousand, arhats were depicted as monks and ascetics, sometimes with exaggerated features such as long eyebrows or domed heads, and some were associated with particular attributes. Although lists identifying each arhat exist, the descriptions are generally vague, and the precise identification of individual figures remains difficult.

The realism and humanity of the Kimbell arhat's face contrast with the simplified but rhythmical form of the body to produce a portrait of great character and presence. An inscription on the back of the statue names the donors who commissioned the work and gives the name of the temple, Yuhua, in Shanxi province, to which it was donated and where it may have been installed as part of a larger group of arhat portraits.

Bowl with Secret Decoration

Jingdezhen, Jiangxi province, China; Ming dynasty, early 15th century Porcelain with transparent glaze (white ware); $4 \times 8^{1/4}$ in. (10.1 x 21 cm)

Acquired in 1971

During the Ming dynasty (1368-1644), an inward-looking period in Chinese history, the styles in much artistic production were set by the emperors. In the early Ming, the establishment of kilns that produced porcelains exclusively for the imperial court made Jingdezhen, in Jiangxi province, the most important ceramic center in China, and the manufacture of porcelain reached its peak. One of the great achievements of the Jingdezhen kilns was a glaze called "sweet white" (tianbai), which was favored by the Yongle emperor (reigned 1403-24) for ceremonial use at court. The best of these wares have a fine-grained, pure white body and a glaze that is transparent and glossy, without any tinge of color. The vessels'

walls were so thin that they were often called "bodiless."

Many monochrome white porcelains of the early fifteenth century repeat the shapes of contemporary blue-and-white vessels and copy the blue designs in incision or low relief. A particularly popular device was to execute the ornament as *anhua* (secret decoration), which was so delicately incised that it is scarcely visible unless held up to the light. This lotus-shaped bowl is incised with such decoration in an interior pattern of radiating petals and wave border in molded slip and an exterior design of incised scrolling floral vine and key fret border.

Flat-Sided Flask

Jingdezhen, Jiangxi province, China; Ming dynasty, early 15th century

Porcelain with cobalt-oxide pigment under transparent glaze; $13\frac{1}{8} \times 7\frac{11}{16} \times 5\frac{1}{4}$ in. (33.3 x 19.5 x 13.3 cm)

Acquired in 1968

Lotus Bowl

Jingdezhen, Jiangxi province, China; Ming dynasty, Xuande period and reign mark, 1426–35 Porcelain with cobalt-oxide pigment under transparent glaze; h. 43/16 (10.6 cm); diam. 83/16 in. (20.8 cm)

Acquired in 1970

Jiangxi province, during the Yongle era (1403–24) of the early Ming dynasty. These wares launched a new chapter in the history of Chinese ceramic art.

The Kimbell's three elegant vessels exemplify the technical and decorative excellence of the finest Ming blue-and-white wares. The particular form of the *Flat-Sided Flask*, with its angled, tubular neck and loop handles, is thought to have been based on Islamic metal prototypes. Its decoration features a medallion of radiating cloud-collar points filled with an abstract woven pattern; at its center is a flower blossom in a depression. Geometric and floral scrolls in concentric bands around the sides of the vessel further emphasize the round shape. The density of the design is characteristic of early-fifteenth-century porcelains.

The precise, fluid decoration of the large *Dish with Melon Design* is orderly and spacious. The flat rim is decorated with

Although the application of blue cobalt-oxide pigment to porcelain wares likely began in the Yuan dynasty (1279–1368), the large-scale production of such blue-and-white wares started with the establishment of the imperial kilns at Jingdezhen, in

Dish with Melon Design

Jingdezhen, Jiangxi province, China; Ming dynasty, early 15th century

Porcelain with cobalt-oxide pigment under transparent glaze; h. 3½ in. (7.7 cm); diam. 17½ in. (43.4 cm)

Acquired in 1970

a pattern of rolling and cresting waves, the cavetto is filled with a scrolling floral vine, and the center medallion contains an unusual and exceptionally well-painted design of melons, leaves, and twisting tendrils. The mastery of the artist is particularly evident in the modeling of the fruit and leaves, in which unpainted areas of white are skillfully transformed into highlights.

The Lotus Bowl represents a popular

type of the Yongle and Xuande (1426–35) periods that seems to imitate the shape of the lotus flower's seedpod. While the borders and flowers vary, in general the decoration of these bowls is remarkably consistent, suggesting that they were massproduced. The interior of this bowl is decorated with a combination of scrolling flowers and a wave border, and the exterior with stylized lotus petals and a key fret border.

Round Dish with Pommel Scrolls

China; Ming dynasty, 15th–16th century

Carved black lacquer with red layers (tixi); diam. 13% in. (35.2 cm)

Acquired in 1993

Since at least the Shang dynasty (c. 1600–1050 BC), the Chinese employed lacquer in artistic as well as industrial capacities. Impervious to liquids, acid, and, to a certain extent, heat, lacquer made an excellent protective coating for wood, leather, and textiles. Its artistic properties were also exploited: combined with pigments, it was used as a painting medium; it could be inlaid with precious

materials or engraved with gold; and, built up to a certain thickness, it could be carved. Considered a luxury item, lacquerware with elaborate decoration was reserved for the elite classes and the court.

Carved, "marbled" lacquer (tixi). unique to China, was made from at least the Song dynasty (960-1279) onwards. In this labor-intensive technique, several layers of thin lacquer in varying colors are applied to a wood substratum, each layer being left to harden before the next is added. Once this coating has built up to a considerable thickness, grooves are cut into the lacquer, revealing a series of colored bands. This large, deeply carved dish has seven alternating bands of black and red lacquer. The interior of the dish is carved with a design of three concentric rows of pommel scrolls (jianhuan) encircling a quatrefoil floret, a decorative scheme commonly employed on tixi lacquers. The pommelscroll motif derives both its name and shape from the ring-pommel of early Chinese swords. The exterior is carved with a classic or "fragrant grass" scroll (xiangcao), and the dish stands on a sturdy foot-ring. The black-lacquer surface layer has been highly polished to a lustrous shine, enhancing the overall decorative effect.

YIN HONG

Chinese, active 1460s-1520s

Birds and Flowers of Early Spring

c. 1500

Hanging scroll; ink and mineral pigments on silk; $66\%6 \times 40\%6$ in. (168.7×102.7 cm)

Acquired in 1982

Colorful flower-and-bird paintings were created by court painters during the Ming dynasty (1368-1644) to decorate the grand halls of imperial palaces, where they could also serve as metaphors for the emperor and his court. Yin Hong, a third-generation court painter, was recognized for his skill at depicting "feathers and fur." This painting evokes the passage from winter to spring with a combination of camellias and blossoming plum. It was probably part of a monumental suite of seasonal paintings and is one of only four of Yin Hong's works to have survived. Unlike earlier, more naturalistic flower-and-bird compositions, the rocks, water, trees, blossoms, and birds are treated here as stylized formal elements in a grand design. Dark washes of ink and vigorous strokes form interlocking planes of strong, flat forms. The jutting boulders and the twisted bough of plum retain subtle gradations of tone that give volume to these shapes. Rich green leaves and red-andwhite blossoms animate the diagonals with touches of brilliant color. The birds—little bulbuls and the red-breasted minivet (on the branch), partridges (on the ground), and brown-eared pheasants (on the rock cliff)—contribute to the patterned effect and tactile richness of the surface. Beyond its decorative qualities, the painting is also an

allusion to imperial allegiance: the pheasants are symbolic of bravery and steadfastness, while the partridges represent the faithful followers of the emperor.

WANG ZHAO

Chinese, active 1500-1525

The Three Stars of Happiness, Wealth, and Longevity

c. 1500

Hanging scroll; ink and light colors on silk; $62\frac{1}{2}$ x $37\frac{1}{2}$ in. (158.7 x 95.2 cm)

Acquired in 1985

This bold and lively painting by Wang Zhao, an eccentric yet skilled artist, depicts a trio of Taoist deities known as the Three Stars of Happiness, Wealth, and Longevity, who are charged with caring for the well being of individuals. In popular legend, each god is derived from a historical person, and although grouped as a trio here, each is worshipped separately. The vigorous brushwork, notable in the strong outlines of the figures and in the trunk of the pine tree, is typical of the expressionistic style favored by Chan (Zen) priest-painters and was particularly suited to Taoist divinities and themes.

The center figure, The Star of Happiness (Fuxing), wears the robes of a bureaucrat and is generally associated with a sixth-century civil official who persuaded his emperor to release the dwarfs taken forcibly from his hometown to serve as entertainers at court. The Star of Wealth (Luxing), on the left, is personified by Shi Fen, a Chinese peasant who became a general and allied himself with the founder of the Han dynasty (206 BC-AD 220). As a reward for his conquests he received both honors and great wealth. The Star of Longevity (Shouxing) is a deity who fixes the time of death for each individual. His presence as a star was a sign of peace; his disappearance, a sign of war. Shouxing stands on the right and holds the peach of immortality in his hands.

Chinese, 1496-1576

The Canying Hall

1572

Hanging scroll; ink and light colors on paper; $54\frac{3}{4} \times 27\frac{1}{2}$ in. (139 x 69.9 cm)

Acquired in 1981

During the Ming dynasty (1368–1644), the wealthy city of Suzhou became the center for a group of painters known as the Wu school. These artists represent the literati tradition, which stressed self-expression in the intimately connected arts of poetry, painting, and calligraphy. The literati were scholar-amateurs who primarily painted for pleasure and to communicate with other artists. Lu Zhi exemplifies the Chinese ideal of the literati artist: he received a classical education but shunned official office and lived by exchanging his works for goods and services. Known for his landscapes and depictions of flowers, and also as a superb colorist, Lu Zhi was distinguished for an eclectic style that combined the literati and professional traditions.

This large landscape, with an inscription and two of the artist's seals, is thought to depict Lu Zhi's own villa. The subject is a traditional literati theme of a scholar playing the *qin* (Chinese lute) for his guest within a walled enclosure; nearby, a servant tends chrysanthemums. The composition is uncluttered and compartmentalized, reflecting a mode of landscape painting cultivated among Suzhou artists. The angular strokes that cross and interweave give the rocks multifaceted surfaces. The charming naiveté that pervades the picture suggests a departure from reality that is consistent with Lu Zhi's reputation as a man with little interest in government

position. The painting's impression of otherworldliness seems a comment on the character of the artist and his desire to disengage himself from worldly affairs.

WEN JIA

Chinese, 1501-1583

Landscape in the Style of Dong Yuan

157

Hanging scroll; ink and light colors on paper; $65\frac{3}{4} \times 20\frac{1}{2}$ in. $(167 \times 52$ cm)

Acquired in 1980

Wen Jia, son of the Wu school literati artist Wen Zhengming (1470–1559), was a recognized poet, critic, and connoisseur of painting and a model Confucian. His paintings, the earliest of which were done when he was in his late fifties, are characterized by meticulous brushwork, cool coloring, and a conservative temperament.

This scroll is one of Wen Jia's largest extant paintings and depicts a tall, narrow landscape crowded with wooded mountains, winding paths, torrents, and leafy trees executed in ink and pale colors. Two travelers on horseback cross a bridge to an inn, above which towers a mountain mass partially concealed by clouds. The rocks at upper left have no geological relationship to the mountain and appear to float above the mist.

The painting illustrates the interest of Wu school artists in the work of earlier masters: Wen Jia's inscription states that the composition was inspired by a specific painting by the tenth-century master Dong Yuan. The bold, rocky mass that curves up the center of the painting is reminiscent of the mountains in many Northern Song (960–1127) landscapes. The use of dots for foliage, and of long hemp-fiber strokes to give texture to the rocks, recalls the technique of the founder of the Wu school, Shen Zhou (1427–1509).

DONG QICHANG

Chinese, 1555-1636

Steep Mountains and Silent Waters

1632

Hanging scroll; ink on paper; $40^{3}/8 \times 11^{15}/16$ in. (102.5 x 30.3 cm)

Acquired in 1980

Dong Oichang, one of the most celebrated figures in the history of Chinese art, is renowned for his painting, calligraphy, and theoretical writings on painting. Born into a poor family in Shanghai, he acquired an education and enjoyed a highly successful career as a government official. His major contribution was to the study of Chinese painting, but he was also an innovative artist who used the elements of traditional landscape painting—line, contour, shading, and spatial relationships—as an abstract, formal vocabulary with which to create a variety of new modes of landscape. In this way, Dong single-handedly infused new life into Chinese painting at a time when the Ming dynasty (1368-1644) schools were in decline.

This scroll is Dong's last dated work. The lengthy inscription by the artist states that it was painted for Minister He Xianggang, with whom Dong shared an office and who endorsed his retirement. The painting's composition and its idiosyncratic stylistic features are characteristic of Dong's mature, highly intellectual style, notably the sharp precipices, bare angular patches, and unexpected spatial juxtapositions of the dry mountain peaks. The form of the mountain that winds vertically up the center of the painting, and the long thin strokes used to define its surface, are recurrent elements in his landscapes. The treatment of the trees and foreground rocks is brittle and drier than in earlier paintings and may be regarded as evidence of Dong's advanced age.

GONG XIAN

Chinese, 1618-1689

Landscape

c. 1650 Hanging scroll; ink on silk; $79 \times 17^3/_{16}$ in. (200.7 \times 43.7 cm) Acquired in 1985

The greatest individualist painter of the Qing dynasty (1644–1911), Gong Xian was a well-educated, accomplished poet and calligrapher but lived essentially as an impoverished recluse. He never attained an official degree, and his association with an intellectual underground opposed to the ruling Manchu government may have cost him a civil post. His lingering loyalty to the vanquished Ming dynasty (1368–1644) contributed to a feeling of displacement and uselessness that would influence his work throughout his career.

Gong is best known for his dark, brooding landscapes painted in strongly contrasting tones with blunt, angular brushstrokes. This painting, with an inscription and two seals, is a rare example of a so-called "white" Gong Xian. The light tonality and linear, spare, ascetic style are characteristic of painting in the Anhui region, where Gong was working at the time, as are the dry brush used to simulate the rough landscape elements, the system of overlapping rocks to suggest bulk, and the minimal use of texture strokes to describe the craggy rocks and gangly trees.

Unlike his contemporaries, Gong sought originality in imagery rather than in brushwork. As a result, most of his works represent a fantastic landscape, or "inner landscape," that describes his state of mind—as here perhaps in the desolation of the empty pavilion in a sparse, uninhabited landscape.

CHEN IIAYEN

Chinese, 1599-c. 1685

Bamboo, Rock, and Narcissus

1652

Hanging scroll; ink on paper; $31\frac{1}{2} \times 17\frac{1}{8}$ in. (80 x 43.5 cm)

Acquired in 1984

This painting of wild narcissi and short sprigs of young bamboo growing at the base of a rock is a masterwork of Chen Jiayen, a relatively obscure painter from Jiangsu province. Forcefully executed in the expressionistic style of traditional Suzhou literati painting, with quick, bold brushstrokes in soft gradated tones of ink wash, the primary forms of the painting have a remarkable solidity. Darker ink is used to define the short, spiky leaves of bamboo, while the gently curving leaves of the narcissi are left white within a lighter ink outline.

What appears to be an unassuming painting of rocks and flora is, in fact, a thinly veiled expression of the artist's innermost thoughts and emotions. It is the earliest of Chen's paintings to include a poem and the combination of bamboo, rocks, and narcissus. The mood of the poem, written on New Year's Day, 1652, is one of despair and desolation, a reflection of contemporary events. The poem laments the bleak days after the fall of the Ming dynasty (1368–1644) with allusions to a famous eighth-century rebellion, which similarly left the country destroyed, and to a Han-dynasty poetess who mourns her feelings of grief and abandonment. Like most Chinese paintings of plants and flowers, especially those executed in monochromatic ink, this work has a moral significance. Despite

the poem's bleak overtones, Chen has painted bamboo, which bends but will not break, and narcissi, harbingers of spring, to symbolize the strength and self-regeneration needed to give hope to a fallen nation.

Ceremonial Pedestal Stand

Korea; Three Kingdoms period, 5th–6th century AD Gray stoneware; 13 x 15³/₄ in. (33 x 40 cm)

Acquired in 1996

By the fifth century AD, Korean potters were producing high-fired gray stonewares. Characterized by robust forms and unglazed surfaces, most Three Kingdoms period (57 BC–AD 668) pots exhibit little surface ornamentation other than simple combed or incised patterns. The decorative use of

geometric perforations is restricted largely to pedestal stands.

This pedestal stand served as a support for a large round-bottomed bowl or jar used as a container for food or liquid. The stand's impressive size and dramatic shape indicate that it had a ritual or ceremonial function. It was later included in a tomb as part of a funerary offering. Its aesthetic appeal derives from its imposing proportions, solid form, and harmoniously integrated decoration of square apertures and combed patterns. Five horizontal bands both above and below the vessel's thin waist define a widely flaring mouth and similarly flared foot. The bands on the mouth are decorated with combed wavy bands divided by vertical incisions into panels, some bearing incised circles. The high, hollow pedestal foot is punctuated by square perforations cut into the horizontal bands of wavy, combed decoration. It was originally thought that the bases of Korean pots were perforated so that chips of wood could be burned within to warm the vessel's contents, but the lack of soot on the undersides contradicts this hypothesis. It is now believed that the cutouts were most likely added for decorative effect.

Bowl

Korea; Goryeo dynasty, 12th or 13th century Stoneware with dark green and white inlay and celadon glaze; h. 25/16 in. (5.8 cm); diam. 71/4 in. (18.4 cm)

Acquired in 1970

Cosmetic Box

Korea; Goryeo dynasty, 12th or 13th century Stoneware with black and white inlay and celadon glaze; h. 19/16 in. (4 cm); diam. 39/16 in. (9 cm)

Acquired in 1972

One of the most significant Korean contributions to ceramic art was the technique of slip-inlay (sanggam) on celadon wares of the Goryeo dynasty (936–1392). Developed around the mid-twelfth century, the technique quickly became a national specialty. The inlay was produced by first incising or stamping designs into the clay and then filling the depressions with white or black slip before glazing and firing. Slip-inlay decoration was quite sparing at first; later, the designs occupied more and more of the vessel surface.

This shallow bowl demonstrates the variety of decorative effects that can be achieved with slip-inlay technique. The chrysanthemum blossoms on the exterior and in the center of the interior medallions were stamped and then filled with white slip.

The greenish black leaves and surrounding design were freely carved with a V-shaped knife. In a technique known as reverse inlay (yoksanggam), the background of the curling, gray green foliage, rather than the leaves themselves, was carved out and filled with white slip.

Cosmetic boxes and small squat oil bottles were among the wide variety of forms made in this technique for the court and aristocrats of the Goryeo dynasty. The boxes all have flat lids with rounded shoulders, a shape that had its origins in the metalwork of the time. The decoration on the lids generally consists of geometric or floral designs and is closely linked with lacquerwork of the period. This cosmetic box is inlaid with yet another variation on the familiar motif of chrysanthemum flowers and leaves.

Arhat and Deer

Korea; Joseon dynasty, late 17th century Ink, mineral pigments, and gold on silk; 31×35 in. $(78.7 \times 88.9 \text{ cm})$

Acquired in 1995

Although Confucianism was the official state religion of the Joseon dynasty (1392–1910), Buddhism survived in Korea as a kind of folk religion with a large admixture of indigenous Shamanist and Chinese Taoist elements. The precincts of large Buddhist temples often included three small side shrines dedicated to Shamanist deities: San Shin (the Mountain Spirit), Tok Song (the Lonely Saint), and Ch'il Song (the Seven Star Spirits).

The resulting blending of the iconographies of Korean Shamanism and traditional Buddhism can be seen in this painting. The sparsely bearded figure of an old man holding a walking staff resembles conventional depictions of San Shin, but his bald head surrounded by a halo and monk's

robes suggests a Buddhist holy man, or arhat (in Korean, *nahan*). Replacing the tiger normally associated with San Shin is a deer, a traditional Buddhist symbol of longevity; the pink polocho, the small flower to the immediate left of the arhat's shoulder, is likewise a symbol of long life. The nearby peonies symbolize prosperity and progeny and may therefore allude to San Shin's capacity to bestow children. The pine tree and waterfall are conventional elements of Mountain Spirit paintings, with the pine also symbolizing venerable old age and endurance.

The skillful conception and execution of this very fine work suggest the hand of a master monk-painter, and it most likely hung in a Buddhist temple or shrine.

Jar with Sculptural Rim

Japan; Jomon culture, c. 2500–1000 BC Low-fired clay; 16% x 1415/16 in. (42 x 38 cm)

Acquired in 1974

Female Figurine

Japan; Jomon culture, c. 1000–200 BC Low-fired clay; $7^{15}/_{16}$ x $5^{1}/_{8}$ x $2^{3}/_{8}$ in. (20.1 x 13 x 6 cm)

Acquired in 1971

Jomon, meaning "cord-marked," refers to the impressions left from rolling braided or twisted ropes across the surface of moist clay vessels and gives the Jomon culture (c. 8000-300 BC) of Japan's Neolithic period its name. Over time, this hunting and fishing culture developed a rich visual vocabulary of distinctive cord-marked and incised decorations and pinched, curvilinear rims to embellish its ceramic utensils and cooking vessels. The mysterious masks, surging peaks, and undulating coils that decorate the Kimbell's Jomon jar are characteristic of Middle Jomon culture ceramics. A decorated vessel such as this was probably not made for daily use but for preparing food at special religious ceremonies.

Jomon clay figurines, called dogu

(earthen idols), began to appear around 1500 BC. Representing humans—usually female—and animals, they have in common with the pottery vessels the characteristic cord-marked decoration on their bodies and faces. They may have been used as protective charms or fertility symbols. Most were found deposited in pit dwellings, burial sites, or ritual shrines. The figurines exhibit a variety of highly imaginative, abstract, humanoid shapes. The Kimbell's Female Figurine has a hollow, thin-walled body supported by short tubular legs and wide hips. The areas of smooth clay and contrasting bands of incised and cordmarked patterns on the face, hips, and chest, as well as the "goggle-eyes," are identifying features of the so-called Kamegaoka type of dogu figurine.

Wide-Mouthed Jar

Japan; Yayoi culture, c. AD 100 Low-fired clay; 11¹³/₁₆ x 5 ⁷/₈ in. (30 x 15 cm)

Acquired in 1985

Ovoid Jar

Japan; Yayoi culture, c. AD 100 Low-fired clay; $18\,\%_{16}$ x $12\,\%_{16}$ in. (46.8 x 31.3 cm)

Acquired in 1984

The Yayoi culture of central Japan marked the first identifiable influx of people from the Asian continent and witnessed the introduction of wet-rice cultivation and bronze and iron metallurgy from Korea. Named after the site in Tokyo where this type of buff-colored pottery was first discovered, the Yayoi culture (c. 4th century BC-3rd century AD) also saw the beginnings of a settled, hierarchical society and a wealthy elite. Yayoi vessels reflect this society's dependence on the cultivation of rice and the widespread use of storage jars for stockpiling reserves. Sturdier, more functional vessels with symmetrical, taut profiles and restrained embellishment replace the irregular shapes and exuberant decoration of the preceding Jomon-period wares.

This graceful Wide-Mouthed Jar is

decorated with a variety of incised patterns in three registers that accentuate the vessel's gently swelling shape. The wavy parallel lines on the mouth and neck, and the diagonal lines around the body, are characteristic of jars made in the Kanto region of eastern Japan.

The large *Ovoid Jar* is a particularly fine example of the fluid lines and uncluttered decoration that characterize the best of Yayoi pottery. The vessel was first shaped by hand and then finished on a wheel to produce thin, even walls and a balanced shape. The robust, swelling body, tapering to a point at its base; the simple, combed incisions on the lip; and the flat, braided cord around the neck are typical of the modest but bold decorative vocabulary of Yayoi potters.

Haniwa Seated Man

Hokota site, Kashima, Ibaraki prefecture, Japan; Kofun period, c. AD 500 Low-fired clay with cinnabar pigment; $29^{15}/_{16} \times 10^{5}/_{8}$ in. (76 x 27 cm)

Acquired in 1972

The Kofun ("Old Tomb/Mound") period (c. 3rd century–538 AD) is characterized by the burial mounds built for the clan leaders

of an emerging upper class, who would form the basis of imperial rule. The practice of building burial mounds and interring valuables with the dead was adopted in Japan from the Asian continent. During this period, great numbers of monumental burial mounds symbolized the increasingly unified power of the governing class.

Haniwa, which means "circle (or tube) of clay," is the term given to large numbers of hollow clay cylinders that were placed in and around the bases of the Kofun-period burial mounds. Their function is unknown, but it is thought that they were used to protect the sides of the mound from erosion or perhaps formed a symbolic barrier around the precincts of the dead, protecting the site from evil spirits. The majority of haniwa are unadorned, but a number of them are decorated with sculpted human figures, animals, or domestic and ceremonial objects, rendered with the typical simplification and abstraction that characterizes the Kimbell figure. Seated on a platform, he has short legs and rounded, tubelike arms that are held in a somewhat formal pose. There is no suggestion of clothing, but the masklike face is marked by triangles on the cheeks and chin, painted in red cinnabar. Although the status and function of the person represented are not known, his distinctive conical cap and the sword at his side suggest a lowranking soldier.

Flask

Acquired in 1983

Japan; Asuka period, 7th century AD High-fired clay (Sue ware); $12\frac{3}{6}$ x $10\frac{3}{6}$ x $7\frac{1}{4}$ in. (31.4 x 26.3 x 18.4 cm)

This flask exemplifies a type of ceramic vessel produced in Japan in the sixth and seventh centuries AD for ritual use or for placement in tombs as offerings. Its technology reflects the contacts with Korea and China that accompanied the introduction of Buddhism and other aspects of continental culture to Japan in the Asuka period (AD 538-710). The production of Sue wares signaled the beginning of a new phase of ceramic art in Japan. Unlike earlier Jomon and Yayoi ceramics, which were built by hand and fired in open trenches at about 700 degrees Celsius, Sue wares are true stonewares, produced with the aid of a potter's wheel and fired in tunnel kilns at 1200 degrees Celsius.

Sue wares frequently exhibit unusual shapes that are sturdy and robust. The vigorous, swelling form of this flask is restricted to one side; the back is flat, its surface incised with thin lines. The fine clay of Sue wares, which were unglazed, fired to a metallic gray color. The spectacular splash of green glaze over one side of this vessel was accidental, created in the kiln by ashes that fell and fused on the surface of the pot during the firing process. This effect was especially prized by later Japanese potters, who consciously tried to reproduce it in their wares.

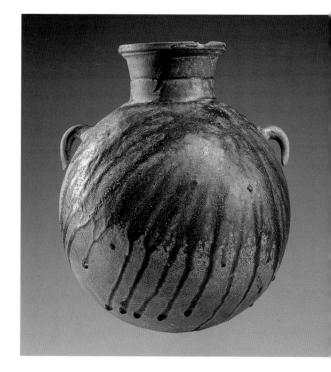

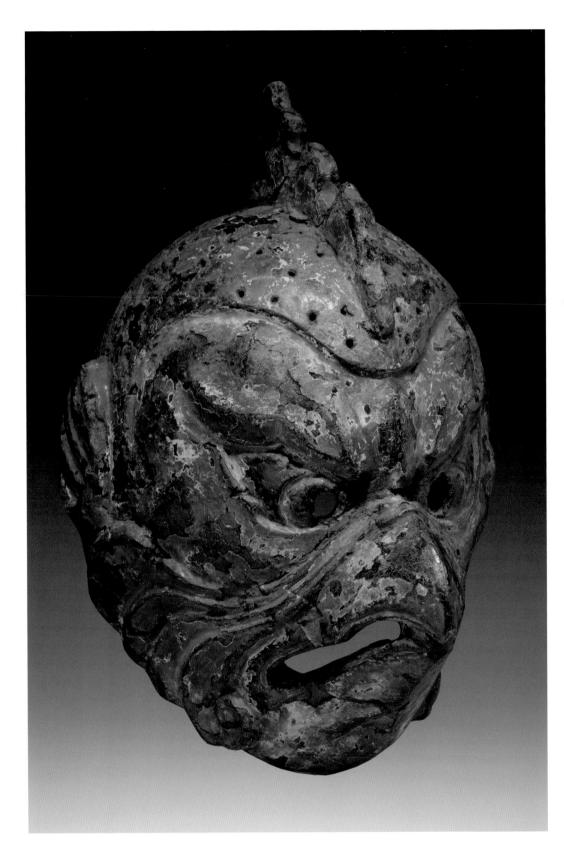

Gigaku Mask of the Karura Type

Japan; Nara period, 8th century AD
Dry laquer (dakkatsu kanshitsu); 14 x 10 ½ x 12 in. (35.6 x 25.7 x 30.5 cm)

Acquired in 2005

This very striking and expressive Japanese mask depicts Karura, one of the fourteen characters in the gigaku, a religious dancedrama that was performed for the Japanese royal court at Buddhist temple ceremonies from the seventh to the tenth century. In the performance, Karura is a mythical giant bird that protects the Buddhist faith. His features include pierced, close-set eyes, which stare down toward the tip of a prominent beak that grasps a round bead, and a cock's comb that projects from the crown of the head. Holes covering the top of the head originally secured tufts of featherlike hair. The mask is constructed in hollow-core dry lacquer, one of the favored methods for making

temple sculpture in eighth-century Japan, and bears traces of the original black lacquer coating and red, green, and blue pigments. The precise nature of gigaku (literally, "skill music") is not clear, but it appears to have been a dramatic form of religious dance and procession performed to the accompaniment of simple musical arrangements on flute, gong, and drum. The masks were robustly expressive and basically comic in nature, as it seems the purpose of the dance-drama was to inject a note of comic relief into the solemn, timeconsuming rituals of Buddhism. Gigaku was introduced into Japan from China in AD 612 and developed along with the spread of Buddhism in Japan.

Hachiman in the Guise of a Buddhist Priest

Japan; Heian period, 11th century Polychromed wood; $19\frac{1}{4} \times 16\frac{1}{8} \times 12\frac{5}{8}$ in. (48.9 x 41 x 32 cm)

Acquired in 1981

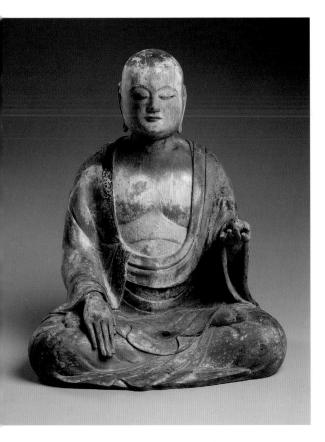

The Shinto god Hachiman has enjoyed special prominence throughout Japanese history. He was originally a local military guardian, protecting a community in Usa, northern Kyushu, which had ties to the imperial house. Since his legendary

birthplace in Japan was near south China, a possible source of military threats, Japanese rulers came to rely upon him for protection against that danger. In this role, Hachiman became known as the Shinto god of war.

The Kimbell's sculpture reflects a complex theological transformation that occurred when the Japanese sought to reconcile Buddhism, a foreign religion, with native Shinto beliefs about the worship of the kami ("spirit" or "god"), which can include human ancestors, legendary heroes, or personified forces of nature like the wind, the rain, a tree, or a rock. Shinto gods could symbolically enter the Buddhist priesthood, thereby acquiring a dual identity. In this image, Hachiman is dressed as a Buddhist priest. Seated in a meditative position, wearing a monk's robe, his head shaven, and carrying a jewel in his left hand, he resembles representations of the bodhisattva Kshitigarbha (in Japanese, Jizo), reflecting the fact that Shinto images shared the same stylistic features as Buddhist sculpture of the period. Carved from a solid block of wood, the figure's generously proportioned chest, shoulders, and legs impart a monumentality that belies the sculpture's relatively small size, while the slight tilt of the head imparts a touch of naturalism.

Seated Nyoirin Kannon

Japan; Kamakura period, c. 1230–50 Wood with traces of gilt and pigment; $19 \times 18 \times 10$ in. (48.3 \times 45.7 \times 25.4 cm)

Acquired in 1985

Esoteric Buddhism was introduced into Japan in the ninth century by way of China. The Esoteric sect worshipped a vast number of deities in an expanded pantheon of new forms. The multiple heads and arms seen in Esoteric Buddhist sculpture symbolize the numerous powers of deities. The several forms of the bodhisattva Kannon reflect this complex theology. Kannon (in Sanskrit, Avalokiteshvara) is the bodhisattva of compassion, the most popular of all the Buddhist deities throughout Asia because of the boundless love he offered to all beings. The Nyoirin Kannon, a prominent deity in the Japanese Esoteric Buddhist pantheon, is one of the six "changed forms" of the bodhisattva, especially associated with the granting of desires. The word nyo-i refers to the cintamani wish-granting jewel; rin means "wheel" and refers to the turning of the wheel of the law. The Nyoirin Kannon was widely worshipped by those who hoped to gain riches and see their requests fulfilled.

This gracious image shows the deity seated in a pose of royal ease. Although drawings frequently depict him with two arms, the six-armed form was also popular in Japan. As in this sculpture, one hand is often shown touching the cheek, with a left arm braced against the lotus pedestal

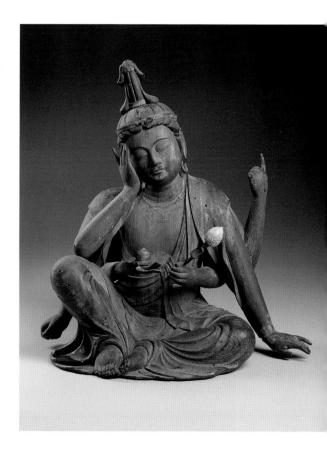

(now missing). Of the other four arms, one of the right hands holds the jewel, one of the left hands holds a lotus, the raised left arm originally had a wheel balanced on the upright finger, and the lowered right arm originally held a rosary.

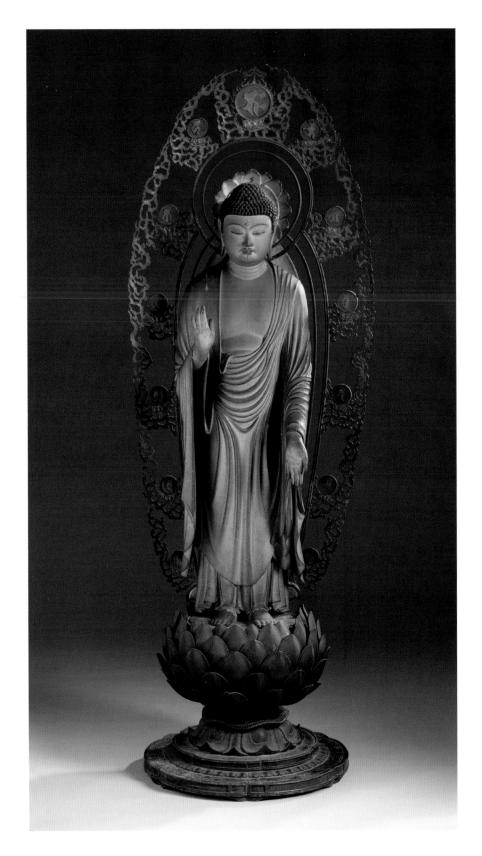

KAIKEI

Japanese, active c. 1185-1225

Standing Shaka Buddha

c. 1210

Gilt and lacquered wood; 54 1/16 x 19 1/4 x 13 1/2 in. (138.2 x 48.9 x 34.3 cm)

Acquired in 1984

Kaikei, the great master sculptor of the Kamakura period (1185–1333), together with his contemporary Unkei (died 1223), established the Kei school, the primary school of sculpture that produced statuary for the major temples in Nara and Kyoto. Together they created a new, realistic style that revitalized Buddhist sculpture. Especially important among Kaikei sculptures is a distinctive style of refined, graceful Buddha, clothed in deeply folded and decoratively draped robes.

Kaikei produced many Buddha images, particularly of Amida (Amitabha), the Lord of the Western Paradise. The Kimbell's sculpture is a rare image of the historical Buddha, Shaka (Shakyamuni), who is identified by the *abhayamudra* (gesture of reassurance, or granting of the "absence of fear") of the right hand. His left foot advancing, the Buddha appears

to move forward to greet the devotee with an expression of gentle and profound compassion. The beautifully proportioned figure is wrapped in an elegant, rhythmically folding robe that ripples across the stomach and cascades over the arms. Entirely covered with gold lacquer, the robe is further embellished with a floral and geometric pattern of fine-cut gold leaf.

The Kamakura period saw a revival of the historical Buddha in a new type of image—as a divine savior who descends from heaven to meet the faithful. This image, called "Shaka *raigo*," is documented in paintings of the early thirteenth century that show the Buddha standing on a lotus pedestal atop a cloud, his hand raised in the gesture of fearlessness. The Kimbell statue is a rare example of this type in three-dimensional form and one of only two known images of Shaka created by Kaikei.

Twenty-Five Bodhisattvas Descending from Heaven

Japan; Kamakura period, c. 1300 Pair of hanging scrolls; gold and mineral pigments on silk; each 39×15^{3} /4 in. (99 x 40 cm) Acquired in 1986

The emergence of the cult of Amida Buddha was an important development of the late Heian period (900–1185). It offered the easiest path to salvation: the devotee merely had to recite the *nembutsu*, a prayer repeatedly invoking the name of Amida Buddha, in order to gain entrance into the splendid Western Paradise. In the concept of *raigo*, Amida descends from paradise with a retinue of celestial beings to personally welcome the soul of the deceased believer into his heavenly realm.

In this pair of paintings, twenty-five small music-making bodhisattva attendants to Amida Buddha, richly dressed in gold and jewels, float down from the heavens on diaphanous clouds. The two

groups are led on the right scroll by the bodhisattva Kannon, who holds a small lotus pedestal to receive the soul of the deceased, and on the left by Seishi, whose hands are held in the anjalimudra, the gesture of respect and salutation. The rest of the entourage play drums, a lute, koto, and other stringed instruments and stand and dance on lotus pedestals, their long scarves and jewels swaying as they move. The figures' garments are executed in the painstaking kirikane technique of cut-andpasted gold leaf. In Kamakura-period raigo paintings, like the Kimbell's, the figures are shown standing in three-quarter view and bending slightly forward, as if rushing towards the devotee.

En no Gyoja

Japan; Kamakura period, c. 1300–1375 Polychromed wood; $54^{15}/_{6}$ x 32 x 26 in. (139.6 x 81.3 x 66 cm)

Acquired in 1984

En no Gyoja was the legendary founder of the Shugendo sect, which emphasized the practice of religious austerities, and he thus came to represent the archetypical ascetic recluse. He is said to have died in the early eighth century after living a hermetic life in the southern mountains. Because he shunned the established religious orders in the capital at Nara in favor of a solitary, itinerant life, subsequent generations of clerics and laymen came to regard him as a model for those who wished to pursue religious devotion in a secular world. During the thirteenth and fourteenth centuries in particular the devotees of austere religious practices claimed En no Gyoja as the patriarch of Shugendo.

This sculpture is one of a small number of posthumous, imaginary portraits of En no Gyoja that survive. This characteristic representation shows him as a bearded old man seated on a rocky ledge, dressed in a monk's robe with a hood and cloak of leaves—references to his secluded life in the mountains—holding a staff and sutra scroll. Typical of Kamakura period sculpture is a taste for vivid realism, evident in the lined, craggy face and expression of intense concentration of this portrait. The eyes are fixed in a hypnotic gaze, and the mouth is open to expose the teeth and tongue, as if En no Gyoja were chanting the scriptures or delivering a lecture. Particular attention is paid to the signs of age and hardship in the priest's wizened body—the sinuous musculature, wrinkled joints, and bony knees, legs, and feet.

Vimalakirti Scroll Used for a Yuima-e Service at Tönomine Temple

Japan; Nambokucho period, c. 1350 Hanging scroll; color and gold on silk; $35\frac{1}{4}$ x $9\frac{1}{2}$ in. (89.5 x 24.1 cm)

Acquired in 1982

This scroll is divided into three sections the top register contains small figures of a thunder god, a Buddhist priest, a deer, and a pagoda, and the bottom register depicts two Chinese lion-dogs facing each other. The central section features the large, bearded figure of the Indian sage Vimalakirti, called Yuima in Japanese, a Buddhist layman who lived in India in the sixth century BC. Having reached the height of spiritual understanding but choosing to remain a layman, he was renowned for his superior insight and wisdom. Previously, the male figure directly below Yuima was thought to be his Shinto counterpart, while the identities of the two smaller figures were not known. Recent research has revealed that the figure below Yuima, dressed in court robes, is Fujiwara no Kamatari (AD 614-669), a famous Japanese statesman and founder of the aristocratic Fujiwara clan. Flanking Kamatari are his two sons, one a Buddhist priest, seated on the right dressed in monk's robes, and the other a government official, dressed in court robes like his father. Kamatari served as minister to three empresses and emperors during the Asuka period (538–710). This work, painted seven centuries after Kamatari's death, was used in a Yuima-e (Assembly for Vimalakirti), a memorial service held annually for Kamatari at the Tönomine temple in Nara, which was built in 678 by Kamatari's eldest son, Jo-e.

Temples in Eastern Kyoto

Japan; Momoyama period, Keicho era, c. 1600 Six-fold screen; mineral pigments on gold; $35\frac{1}{2} \times 110\frac{1}{16}$ x $\frac{13}{16}$ in, (90.2 x 279.5 x 2 cm)

Acquired in 1986

In the Momoyama period (1573–1615), Kyoto emerged as a large urban center with a newly wealthy merchant class that developed a taste for paintings reflecting their vibrant, affluent lifestyle. Called *rakuduu-rakugai* (literally, "in and out of Kyoto"), these colorfully painted screens depicted scenes in and around the ancient capital, often illustrating famous scenic spots and important monuments or seasonal festivals. They were usually painted as pairs

of six-panel screens presenting bird's-eye views of eastern and western Kyoto, with its major thoroughfares, architectural structures, and bustling scenes of daily life. With their great attention to detail and accuracy, they functioned much like photographs in recording the activity and landscape of the time. Most were produced by a professional school of *machi-eshi* (town painters), anonymous artisans working for commercial shops.

This meticulously detailed screen shows a portion of Higashiyama, the eastern hills that border southern Kyoto. The site is made easily recognizable by the inclusion of the still-extant temple Kiyomizu-dera (second and third panels from the left), which is built high on a mountainside and supported by piers. The main focus of the painting is the center structure: the shrine-temple complex called Hokoku Jinja, the Toyotomi family's

mausoleum for the warlord Hideyoshi, built in 1599, the year after his death. The action of the painting moves from the right, with a procession of riders on horseback galloping through the shoplined streets toward the complex. Even among other examples of this meticulous style, the Kimbell screen is exceptional in its precise architectural details, lush landscape elements, and exact rendering of textile patterns on garments.

An Exiled Emperor on Okinoshima

Japan; Momoyama period, c. 1600 Six-fold screen; ink, gold, silver, and pigments on paper; $58\frac{1}{4} \times 137$ in. (148 x 348 cm)

Acquired in 1971

In this melancholy scene, the large sea of rough, billowing waves, the nobleman seated in the hut with only his books and koto as companions, and the dusky tones of ink and silver and gold suggest the solitude of a distant island. A windblown visitor dressed in a straw cape, who appears to have arrived in a small boat moored at the left, trudges along the shore to the hut. The green of the tatami mats and the white and pink of the blossoming cherry trees (indicating springtime) provide the only brightness in an otherwise somber composition reflecting the sense of isolation and the forlorn state of mind of the nobleman.

The painting is thought to represent the exile of a high-ranking nobleman,

possibly an emperor. Exile to a remote area of Japan or to a small offshore island was a common form of punishment for political crimes throughout Japanese history. Two emperors are known to have been exiled to the island of Okinoshima: retired emperor Gotoba-in (reigned 1184-98) and Godaigo (reigned 1318-39). Accounts of both exiles were recorded in the historical work Masukagami. The account of Gotoba-in's exile, in a famous literary passage, is the more likely to have been illustrated on an independent screen—although the scene depicted here could equally represent the events of Godaigo's exile when, after a year on the island, he escaped in springtime in a fishing boat brought by a loyal supporter, Takaoki Chidane.

KANO SHIGENOBU

Japanese, active c. 1620-1630

Wheat, Poppies, and Bamboo

early 17th century Six-fold screen; ink, colors, and gofun on gold leaf paper; $59^{13}/_{16}$ x $140^{9}/_{16}$ in. (152 x 357 cm) Acquired in 1969

This brilliant screen, originally one of a pair, depicts young wheat, blossoming poppies, and bamboo, all of the summer season. Boldly patterned with bright mineral colors on a gold ground, it exemplifies the exuberant decorative style of the Kano school. A heightened sense of realism is achieved with the use of the *moriage* technique, whereby parts of the composition are built up by the application of gesso to create raised designs.

The emerging elite of the Momoyama feudal system were the *daimyo* (feudal lords), who controlled extensive domains and served as advisors to the shogun (military overlords). The magnificent castles of the *daimyo* were embellished with colorful

paintings on screens and sliding doors, often decorated with gold-leaf backgrounds, which served to brighten the huge, dark interiors. Among the retainers in the service of the daimyo were the painters of the Kano school, a family of secular artists who formed the most important school of decorative painting from the sixteenth to eighteenth century. The Kano masters at first followed a true Chinese, monochromeink painting tradition but eventually added colorful and decorative elements to their work, developing a bold style well suited to these grand commissions. In particular, the Kano school painters of Kyoto popularized the kimpeki style of gold-ground screens painted in opaque mineral pigments.

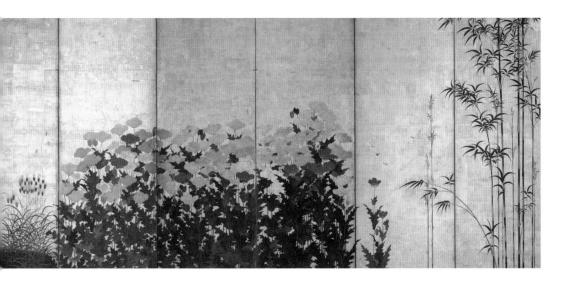

Sliding Door Panel with Design of Imperial Eagle, Plum Tree, and Camellia

Japan; Momoyama period, first half of the 17th century Cryptomeria wood, gesso with pigments; $62^3/4 \times 32^1/6 \times 1^1/6$ in. (159.4 x 81.6 x 2.9 cm)

Acquired in 1995

Beginning in the Momoyama period (1573–1615) and continuing into the Edo period (1615–1868), painted sliding

doors were commonly installed in the magnificent castle residences of the wealthy daimyo (feudal lord) and powerful shogun (military overlord) families. Decorated with painted designs, sometimes with gilt backgrounds, these wooden doors served to brighten dark, damp castle interiors. They were enhanced with a variety of motifs ranging from landscapes, birds, and flowers to historical, mythological, and allegorical scenes. Birds and flowers formed a special genre in Japanese decorative painting, each type and species having its own symbolic meaning. Birds of prey such as the eagle and the hawk, often paired with trees or flowers, were particularly popular subjects.

This sliding door panel, adorned with a majestic white eagle perched on a blossoming plum tree, is the right half of a two-panel sugito (cedar door). The plain wood surface of the door is decorated with gesso mixed with pigments to create a paste; this is applied in successive layers to the untreated panel, building up to create a design in low relief. The motif of the eagle, like the hawk, was most likely a symbol of the samurai (warrior) class in Japan. The eagle represented on this door has been identified as an imperial eagle, a species that originated on the east coast of China and was introduced to Japan as early as the fifteenth century. Plum blossoms are often paired with camellias to represent the rejuvenation that comes with the first signs of spring.

Wine Flask

Japan; Momoyama period, late 16th or early 17th century Wood with black and red lacquer (Negoro ware); $11^{3/4}$ x $8^{3/4}$ in. (29.9 x 22.3 cm)

Acquired in 1981

Negoro lacquerwares constitute a special group of simple food-serving utensils that are distinctive for their austere, functional forms and, in most cases, for their solid, cinnabar red finish. The wares are especially admired when the plain red surface becomes almost translucent with age and is gently abraded from handling, allowing the black lacquer undercoat to show through. The term Negoro comes from the name of the now-destroyed Negoro-dera temple in Wakayama prefecture, where, according to tradition, red lacquer vessels were first made in the thirteenth century for use by the temple's priests.

The Kimbell's wine flask is a fine example of the simple, conservative, yet striking forms distinctive of Negoro lacquers. The broad, softly rounded shoulders curve to a sharp edge that sets off the extreme slope of the body to the narrow waist and broad, flat foot. The shape, called *heishi* in Japanese, derives from a Chinese pottery vessel type of the Tang period (AD 618–907) called *meiping*. *Heishi* is the term for a bottle used for offering sacred sake (rice wine) at the altar of a Buddhist temple. Sake was rarely poured in lacquered wooden bottles like this one, however, since they were intended mainly as ornaments.

Storage Jar

Japan; Momoyama period, c. 1600 Stoneware with wood-ash glaze (Shigaraki ware); $14 \times 11^{5/8}$ in. (35.6 \times 29.5 cm)

Acquired in 1969

Storage Jar

Japan; Edo period, 17th or 18th century Stoneware with wood-ash glaze (Shigaraki ware); $24^{3}/_{16} \times 19^{5}/_{16} \text{ in. } (61.5 \times 49 \text{ cm})$

Acquired in 1980

The Shigaraki kilns in Shiga prefecture have been an active pottery center since the Kamakura period (1185-1333) and continue to produce pottery today. One of the so-called Six Ancient Kilns, the Shigaraki center made use of anagame, the subterranean hillside kilns found at many medieval sites. These achieved an oxidizing atmosphere and higher temperatures than the earlier Sue-ware, reduction-fired kilns. The Shigaraki kilns initially produced functional wares to store seeds and tea. However, by the Momoyama period (1573–1615), the wares' unassuming, natural shapes, earthy colors, and rustic decoration had come to be highly regarded by masters of the tea ceremony.

The distinct feature of Shigaraki ware

is its bright green natural glaze, which appears over the burnt, reddish brown surface of the pots during firing. Most of the wares were undecorated and covered only by this eye-catching, ash glaze. An iron slip was occasionally employed to create a rich reddish brown surface highlighted with yellow ash glaze. The local clay used for making Shigaraki bowls and jars is distinguished by a light sandy texture and a high proportion of feldspar granules that appear as glassy white spots on the surface of the fired vessels. Large storage jars like these were coil-built in stages; they show horizontal registers where the potter stopped to let the pot dry enough to support the weight of the next rise of coils.

Jar with Floral Design

Japan; Edo period, 17th century Porcelain with underglaze blue and overglaze colored enamels (Arita ware, Kakiemon type); $19^{1/4}\times13^{7/6}\,\text{in.}\,(48.9\times35.3\,\text{cm})$

Acquired in 1968

The rapid development and diversification of the Japanese porcelain industry in the seventeenth century was the result of many skilled potters being brought to Japan from Korea. Led by Ri Sampei (1579-1655), who discovered porcelain clays in northern Kyushu in 1616, Korean immigrant potters established a major porcelain production area in Arita, the town near these deposits. Thanks to techniques introduced from China in the 1640s, they succeeded in manufacturing brilliant overglaze enamel colors that gleamed against a smooth, milkywhite porcelain surface. Sakaida Kakiemon (1596-1666) is generally credited with the consequent development of applying polychrome enamels to fired vessels that were then refired at a lower temperature. Kakiemon is the name given to porcelains made by Sakaida and his descendents.

The earliest Arita overglaze designs were mainly copies of Chinese wares. As time went on, however, designs became more thoroughly Japanese in flavor. While the Kimbell's impressive Arita jar derives its form and certain design elements from Chinese Ming-dynasty styles—notably the upright leaf pattern on the rim, the floral scrolls on the shoulder, and the bordered panels on the body that enclose clumps of flowering plants—the free and imaginative execution of the blossoms and leaves has a distinctly Japanese flavor. The

clear, milky-white color of the porcelain body suggests that this jar may date from the early period of overglaze porcelain production, sometime in the last quarter of the seventeenth century.

Handled Dish

Japan; Edo period, c. 1650 Stoneware with transparent glaze, iron oxide, and colored enamels (Oribe ware); $4^{13}/_{16} \times 8 \times 7^{13}/_{16} \text{ in. } (12.3 \times 20.3 \times 19.9 \text{ cm})$

Acquired in 1983

Oribe ware, which is richly decorated with white slip, brown paint, and green glaze, was first produced in the Mino kilns around the middle of the sixteenth century. The name of the ware derives from the tea-ceremony practitioner and warrior of the Momoyama period Furuta Oribe (1544-1615), a devoted student of Sen no Riyku (1522–1591), one of the most famous tea-ceremony masters in Japan. Born in Mino, Oribe is believed to have guided production at some of the Mino kilns, near modern-day Nagoya city. Oribe favored bold, distorted shapes and imaginative new patterns in his teaware. Characteristically, the shapes combine geometric and curvilinear elements, and mechanical as well as organically derived

features, with a variety of painting styles. At their best, Oribe wares are among the most innovative tea utensils made during the Momoyama period.

This irregularly shaped dish was used to serve sweets at a tea ceremony. It appears to have been started on a wheel and finished by hand to achieve the uneven shape. The handle was formed from clay drawn up from the sides of the dish; the trefoil-shaped openwork at each base of the handle makes the piece lighter in appearance. The contrast between the simple decoration of brown floral and geometric motifs and the eyecatching splash of bright green glaze over a finely crackled, cream-colored ground illustrates the special sense of design admired in Oribe wares.

Mukozuke

Japan; Edo period, early 17th century Stoneware with gray glaze and iron oxide (e-karatsu ware); h. $3\frac{1}{2}$ in. (8.9 cm); diam. $4\frac{1}{16}$ in. (10.3 cm)

Acquired in 1971

Mizusashi

Japan; Edo period, c. 1700
Stoneware with brownish black and creamy white glazes (*chosen-karatsu* ware); h. 7⁵/₁₆ in. (18.5 cm); diam. 4 ¾ in. (12.1 cm)

Acquired in 1971

The main products of the Karatsu kilns on the island of Kyushu were tea-ceremony utensils that derived from Korean prototypes. The mukozuke is a small, deep bowl used for serving side dishes in the traditional kaiseki meal that precedes the drinking of ceremonial tea. In the Kimbell mukozuke, a beautiful example of e-karatsu (painted Karatsu), the rim was shaped by hand to form petals and the simple underglaze designs of leafy grass and curled vines were painted in iron oxide prior to glazing. The distinctive lobed shape, graceful proportions, and warm, muted color of the bowl are qualities the tea connoisseur most admired in utensils from Karatsu.

A *mizusashi* is a jar with a lid used to hold fresh water for pouring into the *kama* (kettle) or for rinsing the tea bowls and

tea whisk. The Kimbell's example is in the ware known as chosen-karatsu (Korean Karatsu), which is characterized by the bold combination of two different glazes—a white, straw-ash glaze and an iron-oxide glaze that fires to a glossy dark brownwhich streak and blur when they meet. Many pieces of chosen-karatsu, especially tall jars, were formed using the "patting method" (tataki)—coiling and paddling the clay vessel into shape—rather than on a wheel. The intentionally irregular contour of this jar and the incised X-shaped mark near the rim reflect the Japanese taste for pottery of a natural and often rustic authenticity, in which the direct touch of the potter's hand is not hidden but brought to the fore and prized.

OGATA KENZAN

Japanese, 1663-1743

Bowl with Bamboo Leaf Design

early 18th century

Stoneware with underglaze iron oxide and transparent glaze; 2% for 4% in. (6.2 x 12 cm)

Acquired in 1969

Japanese, 1663-1743

Bowl with Pampas Grass Design

early 18th century

Stoneware with iron oxide, colored enamels, and transparent glaze; 33/8 x 4 in. (8.5 x 10.2 cm)

Acquired in 1971

Ogata Kenzan was one of the three great masters of painted ceramics in the Edo period (1615–1868). He developed an imaginative style characterized by a harmony between deftly painted designs and simple, sturdy ceramic forms. His workshop, based in Kyoto and later in Edo (Tokyo), also developed innovative uses of pigments and glazes. His distinctive style of freely brushed grasses, blossoms, and birds was employed especially for decorating tea ceramics.

Kenzan's early training as a painter is evident in the *Bowl with Bamboo Leaf Design*, where the thinness and tonal variations of the brushwork are evocative of ink painting. The intentionally asymmetrical shape, sharpedged leaves, and contrasting colors and

textures of the glazes reflect the aesthetics of the tea ceremony, which were designed to appeal to different senses during the extended ritual of drinking. The bowl was originally part of a set of five or ten vessels made as mukozuke (side dishes) or kumidashi chawan (cups used for serving tea in a waiting room). Although the graceful design of the Bowl with Pampas Grass Design is just as carefully conceived, the end result appears more casual, with the bright green glaze dripping onto either side of the bowl. It was originally one of a larger set of futa-chawan (covered tea bowls) used for serving steamed food. The two-character signature Kenzan is brushed in brown paint on the bottom of both bowls.

Box with Courtiers, Carts, and Blossoms

Japan; Edo period, mid-18th century Black lacquer with gold and lead designs, mother-of-pearl and shell inlays; $5\frac{1}{6} \times 8\frac{1}{16} \times 4\frac{3}{4}$ in. (13 x 20.5 x 12 cm)

Acquired in 1976

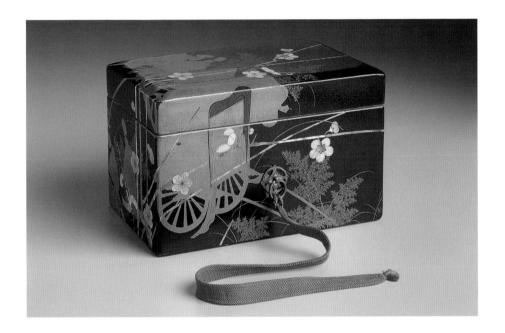

The decorative potential of lacquer has been exploited in Japan since the sixth century. Long admired for their durability and excellent finish, beautifully decorated lacquer objects were used as votive offerings in temples and as luxury items by the nobility. In the Momoyama (1573–1615) and Edo (1615–1868) periods, new, practical lacquer items appeared, including portable boxes in which the decoration continues from the lid and around the sides of the box, creating a harmony of form and decoration.

The decorative use of gold, lead, and mother-of-pearl and shell inlay in the scene of courtiers, carts, and blossoms on this box exemplifies the sophistication of design that Edo lacquerwares had attained. The scene probably comes from the Tale of Genji, a famous Heian-period romantic novel written by Lady Murasaki Shikibu (c. 973c. 1015). The specific subject is difficult to determine, but the prominence of the motif of bullock carts suggests that it might have been inspired by the episode "Karuma arasoi" (Battle of the Carts). On the inner face of the lid is a scene of two musicians and a dancer performing a bugaku dance. Bugaku dances, which derive from Chinese dances of the Tang period (AD 618-907), were adopted by the Japanese imperial court and performed at ceremonies.

Spring and Autumn Flowers, Fruits, and Grasses

Japan; Edo period, 18th century Pair of six-fold screens; mineral pigments on gold leaf; left: $61\frac{3}{8}$ x $142\frac{7}{8}$ in. (155.9 x 362.9 cm); right: $61\frac{3}{8}$ x $142\frac{5}{8}$ in. (155.9 x 362.3 cm)

Acquired in 1983

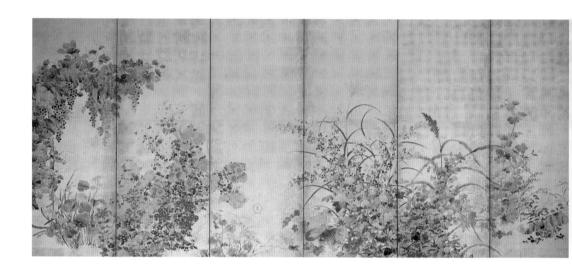

The Rinpa artistic tradition was founded in the Momoyama period (1573–1615) and perpetuated in the Edo period by Ogata Korin (1658–1716), his brother Kenzan (1663–1743), and various followers. The name Rinpa derives from the second syllable of the name "Korin" and the character for "school" (*pa*). Rinpa was characterized by vivid colors and bold, decorative patterning that derived from a

revival of the native *yamato-e* tradition of pictures and themes drawn from classical literature and poetry. Other popular Rinpa subjects included birds and flowers of the four seasons. Rinpa clients were drawn from both the court and the wealthy merchant classes of Kyoto and Edo (Tokyo).

The Rinpa school represents the fullest expression of the highly decorative

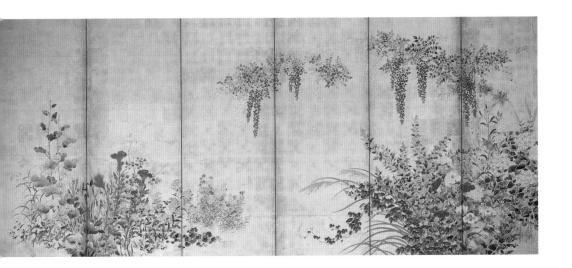

approach to nature painting in Japan. This pair of six-fold screens depicts seasonal flowers, fruits, and grasses rendered in typically bright colors on a brilliant gold background. The wisteria, hydrangea, morning glories, and hollyhocks on the right represent spring and the transition to summer, while the millet, eggplant, bush clover, chrysanthemums, and grapes on the left suggest late summer and autumn.

The rich, glowing mineral colors and the subtleties of a technique called *tarashikomi*, which mixes ink with pigments to produce a puddled effect, heighten the elegant decorativeness that gives these screens their distinctive character. The soft and luscious quality of the brushwork, the sense of depth created by color, and the judicious placement of foliage groupings are hallmarks of the Rinpa school.

TORII KIYONOBU

Japanese, 1664-1729

Beauty in a Black Kimono

c. 1710-20

Hanging scroll; ink, colors, and gold on paper; $23\% \times 10\%$ in. (60.7 x 27.7 cm)

Acquired in 1988

The urban culture of the Edo period (1615–1868) was dominated by a newly affluent merchant class that influenced artistic production through its interest in the colorful world of the pleasure quarters, a walledoff section of the city containing brothels, teahouses, and theaters. Idealized depictions of famous courtesans, their clients, and well-known male actors became increasingly popular, giving rise to a new type of art called *ukiyo-e*—pictures of the pleasure district's ever-changing "floating world." The decorative ukiyo-e school dominated genre painting and prints throughout the Edo period, representing the most current styles and trends.

This painting of a young woman dressed in an eye-catching, boldly patterned black kimono is a rare work by the early ukiyo-e artist Torii Kiyonobu, the son of a kabuki actor and theatrical design painter. Here, the demure pose and coquettish expression of the elegantly dressed woman capture the seductive qualities popular among patrons of the pleasure quarters. As is typical of fashionable portraits of ladies produced at this time, the hair and facial features are stylized, and the artist focuses attention on the garments. The kimono is decorated with a checkerboardpattern, jacquard weave over which are painted peonies in red, ocher, and blue. Gold outlines around the flowers and the edges of the garment further enhance the richness of the fabric and liveliness of the pattern.

MIYAGAWA CHOSHUN

Japanese, 1682-1752

A Young Dandy

c. 1740

Hanging scroll; ink and light colors on paper; $37\frac{3}{4} \times 14\frac{1}{8}$ in. (95.9 x 35.9 cm)

Acquired in 1984

The Edo period (1615–1868) school of *ukiyo-e* (pictures of the floating world) focused on genre scenes and portraits of the courtesans, samurai, and kabuki actors who inhabited the pleasure districts of the great urban centers of Edo (Tokyo), Kyoto, and Osaka. Genre painting had become popular during the Momoyama period (1573–1615) with detailed screen paintings of cityscapes and festivals. In the seventeenth century, less extensive scenes that would have been small sections of the large screens became common in both paintings and woodblock prints. Single-figure studies were increasingly popular, the background and setting fading as attention was focused on pose and costume.

Miyagawa Choshun was one of the great ukiyo-e artists of the first half of the eighteenth century. Trained in the Tosa school of traditional Japanese painting, Choshun is one of the few ukiyo-e artists of his day who did not design the popular woodblock prints but painted exclusively on paper and silk. He was a painter of great delicacy and a skilled colorist. In this painting, a stylish young man pauses under a blossoming plum tree as he surveys the scene around him. He wears an eye-catching striped kimono over a red undergarment and a brown sash. His accessories—a peaked straw hat, wooden clogs, flute in his sash, and kesa, or square apron that is part of a priest's costume—indicate that he is affecting the look of a komuso, or mendicant flute player.

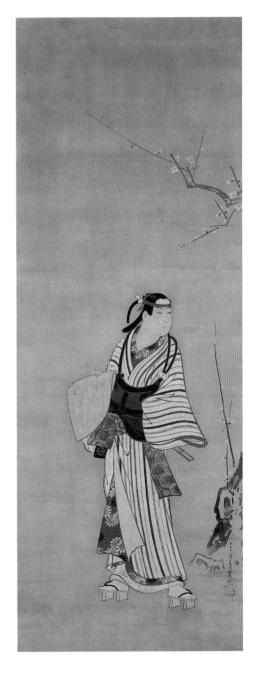

MARUYAMA ÖKYO

Japanese, 1733-1795

Crows

1766

Pair of six-fold screens; ink and gold on paper; 5915/16 x 14311/16 in. (152.2 x 365 cm)

Acquired in 1969

The eighteenth century in Japan saw a new influx of realism in painting best exemplified by the innovative work of Maruyama Ōkyo. A major factor in the development of his style was his direct and intensive study of nature, though he was also influenced by Chinese and Western realism. His interest in natural forms did lead to some criticism

that in rendering his subjects he was too concerned with physical appearance; nevertheless, his work enjoyed wide popular appeal.

In this striking pair of screens, clumps of young bamboo and a gnarled plum tree beside a stream provide the setting for a group of crows in flight and at rest. Soft

washes of gray ink and gold convey the feeling of dense fog and evoke a sense of deep space. Nine birds are boldly rendered in thick, textured brushstrokes in varying tones of gray and black, achieved by laying down the ink with the side of the brush. Every attitude of the crows as they dart up, swoop down,

and rest on the ground reveals the artist's patient study of the actual birds. Painted when Ōkyo was thirty-three years old, the startling realism of the cawing birds and the detailed observation of natural form are characteristic of his work, though these screens demonstrate a free ink style that is rarely found in works of his youth.

SOGA SHOHAKU

Japanese, 1730-1781

Shoki Ensnaring a Demon in a Spiderweb

18th century

Two-fold screen; ink on paper; $62\frac{1}{2} \times 68\frac{1}{16}$ in. (158.7 x 172.8 cm)

Acquired in 1987

Soga Shohaku was one of the Three Eccentrics of the Edo period (1615–1868). Accounts of his life are full of anecdotes about his bizarre behavior, and stories about him took on a legendary character. During his lifetime, he dominated the art world of Kyoto and enjoyed immense popularity in Japan. His paintings were appreciated for their unconventional approach to classical subject matter.

Shoki, the subject of this painting, is the Japanese name of a Chinese popular hero, Zhong Kui, who lived in the seventh century. Trained as a physician, Zhong Kui was unjustly defrauded of a first-rank grade in his civil examinations. Overcome with

shame, he committed suicide on the steps of the imperial palace. The emperor then ordered that he be buried with high honors in a green robe reserved for the imperial family. Out of gratitude, Zhong Kui's spirit dedicated itself to protecting the empire from demons. Shoki the Demon Queller became a popular subject of Japanese painting in the Edo period, and Shohaku painted it in many versions, always with humor and imagination. Though executed in ink with strong and forceful strokes, his paintings are never extreme in their exaggerations but marked by a refinement of brushwork that lies at the core of his achievement.

ITO JAKUCHU

Japanese, 1713-1800

Two Gibbons Reaching for the Moon

c. 1770

Hanging scroll; ink on paper; $45\frac{1}{4} \times 19\frac{1}{16}$ in. (114.9 x 48.4 cm)

Acquired in 2005

Jakuchu, one of the Three Eccentrics of the Edo period (1615–1868) worked in a range of styles, from colorful and meticulous to bold and carefree. Beginning in the 1760s and throughout the 1770s, Jakuchu spent extended periods of seclusion at the Obaku Zen temple of Sekihoji, south of Kyoto. This painting corresponds to that period, when Jakuchu increasingly chose to depict Zen subjects executed in ink-monochrome style, in which basic and geometric forms assumed prominence over realism.

This charming painting depicts a mother gibbon dangling her baby by the arm as she hangs from a tendril suspended from a tree. The title of the painting is a reference to the Zen Buddhist concept that simple people and animals often mistake the reflection of the moon for the moon itself. In this case, both the baby gibbon and its mother are trying to grasp the moon's reflection in the water—though not physically depicted here, its presence is understood. The subject also alludes to the dilemma of the human condition: we reach for the unreal instead of looking for proper spiritual substance. Jakuchu has imbued the subject with both humor and affection the gibbons may be confused, but if they stop searching for the truth, all will be lost. And although the moon is not actually represented, its round shape is mirrored in the gibbons' faces.

ITO JAKUCHU

Japanese, 1713-1800

Fukurojin, the God of Longevity and Wisdom

c. 1790

Hanging scroll; ink and light colors on paper; $45\frac{5}{8}$ x $22\frac{1}{4}$ in. (115.9 x 56.5 cm)

Acquired in 1986

Jakuchu, one of the Three Eccentrics of the Edo period (1615–1868), was a remarkable individualist whose paintings defy easy classification. Born in Kyoto, he inherited his family's green-grocery business but left the running of the shop to his brother and devoted his entire life to painting. Jakuchu's oeuvre is extensive and broad in scope. His style ranges from colorful, decorative works on silk to daring compositions in ink; his subjects include elegant depictions of flowers and barnyard fowl, as well as major Buddhist icons and narrative themes.

This humorous image depicts Fukurojin, one of a group of Chinese divinities called the "Seven Household Gods," who were also popular folk deities in Japan. Fukurojin, an old man, is always distinguished by an exaggerated, tall forehead, which is taken to be indicative of his superhuman intelligence and wisdom. He stands under a pine tree with branches that are softly brushed to create the sense of long, thick pine needles and is dressed in a voluminous robe decorated with cranes and long-tailed turtles. In Asian mythology these three motifs—pine, crane, and turtle—are symbols of longevity. In this freely brushed and seemingly spontaneous work, Jakuchu has employed his unique technique of making a single, wet stroke of ink stand out from the next by a rim of paler ink spread by absorption at its edges. This method effectively adds depth and texture to a largely monochromatic work.

The *nanga* (southern painting) school, also called *bunjinga* (literati painting), was one of the two most dynamic schools of

YOSA BUSON

Japanese, 1716-1784

Landscape with a Solitary Traveler

c. 1780

Hanging scroll; ink and light colors on silk; $39^{15}/_{16} \times 14^{5}/_{16}$ in. (101.5 x 36.4 cm)

Acquired in 1981

Japanese painting during the eighteenth and early nineteenth centuries. In contrast to the sensuous school of native decorative art, called *ukiyo-e* (pictures of the floating world), the *nanga* school was the last manifestation of the centuries-old Japanese preoccupation with China. It was based on the monochrome-ink landscape styles of Chinese literati painters, modified according to Japanese taste, and was patronized principally by the cultivated upper strata of Japanese society living in Kyoto.

Yosa Buson, a famous poet and one of the two greatest painters of the *nanga* school, began his serious career as an artist in 1751, when he finally settled in Kyoto after a ten-year period of wandering. The signature *Sha-in* on the Kimbell's painting is one that Buson used from 1778 until his death. This period is regarded as his most successful, when he best expresses his feeling for poetry through his painting.

This scroll depicts a landscape with a narrow road winding upward through the mountains. A solitary traveler wrapped in a green cloak crosses a footbridge constructed over a swollen, rushing stream. Inscribed on the scroll is the last line of a poem by the Chinese Tang-period poet Han Yu (768–824): A single path in cold mountains through the myriad streams. Using this as his theme, Buson evokes the sense of cold through the pale green and gray coloring, the leafless trees, and the traveler's cloak.

REKISENTEI EIRI

Japanese, active c. 1790-1800

Beauty in a White Kimono

c. 1800

Hanging scroll; ink and mineral pigments on paper; $48^{13}/_{16} \times 10^{3}/_{8}$ in. (124 x 26.3 cm)

Acquired in 1981

This scroll by the ukiyo-e artist Rekisentei Eiri depicts a courtesan who pauses to glance seductively over her left shoulder, proudly displaying her magnificent white kimono and outer cloak, which are designed in a variety of delicate geometric patterns. The snowflake pattern of the kimono is produced by a tie-dying technique, while the outer robe is brocaded with a pattern of quadruple lozenges evocative of ice crystals. The red sash that ties in front features a diaper pattern in gold, called sayagata, and indicates the figure's youth and high rank as a courtesan. A thin strand of hair dangling against the courtesan's cheek is an informal touch that contrasts gently with the perfect formality of her dress and adds to the image's seductive appeal.

Paintings of courtesans displayed the latest styles of dress among the fashionconscious ladies of the pleasure quarters, and they sometimes refer to specific events or special festival days. The all-white costume in this painting was worn only in Edo (Tokyo) on hassaku, the first day of the eighth lunar month, which was known as the "eighth-month snow" or "fall snow." The courtesans of the Yoshiwara district in Edo wore white on that day to commemorate the first time, in 1590, that the Generalissimo Tokugawa Ieyasu (died 1616) entered Edo. Ieyasu, who was later appointed shogun (military overlord) of all Japan, was responsible for making Edo the administrative and cultural capital of the country.

ISODA KORYUSAI

Japanese, active c. 1764-1788

Courtesan Playing the Samisen

c. 1785

Hanging scroll; ink and gold on silk; $15\frac{1}{2} \times 19\frac{1}{2}$ in. (39.4 x 49.5 cm)

Acquired in 1984

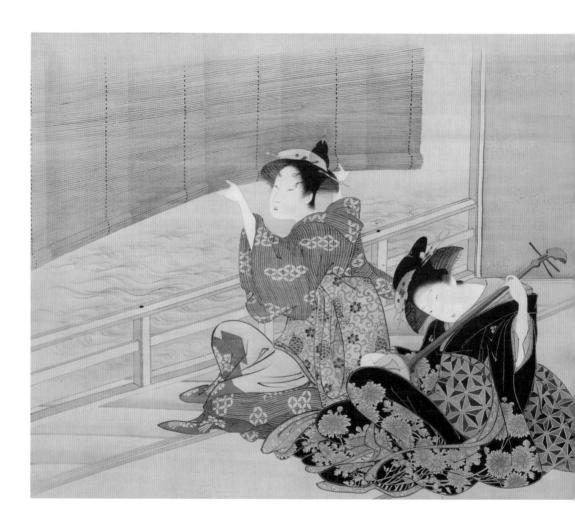

This is a late masterwork by Isoda Koryusai, an important and prolific *ukiyo-e* painter and printmaker in the last quarter of the eighteenth century, a time when artists showed a keen fascination with the natural world. Koryusai is believed to have been born a samurai (warrior) and to have relinquished his rank to become an artist in Edo (Tokyo). In 1781, he received the honorary title *hokkyo* from the Japanese government in recognition of his artistic talent and productivity. He gave up print designing in the 1780s to devote himself entirely to painting, although few of his painted works have survived.

In the Kimbell's painting, the intimate scene of a courtesan and her attendant

in a teahouse overlooking a river subtly suggests the elegance and entertainment of the pleasure quarters. The bamboo shade being rolled up by the young attendant indicates that the weather is warm, while the chrysanthemums decorating the kimono of the courtesan signal the end of summer and the approach of autumn. The wind gently blows ripples across the water. Reflecting the most current modes, the two women wear a popular hairstyle of the period in which the side locks billowed out, taking on the abstract form of a lantern top or open fan. The richly patterned textiles and the strong diagonal formed by the railing of the veranda make this monochromatic painting a work of unusual sophistication and visual appeal.

SHIBATA ZESHIN

Japanese, 1807-1891

Waterfall and Monkeys

1872

Hanging scroll; ink and light colors on silk; $73\% \times 44\%$ in. (187.7 x 113.7 cm)

Acquired in 1984

Shibata Zeshin was a strong proponent of traditional Japanese culture—amidst new influences from the West, he effectively demonstrated in his work that innovation could coincide with tradition. The son of a sculptor, he was apprenticed to a lacquer maker and received painting instruction in a naturalistic style. An energetic and prolific artist, he earned distinction during his lifetime for unusually creative paintings.

Zeshin painted several works showing animals mimicking human behavior, a subject that appears in Japanese art as far back as the Heian period (AD 794–1185). By demonstrating the apparent humanity of the animals, Zeshin creates a kinship between viewer and subject; and because monkeys naturally resemble man in their actions, they were a frequent choice of subject for works of this kind.

Waterfall and Monkeys is exceptional for its monumentality of scale and concept. While both waterfalls and monkeys are popular as singular subjects in Japanese painting, this imaginative and humorous combination is unique. Zeshin creates a lively scene of a troop of young monkeys with their beleaguered mother, crawling about the craggy rocks at the base of a fast-flowing waterfall. The naturalness and variety of the monkeys' poses and expressions suggest that Zeshin observed simian behavior firsthand. His interest in realism is further apparent in the delicate rendering of the monkeys' fur, from the soft washes and short, fine lines that define the youngsters' coats, to the longer, fluid strokes of the mother's thick hair. A large and ambitious painting, Waterfall and Monkeys demonstrates Zeshin's sure sense of space and compositional balance.

Male Figure

Nok culture; northern Nigeria, Africa; c. 195 BC-AD 205 Terracotta; $19\frac{1}{2} \times 8\frac{3}{4} \times 6\frac{5}{8}$ in. $(49.5 \times 22.2 \times 16.8 \text{ cm})$

Acquired in 1996

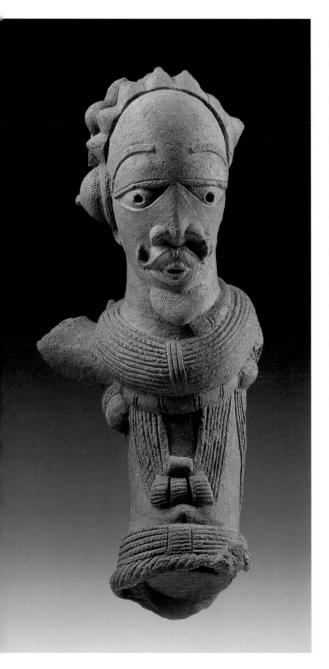

Nok terracottas are the earliest known sculptures from ancient Nigeria, dating from about 500 BC to about AD 500. Among the characteristic features of the Nok style are the treatment of the eyes, which form a segment of a circle or triangle, with the arched eyebrow balancing the sweep of the lower lid; the piercing of the eyes, nostrils, mouth, and ears; and the sometimes unanatomical placement (or absence) of the ears.

In their finest works, the highly skilled Nok artisans created images of great power, beauty, and sophistication. With its expressively modeled head, finely detailed features—especially the lips, mouth, beard, and coiffure—and carefully defined costume, the commanding *Male Figure* represents the fully developed Nok style. The complex hairstyle is composed of three rows of seven conical buns, with

Head

Nok culture; northern Nigeria, Africa; c. 285 BC–AD 515 Terracotta; 12³/₄ x 6³/₄ x 7 in. (32.4 x 17.2 x 17.8 cm)

Acquired in 1996

larger hemispherical caps over the ears. The importance of jewelry in Nok culture is illustrated by the meticulously rendered necklaces and beaded chains. The horn, slung over the shoulders, may identify the figure as a shaman.

The unadorned *Head* represents a more restrained tradition within Nok art. The simple features delineated in the smooth surface of the head are noticeably flatter than those of the *Male Figure*. The uniform, caplike coiffure reaches from ear to ear, covering them completely. The eyes, nostrils, and a spot beneath the covered ears are pierced; the flat, wide, unpierced lips are slightly parted to show clenched teeth. There is no mustache, but the standard small beard projects from the bottom of the chin. The eyes, of typical triangular shape, are surmounted by thin eyebrows decorated with cross-hatching.

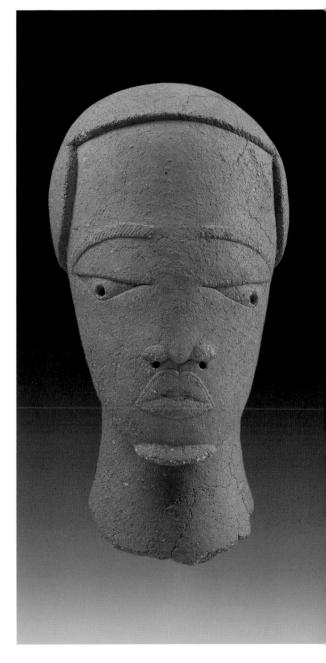

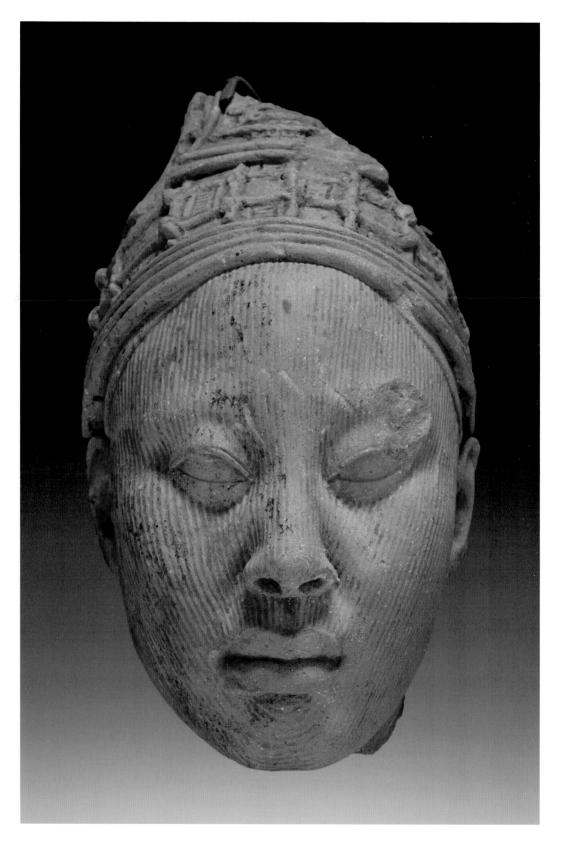

Head, Possibly a King

If e culture; southwestern Nigeria, Africa; 12th–14th century Terracotta with residue of red pigment and traces of mica; $10^{1}/_{2}$ x $5^{11}/_{16}$ x $7^{3}/_{8}$ in. (26.7 x 14.5 x 18.7 cm)

Acquired in 1994

The art of Ife, which flourished from the twelfth to the fifteenth century in the area of southwestern Nigeria occupied by the Yoruba peoples, is unique in Africa in representing human beings with a high degree of naturalism. Most Ife art is centered around royal figures and their attendants, reflecting the political structure of a citystate ruled over by a divine king, the Oni of Ife. Sculpted heads were buried at the foot of giant trees and later exhumed to be used as ritual offerings or sacrifices, sometimes on an annual basis. Ife bronzes and terracottas have been recovered from groves containing sacred shrines, from crossroads, and from older sections of the palace compound.

The physiognomy of this head has been modeled with extraordinary subtlety, and the striations on the face, which may represent scarification patterns, incised with great delicacy. The square crown, formed of four rectangular aprons overlying a conical form and embellished with a network of intersecting beads, is so far unparalleled in Ife art. The two holes above the temples, which are also unique, were perhaps intended to hold feathers during the ceremonies for which the work was originally made. Like the majority of Ife terracotta heads, the Kimbell example seems to have been broken from a fulllength figure. The serene and dignified countenance, as well as the elaborate crown, suggests that this head represents an Oni still today the paramount religious leader of traditional Yoruba peoples. The sculpture's sensitive realism marks it as a masterpiece of Ife art and confirms the status of Ife among the supreme high points of African artistic achievement.

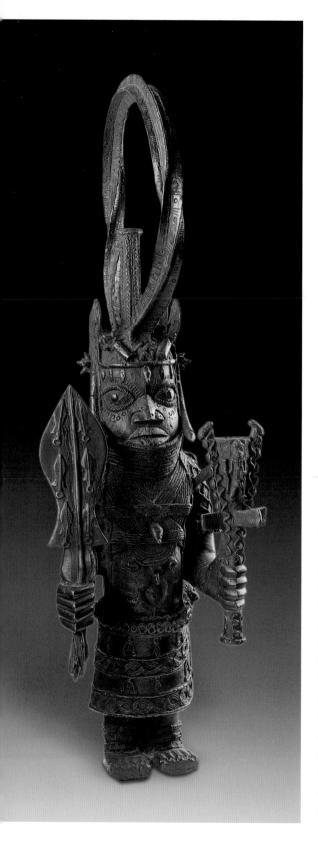

Standing Oba

Kingdom of Benin; Benin City, southern Nigeria, Africa; late 18th century

Bronze (or brass); $22^{5}/8 \times 7^{1}/8 \times 7^{3}/4$ in. (57.4 x 18.1 x 19.7 cm)

Acquired in 1970

One of West Africa's greatest kingdoms, Benin flourished for over five centuries in the forest of southern Nigeria. From the early seventeenth century onward, European travelers reported seeing extensive use of cast metal (actually brass) relief panels and other objects, but the art of Benin did not truly become known in Europe and America until 1897, after a British expedition conquered the kingdom's capital, now called Benin City.

The king, known as the Oba, is the central figure in the Benin kingdom and a frequent subject of Benin royal art. The Oba's ancestors were gods, and it is believed that he controls the forces that affect the well-being of the entire kingdom. The Kimbell sculpture portrays an Oba dressed in full ceremonial regalia. The beads that made up his chest covering, high neckpiece, and net-form headdress were actually made of coral; his gong-shaped proclamation staff was made either of brass or ivory; and his ceremonial sword—with which he would dance to honor his divine ancestors—was brass. In this work, his power is reiterated by the relief of six small swords on the blade of the large one, and the alternating images of a sword and stylized heads of Portuguese soldiers on the Oba's kilt. As the Portuguese arrived in Benin by sea, the inclusion of Portuguese heads symbolized the wealth the Oba gained through foreign trade and his affiliation with Olokun, god of the sea.

Chibinda Ilunga

Chokwe people; northeastern Angola, Africa; mid-19th century Wood, hair, and hide; $16 \times 6 \times 6$ in. $(40.6 \times 15.2 \times 15.2 \times m)$

Acquired in 1978

In Central Africa, the role of chief is often linked with that of hunter. For the Chokwe people, the importance of the hunter stems from the myth of their founding hero, Chibinda Ilunga, the son of a great Luba chief and a passionate huntsman, who wooed and eventually married Lweji, a Lunda chieftainess. He introduced the Lunda to the concept of divine kingship and also taught their tribe the art of hunting. From their union, if rather indirectly, came the Mwata Yamvo rulers of the Lunda, to whom the Chokwe paid tribute and regularly furnished sculptors, who produced court art almost up to the present day. By association, Chibinda Ilunga became a culture hero and model for men in Chokwe society and especially for Chokwe chiefs. He came to represent the archetypal chief who maintains the well-being of his people.

As in much African art, the representation of the coiffure, headdress, and other ornaments serve to emphasize the figure's status and identity. Chibinda Ilunga wears elaborate headgear with rolled side elements as a sign of his royal rank. He holds a wanderer's staff and a carved antelope horn, which is a container for substances that supernaturally assist the hunt. The greatly enlarged hands and feet emphasize his physical strength and endurance, while the beard conveys his wisdom as an elder and ancestor.

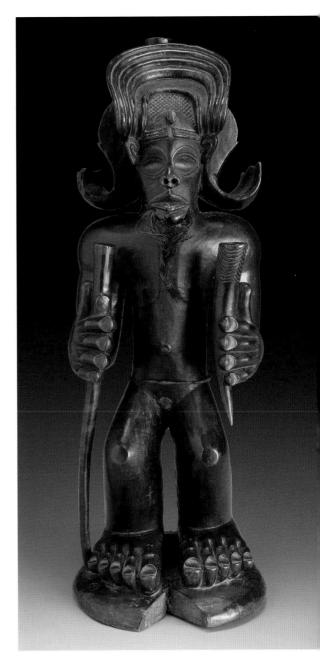

Warrior Ancestor Figure

Hemba people; area of Lualaba, Luika, and Lukuga rivers, Democratic Republic of the Congo, Africa; 19th century Wood; $33\frac{1}{8} \times 10\frac{1}{4} \times 9\frac{1}{8}$ in. (84.1 x 26 x 23.2 cm)

Acquired in 1979

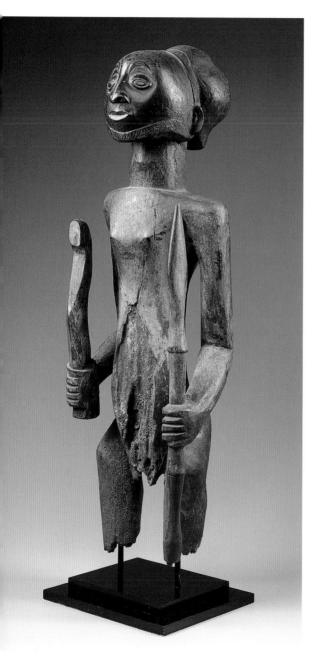

This dignified figure of a Hemba warrior, with his upright posture and lofty, outward gaze, would have served as the focus for ancestor veneration among one of the Hemba peoples of the central and eastern Congo. Each clan possessed an ancestral effigy that was revered as the image of a founder, both actual and ideal, and signified the legitimacy of clan leaders' rule. As a receptacle for the ancestor's spirit, the figure is both conceptually and stylistically universalized; it is not concerned with the specific or momentary. It embodies inner moral values as well as outer signs of power, serving as a forceful example to the ancestor's living descendants. Such figures were preserved in funerary houses or chiefs' houses and expressed the continuing relationship between the living and the dead.

The Kimbell ancestor figure holds a large parade knife and a lance, which, as extensions of his arms, symbolize courage and masculine physical prowess. These emblems of power, along with the carefully trimmed beard and the characteristic, cruciform headdress, probably allude to the office of war chief. Retaining overall the columnar stability of the living tree from which he carved the work, the sculptor has structured the image from bold spherical and cylindrical forms enlivened by the interplay of forceful diagonals and stabilizing horizontals. The focus of energy remains the noble head, the dwelling place of spirit and wisdom.

Diviner's Mask

Yombe people; Democratic Republic of the Congo and Angola, Africa; early 20th century Wood, organic materials; $9\times6\%\times4\%$ in. (22.8 $\times16.8\times10.7$ cm)

Acquired in 1979

In African art, the mask is the primary component of transformation by impersonation. It neutralizes the identity of the wearer and provides a material residence for the inhabiting spirit. Little is known about the use and meaning of many masks in African cultures, where to reveal their secrets is to destroy their reason for being—in effect to kill them.

Among the Yombe people, masks were used in divination ceremonies, through which past or future events were revealed. This example was worn by a nganga diphomba, a divination specialist devoted primarily to the detection of members of the community responsible for various crimes, accidents, and other disasters. The diphomba prosecuted antisocial acts and, during a ritual trial, functioned as the vehicle for the verdict of the ancestral spirit. Yombe masks are generally regarded as idealized representations of the diviners who wore them, but the closed eyes, parted lips, and expression of intense concentration on the Kimbell mask lend it a sense of heightened realism. The mask's crusted, black surface is the result of being stored in the rafters of a building where it was exposed to the oils and smokes of cooking. The black color of the mask is also associated with judgment and divination. Had it been reused, it would almost certainly have been cleaned and repainted as part of its preparation for receiving the spirit.

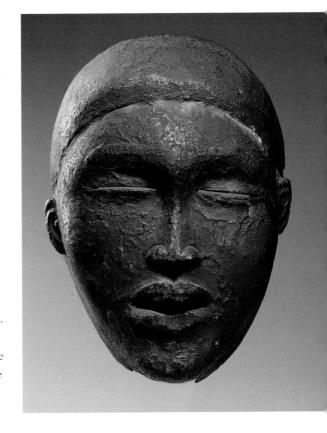

Kneeling Mother and Child

Makonde people; Tanzania-Mozambique border area, Africa; late 19th century Wood; $14\frac{1}{2} \times 5\frac{3}{8} \times 4\frac{3}{4}$ in. (36.8 x 13.6 x 12 cm)

Acquired in 1979

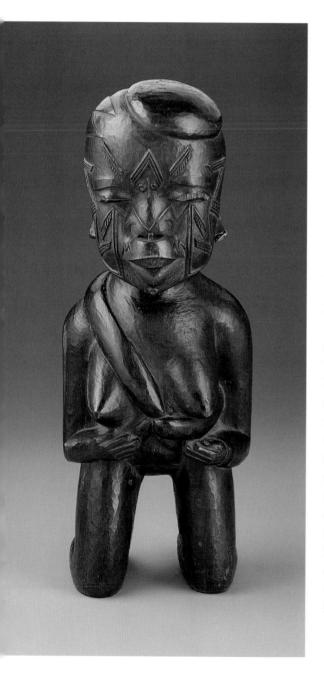

Among the few East African peoples who make sculpture in any quantity, the Makonde are notable for their unusually naturalistic figures. A strong sensuality in the representation of the body is complemented by intricate detailing, which often centers on an elaborate coiffure or tribal markings. Such hair and skin decorations are viewed by the Makonde as indications of rank, status, and identity—Makonde females are scarified as they pass into adulthood. Makonde scarifications are more elaborate than those of any other group in Mozambique, comprising complex designs of chevrons, angles, zigzags, and straight lines, as well as circles, diamonds, or dots.

Most African mother-and-child sculptures are intended to ensure fertility. but this piece is also concerned with the high position of the female in Makonde society, which is matrilineal by succession, inheritance, and marriage. Perhaps intended to represent the primeval matriarch who founded the Makonde tribe, the figure is remarkable for its vigorously carved forms and sensitively articulated detail—the mother's hooded eyes, her fingers holding the sling in which the baby straddles her back, its tiny feet and hands extended. The ears and upper lip are pierced and hold ornaments, which are symbols of leadership in the region.

Standing Ancestor Figure

Maori culture, possibly Rongowhakaata people; New Zealand; Te Huringa period I, c. 1800–1840 Wood: 17^5 /s x 5^3 /s x 4^7 /s in. (44.8 x 13.2 x 11.2 cm)

Acquired in 1989

The Maori tribes of New Zealand excelled in decorating their timber buildings with elaborate relief carvings and sculptures. This powerfully conceived, freestanding figure functioned either as a *tekoteko*—a carved figure placed on the gable peak of an assembly house, food storehouse, or chief's dwelling—or as a *poutokomanawa*, the center post that holds up the ridgepole of a large house such as that of a chieftain. Symbolically, the ridgepole is the backbone of the ancestor who is represented by the house. The figure represents either a god or a recently deceased male ancestor who, in Maori culture, looks after the welfare of his descendants.

The form of the figure—the large head, narrow torso, bent knees, and knobby three-fingered hands—is a familiar type in Maori sculptures of gods and ancestors. As is common with these statues, the face is carved with an intricate curvilinear pattern reproducing the tattoos (moko) that decorate the faces of Maori chieftains. The carvings on the arms are specific patterns that are either unique to a particular family (whanau) or have an individual significance for that sculpture. Spirals mark the joints of the figure at the shoulders, elbows, wrists, knees, and hips; the rough edges indicate that these were cut with stone tools, before the introduction of steel knives in the early nineteenth century. The style of carving is characteristic of works made by the Rongowhakaata tribe in the area around Gisborne, on the east coast of the north island of New Zealand.

Standing Figure

Olmec culture; Mexico; c. 900–400 BC Jadeite; $5^{1/2}$ x $2^{11/16}$ x $1^{1/8}$ in. (13.9 x 6.9 x 2.9 cm)

Acquired in 1981

The earliest complex culture of Mesoamerica, the Olmecs flourished from about 1500 BC to 400 BC and created many of the recurrent elements of later Mesoamerican iconography, art, religion, and ritual. They established the first sacred centers composed of plazas, mounds, and pyramids and represented deities as human-animal composites of jaguars, harpy eagles, snakes, and crocodiles. Figures and facial types tend towards the androgynous; heads are large, probably to emphasize their importance, bodies more short and

stocky. Details are generally limited to those essential for content recognition.

Jadeite had special significance for the Olmec elite and was the preferred material for precious, small-scale, ritual objects. Its translucent green color was venerated as a symbol of life and fertility. Despite the small size of the Standing Figure, it is unusually monumental in impact. Its lifelike proportions and subtle musculature epitomize the extraordinary craftsmanship and sensitivity of Olmec jade carving at its finest. The subject appears to be human rather than divine and may represent a venerated ancestor. Although their purpose is not clear, the numerous extant examples of this kind of figure suggest that they had an important ceremonial function in Olmec ritual.

The hollow ceramic figure of a seated child, with snarling expression, plump proportions, and incised headdress, belongs to a type found throughout Olmec territory. These so-called "hollow baby" figures—asexual, infantile figures with plump bodies—have been variously interpreted as jaguar-human hybrids, as children with deformities that mark them as having supernatural powers, as images of rain gods, or simply as well-fed infants. This highly humanized variant, with its rounded, simplified forms and smooth finish, shares traits with the finest Olmec works in jade and basalt.

Seated Figure

Olmec culture; Tenenexpan, Veracruz, Mexico; c. 1200–900 BC Ceramic with white slip and traces of paint; $10\% \times 9\% \times 6\%$ in. (27.7 x 23.2 x 15.6 cm)

Acquired in 1971

Seated Woman

Xochipala culture; Guerrero, Mexico; c. 1500–1200 BC Ceramic; $4\frac{3}{8} \times 3\frac{1}{8} \times 2\frac{7}{8}$ in. (11.1 x 8 x 7.3 cm)

Acquired in 1971

During the Preclassic period (1500 BC–AD 150), a number of independent, agriculturally based cultures were established in central and western Mexico. These cultures produced an astonishing quantity

and variety of clay pottery and figurines, which provide vivid images of these peoples, their costumes, and their lifestyles. The figurines seem to have been planted in the ground with seeds as magical receptacles for the transfer of harmful forces from a living body; they may also have served as spirit companions or as vehicles placed in burials to carry the dead on their journey to the afterlife.

Among these early cultures, the most inventive tradition of terracotta figurinemaking was located at Xochipala, in the Mexican state of Guerrero. The Xochipala style is characterized by an expressive yet sophisticated naturalism applied to a wide range of everyday subjects. Anatomical details are rendered with consummate skill: fully modeled eyeballs with pierced pupils, parted lips revealing two rows of teeth, finely worked feet with fanned toes, and delicately incised hair fashioned into stylized arrangements. The Kimbell figure showcases all of these elements, and though small in size, is modeled with remarkable subtlety, especially in the intent facial expression, articulated coiffure, and delicately fringed shawl, all accentuated by the extreme simplicity of the dress. Its success in capturing the spirit and physical presence of an actual woman inevitably raises the question of whether it was intended, in some sense, as a portrait.

Singing Priest or God

Teotihuacán culture; Valley of Mexico, Mexico; c. AD 400–600 Fresco; 23¹¹/₁₆ x 43¹/₂ in. (60.2 x 110.5 cm)

Acquired in 1972

The city of Teotihuacán, in the Central Highland Valley of Mexico northeast of Mexico City, was the capital of the first classical civilization of Mesoamerica, dating from around the first to the seventh century AD. Teotihuacán was an urban and ritual complex eight miles long and contained the second-largest pyramid in Mesoamerica. Both its residential and ceremonial structures were characterized by "slope-and-panel" profiles on their platforms and terraces, as well as elaborate polychrome wall frescoes. Around AD 600, internal factional struggles led to Teotihuacán being burned and abandoned.

In this richly symbolic mural fragment from Teotihuacán, a priest or god in an elaborately plumed headdress performs a ceremony involving the scattering of incense while singing. Orderly sequences of such images depicting ceremonies in which specific favors are asked of the gods, painted in true fresco on damp plaster, once formed part of the decoration of Teotihuacán residential and temple complexes. Here, the object of the ceremony seems to center on the glyphlike symbol to the left, depicting five maguey spines thrust into a stack of reeds. In all likelihood this is a place name. The officiating figure holds an incense bag in his left hand, while flower-decorated water streams from his right. Proceeding from his mouth is a large speech scroll edged with vegetation (probably meaning "flowery song"); the hearts, jade, and other symbols in the scroll may stand for the song's content.

Urn in the Form of Cociyo, God of Lightning and Rain

Zapotec culture; Monte Albán IIIa, Oaxaca, Mexico; c. AD 400–500 Ceramic; 28½ x 21 x 18 in. (72.4 x 53.3 x 45.7 cm)

Acquired in 1985

The Zapotec civilization developed over a period of more than one thousand years in relative geographic isolation in the modern state of Oaxaca, in southern Mexico. The primary capital of Zapotec culture was the ceremonial site of Monte Albán, constructed on an artificially

flattened mountaintop, where the Zapotecs worshipped a complex pantheon of nature gods. Zapotec culture is divided into four stages, each associated with the style of gray-ware effigy urns they placed with their honored dead. The urns depict both gods and important human beings, some in ritual garb impersonating gods.

This urn represents Cociyo, the Zapotec name for the Mesoamerican god of lightning and rain. In his Zapotec manifestation, he is identified by a combination of facial elements forming a powerfully sculptural mask. The stepped, two-part forms enclosing the eyes represent clouds and, by extension, the precious water needed to grow crops. The doubly plugged nasal extension is a development from earlier snouted deity elements that combine jaguar and snake allusions. The roar of the jaguar represents the reverberation of thunder. The three fangs that protrude from this snout cover a bifurcated tongue, like the almost invisibly flashing tongue of a snake, symbolizing a lightning bolt. The rest of the dress is as much that of a priest as of a deity, with the large disk-shaped earplugs and the knotted collar of high rank. The striations of the cape may represent feathers. The kilt is decorated with a wavelike pattern, with three attached tassels at the bottom. The ensemble thus echoes the various natural phenomena of a tropical mountain thunderstorm.

Smiling Girl Holding a Basket

Nopiloa style; central Veracruz, Mexico; AD 600–750 Ceramic with white slip and traces of paint; $7^9/_{16} \times 6^1/_{8} \times 3^3/_{4}$ in. (19.2 x 15.5 x 9.5 cm)

Acquired in 1978

A number of distinctive and original forms of small ceramic sculpture were produced by the Precolumbian cultures of central Mexico. Hollow modeled figures from the Totonac culture, which flourished in the Veracruz area of the Gulf Coast during the time of the Maya, are noted for their typical smiling expressions and the great care given to details of ornament and attire. This exceptionally well-preserved piece showcases especially fine modeling in the animated open mouth, softly modeled cheeks, and broadly flattened head. In style it resembles figures from Nopiloa, which likewise contrast smooth mold-made areas with enlivening hand-modeled details, filed front teeth, lively smiles, and broadly sculpted costumes. Particularly noteworthy are the meticulously rendered eyes, teeth, earrings, hands, and jewelry.

Smiling Girl wears an elaborate headdress, with a swag of seeds draped across the front. Her dress is decorated with painted geometric motifs, now rather worn. She eagerly offers a basket of rolled tortillas in her left hand, while extending her right in a way that displays her long tapering fingers and rings.

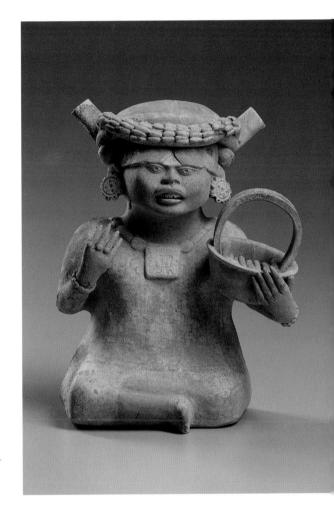

Conch Shell Trumpet

Maya culture; Guatemala; c. AD 250–400 Shell with traces of cinnabar; $11^9/_{16}$ x $5^{1/4}$ in. (29.3 x 13.4 cm)

Acquired in 1984

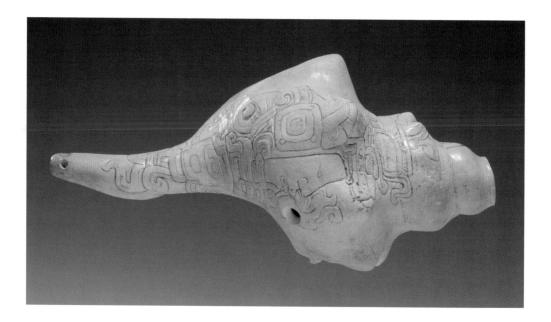

For the Classic Maya, the conch shell served as a basic symbol of the sea—its spiral form suggests volutes of breath and wind, phenomena closely identified with ocean breezes. As wind instruments sounded by breath, conch trumpets clearly reinforced this symbolism. This conch trumpet features an ancestor floating in a cloud; only the head and elaborate headdress are shown. The headdress portrays the Rain God, called Chac, which is also likely part of the name of the trumpet's royal owner, as Chac appears again in a column of glyphs recording his identity. The cloud scrolls swirling below the ancestor's chin convey his ethereal nature as the embodiment of rain. The trumpet was positioned

horizontally when worn or played so that the ancestor would be oriented as if looking down from the sky. The stylized serpent head before the face of the figure also embodies the notion of breath and wind. A hole drilled in the mouth of the serpent head would have allowed breath and music to emanate, quite possibly with a distinct tone, when the conch was played. The aperture also served as the breath and voice of the ancestor, the "resident" of the trumpet.

In early Classic Maya art, royal ancestors commonly appear on marine shells. Marine shells probably held important symbolic significance, as the eastern Caribbean Sea was the source of rain clouds, phenomena closely related to ancestors in Maya thought.

Royal Belt Ornament

Maya culture; possibly Guatemala; c. AD 400–500 Pale gray-green jade; $9^{1/4} \times 3 \times ^{1/8}$ in. (23.5 x 7.6 x 0.3 cm)

Acquired in 2004

This exquisitely decorated jade belt ornament originally formed part of a royal costume that included a belt assemblage consisting of three such pendants. On one side is a full-length profile portrait of a young Maya ruler richly attired in the regalia associated with enthronement. Dark spots on his body signify the supernatural and allude to Hunahpu, one of the Hero Twins of Maya mythology. Smaller spots on his cheeks and nose and a whiskerlike element at the corner of his mouth symbolize his kinship with the jaguar, the feline associated with the night. He wears a jaguar-skin skirt overlaid by a royal belt incorporating elaborate paraphernalia that includes a mask surmounted by a skull (a reference to death) and three celt-shaped plaques like this one. A rope extends from the belt down the leg and supports a small figure of Chac, the rain god. The complex headgear incorporates a ferocious skull, jade beads, and a jester god mask, the symbol of rulers. On the reverse, the principal elements of the incised glyphic text include the presentation of an object (perhaps a badge or a celt) to the depicted ruler, possibly called Machaak, and a date suggesting that his death ("he entered the water") took place nine days after the presentation of the object. The Maya believed that at death an individual entered the watery Maya Underworld (Xibalba) before being reborn in the afterlife and rejoining the sky.

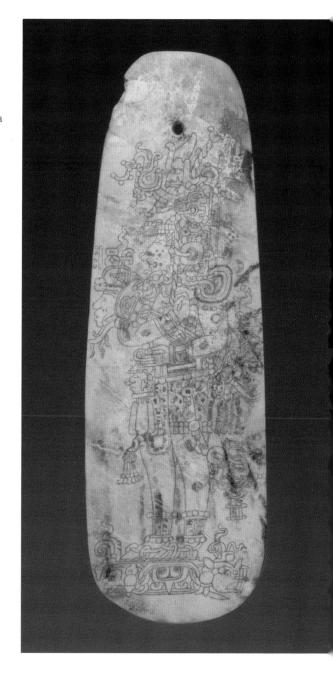

Tripod Vessel

Maya culture; Mexico or Guatemala; c. AD 300–900 Limestone; $9\%_{16} \times 6\%_{10}$ in. (23.9 x 16.8 cm)

Acquired in 1994

Rounded Bowl

Maya culture; Mexico or Guatemala; c. AD 300–900 Limestone; 3% 5 in. (9.1 x 12.7 cm)

Acquired in 1994

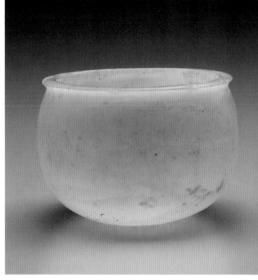

The main corpus of Maya art is noted for its dense and complex pictorial decoration. Like Maya pottery, the surfaces of limestone and other white stone vessels were often carved or painted. The fact that these Maya limestone vessels are undecorated enhances the significance of their simple forms and concentrates attention on the beauty of the material. The Tripod Vessel of limestone is crafted from a single piece of stone into a cylindrical vase with straight flaring sides ending in a slightly everted lip. At the base are three supports of rounded "teardrop" form. The expertly ground walls are so thin as to be translucent, making the piece surprisingly lightweight. The cylindrical shape of the vessel copies that of Teotihuacán ceramics, but the spherical

tripod feet suggest that it may date from the Late Classic period. The small *Rounded Bowl* has the same everted lip and a flattened base. Made of limestone, the walls are not as thin or translucent as the tripod vessel, giving it a whiter, milkier appearance.

The vessels were probably manufactured in central Guerrero, Puebla, or Oaxaca. They were discovered in Maya territory, where they had probably been brought by *podteca*, a special class of traders from the highlands, who were allowed to travel throughout Mesoamerica and beyond bearing cacao, cloth, skins, jade, and pottery. The superior quality of the workmanship suggests that these bowls were intended for a wealthy Maya clientele, probably as funerary offerings.

Tripod Vessel with Lid

Maya culture; Guatemala; c. AD 400–500 Ceramic with stucco and polychrome pigments; $11 \times 6^{1/4}$ in. (27.9 \times 15.9 cm)

Acquired in 1997

The art of the Maya is principally the art of the ruling elite. Vessels were made to honor and commemorate once-living rulers and to venerate their gods and ancestors; these objects, laden with power and symbolism, were then buried in tombs alongside their royal or noble owners. Much of the pottery found in Maya tombs was made especially to accompany the soul on its journey through the Underworld, Xibalba, a watery world that could be entered only by sinking beneath water or by passing through a maw in the surface of the earth.

The stuccoed body of this vessel is delicately painted with images of four chimerical creatures, each with a feathered. snakelike neck and head, a body containing the head of an aged divinity that may be Pawahtun (the god of the end of the year and bearer of the sky and earth), Spondylus shells for "wings," and bird feet. Each figure is distinguished from the others by a different form of decorative "wing" and by colors that indicate its directional orientation. The cover is adorned with a small, sculpted head, Maya in profile, having distinctive ear and nose plugs and an elaborate coiffure. The six glyphs on the cover represent a standard dedicatory verse found on ritual drinking vessels. The iconography, inscription, and very high quality of this vase all suggest that it was a ritual vessel containing the Maya chocolate drink, to be eventually placed in the tomb of a nobleman.

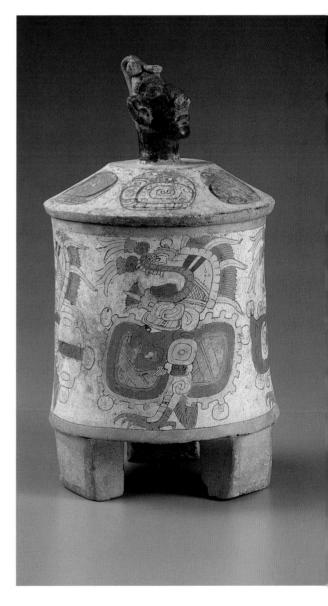

Vessel with a Mythological Frieze

Maya culture; possibly Guatemala or Belize; c. AD 550–950 Polychromed ceramic; h. 10¹³/₁₆ in. (27.5 cm); diam. 5⁵/₁₆ in. (13.5 cm)

Acquired in 2004

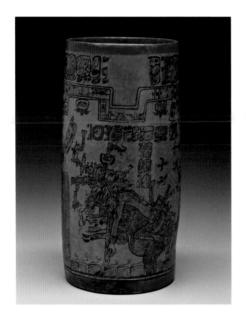

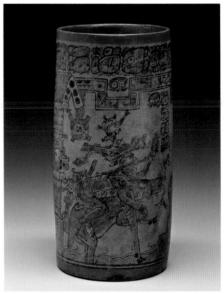

This tall vessel is skillfully painted with a unique mythological frieze depicting two renderings of the aged supreme deity Itzamna, the god of heaven and sun for the Yucatec Maya. One scene portrays the dying or wounded Itzamna lying motionless on the back of a peccary (wild pig), his head turned sharply upward. He is shown with his characteristic hooked nose and large goggle eyes, wearing a thickly padded loincloth and complex headdress with water lily, beads, and scrolls. Moving counterclockwise, a massive wood column incorporating janiform portraits of the jaguar god of the Underworld, with his spotted cheeks, separates the two renderings of Itzamna. The second scene portrays Itzamna energetically

straddling a deer and gesturing to a standing, aged figure (probably a personification of the deer god) who wears a striped cape and carries an upside-down canoe paddle in one hand while pointing with the other to a vaporous offering below. The entire scene is framed above with a stepped sky band enclosing stars and other celestial glyphic signs. Based on related vessels, the scene seems to pertain to a myth concerning the dying or wounded Itzamna being restored to life by the moon goddess Ixchel accompanied by deer, her alter egos. The rim text identifies the vessel as a drinking cup for cacao (chocolate), a beverage of the elite in the Classic period, and ends with titles for the lord who commissioned the vessel.

Codex-Style Vessel with Two Scenes of Pawahtun Instructing Scribes

Maya culture; possibly Mexico or Guatemala; c. AD 550–950 Ceramic with monochrome decoration; h. $3\frac{3}{4}$ in. (9.5 cm); diam. $4\frac{1}{8}$ in. (10.5 cm)

Acquired in 2004

This celebrated vessel depicts two scenes with the deity Pawahtun, a principal god of Maya scribes, in animated lessons with young disciples. Pawahtun is recognizable by his aged features and his netted headdress with a brush wedged into the ties. In one scene, Pawahtun is holding a pointer and reading from a folded codex placed in front of him. As he looks directly at the two individuals seated in rapt attention in front of him, he recites the bar and dot numbers attached to a speech thread, which may represent a date. In the second scene, Pawahtun hunches intently forward and taps the ground as he speaks to two similarly attentive pupils, an Ah k'hun (a keeper of the holy books), who wears a turban with the bundle of quill pens stuck into the top, and a second figure with a goatee. Pawahtun's spoken words appear as a group of glyphs connected to a speech thread that

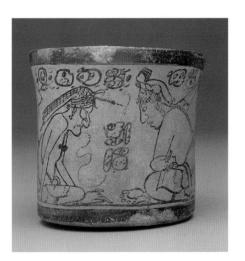

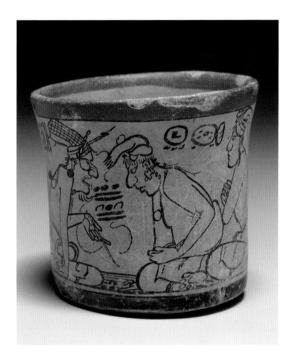

emanates from his mouth, which may be interpreted as "receive my bad omens." The Codex style takes its name from a small group of vessels painted with scenes of great realism in very fine monochromatic lines on cream backgrounds by artists who must have been primarily painters of codices, the folding-screen books that the Maya made from bark paper coated with stucco. These codex-style ceramics give an excellent idea of the high elegance and extraordinary delicacy that must have characterized ancient Maya books, none of which have survived from the Classic period.

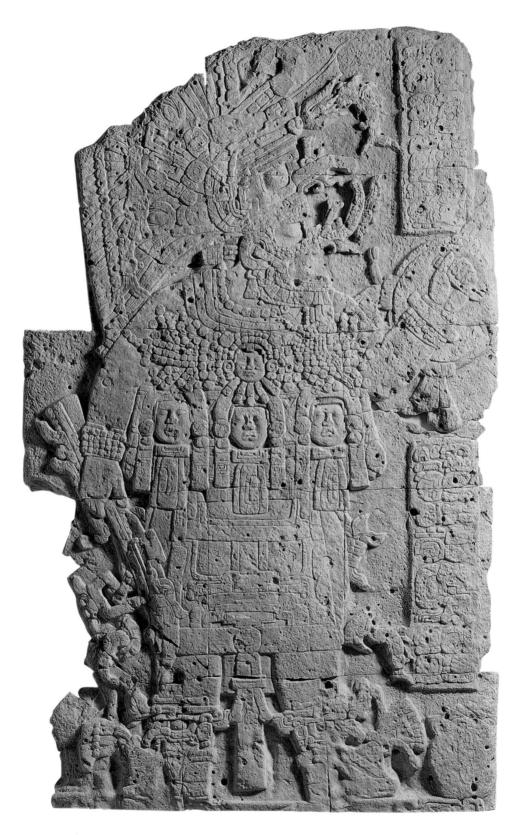

Stela with a Ruler

Maya culture; El Perú, Petén region, Guatemala; AD 692 Limestone: 107 3/8 x 68 3/8 in. (272.7 x 173.7 cm)

Acquired in 1970

The Maya were prolific makers of carved stone-slab monuments, or stelae, which were normally set up within architectural complexes and most often portray specific, named members of the hereditary dynasties that ruled Maya city-states. This imposing figure is identified by the accompanying inscriptions as K'inich B'alam (Sun-Faced Jaguar), ruler of El Perú, a Maya site in the Petén region of Guatemala. The principal event commemorated by the Kimbell stela is the ending in AD 692 of a *k'atun*, or twenty-year period, a date of special importance in the structure of Maya rulership.

The primary elements of K'inich B'alam's costume were intended to situate him not just locally and in his historic role but, more importantly, in his relation to the gods and the cosmos. The main headdress element, repeated in the ruler's anklets, is the head of the Water-lily Snake, a deity symbolizing standing bodies of water and the earth's abundance and patron god of the number thirteen. The several representations of fish leaping toward waterlily blossoms—at the top of the headdress and, less recognizably, at the back of the headdress and at either knee-reinforce this symbolism. Through these devices the ruler is shown as guarantor of agricultural success. The ruler's mosaic mask represents a jeweled serpent, and he grasps a round shield in his left hand, emphasizing the war role of Maya rulers; the ritual object in his right hand has not been identified. Partly hidden by the king's left thigh is a deified perforator, used by the ruler at important period endings like this one to shed blood from his penis as an offering to the gods.

Censer Stand with the Head of the Jaguar God of the Underworld

Maya culture; Palenque, Chiapas, Usumacinta region, Mexico; c. AD 690–720 Ceramic with traces of pigments; 44 x 22 x 12¹/4 in. (111.8 x 55.9 x 31.1 cm)

Acquired in 2013

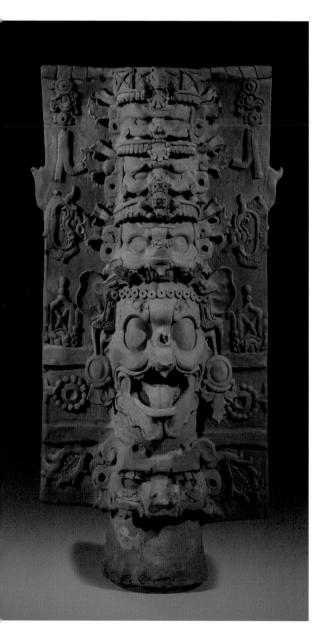

Monumental ceramic censer stands are some of the finest and largest freestanding sculptures created by Maya artists.

The sophistication and craftsmanship demonstrated in these stands are indicative of Palenque, an important Maya city-state located in current-day Chiapas, Mexico, that flourished in the seventh century.

During the reign of Kan Bahlam II (684–702), it was common practice to make offerings in these elaborate censers, nearly one hundred of which have been found in Palenque's Cross Group temples.

Ceramic censers (*incensarios*) were an important component of ritual paraphernalia and ceremonial life at Palenque. They were used to represent and venerate divine beings, primarily the deities of the Palenque triad (called GI, GII, and GIII). Censers were composed of a stand and a brazier-bowl (now missing), which was placed on top and used for burning copal incense. The stands were elaborately embellished with

Censer Stand with the Head of a Supernatural Being with a Kan Cross

Maya culture; Palenque, Chiapas, Usumacinta region, Mexico; c. AD 690–720 Ceramic with traces of pigments; 44% x $21\frac{1}{2}$ x $11\frac{1}{2}$ in, $(114 \times 54.6 \times 29.2 \text{ cm})$

Acquired in 2013

a variety of iconographic elements. These two censer stands are of the "totem-pole" type, characterized by a vertical tier of heads modeled in deep relief on the front of the cylinder. The principal head of each stand features a version of the Jaguar God of the Underworld (GIII) who represents the sun at night during its Underworld journey from dusk to dawn. The side flanges are decorated with motifs of crossed bands, serpent-wing panels, foliation, knotted bands, and stylized ear ornaments. Traces of the original blue, red, and white pigments are still present on the surface.

For the Maya, the center of the universe was the Axis Mundi, or World Tree, which had roots growing deep in the sea under the earth and branches that rose to support the heavens. Symbolically, the tubular bodies of the censers formed cosmic trees that made the movement of deities through the cosmos possible during ritual acts.

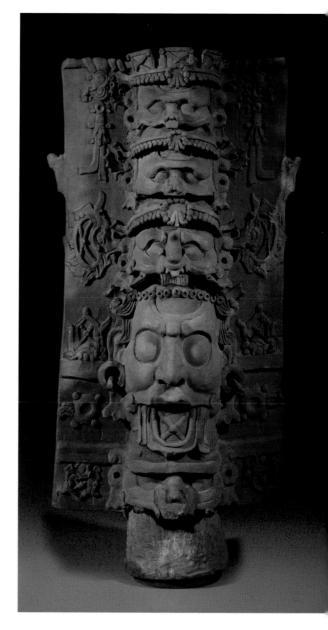

Vessel with Ceremonial Scene

Maya culture, Chocholá style; Campeche, reputedly from Jaina Island, Mexico; c. AD 690–750 Carved ceramic with traces of pigment; $8\frac{1}{8} \times 6\frac{13}{16}$ in. (20.7 x 17.3 cm)

Acquired in 1974

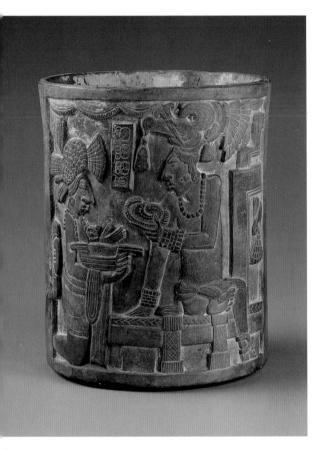

Several Late Classic period (AD 600–900) sites near Chocholá, Maxcanú, and Xcalumkín, in the northern Yucatan, have yielded vessels carved in a distinctive style known as Chocholá. Shapes include cups, straight cylinders with slightly flaring rims, and cylinders with rounded bottoms. The decoration is carved into the clay before firing; some also have postfiring pigment applied to the surface. Many bear carved imagery in a single scene on one side only, with text on the other side, often in a slanted column. Vessels in this style have been recovered from as far as Jaina Island, but must have been manufactured in the Chocholá area.

This vessel appears to depict a ritual being enacted in a sumptuous palace interior, indicated by the swagged curtain framing the top of the scene. A lord seated on a mat-topped throne hands over a fringed object, which may be a decorated mirror, to a kneeling attendant who is holding a bowl or basket. The lord wears an elaborate bird headdress that is pierced through the nostril with a stingray spine, the ancient instrument of ritual bloodletting. The boldly incised text on the reverse of the vessel is a Primary Standard Sequence, describing this as a vase for a certain kind of chocolate drink and ending with the patron's name, which includes the hieroglyph muyal, "cloud."

Vessel with Two Gods before a Mountain

Maya culture; Guatemala; c. AD 700–800 Carved ceramic with traces of red pigment; h. 6% in. (16.8 cm); diam. 6% in. (17.5 cm)

Acquired in 1980

The elaborate mythological scene on this vessel, carved in low relief in the leatherhard clay before firing, achieves at a smaller scale much the same effect as the Maya stone relief carvings. On either side of an inverted L-shaped panel of five glyphs, the Water-lily Jaguar and Chac face one another, paired as actors in a sacrificial death dance. Chac, the god of rain and lightning, is identified by shell earflares and a shell diadem, by his long hair gathered together and tied, and by his thunderbolt axe. He is seated before the so-called Kawak Monster. the head of a creature covered in reptilian scales, with half-closed eyes and a huge tongue that drops to the ground from its gaping mouth. This is actually the iconic form of witz, "mountain," and it seems as if the rain god, who dwells in mountain caves, has just emerged from his home. The Water-lily Jaguar is identified by a waterlily blossom or leaf on his head, death-eye cuffs and collar, and a pattern of spots on his body. While he is a jaguar, his motions and postures are, in most representations, those of a human.

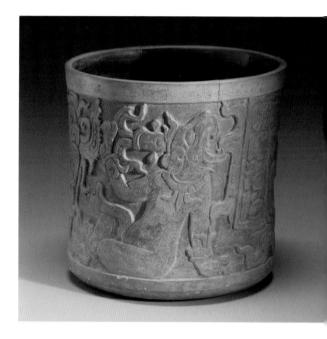

The scene represented is part of a now-lost mythic cycle in which the Water-lily Jaguar—sometimes in infantile form and usually lying on top of the mountain glyph—is sacrificed by the axe-wielding Chac. Since this episode does not occur in the *Popol Vuh*, the great Maya religious epic, its meaning still eludes us.

Rollout

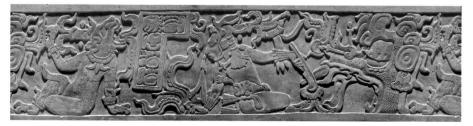

Vessel with Five Figures

Maya culture; Usumacinta River Valley, Chiapas, Mexico; c. AD 750–800 Polychromed ceramic; h, 10³/₁₆ in. (25.8 cm); diam. 6 ¹/₄ in. (15.8 cm)

Acquired in 1979

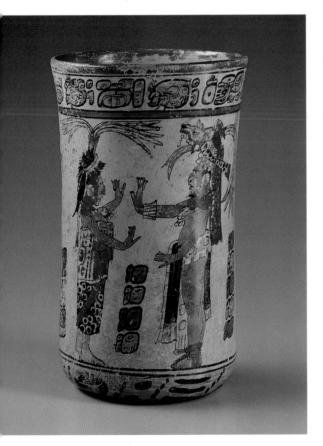

The painted vessels of the Maya rank conspicuously among their most impressive artistic achievements. The finest vessels, intended for the Maya elite, were elaborately decorated with sophisticated pictorial imagery. The wide range of subject matter includes scenes of Maya nobility performing public and private rituals, victories in battle or the ritual ball game, the natural environment, images of supernatural characters and mythical deities, and depictions of the Maya Underworld, called Xibalba, and its occupants. Many of these vessels were ultimately filled with the Maya chocolate drink and placed in tombs to accompany and nourish the soul on its journey through Xibalba. Pictorial vessels provide an idea in miniature of the richness of Maya mural painting, most of which no longer survives.

Three of the four Kimbell painted vases depict processional scenes, a common mode of representation on Maya vessels. On each side of the *Vessel with Five Figures*, a noble

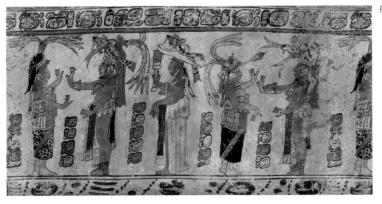

Rollout

Vessel with a Procession of Warriors

Maya culture; Usumacinta River Valley, Chiapas, Mexico; c. AD 750–800 Polychromed ceramic; h. $6\frac{5}{16}$ in. (16 cm); diam. $6\frac{5}{16}$ in. (16 cm)

Acquired in 1976

lord prepares to dance with a lady. While the two women are clearly differentiated in dress and facial expression, the opposing male figures may in fact be the same individual, as the facial profiles with goatee beards are identical. The lord's headdress features a band of jaguar pelt crowned by an animal head. Another male, standing between the two pairs of figures, is possibly an attendant. He holds a baton of a type that appears also in war scenes, here perhaps indicating his status. Just below the rim is the Primary Standard Sequence, a formulaic text that here describes the vessel as a vase for the chocolate drink; following it are the name glyphs of the vase's royal owner or patron.

The Vessel with a Procession of Warriors is one of three known pots assigned to the same hand; the Kimbell vessel shows the outcome of a battle depicted on the other two. An elaborately dressed warrior leads a captive—the naked figure with bound arms—for sacrificial display. The leader of

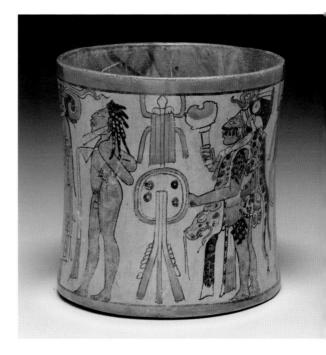

the party may be the figure wearing a full jaguar pelt and wielding a bloody weapon. The person in front of the captive wears a costume of cloth and paper strips studded

Rollout

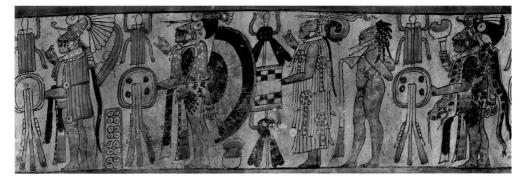

Vessel with a Ball Game Scene

Maya culture; Mexico or Guatemala; c. AD 700-800 Polychromed ceramic; h. 8¾ in. (22.2 cm); diam. 4¾ in. (12.4 cm)

Acquired in 1989

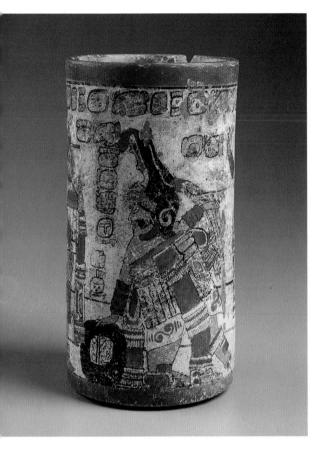

with bloodied medallions; he has a spiny bloodletter in his headdress and may be responsible for carrying out the bloodletting rituals. The fourth person wears a feathered cape and the petal cap characteristic of secondary figures.

The figures on *Vessel with a Ball Game Scene* are engaged in a ritual ball game commonly played in Late Classic period (AD 600–900) Maya cities. Their protective equipment includes a heavy wood-and-leather belt and kneepad. The figure with his hand on the ball sports a deer headdress, often worn by victorious ballplayers. The glyphic text in front of his head gives his name and describes him as a prince (*dnok*). The background shows the pyramid steps upon which spectators would have watched the game.

Far more complex in composition and spatial arrangement, *Vessel of the Ik' Dancer* is one of a series of vessels depicting the life of a king nicknamed the Fat Cacique,

Rollout

Vessel of the Ik' Dancer

Maya culture; "Painter of the Pink Glyphs"; Guatemala; c. AD 750 Polychromed ceramic; h. 8¾ in. (22.3 cm); diam. 4¾ in. (11.1 cm)

Acquired in 1985

ruler of the Ik' polity. The action is divided between the interior of a palace building raised on a low platform with two steps and an exterior plaza. Inside the building, Fat Cacique is seated on a throne with a huge pillow, both covered with jaguar pelts. On either side of him is an attendant, partly obscured by the doorjambs that frame the scene. A dark-skinned dwarf sits on the first step below, mimicking the gestures of the king. Three dancers stand in front of Fat Cacique before the blank outer wall of the building performing a ritual bloodletting dance on the plaza. Their white loincloths are spattered with blood from this ceremony in which they would perforate their genitals. As they whirled, blood would be drawn into the paper panels extending from their groins. The Maya elite routinely practiced such bloodletting as an offering to the gods, who had shed their own blood to create humanity. The blood of captives was also often shed to give to the gods.

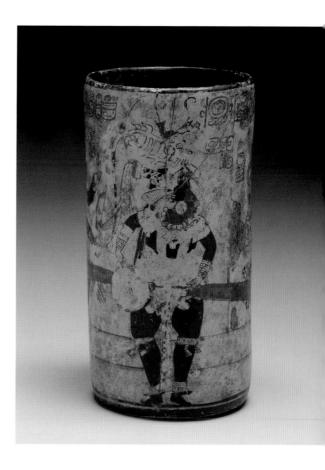

Rollout

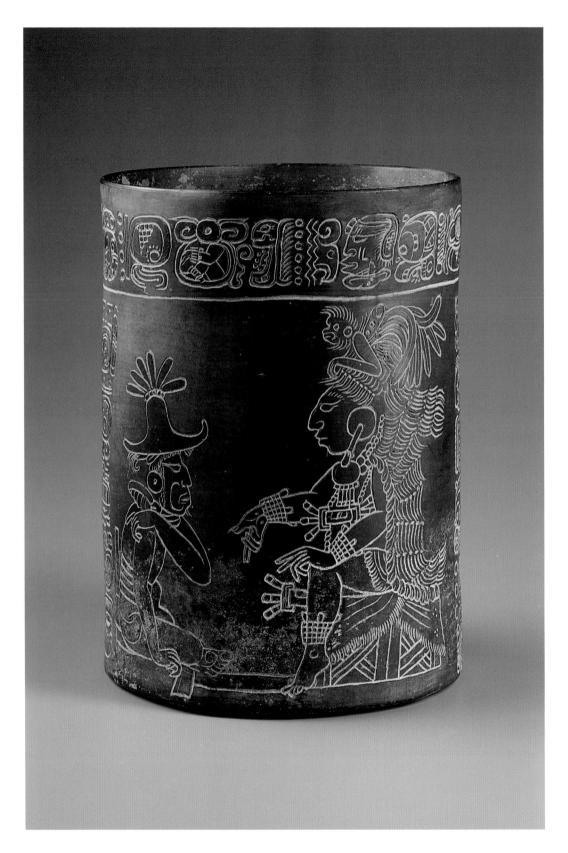

Vessel with an Enthroned Lord and Seated Figure

Maya culture; Xcalumkín, Campeche, Mexico; AD 765 Incised ceramic (fine gray-ware) with traces of red pigment; h. 9 in. (22.9 cm); diam. $6\sqrt[3]{4}$ in. (17.2 cm) Acquired in 2000

This vessel is decorated in the rare incised technique typical of the area around the city of Xcalumkín, in northern Campeche, Yucatán peninsula. It depicts a young lord—possibly the son of the reigning king of Xcalumkín—seated upon a low wooden basketry throne draped with a fringed jaguar skin. He is elaborately dressed in a luxurious fur or feather cape and wears a feathered headdress inside of which perches a stuffed monkey. The lord gestures with both hands toward the figure seated cross-legged before him on the floor, who is more simply clad in a loincloth with a broad sash, a scarf tied around his neck, and a brimmed hat

topped with six feathers. This plumed sombrero identifies him as a *sahal*, a military chief, usually a close relative of the ruler. The sahal's left arm crosses over his right shoulder in a gesture of loyalty, obedience, and submission to the lord. The glyphs in a horizontal register below the rim and in vertical bands on either side of the two figures define the "interior" space in which the meeting is taking place, most likely a palace. The hieroglyphic text to the left of the figures gives the year the vase was dedicated, AD 765, while the names of the vessel's owner and the reigning king appear along the rim.

Rollout

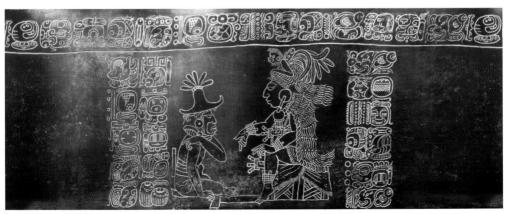

Standing Ruler

Maya culture; Guatemala; c. AD 600–800 Ceramic with traces of paint; $9\frac{3}{8} \times 3\frac{7}{8}$ in. (23.8 x 9.9 x 9.8 cm)

Acquired in 1984

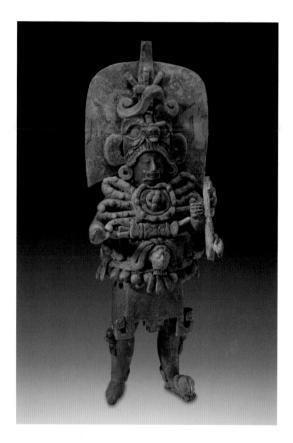

Among the greatest achievements of Maya art are their small-scale ceramic sculptures. Despite their diminutive scale, these are among the most fully realized of Maya sculptures in the round. Most known examples come from the cemetery island of Jaina, off the coast of Campeche, but high-

quality figurines have also been recovered from Palenque, in Mexico, and Río Azul, in Guatemala. In their extreme sensitivity and realism these exquisitely detailed figurines represent the apogee of Maya ceramic sculpture. Their role in Maya belief and ritual is not clear, but their common appearance in Maya burials suggests a ritual function of some importance.

The Kimbell's Standing Ruler represents a Maya lord costumed to impersonate a dynastic ancestor. The rectangular device over the mouth along with the shield in one hand and the now-missing spear in the other closely resemble the accoutrements of the nine ancestral figures in the sarcophagus chamber of Palenque's Temple of the Inscriptions. The ruler's wide belt once supported a rack of feathers across his back. and his knee-length apron is marked with a symbol of the World Tree, the central axis of the Maya world. Elements of the complex costume below the headdress recur in other portrayals of Maya rulers; these seem to define and reiterate his rank and position in the cosmos. As a complete three-dimensional representation of a figure type more familiar in low-relief stelae, this figurine is extremely rare. It may have been made to commemorate a rite performed by the king.

Presentation of Captives to a Maya Ruler

Maya culture; Usumacinta River Valley, Mexico; c. AD 785 Limestone with traces of paint: 45 % x 35 in. (115.3 x 88.9 cm)

Acquired in 1971

This carved and painted relief panel shows the presentation of captives in a palace throne room, indicated by swag curtains at the top. The five figures are the king of Yaxchilan, Itzamnaaj Balam III, seated at top left; his sahal (a military chief), Aj Chak Maax, at the right; and three bound captives in the lower-left corner. The glyphic text, which gives a date of August 23, 783, records the capture of a lord named Balam-Ahau by Aj Chak Maax and a sacrificial blood-letting three days later under the auspices of the ruler. The three prisoners may be scribes from a captured city, as the one seated in front holds a "stick bundle" normally associated with depictions of Maya scribes and all three wear headdresses with hun (book) knots. All but the leftmost captive are identified by name. The inscription on the throne front beneath the seated lord is carved with the king's name and titles, but the glyphs are inscribed in reverse order, from right to left. The name of the artist responsible for sculpting this relief appears on the vertical panel of four glyphs under the sahal's outstretched arm, perhaps indicating that the sahal was himself also the creator of this work.

The Kimbell relief, which comes from an unidentified site named Laxtunich, probably served as a wall panel inside

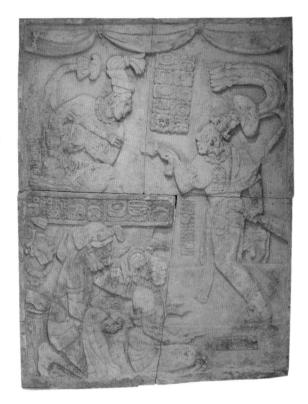

a Maya building or as a lintel over an entrance. Lintels as large as this often recorded significant dynastic events. It is assumed that their placement at points of transition between the outside, secular world and an inside, more sacred realm was of primary importance.

Xipe Totec

Nahua culture; Mexico; c. 900–1200 Ceramic; 15³/₄ x 6⁵/₈ x 3 ³/₈ in. (40 x 16.8 x 9.8 cm)

Acquired in 1979

Xipe Totec, the Aztec god of spring and regeneration, figures in many Mesoamerican cults. A fertility deity, he vividly conveys the concept of death and rebirth by wearing the flayed skin of a sacrificial victim. Meaning literally "our lord, the flayed one," Xipe Totec is also associated with the arrival of spring, when the earth covers itself with a new coat of vegetation and exchanges its dead skin for a new one. During the cornplanting festival, the god was worshipped by a priest who, dressed in the skin of a flayed victim, ritually enacted the deathand-renewal cycle of the earth. Xipe Totec was the divine embodiment of life emerging from the dead land and of the new plant sprouting from the seed.

In this sculpture, the face of a living being is seen behind the mouth and eye openings of the sacrificial victim, whose skin is laced together by cords at the back of the wearer's skull. Similar lacing is also seen on the chest, amid the vigorously articulated body covering. This work closely resembles Aztec stone figures in the smooth modeling, sturdy body, and rounded lips and eyes. Clay sculptures of Xipe are common in the pre-Aztec art found in Nahua areas such as the Valley of Mexico and southern Veracruz, where figures in a similar redorange clay have been discovered.

Rain God Vessel

Mixtec style; El Chanal, Colima, Mexico; c. 1100-1400Polychromed ceramic; $9\sqrt[3]{4} \times 8\sqrt[4]{4} \times 11\sqrt[4]{4}$ in, $(24.7 \times 21 \times 28.5 \text{ cm})$

Acquired in 1974

Mixtec culture, which came to prominence between 1200 and 1400 in northern Oaxaca, is noted for its extraordinarily skilled arts and crafts. Works in a broadly Mixtec style were made from west Mexico to the Gulf Coast and into the Maya regions. Sculpted figures are relatively rare in Mixtec art, which is generally twodimensional in form and is noted for its dense and brilliantly colored patterns, in contrast to the vigorously modeled and painted figures of west Mexico cultures. The complexity of the three-dimensional form and elaborately painted and incised surface of this vessel reflect a brilliant conjunction of west Mexican and Mixtec stylistic traits.

The Rain God Vessel represents an important aspect of Mesoamerican religious practice—deity impersonation—by which the gods were brought directly into the world of experience. The disguise portrayed in this piece is actually a double one of both warrior and rain god. In the ancient shamanic traditions of west Mexico, this crouching figure is a shaman warrior, positioned as if ready to leap. He holds a club in his right hand and has a shield attached to his left wrist; his entire head is engulfed in an animal-head helmet resembling a coyote. These are all appurtenances of the warrior, yet the small

size of the weapon and shield suggest a fight more symbolic than real. The mask covering the face is the other element in the double disguise, and relates directly to deity impersonation. The ringed eyes, long fangs, and mustache markings are traits of the rain god, worshipped widely throughout Mesoamerica from Olmec times onward.

Seated Man, Possibly Huehueteotl

Aztec culture; Mexico; c. 1500

Basalt; 25¹/₄ x 15¹/₄ x 12¹/₈ in. (64.1 x 38.7 x 30.8 cm)

Acquired in 1969

Around 1337, the Aztecs settled on an island in the middle of Lake Texcoco and named it Tenochtitlan (modern-day Mexico City) after their chief, Tenoch. Aztec society was militaristic and regimented, and their art and culture show a pervasive interest in ritual and the symbolism of death. Guided by a sense of divine destiny and a complex religion that included the practice of blood-sacrifice to ensure the daily reappearance of the sun and the survival of their people, the Aztec established themselves as masters over much of Mesoamerica north of the Maya area until the conquest by the Spanish in 1521.

The Aztec pantheon included a vast number of gods who encapsulated almost every function of time and life. Many of these deities were borrowed from other cultures and given a distinctively Aztec cast that reflected their political and social structures. The Kimbell's Seated Man was probably a local cult image and may have served as a guardian figure for the stairway of an Aztec temple platform. On ceremonial occasions, he may have held a banner staff in his right hand and perhaps wore a special costume. His sturdy body and coarse features indicate that he is an old macehualli, or man of the people. The bold facial scarification and more subtle. abstract patterns on the kneecaps, shoulder blades, and vertebrae suggest that he also represents the "Old God," Huehueteotl, the Aztec patron of fire and lord of the center of the universe.

Pendant: Twin Warriors

Conte style; Azuero Peninsula, Panama; c. 700–1200 Gold; $31/4 \times 4^{13}/_6 \times 1$ in. (8.2 $\times 12.2 \times 2.5$ cm)

Acquired in 1979

Pendant: Two Deer Heads

Conte style; Azuero Peninsula, Panama; c. 700–1200 Gold; $2^{13}/_{16} \times 4^{11}/_{16} \times 1$ in. (7.2 \times 11.9 \times 2.5 cm)

Acquired in 1979

The art of casting elaborate designs in gold had emerged in Panama by the middle of the first millennium AD. Gold became the primary prestige material in this region, and high-status individuals wore numerous ornaments in this material, which were later placed in quantity in their burials.

One of the most distinctive regional styles of Panama is that of the Conte group. In the *Two Deer Heads* pendant, the decorative elaboration above the deer heads is in fact an artful stylization—a pair of outward-facing profile heads of an important deity, a crested saurian. The long,

many-toothed snout of the crocodile is topped by a notched "crest" that alludes to the skin texture of the crocodile and other lizards. The eyes of all four heads were once inset with bone, amber, or hardstone. The pendant may have had a talismanic function, invoking saurian or other animal spirits that were believed to have a special protective relationship to the wearer.

The subject of the Twin Warriors pendant is one of the most central to the Conte style, rendered here with exceptional technical and sculptural skill. A pair of standing bat-human figures hold paddleshaped clubs in their outer hands. Each has a crested saurian head hanging from either side of its waistband. Their batlike heads are surmounted by what may be a pair of frontal birds, with simplified profile bird-heads at either side doubling as ear ornaments. These figures may represent warrior chiefs who were intermediaries between the earthly and cosmic realms. Pendants of this type probably functioned as emblems of status or as amulets.

Standing Dignitary

Wari culture; South Coast, Peru; c. AD 600–1000 Wood with shell-and-stone inlay and silver; $4 \times 2^{1/2} \times 1$ in. (10.2 \times 6.4 \times 2.6 cm)

Acquired in 2002

This rare Wari freestanding figurine is composed of intricate and densely patterned inlays of mother-of-pearl, purple and orange *Spondylus* shell, mussel shell, turquoise, pyrite, greenstone, lapis lazuli, and silver (for the headdress) on a wood matrix. The torso is cloaked in a long ceremonial

tunic decorated in an interlocking tapestry weave with three rows of a simplified and abstracted zoomorphic motif. The motif resembles a standing camelid (llama) with bulging chest but more likely depicts a downward-facing animal head in profile with an upright ear, curving forehead, and rectangular open mouth, which can be read as a feline (jaguar or puma) head. The wearing of a court tapestry tunic identified one's rank in the Wari empire, and the emphasis on the elaborateness of this costume suggests that the figure represented was a dignitary of some status. In life, tunics were worn as ceremonial garb, and in death they were placed over the wearer's mummy bale. In shell-and-stone inlay, the complex textile patterns of the tunic are inevitably simplified.

The corpus of Wari inlaid material is very small. This is the only published example of a freestanding figurine entirely covered in the inlaid shell technique, which is here particularly finely conceived and executed. The high-level craftsmanship and wide range of materials used in its manufacture indicate the presence in Wari society of an elite that could afford and appreciate such a luxury item, which probably served to convey the social status of the owner.

Acknowledgments

The text of this *Guide* has been written by current and former staff of the Kimbell Art Museum and Kimbell Art Foundation.

Colin B. Bailey

William B. Jordan

Jennifer Casler Price

Charles F. Stuckey

Brenda Cline

Timothy Potts

Ruth Wilkins Sullivan

C. D. Dickerson III Nancy E. Edwards

George T. M. Shackelford

Malcolm Warner

The text was edited by Eric M. Lee, director of the Kimbell, assisted by deputy director George T. M. Shackelford and curators C. D. Dickerson III, Nancy E. Edwards, and Jennifer Casler Price. The *Guide* was designed by Tom Dawson, museum designer, and copyedited by Megan Smyth, manager of publications.

Index of Artists and Titles

Abraham Leading Isaac to Sacrifice (Domenichine	0)67
Adoration of the Magi, The (Bassano)	59
L'Air (Maillol)	193
Allen Brothers (Portrait of James and John Lee Al	len),
The (Raeburn)	139
Amphora-Shaped Vase	235
Angel with the Superscription and Angel with the	2
Crown of Thorns (Bernini)1	10-11
Angelico, Fra (Fra Giovanni da Fiesole)	30-31
Anger of Achilles, The (David)1	46–47
Apollo and the Continents (Tiepolo)	120
Apostle Saint James the Greater Freeing the Magi	cian
Hermogenes, The (Fra Angelico)	30-31
Arhat and Deer2	64–65
Arhat Taming the Dragon	249
L'Asie (Asia) (Matisse)1	98–99
Bambaia (Agostino Busti)	52
Bamboo and Rocks (Tan Zhirui, attributed to)	245
Bamboo, Rock, and Narcissus (Chen Jiayen)	261
Barnabas Altarpiece, The	26–27
Bassano, Jacopo (Jacopo dal Ponte)	56–59
Bastis Master	2
Beauty in a Black Kimono (Torii Kiyonobu)	294
Beauty in a White Kimono (Rekisentei Eiri)	303
Bellini, Giovanni 34,	46–47
Bernini, Gian Lorenzo1	08-11
Birds and Flowers of Early Spring (Yin Hong)	255
Bodhisattva Khasarpana Lokeshvara	213
Bodhisattva Maitreya, The	22–23
Bodhisattva Torso 2	38–39
Boilly, Louis-Léopold1	42-43
Bonington, Richard Parkes	150
Boreas Abducting Oreithyia (Boucher)	133
Boucher, François 1	30–33
Bourdelle, Antoine	192
Bowl (Goryeo)	263
Bowl Carved with Design of Boys among Peonie	es
(qingbai ware)	242
Bowl with Bamboo Leaf Design (Ogata Kenzan)	

Bowl with Pampas Grass Design (Ogata Kenzar	1)290
Bowl with Secret Decoration (white ware)	251
Box with Courtiers, Carts, and Blossoms	291
Braque, Georges	184
Brygos Painter	12
Buddha Enthroned	224-25
Bust of a Young Jew (Rembrandt)	106-7
Butcher's Shop, The (Carracci)	62–63
Caillebotte, Gustave	.168–69
Canaletto (Giovanni Antonio Canale)	.118–19
Canova, Antonio	144
Canying Hall, The (Lu Zhi)	257
Caravaggio (Michelangelo Merisi)	64–65
Cardsharps, The (Caravaggio)	64–65
Carpeaux, Jean-Baptiste	161
Carracci, Annibale	
Cavallino, Bernardo	98–99
Censer Stand with the Head of a Supernatural E	Being
with a Kan Cross	337
Censer Stand with the Head of the Jaguar God	of the
Underworld	
Ceremonial Pedestal Stand	262
Cézanne, Paul	.176–79
Chardin, Jean Siméon	117
Cheat with the Ace of Clubs, The (La Tour)	82–83
Chen Jiayen	
Chibinda Ilunga	
Christ and the Woman of Samaria (Guercino)	72-73
Christ Blessing (Bellini)	46-47
Christ the Redeemer (Lombardo, attributed to)	45
Claude Lorrain 88–89,	
Clodion (Claude Michel)	
Coast Scene with Europa and the Bull	
(Claude Lorrain)	88–89
Cocoon-Shaped Jar with Cloud-Scroll Design	
Codex-Style Vessel with Two Scenes of Pawah	
Instructing Scribes	
Composition (Léger)	
Composition No. 8, with Red, Blue and Yellov	
1939–42 (Mondrian)	

Conch Shell Trumpet	328	Equestrian Portrait of the Duke of Buckingh	am
Constellation: Awakening in the Early Mon	rning	(Rubens)	78–7
(Miró)	196–97	Ercole de' Roberti	3
Constellation (for Louis Kahn) (Noguchi)	203	Exiled Emperor on Okinoshima, An	282
Coronation of the Virgin, The (Tiepolo)	121		
Corot, Jean-Baptiste-Camille	151, 160	Female Figure (Bastis Master)	4
Cortona, Pietro da	94–95	Female Figurine (Jomon)	26
Cosmetic Box (Goryeo)	263	Figure in a Shelter (Moore)	202
Country Road by a House (Wals)	75	Flask (Sue ware)	269
Courbet, Gustave	156, 164–65	Flat-Sided Flask (blue-and-white ware)	252
Court Lady	236	Flight into Egypt, The (Elsheimer)	60
Courtesan Playing the Samisen (Isoda Koryu	usai) 304–5	Fortitude and Unidentified Virtue, Possibly I	Норе
Cranach the Elder, Lucas	48–49	(Bambaia)	52
Crespi, Giuseppe Maria	116	Four-Armed Ganesha	21
Crouching Aphrodite	17	Four Figures on a Step (Murillo)	102-3
Crows (Maruyama Ōkyo)	296–97	Four Mandalas of the Vajravali Series	218–19
Cylinder Seal with Griffin, Bull, and Lion	7	Friedrich, Caspar David	152–53
Cylinder Seal with Winged Genius and		Fukurojin, the God of Longevity and Wisdom	
Human-Headed Bulls and Inscription	7	(Ito Jakuchu)	301
Dancer Stretching (Degas)	174	Gainsborough, Thomas	122–23
David, Jacques-Louis	146–47	Gauguin, Paul	175
Degas, Edgar	174	Geography Lesson, The (Portrait of Monsieu	r
Delacroix, Eugène	157	Gaudry and His Daugher) (Boilly)	142-43
Dentist by Candlelight (Dou)	101	Géricault, Théodore	145
Dish with Melon Design (blue-and-white v	ware)253	Gheyn II, Jacques de	70-7
Diviner's Mask	317	Gigaku Mask of the Karura Type	270-7
Domenichino (Domenico Zampieri)	67	Girl with a Cross (Braque)	184
Donatello (Donato di Niccolò di Betto Bar	di),	Girls on a Bridge (Munch)	189
attributed to	32-33	Glaucus and Scylla (Turner)	154–55
Dong Qichang	259	Gong Xian	260
Dou, Gerrit	101	Gossart, Jan (called Mabuse)	50-51
Douris	10–11	Goya, Francisco de	140-41
Duccio di Buoninsegna	28–29	Grand Canal, Venice, Looking toward the	
		Rialto, The (Bonington)	150
Earth Spirit	237	Greuze, Jean-Baptiste	125
El Greco (Domenikos Theotokopoulos)	68–69	Group Statue of Ka-Nefer and His Family	
Elsheimer, Adam	66	Guardi, Francesco	135
En no Gyoja	278	Guercino (Giovanni Francesco Barbieri)	72–73
Encar James	172 73		

Hachiman in the Guise of a Buddhist Priest	272	Landscape in the Style of Dong Yuan (Wen Jia)	258
Hals, Frans	74	Landscape with a Solitary Traveler (Yosa Buson)	302
Handled Dish (Oribe ware)	288	Lawrence, Thomas	148–49
Haniwa Seated Man	268	Le Nain, Louis (or Antoine?)	92–93
Harihara	220-21	Léger, Fernand1	85, 200
Head (Nok culture)	311	Leighton, Frederic	158–59
Head of a Woman (Sebastiano del Piombo)	54	Lion (Roman)	21
Head of an Athlete (Apoxyomenos)	14–15	Lombardo, Tullio, attributed to	45
Head of Meleager	16	Lord Grosvenor's Arabian with a Groom (Stubb	s)128
Head, Possibly a King (Ife culture)	312-13	Lotus Bowl (blue-and-white ware)	252
Heureux age! Age d'or (Happy Age! Golden		Lu Zhi	257
(Watteau)	114–15		
Horse and Rider	230	Madonna and Child, The (Bellini)	34
Houdon, Jean-Antoine	134	Madonna and Child, The (Parmigianino)	53
		Madonna and Child with a Female Saint and the	ē
Ideal Head of a Woman (Canova)	144	Infant Saint John the Baptist, The (Titian)	55
Interior of the Buurkerk, Utrecht (Saenredam)96–97	Madonna and Child with Saint Martina, The	
Isoda Koryusai	304-5	(Cortona)	94–95
Ito Jakuchu	300–301	Madonna and Child with Saints Joseph, Elizabet	h,
		and John the Baptist, The (Mantegna)	36–37
Jacob Obrecht	42-43	Maillol, Aristide	193
Jar in the Shape of a Stupa	234	Maison Maria with a View of Château Noir	
Jar with Floral Design (Arita ware)	287	(Cézanne)	178-79
Jar with Ribbed Decoration	229	Male Figure (Nok culture)	310
Jar with Sculptural Rim	266	Man in a Blue Smock (Cézanne)	176–77
Jar with Stamped Decoration	228	Man with a Pipe (Picasso)	182–83
Judgment of Paris, The (Cranach)	48-49	Manet, Édouard	170-71
Juno Asking Aeolus to Release the Winds		Manjushri on a Lion	241
(Boucher)	130	Mantegna, Andrea	36–37
Jupiter Among the Corybantes (Crespi)	116	Martyrdom of Saint Ursula and the Eleven	
		Thousand Maidens, The (Rubens)	76–77
Kaikei	274-75	Maruyama Ōkyo	296–97
Kano Shigenobu	283	Matisse, Henri	198–99
Kneeling Mother and Child	318	Meiping Vase (qingbai ware)	243
Kneeling Statue of Senenmut, Chief Steward		Meléndez, Luis	126
of Queen Hatshepsut	4-5	Mercury Confiding the Infant Bacchus to the	
		Nymphs of Nysa (Boucher)	131
La Tour, Georges de	82–83	Michelangelo Buonarroti	4041
La Tour, Georges de, attributed to	84	Miró, Joan	97, 201
Landscape (Gong Xian)	260	Mirror with Animals and Figure	233

Mirror with Dragons	240	Portia and Brutus (Ercole de' Roberti)	35
Miyagawa Choshun		Portrait of a Franciscan Friar (Bassano)	58
Mizusashi (chosen-karatsu ware)	289	Portrait of a Woman, Possibly Elizabeth War	rren
Modello for the Fountain of the Moor		(Reynolds)	124
Molo, Venice, The (Canaletto)	118–19	Portrait of a Woman, Possibly of the Lloyd F	
Mondrian, Piet	.186–87, 194–95	(Gainsborough)	122
Monet, Claude		Portrait of a Woman, Probably Isabella d'Este	e
Moore, Henry		(Romano, attributed to)	44
Mountain Peak with Drifting Clouds,	A	Portrait of Aymard-Jean de Nicolay, Premier	r Président
(Friedrich)	152–53	de la Chambre des Comptes (Houdon)	
Mucius Scaevola Confronting King Po	rsenna	Portrait of Charles Carpeaux, the Sculptor's I	Brother
(Cavallino)	98–99	(Carpeaux)	
Mukozuke (e-karatsu ware)		Portrait of Doge Pietro Loredan (Tintoretto)	60–61
Mummy Mask	18	Portrait of Don Pedro de Barberana	
Munch, Edvard	189	(Velázquez)	86–87
Murillo, Bartolomé Esteban	102–3	Portrait of Dr. Francisco de Pisa (El Greco)	68–69
		Portrait of Emperor Marcus Aurelius	20
Nao Bell	227	Portrait of Frederick H. Hemming (Lawrence	ce)148
Near Sydenham Hill (Pissarro)	166–67	Portrait of Georges Clemenceau (Manet)	170–71
Noguchi, Isamu	203	Portrait of Hendrik III, Count of Nassau-Bro	eda
Nude Combing Her Hair (Picasso)	180–81	(Gossart)	50-51
		Portrait of Heriberto Casany (Miró)	188
Ogata Kenzan	290	Portrait of H. J. van Wisselingh (Courbet)	156
On the Pont de l'Europe (Caillebotte)	168–69	Portrait of Mary Ann Bloxam, Later Mrs. Fr	ederick
Orpheus Lamenting Eurydice (Corot).	160	H. Hemming (Lawrence)	149
Ovoid Jar (Yayoi)	267	Portrait of May Sartoris (Leighton)	158–59
		Portrait of Miss Anna Ward with Her Dog	
Pair of Winged Deities	8–9	(Reynolds)	138
Parmigianino (Girolamo Francesco Ma	ria Mazzola)53	Portrait of the Matador Pedro Romero	
Parvati	215	(Goya)	140-41
Pastoral Landscape (Claude Lorrain)	112–13	Portrait Statue of Pharaoh Amenhotep II	ε
Peasant Interior with an Old Flute Play	ver	Portrait Study of a Youth (Géricault)	145
(Le Nain)	92–93	Poussin, Nicolas80	-81,90-91
Pendant: Twin Warriors	351	Presentation of Captives to a Maya Ruler	347
Pendant: Two Deer Heads	351	Priestess of the Imperial Cult	19
Penelope (Bourdelle)	192	Pythagoras Emerging from the Underworld	
Picasso, Pablo	180–83	(Rosa)	104-5
Pink and White Lotus	248		
Pissarro, Camille	166–67	Raeburn, Henry	139
La Pointe de la Hève at Low Tide (Me	onet)162–63	Ragamala Painting of Dhanasri Ragini	216

Rain God Vessel	349	Self-Portrait (Vigée Le Brun)	136–37
Raising of Lazarus, The (Duccio)		Selim and Zuleika (Delacroix)	
Red-Figure Cup Showing the Death of Per	ntheus	Shibata Zeshin	
and a Maenad (Douris)		Shoki Ensnaring a Demon in a Spiderweb	
Red-Figure Lekythos Showing Eros in the l		(Soga Shohaku)	298–99
of Archer (Brygos Painter)		La Simplicité (Simplicity) (Greuze)	
Rekisentei Eiri		Singing Priest or God	
Reliquary Arm		Skeletons Warming Themselves (Ensor)	
Reliquary Casket		Sliding Door Panel with Design of Imperial	
Rembrandt van Rijn	106–7	Plum Tree, and Camellia	-
Returning from a Visit (Zhu Derun)		Smiling Girl Holding a Basket	
Reynolds, Joshua		Soga Shohaku	
Ribera, Jusepe de		Spring and Autumn Flowers, Fruits, and	
River Rhine Separating the Waters, The		Grasses	292–93
(Clodion)	127	Standing Ancestor Figure	
Roe Deer at a Stream (Courbet)	164–65	Standing Bodhisattva	
Romano, Gian Cristoforo, attributed to	44	Standing Buddha	
Rommel-Pot Player, The (Hals)		Standing Buddha Shakyamuni	
Rosa, Salvator		Standing Dignitary	
Rough Sea at a Jetty (Ruisdael)	100	Standing Dog.	
Round Dish with Pommel Scrolls (tixi)		Standing Female Deity	
Rounded Bowl (Maya culture)	330	Standing Figure (Olmec culture)	
Royal Belt Ornament	329	Standing Oba	
Rubens, Peter Paul	76–79	Standing Ruler (Maya culture)	
Ruisdael, Jacob van	100	Standing Shaka Buddha (Kaikei)	
		Steep Mountains and Silent Waters	
Sacrament of Ordination, The (Christ Preser	nting	(Dong Qichang)	259
the Keys to Saint Peter) (Poussin)		Stela with a Ruler	334–35
Saenredam, Pieter Jansz	96–97	Still Life with Oranges, Jars, and Boxes of S	weets
Saint Matthew (Ribera)	85	(Meléndez)	
Saint Sebastian Tended by Irene (La Tour,		Storage Jars (Shigaraki ware)	
attributed to)	84	Storage Jars (Yangshao culture)	
Seated Arhat	250	Stubbs, George	
Seated Buddha with Two Attendants	206–7	Suffolk Landscape (Gainsborough)	123
Seated Figure (Olmec culture)	323	Supper at Emmaus, The (Bassano)	56–57
Seated Man, possibly Huehueteotl	350		
Seated Nyoirin Kannon	273	Tableau No. 1/Composition No. 1/Comp	ositie 7,
Seated Woman (Xochipala culture)	324	1914 (Mondrian)	
Sebastiano del Piombo (Sebastiano Luciani).	54	Tan Zhirui, attributed to	245
Self-Portrait (Gauguin)	175	Temples in Eastern Kyoto	